Educating for Art
critical response and development

by
Rod Taylor

LIME

Critical Studies in Art Education Project
Sponsored jointly by the School Curriculum Development Committee,
the Arts Council of Great Britain and the Crafts Council

 Longman

LONGMAN GROUP UK LIMITED

Longman House, Burnt Mill, Harlow, Essex, CM20 2JE, England
and Associated Companies throughout the world

© *SCDC Publications 1986*
Fourth impression 1988

This title, an outcome of work done for the Schools Council before its closure, is published under the aegis of the School Curriculum Development Committee, Newcombe House, 45 Notting Hill Gate, London W11 3JB.

ISBN 0 582 36152 4

Set in 10/12 pt Linotron Plantin

Produced by Longman Group (FE) Limited
Printed in Hong Kong

During a brief collaboration with David Hargreaves, he openly shared with me some of his research methods. It was he who led me to the means of eliciting from young people their innermost aesthetic thoughts and experiences.

This book is dedicated with gratitude to David Hargreaves, an educator extraordinary.

Rod Taylor

Contents

List of illustrations appearing with the text

Foreword

This book arises out of the work of the Critical Studies in Art Education Project. The aim of the Project was to explore the role and implementation of the teaching of art history and critical studies in secondary schools, and to link this to the use of external resources such as museums, galleries and art centres; the contribution which can be made within schools by visiting and resident artists and craftspeople; and the loan collections of art and craft objects.

The Project arose from our belief that the experience of pupils in art studies should be a combination of practical, theoretical and critical work. In 1981, when the project started, it was funded by the Arts Council and by the former Schools Council; shortly after the project began the Crafts Council expressed interest in being associated with the work and became a welcome partner in the enterprise – particularly valuable in that its contribution enabled the Project to continue for a third year.

The Project is therefore the result of a unique collaboration between three major organisations – the Arts Council, the Crafts Council and the former Schools Council, whose responsibilities were taken over by the School Curriculum Development Committee.

We were fortunate in obtaining the services as Project Director of Rod Taylor, Art Adviser for Wigan, who is based at the Drumcroon Education Art Centre. We pay the warmest tribute to his untiring work, to the stimulus the Centre provided and to the enthusiastic and generous support of the Wigan Education Authority, and in particular its former Director of Education, Charles Hopkinson.

This book represents the distillation of what was a short, intensive enquiry. Much has inevitably had to be omitted; the book is intended to serve as a starting point and source for ideas. It raises many issues for teachers to consider, giving fascinating glimpses into how pupils have responded to the experience of art and craft objects, and how they have developed an increasingly complex language with which to explore and gain insights into their work and that of others.

We hope that this book will interest all those concerned to foster and extend the aesthetic education of young people, and that it will encourage teachers and those in galleries, museums and other institutions involved in the arts to examine and develop their practice.

We wish to thank the many people who helped and supported the project throughout its development and in particular Pat Eastop, Christopher Green, Helen Luckett, Geoffrey Peaker, Maurice Plaskow, Martin Rogers, John Rowe, Lawrence South, Harman Sumray, Pat Van Pelt and all members of the working parties.

Arts Council of Crafts Council School Curriculum
Great Britain Development Committee

The views expressed in this book are those of the author and do not necessarily reflect those of the sponsoring organisations.

Acknowledgements

Many people contributed to and made possible the work and researches of the Critical Studies in Art Education Project. Though far too numerous to list in their entirety, the following must be mentioned.

The representatives of the three funding bodies who gave so generously of their time and who offered much invaluable support and advice; the Wigan Education Authority, particularly Charles Hopkinson, the Director of Education during the life of the Project, and Kevin Hampson his successor for his continuing support, so essential to the dissemination of the work of the Project. My colleagues at the Drumcroon Education Art Centre who have helped in innumerable ways. In particular, Bryan Edmondson's skilful adoption of critical studies approaches provided a constant flow of invaluable evidence, and Doreen Place, the Project secretary, was always willing to rearrange her schedules to meet the deadlines which arose at various stages during the writing of this book.

Members of the Project's Monitoring and Advisory Groups and the chairpeople and members of the Working Parties. The work of the following groups (their chairpeople in brackets) feature in this book: Berkshire (Pat Eastop), Cheshire (Chris Tyzack), Devon (Bob Clement, Annette Gridley), ILEA (Fred Palmer, Will Brereton), Leeds (Rod Wells), South Glamorgan (Ron George), West Midlands (Arthur Hughes), Wigan (Project Director). Bob Clement and Arthur Hughes for also organising numerous additional meetings and conferences because of their personal commitments to critical studies issues. Leslie Perry for acting as reader of the publication draft and Irene Macdonald for her perceptive work as editor.

The many pupils and students whose recorded testimonies are such an essential characteristic of this book, and the following art educators whose recorded statements are amongst those which feature in the text: Jill Archer, Anthony Barratt, Oliver Bevan, Frank Bowdler, Bev Bytheway, Bryan Edmondson, Barry Gregson, Wendy Hitchmough, Arthur Hughes, Nigel Leighton, Jan Liddle, Patrick McCormack, John McGowan, Frank Milner, Claire Newbould, Pat Powell, Tim Searcy, Jane Sellars, Dorothy Taylor, Roy Thomas, Georgina Walker, Rod Wells, Cen Williams.

The schools, colleges, galleries and centres which are featured in the text arising out of case study visits include the following:

Birmingham Polytechnic
Brentwood County High School, Essex
Brighton Polytechnic
Buckshaw County Primary School, Chorley, Lancashire
Cardinal Newman R C High School, Hindley, Wigan
Chesterfield School, Derbyshire
The Drumcroon Education Art Centre, Wigan
Fred Longworth High School, Tyldesley, Wigan
Golborne Comprehensive, Wigan
Greenhill School, Cardiff, South Glamorgan
Lamberhead Green Junior School, Orrell, Wigan
The Langley Furrow Gallery, Middleton, Rochdale
Leeds City Art Gallery
Littleborough High School, Rochdale
Milton Keynes Library Exhibition Gallery
Northampton Museum and Art Gallery
Padgate High School, Cheshire
Primrose Hill High School, Leeds
Rochdale Art Gallery
The Royal Grammar School, Lancaster, Lancashire
St John Rigby RC VI Form College, Orrell, Wigan
St Martin's College of Higher Education, Lancaster
The Tattenhall Centre, Cheshire
Tyldesley County Primary School, Wigan
The Walker Art Gallery, Liverpool
Worth Valley Middle School, Keighley, Yorkshire

Rod Taylor 1986

We are grateful to the following for permission to reproduce paintings and photographs:
Birmingham Museum and Art Gallery, opposite pages 243 and 258; Boyd and Evans, page 154; City of York Art Gallery, Milner-White Collection, Victoria and Albert Museum, page 89; Crafts Council, photo David Ward, page 162; J. P. Jacobs, page 41; David Labrum, pages 15, 113, 228, 230 and 251; Ian Macdonald, page 117; John McGowan, page 144; Munch Museet, Oslo, page 117; National Gallery, London, opposite page 35 (below left and right); Northampton Museum and Art Gallery, photos John McGowan, page 146; Michael Rothenstein (woodcut), page 85; Brian Shaw, page 179; Tate Gallery, London, pages 13, *SPADEM* and opposite page 35 (above right) *Redfern Gallery* (above left).

Introduction

The Critical Studies in Art Education (CSAE) Project commenced in September 1981 and ran for three years until the summer of 1984. It arose out of a number of major concerns which were being increasingly expressed about art education. These can be summarised as follows:

1 There was a growing concern that the emphasis on practical work in many schools had become so dominant that the contemplative aspects of art education had virtually disappeared.
2 There had been a consequent reduction in the amount and variety of verbal communication which takes place in the art department.
3 A belief was being expressed that individual creativity is best nurtured and developed in a climate which also emphasises 'judgement, rigour, knowledge', etc.
4 The majority of art teachers had rejected the art history lecture as the means of giving pupils an understanding of the visual arts and of art and craft objects. There was therefore a need to develop and clarify a range of alternative approaches.
5 Some art educators were stressing the importance of helping children to see that their own endeavours in art and craft exist within a broader context than the specific lesson itself.
6 There was a need for children's study of the arts and crafts to be undertaken through personal involvement rather than as a fact-learning exercise.
7 There was an increasing acceptance that practical activity alone does not necessarily lead to critical awareness and understanding.

Taking account of these concerns, at the outset of the CSAE Project six main aims were defined. These were:

1 To complement the essentially expressive nature of art teaching by developing the more reflective and contemplative aspects of the subject and by helping pupils to become more critically aware.
2 To develop and extend pupils' opportunities of studying original works of art and craft.
3 To develop closer working links between the education service and the art gallery and museum services so as to enable pupils to obtain the maximum benefit from experiencing works of art and craft first hand.

4 To explore methods and approaches which will enable pupils to develop a critical vocabulary, to enable them to express adequately the ideas and insights which reflect a developing awareness of their own work and that of established artists and designers.

5 To determine the basic resources an art department needs to develop the critical aspects of the subject: books, slides, filmstrips, etc., and original works of art.

6 To help schools develop (5) above in relation to the centrally administered resources available to art education, whether nationally, regionally, LEA or gallery-based, by way of museums' loan services, schools' picture loan collections, book/slide/film loan schemes, Artists-in-School schemes, etc.

Initially a jointly funded project by the (former) Schools Council and Arts Council of Great Britain, CSAE also became funded by a third body, the Crafts Council. The aims already made a number of references to the crafts, but in the event the Project's work came to embrace the whole range of original works in schools' loan collections, and also took account of Craftspeople-in-Schools schemes.

The aims inevitably led to conjecture about some of the possible eventual outcomes of the CSAE Project, that is if its principles could be successfully realised. Many of these outcomes have lifelong implications, and therefore it will not be possible to gauge them until well after the lifespan of the Project, but conjecturing about them was beneficial to some of the working procedures. Some eventual outcomes of the CSAE Project, then, could be that:

1 Its contribution will enable art departments to develop more sequential and coherent art courses.

2 Pupils will be more able to see their work in relation to that of others, rather than in isolation.

3 Pupils will become more skilled in discussing matters and articulating ideas relating to the arts and crafts.

4 Pupils' vocabulary should be beneficially broadened, both specifically in relation to art matters and generally through increased understanding and application of words which also have relevance in everyday usage.

5 Some pupils will begin willingly to read about art and artists, and the crafts and craftspeople.

6 Pupils will begin to admire and respond to works of art and craft which have been produced at different times and in different places.

7 Pupils' sensitivity to the world around them will be heightened through their understanding of artists' responses to that world.

8 An increasing number of pupils will willingly visit art galleries and museums.

9 Pupils will derive a lifelong interest in the visual arts, irrespective of whether they continue to be engaged in practical activity.

10 Pupils will come to see the arts as an integral and essential part of life.

A number of further important issues were hidden beneath the surface of these inevitably generalised aims and concerns. Some found the actual title, 'Critical Studies in Art Education', too cold and clinical for an area which would inevitably include feelings and emotional response. From the outset the Project Director was committed to an enquiry which would embrace all the means whereby children might be brought to a fuller understanding, awareness and enjoyment of the visual arts. It was equally important to consider whether or not children of all ages, intelligence and from whatever backgrounds might benefit from being regularly exposed to the visual arts. There was the problem of what, if anything, might be done for pupils who opted out of the subject at the various educational stages. The issue of examinations would need to be confronted. Though a great deal has been written over many years about the theoretical justifications for critical studies and its importance, and though most art department schemes of work make allowance for it by referring to pupils 'learning about their cultural heritage and the works of artists, past and present', these aims all too often remain words which are not translated into action. What, then, are the implications at both the initial and in-service levels for educators in both school and gallery work?

Accepting that the theory already exists but has not led to sufficient implementation in the classroom, there was little point in the Project simply summarising that theory or adding further to it. There was a need to draw together and pull out the essential elements of critical studies practice which were already taking place, and to stimulate further work of this nature. The efforts of the working party members and the individual schools, colleges, centres and galleries who have become involved in the Project have proved invaluable, as the wealth of detail and information about actual critical studies practice contained in these pages indicates.

Finally, in writing any art education syllabus or scheme of work, its course and logic are determined by the teacher's assumptions about what will happen, or is intended to happen, to the pupils as a consequence of their doing this or being taught that – but these assumptions are rarely put to the actual test. To this end, therefore, I have also sought out information and opinions from the consumers of art education – the pupils and students themselves. The reader will hopefully find it of value to be able to set their descriptions of what actually happened to them as a result of their art educational experiences against the methods and approaches adopted by art educators active in the critical studies field.

Part I
Motivation and Aesthetic Learning

Section 1 Critical Studies and the Present Climate
This section describes why critical studies are particularly important in the current educational climate. An account is given of the circumstances in which the CSAE Project was undertaken.

Attention is paid to present art education practices, the curriculum and organisational pressures upon schools and to the debate on the importance of the arts in education.

Other important factors taken into account are the needs of a multi-cultural society, the influence of a visually complex environment beyond school and the growing involvement of museums, galleries and external resource-providers in education.

The author indicates why emphasis has been laid on access to works of art in the original, describes the means by which pupil reactions and responses have been elicited and makes a case for the importance of clarifying the process by which children are affected by art.

Section 2 Hidden Interests
Using a case study based on an interview with Lara, the author examines the implications of certain pupils developing interests when they are deeply affected at a personal level by visual arts objects. He analyses what this means for the pupils, questions the validity of existing examinations as a way of evaluating such development and suggests steps teachers can take to make such pupil interests likely to form.

Section 3 Illuminating Experiences
This section begins with another case study, that of Lydia, illustrating the educational importance of art gallery and museum visits. Drawing upon existing research and describing the 'conversive trauma' theory, the author develops his ideas on the significance of 'illuminating experiences'. He traces the implications this has for the role of the school and the structure and content of courses.

Section 4 Aversive Experiences
In contrast to conversive or illuminating encounters, those experiences which

can cause pupils to react against art are considered here. Using pupils' accounts and his own observations, the author produces a critique of gallery approaches that can lead to such aversive reactions. He also shows that aversive experiences can be engendered in the classroom both in regard to art objects and to practical work.

Section 1 Critical Studies and the Present Climate

There is a world that exists beyond the individual, a world that exists whether or not he exists. The child needs to know about this world, to move in it and manage himself in it. The curricula of our secondary schools are filled with this world. Everywhere the child turns he encounters it in the brute facts of history, chemistry, mathematics, and so forth. There is another world, however, a world that exists only because the individual exists. It is the world of his own sensation and feelings . . . He shares [it] with no-one. It is the world of private space and of the solitary subject . . . If his existence in the world disturbs his being in ways that fragment him and render his relationships in the world emotionally confused or even meaningless, then he is ill-adapted, and no amount of intellectual grasp of logical or factual relationships will change that.

If the price of finding oneself in the world is that of losing the world in oneself, then the price is more than anyone can afford.[1]

Robert Witkin

Because of their belief that one of the primary concerns of art education is to facilitate personal expression, relating to the child's inner world, but allied to an equal conviction that the visual arts can and must be taught, many art and craft teachers find themselves having to attempt a precarious balancing act which many other subject teachers barely discern. It is hardly surprising that in practice the teaching of the practical aspects of the subject becomes separated into two sections, one dealing almost exclusively with the so-called 'basics', and the other with great emphasis on the pupil expressing him or herself, with the teacher now on the sidelines. These two extremes of visual arts education have always existed, but at a time when curriculum pressures have caused many schools to reduce the length of lesson times so as to increase the number of periods in a week, and when rotational practical timetables have put pressure on teachers to produce end-product artefacts, sometimes in as little as six-week compartments, the extremes have become exaggerated. When pupils therefore opt for Art as an examination subject they are frequently told that from now onwards the teacher is in an advisory role and it is their ideas that count. The teacher-controlled exercises of the lower school contrast starkly with the onus on the pupils to 'express themselves' in the upper school. This often causes pupils to resort to clichés drawn from the multi-media influences so prevalent in contemporary society – the helmeted skull, the bleeding eye, the swastika, the

eye with the teardrop, etc. The examples are endless but predictably derivative. The invigorating link with the whole world of art, craft and design, past and present, has been largely neglected.

That aspect of the subject traditionally known as 'art history and appreciation' used to be taught with confidence in the grammar schools, but virtually as an academic subject with great emphasis on dates, detail and quotable 'proven' facts. It was likewise taught, suggests Arthur Hughes, to potential teachers while art students, involving the objective transmission of 'a body of knowledge which is "out there", largely indivisible and unrelated to [the student's] personal artistic struggles'.[2] It is therefore this uncomfortable model inherited from the art teacher's own training which has been seen as the one to be used in the school context. Not surprisingly the majority of teachers working in, for example, urban comprehensive schools with mixed-ability art groups have rejected this model as irrelevant to their pupils' needs; it has come to be seen as the aspect of the subject to do with 'the brute facts' of the visual arts unrelated to pupils' needs and therefore seen as boring. Even at sixth-form level, many teachers select a variety of art and craft A-levels primarily on the grounds that their students can be entered for purely practical examinations, thus removing the need for an accompanying history and appreciation course.

In rejecting art history and appreciation lessons as such, though, many art teachers have failed to replace them with any systematic means of bringing their pupils to a broader understanding and awareness of the visual arts other than that which might come about through simply engaging in practical activity. Though practical involvement will probably always remain the central activity of primary and secondary school visual arts lessons, it should not exist in isolation. As is said in the Gulbenkian's report, *The Arts in Schools*, 'Participation and appreciation are complementary aspects of arts education: not one or the other, but both.' The word 'complementary' is not being used in a loose manner because, as the report points out, 'To come to know a work of art is to grapple personally with the ideas and values which it represents and embodies. By giving form to their own perceptions, artists can help us to make sense of ours.'[3]

In this process, the child comes to see a relationship between his or her inner world and elements in the world 'out there'. Hughes elaborates on this:

> Art, or an aesthetic orientation to the world, does several things. Firstly it transcends historical time – it closes the gap between past, present and future. Secondly, it does not treat the observer and observed as separate, nor does it separate the internal events of the observer from the events in the external world . . . the link between cause and effect cannot actually be perceived . . .

He suggests that such a view is at variance with the rational world of conventional Art History which is ruled by a concept of linear, historical time.[4] Equally important, consideration has to be given to the multi-cultural make-up of our society and the way it is reflected in many of our schools. The familiar chronological art history model is an awkward one through which to

communicate concepts of both time and place. Not only is the course content usually 'locked' within Western Civilisation, but it often inadvertently (as well as consciously) sets up the work of one nationality as being superior to that of another – even within the confines of Western Art – as it traces first one national strand through the centuries and then another. The works, and possibly the values, of other civilisations become momentarily relevant as they impinge on Western artists through their influence on Florentine, Impressionist or Cubist artists, but rarely figure as objects in their own right.

With these issues in mind, the CSAE Project has set out to explore the various approaches whereby children can be helped to that fuller awareness and understanding of the visual arts which, it is suggesting, does not necessarily come about through practical work alone. It therefore subsumes both the history and appreciation aspects of the subject, is concerned with the relationship between practical activity and the enjoyment and study of the works of others, and with children's abilities to be responsive to and able to evaluate the art and craft products of their peers and themselves.

Whilst accepting the importance of slides and reproductions to facilitate the everyday work of visual arts departments, the above concerns have led the CSAE Project to put considerable emphasis on pupils and students having access to works of art and craft in the original. To this end the unique collaboration between the Schools, Arts and Crafts Councils is not only concerned with funding, but also with the potential educational usage of art and craft centres, galleries and museums and the various resources which the Arts and Crafts Councils help to administer. The Project has therefore attempted to involve the staffs in art and craft centres, galleries and museums and those who administer school and museum loan resources so that two-way initiatives can be developed between teachers in schools and those responsible for running such services.

In this respect it is fitting that the host centre to the Project has been the Drumcroon Education Art Centre, administered by the Wigan Education Department. The 1903 building was previously a doctor's house and surgery and is situated close to the Wigan town centre. It was converted for its present purpose and began operating in November 1980, being officially opened by Sir Roy Shaw, Secretary General of the Arts Council, in December 1981. Begun as an LEA initiative prior to the existence of the CSAE Project, it was, nevertheless, envisaged as a focus for the type of initiatives which the Project is attempting to foster on a national basis. The Centre is open to the general public and all Wigan schools have access to its resources. Individual students and teachers make good use of its reference library facilities and school and college groups make visits to the gallery exhibitions, of which there are six relating to the school half-terms.

Artists and craftspeople regularly visit the Centre to practise and discuss in relation to their exhibited works, and in addition resident visual artists are based at Drumcroon for periods of up to a year. One such person is a Wigan teacher, for the authority seconds a teacher for a year at a time to work in the Centre as a resident artist or craftsperson. All Wigan teachers are invited to the preview of

each exhibition and the provision of a coffee lounge ensures that Drumcroon is an informal meeting place for teachers, though organised in-service meetings and courses are also undertaken. As a host centre, Drumcroon has furnished the Project with a great deal of valuable information through the evidence of individual pupils, students and teachers who make use of the facilites and through the observation and study of school groups in a gallery situation designed specifically to meet their needs.

An important, albeit brief, collaboration at an early stage in the Project was that with David Hargreaves, University Reader in Education and Fellow of Jesus College, Oxford, at the time. In *The Challenge for the Comprehensive School*, he cogently argues the case for arts subjects to be an essential part of the core curriculum in our secondary schools.[5] I have drawn extensively on his subsequent researches into how numerous people have, on the evidence of their own testimonies, developed a commitment to one or more art forms. The interviews from which he conjectures a theory of how an important aspect of aesthetic learning occurs were all undertaken with adults, but we conducted a series of similar interviews together at Drumcroon in September 1982, all of which involved students who were studying for A-levels at sixth-form level or who had recently gone into the higher education sector to study the visual arts on a full-time basis. I have subsequently conducted many interviews of my own, and have derived a wealth of material from pupils and students, particularly in the 14–18 age range. My informants, however, invariably also speak with clarity about experiences relating to the visual arts which go back to early childhood days.

Though there is a consistency in the interviews which many might find surprising, the procedure used is not a standardised one in which the same pre-determined questions are put in the same manner to each individual. The informants have normally been selected because one discerns a motivation and commitment in them towards the visual arts – they voluntarily work in their own time, they use gallery or library reference facilities of their own volition, they collect their own art books or they are determined to pursue a career in art, etc. The initial question is normally one which asks them to recall their earliest memories relating to the visual arts. The second question is usually determined by their first answer, so the interview is essentially autobiographical and is in no way to do with the ability to answer questions which imply an understanding of a set body of knowledge.

The interviews might even be classed as conversations except that my contribution in terms of number of words spoken or percentage of time utilised in talking is very small indeed. Each interview is of varying length, and continues until the person in question feels that he or she has given adequate expression to what they wish to say. Though many of the pupils and students interviewed were chosen because one discerned in them that there was already an interest in the visual arts, others – Andrew for example – were chosen completely at random or, as in the case of Lara, because they asked to participate.

The consistent element in interview after interview in which individuals talk about responses to visual arts objects is that of identification or empathy with the object(s) in question, and this 'personalising' process is an essential factor in Hargreaves' writings – what he refers to as 'sense of revelation'. Though I have naturally drawn heavily on his work, having collaborated with him, many other writers on the arts have likewise put great emphasis on this identifying process, and I believe it to be the essential ingredient which determines whether the pupil dutifully learns about the visual arts or whether he or she becomes personally involved in them in a motivating manner. Wittgenstein, Roger Fry, Herbert Read and Louis Arnaud Reid, for example, have all written persuasively on this subject, as when Roger Fry observes that

> It may be objected that many things in nature, such as flowers, possess these two qualities of order and variety in a high degree, and these objects do undoubtedly stimulate and satisfy that clear disinterested contemplation which is characteristic of the aesthetic attitude. But in our reaction to a work of art there is something more – there is consciousness of purpose, the consciousness of a peculiar relation of sympathy with the man who made this thing in order to arouse precisely the sensations we experience. And when we come to the higher works of art, where sensations are so arranged that they arouse in us deep emotions, this feeling of a special tie with the man who expressed them becomes very strong. We feel that he has expressed something which was latent in us all the time, but which we never realised, that he has revealed us to ourselves in revealing himself. And this recognition of purpose is, I believe, an essential part of the aesthetic judgement proper.[6]

Many who are involved in the visual arts will readily recognise the truth of Fry's observations, but such theoretical statements have invariably remained separate from the everyday problems of the classroom teacher. I have deliberately incorporated into the fabric of the book many of the statements made by the students themselves to illustrate that quite young children – in possibly rather surprising numbers! – can be susceptible to these experiences. Their own words transform what might remain as theoretical niceties into forcible reality. Some of the material revealed through the Project's researches does, I believe, have important implications of a general educational nature, emphasising aspects of adolescent development through growing personal awareness. Likewise, I believe that many of the recommendations in *The Arts in Schools* could revitalise many areas of the school curriculum, rather than just being applicable to arts subjects, if sensibly applied. However, Fry does put his finger on the essential element which separates, for example, the enjoyment of a flower show or a commitment to horse riding from the need for education to guide pupils sensitively to aesthetic insight and awareness.

If art teachers have to attempt a balancing act between the imparting of skills and the drawing out of personal responses, the pupils too are demanding in this respect. Many pupils who appear to accept their art departments' diet passively express extremely strong opinions about that same diet in the interviews.

Though they accept a passive role as the history teacher, for example, imparts information for future examination-day regurgitation they emphasise that the art room is one of the few places in school where their own ideas should also count. In relation to the degree that this demand is met, many of the pupils describe opting out or going through the motions. 'At the end of the second year I never thought that I would opt for art in a million years!' observed one young woman after describing the various tedious exercises which she had had to do throughout the first two years of secondary art. It is possibly not surprising, therefore, that so many of these youngsters describe a quite separate, and often private, practice of art done at home. They frequently describe this as being 'just a form of personal expression'. Ranging from what is possibly little more than therapeutic doodling to quite unusual interests and commitments, it features so largely in the interviews as to be of considerable significance. I have called this practice 'Home Art' and believe that it has some important implications for the art teacher. In its strongest forms it can be as motivating as the sense of revelation through the kind of gallery experiences referred to earlier. The feelings and impulses which underlie this work relate to the personal qualities which the pupils and students feel should be intrinsic to art education at all its stages.

The CSAE Project began in September 1981 when the morale of the teaching profession was low. Education services had been a high priority for financial cutbacks in the drive against public expenditure, and there was a strong feeling amongst teachers that society no longer held the belief that education was a necessity for its future health and well-being. Arts teachers felt particularly vulnerable. Successive government papers made only passing and fairly dismissive reference to the place of the arts subjects in the curriculum and though the DES 11–16 curriculum investigation identified an aesthetic/creative element as being one of the eight areas of experience which should be an essential element in general education throughout 11–16 schooling, in much of the resulting practice *any* practical activity was deemed to be aesthetic/creative. Falling rolls appeared to be having a disproportionately damaging effect on arts departments, threatening the very existence of music and drama in some schools, and seriously affecting the work of visual arts departments through a return to over-large groups and a reduction in the range and variety offered.

Witkin contrasts the brute facts with which so much of the school curriculum deals with that world which exists only because the individual exists,[7] and Professor Leslie Perry observes that there are three categories into which subjects traditionally belong because of 'a tendency to grade subjects in importance according to their *knowledge* content.' In this respect art, craft, music and drama all belong to the third group and 'are constantly called upon to justify their existence, and are widely judged to be doing a minor function' and in 'times of economic stringency the question whether such subjects are necessary, or on such a scale, or in such a form, is raised as a recurring procedure. Hence . . . the uproar, disturbance and pressures at present around creative subjects.'[8]

Some have suggested that a project relating to critical studies, with an inevitable emphasis on necessary resources, must be badly timed in these circumstances but there is considerable evidence that many art teachers and gallery education personnel have found the accompanying reappraisal and raising of consciousness it has generated to have been both necessary and re-invigorating. *The Arts in Schools*, published during the life of the Project, in cogently arguing the case for arts subjects to be at the core of both the primary and secondary curricula, has made an invaluable contribution.[9] It emphasises that to fail 'to involve children in the arts is simply to fail to educate them as fully developed, intelligent and feeling human beings' because the aesthetic and creative is one of the 'distinct categories of understanding and achievement' as exemplified by music, drama, literature, poetry, dance, sculpture and the graphic arts. It further emphasises the whole area of value judgements which the arts can develop and sees our schools as 'agencies of cultural education', but with the children as active participants. It means enabling children to 'get their coats off' and to 'do' the arts themselves and to 'give pupils a sense of excellence and quality in human achievement' through acquaintance with 'the finest creations of the eyes and ears, hands and mouths of men and women [of] those works that have proved to be of enduring worth'. The report continually stresses the balance between these two inter-related aspects of 'doing' and 'knowing'.

The CSAE Project, looking at one major area represented in *The Arts in Schools*, has in fact, been well-timed in that it has acted as a focus for the present debate among art teachers about the 'relative emphasis given to making and doing art on the one hand, and learning about art on the other'. The DES publication, *Art in Secondary Education, 11–16*, likewise published during the life of the Project, also notes that, in the schools which it observed:

> There is no doubt . . . that there is evidence of a change in thinking about the balance of the art curriculum. Many of the schools . . . while producing artefacts of great quality, also lay stress on the need to educate their pupils to know about the work of other artists and designers both past and present and to be articulate in the judgements they make about them.[10]

Further evidence of this change in thinking is demonstrated through the interest and support which so many teachers, gallery staff and others involved in art education have shown in the CSAE Project. Related conferences and meetings have been well-attended, audiences and course members often exceeding a hundred. Some of the work involving members of working party groups is documented in Parts IV–VIII of this book, as is that of some individual schools, galleries and centres who have been involved from the outset because of their already existing belief in a way of working related to that of the Project. Each of the case studies used in Parts IV–VIII has been chosen to make one or more specific points, meaning that a great deal of equally relevant material which also reflects those points has had to be left out; the examples chosen all reflect good practice but are not meant to be seen as being the only ones. As it has gathered

momentum, though, the time devoted to the application and implementation of CSAE ideas and principles by members of the numerous working party groups around the country, and the work of those involved in in-service and the training of art teachers, has been most gratifying and will certainly continue and develop beyond the lifespan of the Project. Being one individual with responsibility for a national project, I have inevitably had to rely greatly on the commitment and support of other people. To generate the interest already referred to above, many art advisers, lecturers involved in the training of art teachers, etc., have borne the brunt of advertising and organising many memorable meetings and conferences. Likewise, chairpeople and working party members have worked hard to sustain their groups in the task of making headway in an art curriculum area which has inevitably posed difficulties through having fallen into such neglect.

Though the Crafts Council's involvements include areas which correspond to the work of school craft, design and technology and home economics departments, a decision had to be taken to restrict craft investigations to those which impinge most upon the work of the school's art department. To avoid superficial breadth at the expense of depth, other decisions had to be taken. Any study of how learning in the visual arts takes place, or might take place, inevitably provokes the question as to what 'Art' should be involved, and many important avenues have inevitably had to be neglected or have only been touched upon in passing. The recently concluded 'Art and the Built Environment' Project put considerable emphasis on the critical appraisal of the man-made environment, and there is certainly scope for a future project to look at the whole field of design in the modern consumer society. Equally, the effects of multi-media communication impinge on any investigation into education and the visual arts and could form the central point of reference for a similar study. The two 'Home Art' examples used in this book show the impact which comics and animated cartoons have had on two youngsters, but the all too prevalent art-room use of magazine photographs and imagery often leads to 'easy' lessons which have contributed to fragmentation of courses and the separation of much classroom art activity from other aspects of art and craft in the world at large. The immediate results promised by many of the children's television programmes specialising, as they invariably do, in instant slick techniques are equally illusory and harmful.

Likewise, even if familiarity does not always produce contempt, it can blunt responses and lead to passive acceptance. Many children have seen certain works of art reproduced many times in many different ways and contexts long before they might see those actual works in the original – this is reflected in many individual students' responses in this book – and there are implications peculiar to modern life involved in this situation. Possibly the most popular book in the Drumcroon library is *Photorealism* (Abrams, 1980) in which all the works are developed from photographs but often enlarged considerably, for example to 9′ × 6′ canvases in the case of some Chuck Close portraits. In the book those paintings are then reproduced having reverted back to the size of the

photograph from which they derived! Patrick Hughes makes us aware of the many complexities in this field, most of which we now take so much for granted, in the caption he provides for his *Print of Prints* (1982) reproduced in the book *Behind the Rainbow*: 'On the opposite page is a four-colour lithographic reproduction of a colour photograph of a fourteen-colour screenprint made from a collage of reproductions of photographs of earlier prints.'[11]

The principles underlying how children can be demonstrated to have become meaningfully involved in the visual arts during the CSAE Project are, I believe, applicable to all its aspects. At one meeting, a teacher made a criticism to the effect that too many of the examples cited involved gallery works in frames. She illustrated her point by saying that she had recently taken a group of fourth-form pupils to a major gallery and they had been bored to the point of hostility. Subsequently, though, they had been excited on coming across a shiny chrome motorcycle on display elsewhere. One would have been surprised had they not been responsive to the motorcycle – which obviously provides a legitimate source of stimulus for further work and is worthy of study as a functionally efficient designed object in its own right – but the appropriate preparation and support in the gallery could have helped to make the time spent there equally significant. Considering the almost infinite variety of visual imagery to which children are now subjected, it is fascinating and important that a small, non-functional painted canvas or woven hanging on a gallery wall can still assume such an influential significance for many youngsters, once their interest has been aroused; this is an important educational matter which has been neglected for too long. Rather than inhibiting the teacher by too much debate as to what 'art' their children should be studying, it is essential that some such study should become a matter of course. This study should obviously

embrace a variety of art and craft objects, past and present, and should include examples of Western Art and of other cultures and peoples.

The students' testimonies reveal that once they have begun to enjoy certain works, their appetites are invariably aroused for further and increasingly diverse explorations – and these often extend well beyond schooldays. At a time when the majority of children leave school relatively unaffected and untouched by the art of others, it is important that the criteria whereby this process is set in motion are clarified and built upon. Though a great deal has been written about the importance of the appreciative, historical, cultural, and critical aspects of art education, there has traditionally been a gulf between the teaching of the theoretical and practical strands of the subject. The insights into the young adolescent mind which Lara reveals suggest that the attempt to bridge this gulf might be a worthwhile exercise.

Section 2 Hidden Interests

Critical studies approaches – all those means whereby pupils can be led to an understanding and enjoyment of the visual arts – are generally lacking, or are at

best only haphazardly applied, in most day-by-day teaching. In consequence the methods of eliciting insights or interests about the subject from pupils remain similarly under-developed. In their absence, it is frequently assumed that pupils of secondary school age have no valid responses to offer. And yet when these responses are sought they can reveal important interests: important because they are perceived by the pupils as relevant to their needs, making them highly motivating in a way that much classroom learning unfortunately is not, for the pupil has the desire to repeat or build upon the experience. Once revealed, the hidden interests of pupils like Lara are surprising to many art educators.[12]

Lara was just completing her fourth year in a South-East secondary school when I met her in July 1983. She was in an art lesson, and the school has acquired a reputation for the quality of its art department and the standards which have been achieved. I was questioning a number of individual pupils about their attitudes and awareness to art, and the art staff were also introducing me to particular pupils whom they thought might have something significant to contribute. When I had interviewed the last such pupil in this group the Head of Art came and told me that I had not finished yet because a pupil called Lara was adamant that she wanted to talk to me. The teacher added that she could not recollect this pupil ever speaking in an art lesson and that her work was not very good. Though she would never have picked her out herself and though there would probably be nothing in it for me, she would appreciate it if I spoke to Lara, as the girl was so insistent. I naturally agreed, explained to the pupil who I was, why I was in the school, etc., and then I switched on my cassette recorder. Lara is the only pupil, in this context, to whom I did not put an initial question, for she spoke first. The conversation then unfolded as follows:

LARA Well, I'm going to the Tate Gallery soon to see the Cubist Exhibition with my friend Liz, because I'm interested in the Cubists, I think they're good. We went with the school as well to the Tate.

ART* How do you come to be interested in Cubism?

LARA Well, I don't know. I just saw a couple of their paintings. I saw some in the Tate and I saw some in a book.

ART Do you look at art books generally?

LARA Yes, my dad has a whole set of different painters – Seurat, van Gogh, and people.

ART Oh, so your dad is interested?

LARA Yes – up to a point. I'm not sure that he's really interested. He just likes looking at them. It's more me who's really sort of interested. He was given the books. He doesn't really sort of feel it, he just looks at it and says, 'Oh, that's quite good', but he doesn't really – he wouldn't try and get any other books and read up on it or go to galleries or anything.

ART You said, 'He doesn't feel it'?

LARA Yes, he doesn't really. I sort of look at a picture and I can sort of see what is happening, and then you look at it for longer and it just becomes something else.

* Author's initials

ART It becomes something else?

LARA Well, it just becomes more as you look at it more, and you see more as you look at it more, and it just sort of carries on – I can't explain really!

ART So you 'feel' pictures?

LARA Yes. You don't just look at them and say, 'That's quite good', you have to feel something for them, feel you like them or feel sadness in them or feel happiness in them or something like that.

ART Does your father admire them for their skill then?

LARA Yes, I think that's more it. He just looks for skill in pictures – he doesn't look for anything else – just skill.

ART Are there some artists your father doesn't admire then?

LARA Yes, like some David Hockney pictures. I like David Hockney's paintings. Well, my dad, some of them he doesn't think they are good because they don't actually look like the thing he's drawing. It's like Modern Art!

ART So he doesn't like Modern Art?

LARA No – No –.

ART Because he thinks that anybody can do it?

LARA Yes – that's the thing. I think some Modern Art anyone *can* do, like the ones just of squares and the pile of bricks in the Tate and that sort of thing. There are some Modern Art pictures that not anyone could do, not anyone could even think them up. Like, I think, George Grosz, the German painter – Surrealist is it, Expressionist? I was watching the television programme and he was on there, too, and I saw one of his pictures in the Tate. It's Modern Art, but it's just got something to it! Like the picture of the married couple – it doesn't actually show two people walking down the street, it just has the feel of two old people together and it just shows it. It doesn't show it as a photographic painting but it has the feel.

ART Did anything else in the Tate stand out particularly?

LARA There was one picture – I don't know who it was by or what it was called – it was done on wood. It was sort of raised. There was a diamond in the middle, and then outside there were the four triangles to make up the square, and I think the diamond was of an old man and a woman. You saw them from a top view sitting in a lounge or something. Then the four triangles around the edge were of the man at his different works – shopping, and working at something or other, I'm not really sure.

ART You particularly liked that. Why?

LARA Well, you sort of saw this little old man and lady, and it was drawn in a way that it – it wasn't photographic – but it just sort of depicted the little old man and lady with their wrinkles and her flowery dress and that. And it just really showed it – showed – oh, it's difficult to describe, but that was one that really stuck out in my mind.

ART It's by Anthony Green, the painting that you have described.

LARA Is it?

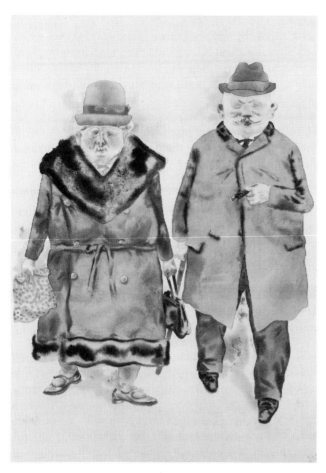

George Grosz, A Married Couple, *1930.*

ART Do you enjoy doing art yourself?

LARA I do. I think I prefer it out of school than in school, because I like doing things out of my imagination. I don't particularly like copying things. I prefer thinking up something and getting it down on paper and then getting on with it. I went down the Kings Road not long ago in London, where like the punks and things are. There's like a particular type of people that go up there and I just sort of remembered them and put them down on paper. A person with a beret and spiky hair coming out at the front and a long coat on. I just remembered it from being up there and I just put it down on paper.

ART So it was based on what you had seen?

LARA Yes – what I had seen, but at the same time it wasn't just copying, sort of thing.

ART So what you are doing now in class, working from a model, is what you

regard as copying?

LARA Well, no. In a way it's like copying the person. I dunno, I prefer seeing something and then thinking about it, and then putting it down on paper without having it in front of me.

ART Do the two relate? Or is what you do at home quite distinct from what you do at school?

LARA Well, it's distinct in not having got a reference in front of me that I can refer back to, and if something goes wrong with it then I can just sort of correct it, and I can just use any colour that I want. I don't have to use the colour that's sort of sitting there.

ART Do you think the things you like doing at home, you should really be doing in school?

LARA No – No. Because some people, I don't think, can just put something down on paper that they've thought up. I mean, I'm not good at it. I'm not saying I'm good at it, but I can just put it down without having it in front of me. Some people – I mean, the better people in our class, the ones who are really good – they're the ones who are better at having something in front of them and they can just put it down as they see it. I think that's different to thinking about something and then putting it down.

ART So why is one better than the other? You say 'the better people'.

LARA Yes, the people who – well – who can actually draw. They can just copy something so far as it is, whereas I'm not very good at that, but I'm better at just putting something down. Just say, like, you've got the image of it – not so it looks exactly like the thing but so you can see it, you can see what it is. A bit like a cartoon drawing, I think. You can see what it is, and some bits are exaggerated and some bits aren't, and it's not sort of photographic.

ART You've described a George Grosz and an Anthony Green from the Tate, and you've described what you like doing. Is there a connection between the two in your mind?

LARA I think so. Because, well, the way they draw it doesn't look like they've just gone out and copied something as it is. I think they've just – I don't know if they have actually done actual studies of people – but theirs are more – they've get something in them and you can see what it is and it's – oh, it's so difficult – I don't know, there's just something about them. It doesn't look as if totally copied. It's got something to it – it's got something to it that isn't just there like as if it's been posed.

ART So those are the things that you are attracted to in the gallery as well as being what you like doing –?

LARA Yes. Definitely![13]

How many pupils like Lara remain unidentified, and with them their specific needs, in art rooms? I have quoted this first section of the conversation with Lara in full, all the questions and answers unedited, because it gives such a vivid insight into an individual pupil's mind and intense personal world. She is

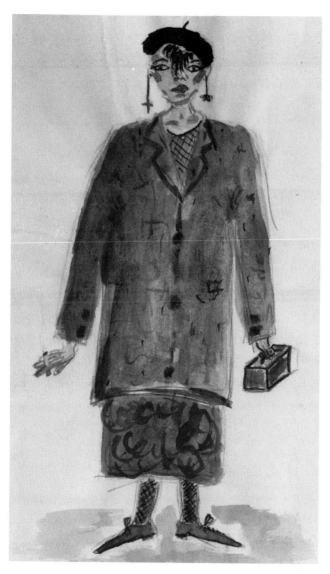

Lara, Figure on the Kings Road.

already quite critically conscious. On occasions she might struggle for words, leaving a sentence incomplete and an idea floating without being fully resolved – 'oh, it's so difficult to describe!'. Nevertheless she perceptively relates her attitudes to those of her father; she can distinguish her needs in her own work from what she discerns as those of her classmates and she enjoys certain art works in their own right. She is clear and analytical in describing the differences in approach between her work done at home and that she produces in school. She sees why it is necessary to go and look at original works in the gallery, and

feels the need to read around the subject. She understands that she is responsive to particular qualities in the work of George Grosz and Anthony Green because they strike a personal chord and – though clearly with an effort – she beautifully describes what it is that links their work with what she is attempting to do in her own. She has sufficient motivation and interest to work at home and the pleasure which she derives from certain works of art suggests that she will continue to explore and in the process extend the range of works to which she is particularly responsive.

And yet she had hitherto revealed none of this in school! Most art examinations are to do with the assessment of end-products. In *Broadening the Context* I pose the question as to whether the kind of understanding and awareness which the CSAE Project seeks to encourage can be assumed to be fully represented or reflected in children's art and craft work,[14] and what Lara has to say alters our assessment of her without us even necessarily referring back to her practical work. Her interests, once expressed, likewise pose a problem for her art teacher who may have to re-evaluate some of her teaching approaches in the light of such new evidence. Is it sufficient to accept that Lara simply does something different at home? If allowance is made in the art room for Lara's needs, would this be harmful or beneficial to other students who are seemingly happy in what they are already doing? Might there not be other students who have similar interests to those of Lara? If, say, as one possible way of reconciling Lara's needs, sketch-books were introduced on a regular basis, would this enable such private and personal interests, for other pupils as well as for Lara, to be developed in the art room where the teacher can then help in the development of such ideas through technical support, guidance and discussion? In the process, the course offered would inevitably be modified, but might not this be beneficial to all the group? For to 'see something, think about it, and then put it down' is a time-honoured way of working practised by many artists through the centuries. Lara has obviously become sufficiently motivated to substantiate previous gallery visits with ones of her own, and it is obviously an advantage that her father has some art books to which she has access, but her teacher has also played her part. It was she who had initially taken them to the Tate and in her practical lessons she has systematically referred the group to reproductions which related to the practical work in hand. The discussion generated through these examples looked at in the art room – even though Lara has not made a positive contribution herself – has doubtless played its part in her awakening critical awareness.

Many art teachers have been trained, and are still trained, with the art history lecture comprising the appreciation element in an otherwise practically orientated course. Many have rejected such lectures as being inappropriate to meet the needs of their pupils, and the CSAE Project has therefore put great emphasis on the need to develop and clarify a range of alternative approaches, of which the enmeshing of the practical with the appreciative is of paramount importance. Though emphasising that it was non-existent in the teaching that he observed, Witkin talks about 'art appreciation properly integrated with

creative work'.[15] Lara's teacher does this effectively as a matter of routine. Her present methods, she emphasises, have evolved over quite a period of time but there was, in fact, an important moment:

The turning point for me was about ten years ago. We had a 'Top of the Form' in school, with the sixth form, and I listened to them, and one of them was on art – what nationality Picasso was – and they didn't know and I was shaken. I thought, 'This is my responsibility' and then I thought, 'I've got to do something about this!' I'd already tried the lectures on art and found that a lot of them didn't really carry through to them, and that's when I started trying to bring paintings into my lessons . . . To put the painting into the practical lesson is much more valuable because they can relate it to what they are doing and they sort of say, 'He hasn't done this and he has done that', and they start getting involved because they're involved in what they're painting. If they just come and sit in this room and look at the screen I find that they don't relate it to what work they were doing last week, or that they are going to do.[16]

She sees her approach as part of a process of

Getting them very interested in going to see galleries themselves, because we can't take them very often because of the money problem. Putting examples in their way, really, showing them the books out of the library and sort of leaving them out on the desk and letting them thumb through them – that more casual approach is far better, whereas if I said 'Each of you are going to study this for half an hour', forcing it upon them, you don't get the same enthusiasm. It's there, and they can thumb through when they feel it's relevant. I've had quite a good response. So it's done very, very loosely and it developed gradually – it hasn't just happened . . . it's something that has got more and more and more important to the work that we do over the last six years – quite unconsciously, really. I find we are doing it all the time. Initially we were doing it occasionally – now I can hardly survive without it!

In spite of the money problem, all the pupils who study art in the fourth year visit the Tate, and it is interesting to note that all the pupils and students I spoke to had made or were planning to make, additional visits to galleries. From the teacher's initial shock at her older students' ignorance over basic factual knowledge about art, her department has developed a quite unusual climate in which the pupils are involved with, and derive enjoyment from, a variety of works of art but particularly French nineteenth- and early twentieth-century examples and have sufficient motivation to go out of their way to track down relevant examples in the art gallery itself – and Lara is one such pupil. Given her obvious awareness, it might seem strange that she had kept this interest to herself to the point where her teacher could be forgiven for assuming that her silence denoted that she had nothing to say. It will be demonstrated, though, that 'inarticulateness' is a natural aspect of a type of gallery experience which can touch the innermost thoughts and feelings of a person.

Section 3 Illuminating Experiences

Using museums and galleries is not always easy for schools. Journeys even of only a few miles are time-consuming and difficult to organise in the context of school timetables. Yet well-planned visits using, where possible, the specialist knowledge of museum and gallery staffs, have in the long term an irreplaceable value which may in future years be recalled when much which was experienced in the classroom may have been forgotten.[17]

DES, *Art in Schools*

In addition to being time-consuming and difficult to organise, such visits present financial problems, as Lara's teacher has emphasised. This is probably a more important consideration today than it was in 1971. Add to this that many art teachers are unconvinced of the value of such visits, because of their own emphasis on art as a practical activity and the time pressures in relation to getting out enough work for examination displays, and it is hardly surprising that many pupils leave school at sixteen without having ever set foot in an art gallery. Yet the memorable effects of many such visits form an important part of the testimonies of so many youngsters and adults alike. Lydia, for example, visited the Courtauld Institute with her family when she was ten, but now as a young teacher she still recalls that day as being when she first became interested in art.

> It was probably when I visited the Courtauld Institute and we were just walking around there and I saw a Seurat painting and I was amazed at the effect that was given with the dots, all the colours merging together, and the kind of soft overall appearance that was given because of the use of dots with no harsh lines or edges . . . It was probably that that first made me start look-ing at other artists and other galleries and I always had this interest in Impressionism and Post-Impressionism . . . I did my A-level thesis on Seurat and . . . I became very interested in Van Gogh around the same time and the emotion he was able to put into his pictures with directions of brushstrokes and things like that. I became very interested in Renoir as well. I loved the kind of luscious feeling that he gets into his paintings and he seems to do it by creating a circle with the brushstrokes, say in a face.[18]

Lydia eventually went on to Art College, where she studied embroidery. She is now an art teacher, and in describing the many and varied techniques which she uses in her own embroidery work, she puts particular emphasis on a favourite device which enables her to animate the surface of the embroidery with a dot-like surface:

> Another one that I'm very keen on is to snip up small bits of different coloured fabric. I put them down and machine them down so it's just like dabs of paint really, dabs of different coloured paints but it's just little bits of different coloured fabrics stitched down. It has a very painterly appeal to it.

Though many years have elapsed since that first visit to the Courtauld, Lydia is still quite conscious of its significance to her current work:

> I've never really got over the impact of Seurat. No matter how many other artists I do get a strong feeling for – for instance, sometimes I go through a phase of liking Van Eyck's work, or I go on to somebody else and for a while I'm just looking at books with their work in, Gustav Klimt or whoever – but I always seem to have this strong feeling for Seurat as well. I never seem to have lost that respect for Seurat's work or the great enjoyment that I've always got out of it.

The great enjoyment which she has subsequently derived from Seurat's work has obviously been a strongly motivating influence on Lydia and she describes how that first visit has led her to further explorations and discoveries relating to other artists. Her story is entirely consistent with an argument which Brian Lewis puts forward in arguing that museums have a function as an educational facility:

> The French poet De Vigny was once asked, 'What is a great life?' He replied, 'It is a thought of youth wrought out in maturity.' The reply has some substance . . . there are good grounds for believing that a single experience, or a single captivating idea, can initiate a whole chain of investigating activities that can last over a whole lifetime. Psychoanalysts also tend to concur with this view . . . a single emotionally arousing sexual experience can have the most powerful imprinting effects! The conjecture being made here is that the same holds true of any experience that is accompanied by strong emotional arousal.[19]

He suggests that critics might object that such experiences merely create fixations and emphasises that

> . . . it is necessary to insist that such imprinting would (if it occurred) be an educational experience only in the limited sense that it would affect the imprinted person's educational (knowledge-seeking) DESIRES . . . If the idea were to be exploited in the context of museum exhibitions, and if it were considered ethical to try to do so, we might expect to see some visitors becoming sufficiently captivated to want to know much more about the subject matter being displayed.

Lewis makes these observations specifically in relation to the big blockbuster-type exhibitions such as 'Tutankhamun' and 'The Vikings' which he labels as 'Ooh, Aah' spectaculars that can, he argues, do a great disservice to knowledge in general by merely encouraging an 'how fascinating' response. However, he continues:

> Possibly on the credit side is the potentiality that 'Ooh, Aah' exhibitions have for imprinting – for creating the kind of fixation that have so often seemed to direct the lives of 'Great Scientists'. [Note: Lewis is talking specifically about

museums as opposed to art galleries.] The conjecture is that, just once in a while, some visitor (a young teenager, perhaps) might find some facet of a spectacular exhibition to be so fascinating that he or she becomes 'hooked' on the quest to discover more. If that happens to just one teenager in ten thousand it might be the beginning of a De Vigny 'great life'. In societies (such as ours) which worship prowess of almost every kind, the launching of some hapless teenager on a great life will be regarded as a highly creditable achievement.

Perhaps so, but earlier he has spoken about exploiting the person's educational, or knowledge-seeking, desires in the context of museum exhibitions, and it is my contention that for every 'great life' which might develop from such a visit there are many, many more than we would normally give credit for which might be beneficially enriched by similar visits. Lydia went with her parents; for many others, if the school does not accept the responsibility, nobody else will. My interest is in just how many children can be so enriched and the ways in which we might go about it, even though perhaps no particular educational strategy can account for the one person in ten thousand! David Hargreaves suggests that it might be of value to discover how at least some people have come to develop their interest in a particular art form or art forms:

> Perhaps we have misunderstood or forgotten about how many people come to appreciate art. Maybe it is not at all like most of our learning in school – learning THAT or learning HOW. For many people, the appreciation of art [and music and literature] is like a religious conversion. One is swept off one's feet by the experience and naturally searches for more of what was so satisfying. How much do we know about how many people [art teachers included] are naturally converted to art? When? How? At what age? Under what circumstances?[20]

It is interesting to observe how close Lewis and Hargreaves are in pinpointing a fundamental type of experience which both see as being educationally significant; 'strong emotional arousal' and being 'swept off one's feet' are both phrases which recognise that it is an initial emotional impact that frequently triggers off the individual's subsequent voyage of discovery. It is equally interesting to note the widely differing outcomes which each perceives; Lewis puts his emphasis on the possibility of a future genius emerging whereas Hargreaves is asking how many people are or might be so affected. If we can draw out the essential factors which have led to them being affected, it might be possible to adopt approaches which would make it possible for many more to benefit likewise.

To this end, he has interviewed numerous adults with a particular commitment to a particular art form, and in the process has unearthed what might be termed their 'aesthetic autobiographies'. His adult informants were able to look back over their key formative experiences and articulate about them with the sense of perspective which time gives. At a relatively early stage in the

CSAE Project, Hargreaves combined with me and we interviewed a number of students, either still on A-level courses or who had recently entered higher education art courses. They were selected on three basic criteria: they worked in lunchtimes and after school or college at extra art sessions out of interest, they worked at home of their own volition and they voluntarily made use of the exhibitions and library facility at the Drumcroon Education Art Centre.

We had one slight reservation prior to the first interview with an A-level student. By comparison with the mature adult, the younger students might be too close to, or still in the midst of, any relevant experiences and might therefore find it difficult to talk adequately about them, but in the event their testimonies confounded this doubt. They contributed further confirmation of the theory which Hargreaves had formulated from his analysis of the interviews which he had already conducted. A high percentage of his informants describe their interest in a particular art form as having been initially aroused by a particularly significantly and memorable experience, or set of experiences. Sufficiently so for him to propose an alternative or complementary method of 'learning' to that which predominates in our secondary schools, and he calls this the 'traumatic theory of aesthetic learning'. The predominant, existing model he describes as being essentially incremental, 'brick by brick'. This approach rests upon

> a deeply held, common-sense theory of learning shared by most teachers . . . According to this view, learning, whether it be skill-acquisition or the understanding of a principle, is a cumulative or additive process which succeeds as bit is built upon previous bit. The theory is most evident in the learning of mathematics or a foreign language: it is all a slow, systematic and progressive movement from the simple to the complex.[21]

It does, of course, find its way into the art room as well. Art history and appreciation courses, where taught, are most frequently approached from a chronological standpoint, and in the primary school as well as in the early years of the secondary school a strong emphasis is placed on an approach to drawing which develops from stage to stage in a Piagetian manner. Likewise many art teachers will recognise something of their own assumptions when Feldman says:

> The technical curriculum can also be organised according to a primitive scheme of the development of artistic skills: from simple techniques in the lower grades to difficult techniques at the upper levels. Painting in oils and carving in wood or stone is accordingly reserved to the later grades while elementary school pupils model in clay or draw with pencil, crayons and pastels.[22]

Loosely structured art courses based on the assumption that pupils have to develop from the simple to the complex in relation to the use of media are to be found in many schools. Hargreaves emphasises that there are many sound reasons for structuring courses in an incremental manner, but suggests that account should also be taken of the complementary approach which his adults' accounts revealed:

good page

I am asserting not that incremental theory is mistaken, but that it is only part of the account of learning. And more, that the part which is neglected by incremental theory is of singular importance to aesthetic learning in matters which relate to appreciation as opposed to skill acquisition.[23]

To outline his theory he stands back from the classroom: 'The classroom is not likely to help in this search, for I have argued as part of my case that it is neglected there.' On the evidence of his informants it is rather that 'Theatres, galleries, opera-houses and concert-halls are the natural arenas in which the full force of conversive trauma can take its effect.' So what is the conversive trauma?

Many individuals describe an experience, sometimes being able to date that event with considerable precision, which was essentially disturbing and remembered so clearly because it was disturbing. Hargreaves seeks to give the word 'trauma' both a positive and negative meaning in relation to this memorably disturbing aspect. 'It did indeed cause a kind of wound, one which injured or destroyed all their preconceptions about the art form, to which hitherto they were often hostile or indifferent.' (Some describe the experience as shattering, a word which can be equally used to describe something either distressing or extremely pleasant.) He acknowledges that such a conception of learning is not entirely new, and refers to William James' *The Varieties of Religious Experience*, written in 1902, and there are obvious connections between an aesthetic experience of an initiatory nature which is dramatic, memorable and sudden and such religious conversions as that which occurred on the road to Damascus. There is an equal parallel, which Hargreaves also stresses, between a gallery, theatre or concert hall visit and one to, say, a revivalist meeting. Similarly, the same 'objective' events which can bring about conversion in one person can be aversive to another. (I will return to the aversive form later.)

The conversive trauma then is characterised by being a relatively sudden and frequently unexpected form of initiation into an art form, and in its clearest form is dramatic, intensive and therefore memorable. Hargreaves detects four main elements in the experience or set of experiences. The first is a powerful concentration of attention. The individual becomes totally caught up and absorbed in the art object. 'In a strong form of the trauma, one's sense of time and space is suspended and one loses consciousness of all extraneous matters. One is lost in the art object.' For example, in a 1933 *Manchester Guardian*, Neville Cardus is bemoaning a music critic's life because, in order to get his work done in time, he has had to leave a performance of *Die Walküre* at the peak of magnificence:

Tonight (May 3) I found myself in the squalor of Bow Street just after the end of the second act, and the contrast of reality with the splendour of Wagner's remote world was too great to bear. Still bereft of ordinary senses, I wandered about the maze of Long Acre and Drury Lane until I woke up and discovered myself a mile from where I ought to have been. The true reality, of course, was not Bow Street but Wagner's teeming universe.[24]

Cardus, of course, was already responsive to Wagner's music, illustrating that this type of concentration of attention can be a recurring delight.

The second element is a sense of revelation. 'One has a sense of new and important reality being opened up before one or of entering a new plane of existence which is somehow intensely real.' One's senses, in contrast to the mundane everyday living, become heightened and this is accompanied by a profound emotional disturbance. 'There is also a feeling of discovery as if some already existing core of the self is suddenly being touched and brought to life for the first time, and yet inevitably so. The experience has cognitive or intellectual features certainly, but the emotional aspects are paramount.' An appropriate example from the world of literature might be that of Brenda Polan writing about Zola's *Germinal*. She was ill in bed, a friend had brought a copy of *Germinal* for her. She put it to one side, only taking it up because she had run out of light reading:

> So I started *Germinal*. From the opening images of desolation and hopelessness, the description of the night-shrouded flat and cheerless landscape of industrialised Northern France and the crude personification of the mine as an 'evil-looking voracious beast crouching ready to devour the world', I was hooked. I consumed the book in hour after hour of feverish reading. My throat, already sore, was frequently lumpy and many were the tears that coursed down my fever-flushed cheeks . . .
>
> I was an experienced reader . . . yet I might have been a neophyte enchanted and entrapped by my first heady encounter with the magic words. Looking back after re-reading the book, I realise now that it was not so much the magic of the words . . . but the power of a previously unexperienced point of view.[25]

The third element is inarticulateness. The individual feels unable to express in words what has happened, either to him or herself, or to others. Some people can go for years without revealing anything of the experience, or have no desire to do so. However, on the other hand, 'when this urge is present it is usually impossible to achieve'. Such phrases as are often used, for example 'I was struck dumb', are in sharp contrast to the sudden 'insight' that can occur in intellectual matters: 'it is usually a test of the understanding of a scientific principle that it can be recounted in words'.

The fourth element is the arousal of appetite. 'One simply wants the experience to continue or to be repeated, and this can be felt with considerable urgency.' In weaker versions of the experience 'there is still a lingering fascination which leads people to say that they felt "hooked" on the art object in some way'.[26] Melanie Phillips, writing about *Sons and Lovers* by D. H. Lawrence, certainly refers to the most powerful form of arousal of appetite:

> But it was a peculiar fact that . . . that book became almost more real to me than my own life . . . It is hard now to understand the enormous impact that book had on me. Perhaps it was the details in which we dissected it, holding it

in our heads for two years. Perhaps it was because we read it at a time when we were particularly receptive and vulnerable to powerful works about emotions and sexuality . . .

And the heightened style affected the way I, too, saw things. I began to think of the most banal activities in the same intense way . . . I started to read my way through the other Lawrence novels, and his poetry, and any biographies I could lay my hands on.[27]

'Conversive trauma, then, is always a first step in the process of initiation, but the one which drives the person forwards. One has moved, quite suddenly, from being on the "outside" to being on the "inside": there is more to come and one rejoices in it.' In what she says about *Sons and Lovers*, Melanie Phillips illustrates the first two analytically distinct steps which are a consequence of the initial experience, when it is powerful enough. These steps, however, 'should not be regarded as discrete stages which follow one another in any mechanical way'. The first is that the initial experience leads to commitment, which in turn leads to exploration. Initially one might simply want to return to the particular work which was involved, or re-read a book, or buy a record, but one soon begins to seek out other works by the same artist, and this then leads to a more general exploration of the art form, 'often in a rather tentative and experimental way, by selecting works which are similar to the original traumatising work'.[28] This exploration inevitably leads to discrimination. Initially the individual is trying to repeat the impact of that first encounter, and there are likely to be some disappointments and anti-climaxes on the way, but equally there might be even greater surprises in store. 'One's preferences begin to change, to become more subtle, and the pleasure one derives can be at its most intense in unexpected places.' The original work can come to seem less good in relation to subsequent discoveries, 'though there often remains an ineradicable fondness for the traumatising work'. I said that Melanie Phillips illustrates two of the four steps in the *Sons and Lovers* passage. She does, in fact, also illustrate that exploration leads to discrimination, because:

. . . even before I had left school, the Lawrence spell had begun to fade. There were unpleasant overtones of fascism; his attitude towards women was monstrous; even his style, heresy of heresies, I began to find absurdly overblown.

But the images of *Sons and Lovers* remained just below the surface of my memory. I still find that phrases or even whole paragraphs bubble up from time to time . . .[29]

and implicit in this passage is that she had developed attitudes by reading around the subject – this is the fourth outcome. This final step usually comes fairly late, and is that discrimination leads to the search for background knowledge. 'Only after exploration and discrimination have been set in train is one motivated to seek out relevant background knowledge, such as a biography of the artist, critical appraisals of the art form, studies of the artist's particular techniques.'[30]

On average, there is a five-year timelag between the initial experience and this final step being set in motion!

Though this book's concern is with the visual arts, examples have deliberately been used from other areas – opera and literature – to illustrate the main elements in the conversive traumatic experience so as to emphasise that they are relevant and applicable to all the arts. Hargreaves quotes from Harrison and Waters an example relating to the painter Edward Burne-Jones, important because of the major part it played in his deciding to be an artist. It vividly combines the musical with the visual. He had been 'moved to ecstasy' by High Mass in Beauvais Cathedral and recalled the event many years later in a description potent with the overtones to be found in his paintings:

> I saw it and remembered it all – and the processions – and the trombones – and the ancient singing – more beautiful than anything I had ever heard and I think I have never heard the like since. And the great organ that made the air tremble – and the greater that pealed out suddenly, and I thought the Day of Judgement had come – and the roof and the long lights that are the most graceful things that man has ever made . . . What a day it was, and how alive I was, and young – and a blue dragon-fly stood still in the air so that I could have painted him. Oh me, what fun it was to be young. Yes, if I took account of my life and the days in it that most went to make me, the Sunday at Beauvais would be the first day of creation.[31]

How clearly Burne-Jones obviously recollects the whole experience all those years later when that blue dragon-fly stood in the air so long that he could have painted him! I am inclined to add a fifth main element of the conversive trauma to those already outlined – that of memory retention. Hargreaves states that 'it is because the experience was disturbing that it is remembered'[32] but it is also apparent that those involved not only remember the experience itself, but also retain an exceptionally clear memory of the work or works associated with that experience, often down to minute details. Bernard Levin recalls the first fully adult book which he read in early childhood. It was *Moby Dick* and 'fixed' in him a love of reading, 'it was Moby Dick that kicked loose the first stones of the avalanche':

> I can remember the author; I can remember the book; I can remember the effect on me of its famous first sentence, which is not altogether surprising, because the effect was that of what I supposed electrocution would feel like, and I knew, instantly and without doubt, that I had finished with *The Hotspur* for ever. 'Call me Ishmael.' I know of no novel in English with a more arresting first sentence; any reader with an imagination capable of being caught at all is at once harpooned . . .[33]

In their testimonies, it is often apparent that the students similarly affected can both remember precise details of the works in question and exactly where they were hung and their relationship to other relevant works in the room or gallery. In an age in which so much of the second-hand material to which we are

subjected is so instantly forgettable, and in which Study Skill techniques are being avidly devised to enable students to memorise facts and details for future regurgitation, this element of memory retention would appear to be of considerable educational significance.

Hargreaves, however, sees arousal of appetite as being the most important element from an educational standpoint because it is so highly motivating – a quality which the strongest advocate of incremental learning will admit is often missing, certainly at an intrinsic level. Though the majority of these experiences appear to take place out of the classroom, they have important implications for the school and the way in which it approaches the arts:

> The interest in acquiring relevant background information typically comes after and some time after conversive trauma. One is not talked into trauma. At the pre-traumatic stage working-class pupils find such talk either difficult or tedious. Only after the trauma has done its work does one have something to talk about and the motivation to use the cultural capital in a genuine and purposeful way, or (as with working-class pupils) – the motivation to find a language in which to communicate one's feelings and acquire some cultural capital. In other words, only after traumatic initiation can aesthetic experience and cultural capital be truly conjoined.[34]

'Conversive trauma' is a phrase chosen to emphasise those initiatory moments which Hargreave's informants describe as the first crucial step in involving them in a particular art form. But absorption in the art object, implicit in 'concentration of attention', can be a recurring delight as has already been seen and a 'sense of revelation' is by no means exclusive to the initial experience – though that first occasion so often remains the most dramatic and memorable. Nevertheless, whatever our previous experience, any of us can unexpectedly discover an aspect of an art form of which we have not previously been aware; Brenda Polan was already 'an experienced reader', but *Germinal* brought home to her 'the power of a previously unexperienced point of view'. And this sense of revelation need not even be confined to newly encountered art objects. 'But these great works are deep. The more I try to penetrate them the more conscious I become that their central essences are hidden far further down', wrote Lord Clark.[35] However familiar one might be with certain works of art, they only reveal their secrets gradually over repeated hearings, readings or viewings – they retain a power to surprise! The phrase 'illuminating experiences' is one chosen, therefore, to categorise all these moments, at whatever stage in a person's encounters with the art form they occur – all have relevance to the work of the art teacher.

One further aspect which must be emphasised is that of increased or heightened awareness of the world around us. Though not unique to the visual arts, this is particularly relevant to them. Under the influence of the art object, the individual becomes unusually receptive to aspects of the immediate surroundings or to the inner world. In Beauvais Cathedral Burne-Jones was in

the midst of an architectural space of which musical sound and the 'blue dragon-fly stood still in the air' were both a part, but the impact of looking at an art object, whether large or small, can be just as great. At the age of fifteen Jerome Bruner 'discovered' Monet, Degas and Renoir in the Metropolitan in New York. 'They seized me: I looked and looked, I created those pictures, created them and a "real" world in which they existed.' And then,

> Forty years later, visiting in Paris, my wife and I went to see the great exhibition of French Impressionists at the Grand Palais. The queue was a half-mile long. The Palais was packed. On the wall facing the entrance to the first gallery there hung the crowded Moulin Rouge painting of Renoir, surrounded by Parisians. It was as if the dancing crowd in the canvas overspilled into the room – not 'as if': they *did*. I said to Blanche, 'They've come out of the picture', and when I turned to her, she looked stunned. 'Yes,' she said, 'they've danced right into the room.' The picture had not only created a world of its own; in that charged situation, it had even captured the 'real' world.[36]

Similarly, in arguing that looking at pictures requires active participation, Lord Clark concluded an analysis of his thoughts and feelings before great paintings by observing that

> Finally I become saturated with the work, so that everything I see contributes to it, or is coloured by it. I find myself looking at my room as if it were a Vermeer. I see the milkman as a donor by Rogier van der Weyden, and the logs on the fire crumble into the forms of Titian's *Entombment*.[37]

In addition to helping pupils to understand more clearly the links between the arts and their own lives, and that the arts are a manifestation of life, this heightening of awareness has obvious implications for their own practical work in the classroom, because it constitutes a potential bridging link between the study and practice of art. It is all too rarely exploited in the classroom, but was already being utilised by Lara in the work she was producing at home, for she was aware of the relationship between the George Grosz and Anthony Green paintings in the Tate and her response to those figures down the Kings Road which she selected as her subject matter. These links between the study and practice of art will be explored more fully at a later stage.

The characteristics of the illuminating experience or conversive trauma can be set down in diagram form as follows:

ILLUMINATING EXPERIENCE or CONVERSIVE TRAUMA =

CONCENTRATION OF ATTENTION + SENSE OF REVELATION
+ INARTICULATENESS + MEMORY RETENTION

and of particular educational significance

AROUSAL OF APPETITE

Their motivating nature leads to, but not necessarily in discrete order

COMMITMENT – EXPLORATION – DISCRIMINATION – SEARCH FOR
BACKGROUND KNOWLEDGE

+ one further manifestation

HEIGHTENED ENVIRONMENTAL AWARENESS

which can act as an important bridging link between the study and
practice of art.

In the case studies which follow shortly, the reader will be able to recognise
examples of all these characteristics in the students' testimonies. But reference
has already been made to the illuminating experience's aversive counterpart –
the turn-off. It is probably as educationally significant, but for negative reasons,
and it is therefore equally important to look at some aversive examples and how
they came about.

Section 4 Aversive Experiences

Many art teachers accept the validity of the illuminating experience because
they recognise that similar important moments were influential in their own
training and to their artistic development. A number of references have already
been made to the aversive counterpart, though, and art teachers are sometimes
reluctant about embarking on gallery visits because of a fear that their pupils
will find them boring. Witkin records one teacher's dilemma:

> I must confess to a certain amount of dismay when I am faced with people
> with a very superficial or immature approach to the work. I know this is a
> personal weakness that I am continually fighting. I took ninety pupils to an
> exhibition of Indian Art *for half an hour*. I felt a certain sort of regret *that
> children can be so utterly illiterate as to pass by things which really are tremendous
> masterpieces without even a second glance*. One knows that one is exposing
> children to these things and one hopes that at some time in the future this
> experience will be remembered and have some kind of impact upon them.
> But the experience for me is tinged with a certain amount of regret that they
> aren't mature enough to be able to appreciate, to even begin to appreciate,
> what they're being exposed to.[38]

According to Witkin, this teacher was deeply considerate of his pupils and hurt
that what touched him deeply should leave them cold. One can easily picture his
indifferent pupils wandering aimlessly through that gallery. On a recent visit to
the Modern Masters exhibition at the Royal Academy, I observed a group of
15–16-year-old pupils. Half of them dashed straight for the central seating on

entering the gallery, but the poor teacher had to leave immediately to retrieve the remainder who had walked straight in and out again through an adjacent exit without having even given a single work a cursory glance. Whatever the teacher's intentions in taking them to that exhibition, his pupils' preconceptions had ensured that the visit was a disaster.

Anita (one of the pupils whose experiences are covered in the next Part) thought that the only difference between her and her friend who was 'really bored to tears' in the National was that her friend, as part of her course, 'hadn't looked at the paintings before' and 'hadn't had it explained'. (For a detailed description of this incident, see Part II, Section 2(a).) Witkin states that:

> the great wealth of the art world achieves no integral place in the creative work of the art departments themselves and yet teachers are continually surprised and often secretly furious with their recalcitrant barbarians whose own work they may have praised or found worthy in the past . . . the pupil has little respect for what he cannot use and he cannot use anything that he has been inadequately prepared to contact in experience.[39]

In addition, obviously, to preparing pupils for what they are going to see in a particular exhibition by discussing something of its content prior to the visit, Witkin is suggesting that there is a deeper and longer-term form of preparation – that of utilising the wealth of the art world as a natural, integrated part of practical art room activity. Anita gives examples of how she benefited from this kind of integrated learning (see Part II).

If it had been possible to talk to those pupils at the Modern Masters exhibition, it would have been difficult to proceed beyond that one predictable word: boring! Where classroom preparation has been adequate, the pupils are more likely to attain some measure of independence in the gallery. The teacher is then able to operate more informally with small groups at a time, generating mutual discussion. This allows for genuinely meaningful teaching which falls between the extremes of no support at all on the one hand, and the predictable, mechanical gallery tour on the other. 'As we know, the old "crocodile" format for the museum visit has often produced a passive or even negative response in the child and new basic patterns are coming into use', observes Terry Shone.[40] Nevertheless, one does still observe whole groups being talked at by gallery guides. A fifth-form pupil plaintively complained after one visit, 'Why didn't that man show us how to do it? The stuff was there, but he just talked. He didn't do anything – just talked all the time.' It is particularly difficult for the gallery guide to gauge exactly where to pitch such talk, a good percentage of which is often at a far remove from any of the children's actual experience.

An increasingly common reaction, therefore, is for the guide's talk to be replaced by a question-based approach aimed at involving the pupils as active participants. But this can be just as aversive to many adolescent youngsters who hate to speak out, having been 'picked on', in an unfamiliar public setting. I recall one gallery officer stating that in these situations she would ask increasingly simple and obvious questions – in practice, as they become more

obviously simple so the patronised pupils correspondingly clam up further, creating a vicious circle which is extremely difficult to break.

Anthony found himself caught up in a particularly vivid example when, as a member of a group being questioned in this manner, he found himself getting so hot under the collar that he had to disengage himself from the group and continue looking round on his own: '. . because it was of no relevance really. She wasn't making it interesting at all. She was just saying, "What do you like about this painting?" and just merely asking us questions that we could form on our own.'[41] Though he knew a lot about the paintings in question and knew exactly what he thought about them, he did not contribute and found himself becoming increasingly disillusioned: 'I was expecting more out of it, to gain some knowledge from what she was saying because she was an established art historian. But she just wasn't delivering any of that knowledge to us. She was just looking at the picture surface and not going any deeper into them.' He felt that the group was being patronised – a number of them complained afterwards that they felt they had been treated like babies:

> I presume that she was probably assuming that it was our first introduction to these paintings. She was looking down upon us as mere students, as if she was the expert. But she just wasn't delivering anything to expert quality. She should have looked at the paintings, gone into them more deeply and said what relevance they had on the painter's life as well – what provoked him to paint this certain picture, and she mentioned nothing about technique.

What he was demanding of her was that, while asking them questions, she should also have been simultaneously imparting knowledge: 'You wanted her to tell you things which you were not aware of already.' Ironically, he felt that if she had been doing that, he and his colleagues would have then given of themselves at a deeper level, too, rather than standing in uncomfortable and resentful silence. He illustrated his point by adding that:

> When you talk with your friends or with a teacher who knows quite a bit about the work, you get involved in it and through the discussion you can go deeper into it and into each of your thoughts on a certain work. It is interesting to see exactly what other people feel about a work, and if you feel differently you tell them. She was giving none of her own thoughts and just asking ours. There was no involvement between the two.

On a visit to the Tate, he and some colleagues had had 'a really deep and emotional discussion' about the Rothko canvases. At the end they agreed to differ, 'but it was really worthwhile', he added. What is being said here is of the utmost importance: *the gallery guide had to give of herself if the students were going to give of themselves, too*. Neither a formal lecture, with the guide just giving out, nor questioning 'to involve' the students with all the onus thrown on them was the answer, but a skilful fusion of the two. Anthony has sufficient interest in the subject to withstand an obviously aversive experience and to say much more about it than the customary 'boring'. But he was quite emphatic that if it had

been his first gallery visit, 'that would have been a definite turn-off. You would be seeing painting after painting and they would all appear very similar with nothing to make any one stand out.' He might well have stayed out of galleries for the rest of his life.

Attempts at explanatory classroom preparation prior to gallery visiting can in themselves be aversive, as many teachers of Shakespeare can testify. In Part II, one of the pupils, Joe, talks about the printmaker Gerd Winner being alive and here, not dead in a history book, and to many pupils Shakespeare fails to come alive, remaining remotely in the past and disjointed from all the other literature being studied. An eighteen-year-old student with a deep interest in art and active in amateur dramatics recently told me how she detested a particular Shakespearean play. Given her interests, was not this rather strange? She responded by saying that it was to do with how she had been taught. The very first lesson of the course had commenced with analysis of the opening lines of the play, and this process had then methodically continued, page by page, week in week out. The student felt that this was ridiculous because none of the group had any overall conception as to what the play was about. She felt that an attempt should have been made to give them some general understanding of the plot and why this play was considered to be so significant, but the teacher countered these objections by emphasising that detailed analysis of the play was an essential examination requirement. The student came to dread each lesson, the play seemed unbearably long and she could not envisage herself ever going to see a live performance of her own volition. The teacher had unintentionally induced an aversive reaction. Are there not parallels here with the showing of, for example, Renaissance Art filmstrips accompanied by the teacher reading out the supporting written notes as if they contained the only relevant 'facts' about those works? In this context it is difficult for the pupils to participate actively and they sense that if the teacher does possess responses and attitudes to the works in question, they remain hidden behind a barrier of supposed 'objectivity'. If the children have not had sufficient previous experience of looking at and discussing art for them to place the information being given into any relevant context, is it surprising if they switch off?

Even though Hargreaves' adult informants might rarely mention the classroom, a number of references in the student examples reveal experiences of similar significance and impact to those in the gallery. Bev describes how positive attitudes formed in the classroom were all but destroyed at the next educational stage:

I had this wonderful opening up to the history of art. I just gave everything to reading and finding out about the history of art. I started with Giotto and I thought Giotto was really wonderful. I was engrossed with his paintings and the idea of the figure and gestures and perspective, and how wonderfully primitive it all was, and the great naiveté of it – and that really rang true. I then wanted to go out and find out what had happened to Giotto – I had never come into contact with this before and then all of a sudden here was Giotto

painting in the 1300s and I had got the rest of six centuries to find out about! It was purely digested from books and reproductions, but towards the end of the course I actually went across to the Louvre and I saw some wonderful Early Renaissance pieces and it all came to life. That wave, that surge of enthusiasm, carried me right through to the twentieth century. It was wonderful, actually – I just decided that was what I wanted to do.[42]

Having discovered Giotto, Bev's realisation that there were centuries more of discoveries to be made vividly communicates the idea of her being just on the inside, realising that this was the case and that there was more to come. Not surprisingly, she decided that she wanted to pursue these interests further at higher education level:

I was the only person ever from our school to have wanted to do the history of art. When I was at university I actually decided to specialise in the Renaissance and started off my Major doing exactly that which filled me with so much enthusiasm. One tutor was terribly interested in Mantegna and Early Renaissance but he had a very classical training and I didn't have any knowledge of Greek, Roman, etc. and it was just his whole approach! He would look at the vases depicted in the paintings and you would hunt through big dictionaries on Greek and Roman vases until you found the actual vase. Then we would look at portraits and do the same with the coins – and I hated it. At the end of the term I withdrew from the Renaissance because I hated it!

Bev had developed enough interest in the visual arts to change to another period, though, rather than leave the course as might well have been the case. Nevertheless, the aversive effects of the experience were so strong that she confesses that it was over five years before she could begin to enjoy Early Renaissance works again. Had she given up all art study at that stage, the damage would probably have been permanent.

It is interesting that many art teachers worry that their pupils will be bored if any time is devoted to the study of art, because the interviews I have conducted with pupils reveal a high degree of passively accepted boredom in the art room during the execution of exercises with predictable outcomes (see p. 182 for examples). Practical lessons, too, can be aversive and, in turn, frequently build up prejudices against art in general. Some of the pupils so affected are likely to resist future opportunities to engage with the visual arts. One pupil's observation that you build up an idea that paintings are as boring as those you have to do in school is recorded later in this book. This aversive reaction to practical work can be surprisingly dramatic. One student, having been told that she will need a portfolio of course work for higher education applications during the first term of her final year at school, shows how strong such aversions can be:

I was told to get some work together, to do some sketching in the summer, because at that point I had absolutely no paintings – I couldn't paint. The idea of picking up a paintbrush and doing an oil painting was absolutely terrible. I just couldn't paint, I had this great big idea that I couldn't paint. I just knew I

couldn't paint, and everyone was saying, 'You know you can paint. Just try!'[43]

In an otherwise flowing interview, the student almost comes to a standstill at this point as she repeats the same negative phrases over and over again, so strong was her aversion. Hargreaves suggests that there would appear to be two ideal-type teachers; one conversive and the other aversive in their effects (the majority obviously being amalgams of these extremes). Bev suffered in the change of institutions, but it is salutory to observe the different levels of attainment achieved by some pupils within the same institution, according to which art teacher teaches them. In spite of her painting phobia, this student committed herself to sketching during the summer holidays but on returning was taught by another teacher. The effect was dramatic because the new teacher, on seeing her sketches, immediately filled her with enthusiasm. Until then, her imposed discipline had just been 'hard work, hard slog, and then I was fired up again with the idea of trying to paint':

It was solely this enthusiasm for my work that inspired me, rather than my own enthusiasm for my own work. Had the attitude been 'Well, it's O.K.', at the time I don't think I would have gone as far as I did had the teacher not been so enthusiastic for me, as I was at a dead end really, then.

Important though enthusiasm and encouragement are, they are still not enough on their own. Nevertheless, the absence of enthusiasm the previous year had made intended help seem like negative criticism. It seemed to be only about correcting things that the teacher saw as wrong. She felt she was working all alone, criticism only being proffered when the painting 'was falling to pieces'. After the summer, by comparison:

The teacher talked to me about various ideas, and before I did any painting at that time there would be discussions about it and how I was going to approach it, and what colours I was going to use – and all that helped me. That first painting turned out alright, it was O.K. I was quite pleased and fired up again to do another one. In about a month or six weeks, I did about six paintings – whereas the year before it had taken me a full year to do one and a half, and that was the difference!

One and a half pieces of work in a year! And yet, once motivated, her increased output was also determined by her desire to paint in any spare moment, at lunchtimes or at home rather than only reluctantly at prescribed times. The teacher's influential discussions with her were 'in the round', about her ideas, technical means of realising them – the whole approach, illustrating that critical studies is not just something to be applied to the study of other people's art, 'great' art, but is equally relevant to the work of the pupils themselves. That similar criteria can be applied to both is an important means of helping them to see relationships between their own work and that of others, whereas an approach which just finds faults to criticise belittles their work and divorces it

from any existing art which they might admire or which is relevant to their needs.

Aversive experiences, therefore, arise not only from insensitive or inappropriate handling in the art gallery, but can be intimately bound up with what has or has not taken place in the classroom immediately prior to the visit and over sustained periods of art room activity – whether or not the actual experience is associated with gallery or classroom. Though the majority who are passively bored in the art room would appear to accept it quietly as part and parcel of school life, they will usually tell the teacher that a gallery visit was boring. Hargreaves conjectures about why two people on the same gallery visit at the same time can respectively be conversively and aversively affected. This will presumably always remain the case, but the young people themselves give numerous clues which can help the sensitive art educator to increase the percentage conversively affected, minimising aversive reactions in the process.

It is unfortunate that pupils saying they were bored in a gallery can inhibit many teachers from organising future visits, when it is considered that those who were deeply moved and affected by particular works are likely to have kept their reactions to themselves because they were so private and personal. In contrast to the deadening nature of the aversive experience, some positive gallery experiences are set out in Part II as case studies. They contain many passages which illustrate the various aspects of the illuminating experience.

Conclusion

We can conclude from Part I that an important educational task has to be undertaken if the majority of children are to be helped to a fuller awareness and understanding of the visual arts. This task arises from the need to reconcile the practical elements of art in schools with those theoretical aspects which, in the art history model, have been largely discarded by teachers. It is further complicated by the changed and changing circumstances in which schools have to operate.

(*Top left*) Wet Paint, *a screenprint by Patrick Hughes, really struck Jane 'because it was very bold and very bright'* (see p. 38).

(*Bottom left*) *Marie was 'taken aback and amazed at the weavings done by Tadek Beutlich'* (see p. 44).

(*Top right*) *She found herself wanting to know how* Bird of Prey *had been made* (see p. 45).

(*Bottom right*) *A detail from the* St Katharine's Way *suite of screenprints by Gerd Winner* (for Joe's analysis see p. 68).

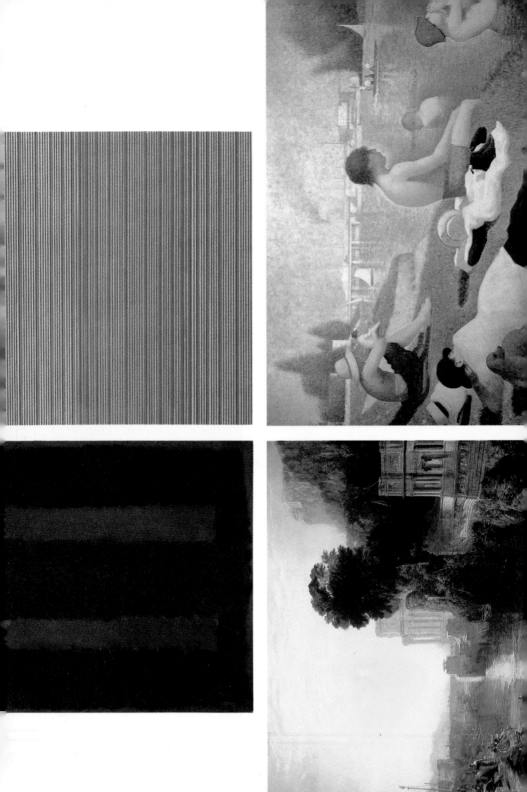

The critical studies method being propounded is one which combines a variety of approaches but which emphasises two imperatives. First, there should be integration of the critical and the practical, each reinforcing the other. Second, pupils should be exposed to original works as a high priority.

From existing research and from interviews conducted as part of the Project, it is possible to construct a theory as a basis for educational practice. Given certain conditions, children and adults can experience a dramatic initiation into an art form because of the impact of a particular work of art which has immediate personal meaning for them.

The emotional arousal which accompanies this revelation or 'illuminating experience' has considerable motivating consequences. The individual can become voluntarily involved in pursuing interest in that work or originator and subsequently in a wider range of material, thus coming to make discriminatory judgements. An alert educator needs to play a part in providing the opportunities for the initial experience and in trying to prevent aversive experiences. Also important is to see the possibilities in harnessing and applying this strong motivational urge, not least in the reinforcement of practical work by insights gained through study.

The findings go beyond the arts, having a general educational significance. They shed light on adolescent development and have implications for curriculum organisation. The learning model offered is one which might beneficially complement the essentially incremental approaches which predominate in most schools.

(*Top left*) *The Rothko Room was 'a complete eye-opener' to Julie (see p. 60).*

(*Top right*) Yellow Attenuation *by Peter Sedgley (for Anita's analysis of this painting see pp. 54–6).*

(*Bottom left*) *Time just flew past when Anthony was studying Turner's* Dido Building Carthage *(see p. 65).*

(*Bottom right*) Seurat's The Bathers *created an effect of harmony around Andrew so that he became unaware of the works on either side (see .p. 63).*

Part II
Pupils and Students Talking

Section 1 Formative Gallery Experiences

Focusing upon two pupils, Jane and Marie, who had memorable experiences viewing art in galleries, the author highlights certain aspects for further consideration. He covers factors common to both, such as negative anticipation, and describes the individual responses, how these came about and what shape they took. Also remarked upon are the criteria evolved for judging work and the relationship between these experiences and the pupils' own practice. From the particular the author forms more generally applicable points relating to pupil expectations for continuing development, the responsibilities of the teacher and also conjectures upon the comparative force of illuminating experiences at different ages.

Section 2 Critical Studies Courses and the Original Work

The main concern of this section is the traditional art history and appreciation course. Reporting upon the effects such courses had upon Anita and Julie, the author posits some reasons for success and failure in this area. The pupils provide vivid accounts of their aesthetic development and an extract is included of Anita's special study which itself illustrates the resolution of combined feeling, perception and analysis. Additionally, the author contrasts and compares responses to original works and reproductions.

Section 3 Three Male Responses

As a counterbalance to the two preceding sections, with examples of female response, the author describes the experiences of three young men, Andrew, Anthony and Joe. In addition to the factors and effects already reviewed – such as behaviour of gallery staff, preparatory art history lessons, concentration of attention consequent on revelation, different perceptions of originals and reproductions, effective use of language – other elements are either uncovered or emphasised. Those most prominent relate to increased environmental awareness, the impact of encounters with the artist, the relevance of contemporary work and attitudes towards possession of objects.

Section 1 Formative Gallery Experiences

(a) Jane and *The Death of Lucretia*

There were a lot of other pictures that I liked and I found it all very interesting and after that I went to some more galleries to see what they were like, and I had a look in the art shop in Littleborough, and it had actually got a print of one of Carel Weight's pictures in the window – the one that shows the lion escaping from the zoo, where all the people are turning to flee. You know, the one where he'd used his mother to pose for one of the characters.

In Uppermill, that's in Saddleworth – it's near Oldham – there's a museum there and the top floor, that's an art gallery, and I went there with my dad and my brother to see what the pictures are like there because I said, 'Oh, I've been to Rochdale Art Gallery and I liked it. Let's have a look in here.' There were quite a lot that I liked in there, but there was nothing that quite impressed me as much as Carel Weight's pictures did though.[1]

Arousal of appetite is the most educationally significant element in the illuminating experience. Jane had visited the Carel Weight exhibition at Rochdale Art Gallery while she was a fourth-year secondary pupil. She was one of seventeen out of nineteen in the group who had never previously set foot in an art gallery. Carel Weight's paintings, and the overall effect of the first visit, were sufficient to encourage Jane to make further gallery visits, the first of which was to the art gallery above the museum in Uppermill. She says that nothing impressed her as much as Carel Weight's paintings did, though. In fact, she was quite disappointed:

> . . . there were lots of paintings that were just sort of landscapes and things like that. Now when Carel Weight had landscapes in he always had something unusual in them and that's what stood out so much in his. I felt slightly let down by those in the gallery above the museum in Uppermill because they were so ordinary, really. There was nothing that really stood out.

On her first exploratory visit, it is already apparent that the considerable impact which Carel Weight has made on her is the yardstick against which she judges subsequent visits; her discriminatory powers are set in motion by that experience. Even though she feels slightly let down she is sufficiently undeterred to make further visits:

> I've been to a sort of mini-art gallery in Uppermill. There's a shop called The Campion which sells a lot of really novel gifts and things like that, and upstairs they've got an art gallery where they've got pictures by various people from Uppermill and round about. There were some really good ones there because they were very impressive. The first that I saw when I walked in there was a picture and it showed a corner of a room and then there was a big pot of paint upturned and rainbow coloured paint spilling out and that just really struck me because it was very bold and very bright. It was the first thing that my friend saw, because she went with me. [See facing p. 34.]

She had looked at the artist's name but could not recall it: 'It was gorgeous though – a big rainbow coloured circle of paint coming out of the tin. I think that was really great, because it was so bold and everything.' She has, in fact, given an unmistakeable description of *Wet Paint* by Patrick Hughes; there were some other works in The Campion which also caught her attention: 'There were two others that I liked. They were done in very very pale ink washes and then embroidered over, and they were really beautiful – very sort of delicate. Nothing quite as striking as the picture of the paint tin. That was very bold, but these were very delicate – beautiful really!' She felt let down at the previous gallery 'because nothing really stood out'. 'But in the art gallery above The Campion there were some that really stood out, and there were those beautiful embroideries, and I really liked those as well as the Carel Weight ones.'

These first attempts of Jane's to repeat the experience of the Carel Weight exhibition have therefore already met with some success and they are completely consistent with Hargreaves' observation that 'One has moved, quite suddenly, from being on the "outside" to being on the "inside": there is more to come and one rejoices in it.'[2] What exactly happened at the Carel Weight exhibition to generate such interest in Jane? The visit had obviously impressed her, but she had not gone with much sense of anticipation. She remembers writing about it in her diary when she got home because she was so very impressed; she put:

> We went to an art exhibition today at the Art Gallery in Rochdale. I thought it was going to be really boring but it wasn't! It was an exhibition by a man called Carel Weight and some of his pictures really meant a lot and they've given me ideas for my Art now. Now I feel a lot differently about Art than I did before.

Why did she think that it would be really boring?

> I'd never been to a gallery before . . . I suppose I'd always thought that it would be boring really, only at the Carel Weight exhibition it was different because the pictures all had a lot of meaning really . . . The art teacher had said 'I'm going to take you to the art gallery', and everybody was saying, 'Oh, good, we'll get out of doing Art.' Then a lot of people said, 'Oh, it's going to be boring! We're going to have to walk around and look at pictures of trees and things, and say how good they are when they'll probably be really awful.' And I was going expecting to be bored . . . Everybody else had been thinking that they'd be bored and I suppose I'd been carried along with the media and I'd thought I'd be bored as well . . .

On arriving in the gallery, the nineteen pupils, having had a brief look round the exhibition, divided into two groups and each group then looked at particular paintings in greater depth, considering their content and formal considerations. The two staff, whilst imparting information, also attempted to involve the pupils in discussion and they became quite fascinated by the artist's unusual approach to his subject matter. Jane felt that this had been more beneficial than if she had just walked into an empty gallery:

Because in a way it was like being introduced to the pictures. Like if you just met someone in the street and you hadn't been introduced to them, then you'd just walk straight by them. You wouldn't stop and say 'Hello' or anything like that, but if it's somebody you'd been introduced to, you'd stop and say, 'Oh, hello. How are you?' It was a bit like that with the pictures, because we'd been introduced to the pictures. We'd stop – small groups of children would stop and look and say, 'Oh yes, I feel that way about that one' and 'Yes, I think it's true about this picture', and 'I think such and such happens in this', and things like that.

The pupils had, therefore, become quite involved in the paintings as a result of this discussion session. This led into a workshop session and, because of the strong narrative content of Carel Weight's work, the pupils were given a choice between doing practical work of their own or writing. Of the nineteen, Jane was one of three who chose to write.

There were a number of the works to which she was responsive because of

His approach to it, really, because looking at the pictures I could sort of feel what he'd been thinking, what his emotions were when he'd painted them. He didn't just do them in one style all the way through, he had some which were sort of more cartoonish style, like the one about the lion escaping from the zoo, and some which were much more the way art teachers prefer you to paint, getting down the details exactly, but then he'd go and put something unusual in the picture like a ghost or something like that, or something that was upside down . . . They were very original, you see. There was one of the seven deadly sins and they were arranged in the shape of a cross, there were seven separate pictures and they were very well done. And there were a lot of other pictures that I liked . . . The way he used his colours as well – there was one called *Uneasy Portrait* and that showed a girl sitting on a chair in a room, and he'd used reds and blues together, you see . . . Instead of having the walls and things exactly straight, he'd got them slanting from one way and another. It just sort of drew you into the picture and and – I don't know – you could just sort of feel what it was like to be in the picture, really . . . When I looked at *Uneasy Portrait* it made me feel as if I was sitting somewhere. It reminded me of when I was at the dentist and I'd been wondering whether I was going to get loads of fillings and have teeth out, or just a check up . . . It made me feel like that, when I've been waiting for something to happen, and I've just not been sure what is going to happen.

The work she selected was a painting called *The Death of Lucretia*. It was a relatively small canvas at the end of a long wall of paintings in the largest room and it had not featured at all in the preceding discussion. The reason why she selected this particular painting was because

In the first place I was just looking at the pictures, and I saw that one and I thought, 'Why paint somebody killing themselves?' and then I looked into the picture, not just at the two people in the picture – the girl killing herself

and the person behind her – but I looked at the way everything else was painted, and the background seemed to be very menacing and I thought, 'Well, I'd like to know really why she was killing herself,' and why this picture made me feel uneasy because of the way the background was painted. There were very tall chimneys which seemed to be rising up aggressively as if they were an army or something, and the shade of green used for the lawn, that was very violent. I got the feeling that if I wrote about it, I'd be able to look at what I'd written and think about it, and maybe find out who Lucretia was.

The sixteen pupils who were engaged in practical work used the floor as a work surface, and the other two who had chosen to write were both in a smaller adjacent room. Jane sat down some distance from *The Death of Lucretia* but made periodic visits to the painting itself to inspect details more closely. She wrote:

> *The Death of Lucretia* shows a normal everyday scene of buildings, lawn, wall and path, but along the path runs a girl – presumably Lucretia – with face distorted into a contortion of despair. Her blouse lies open, exposing her flesh, and in her hands she clutches a knife. She is obviously just on the brink of plunging the weapon into her heart. Behind Lucretia, wildly pursuing her, a proportionally unreal youth is to be seen. Both he and Lucretia have white faces and their dark hair is layered with white on the crown. On the whole the painting has a disturbing and terrifying effect. In the background behind the two, leaning buildings contribute to the uneasy atmosphere; and the patch of lawn – in a green that would be normally calming or soothing to look at – suggests violence and sorrow. Death is also symbolised in the blood red woodwork of the houses behind the two characters, and the path curves frighteningly away from both the pursued and the pursuer. Chimneys rise up threateningly from the roof of the centre house – there is an element of dread and fear in the painting which adds to the macabre interest in Death.
>
> *The Death of Lucretia* is a painting which draws the critic to it. He is moved to ask: 'Who is Lucretia? Why is she so intent on her self-destruction? What is her connection with the young man pursuing her?' and 'What will happen when she does finally plunge the dagger into her breast?' Maybe the reason why the critic is so interested in this particular painting is the fact that HE could be walking along the path, could be in one of the buildings, see the drama enacted. There is a savage, yet real beauty in the painting – the crude dagger, the orderly pattern of flowers in the lawn's borders, the terrifying length of the youth's arms – savage, because Death is symbolised; real because such an incident could happen to you or me.[3]

We have already seen that in the seven months which elapsed between the gallery visit and my subsequent conversation with Jane, she had followed up the event by visiting other galleries in the hope that she would experience again what she had got from the Carel Weight exhibition. This was not all that she

Carel Weight, The Death of Lucretia, *1963.*

did. She began to read art books, something which she had not previously thought of doing, because 'I like to read books that criticise art as well, to see what other people think about certain paintings.' Also, in giving her reasons for writing about this particular work she expresses a desire maybe to find out who Lucretia was, and this was something, too, which she followed up later:

> After that I went and thought I'd try and find out all I could about Lucretia, to find out who she was. I looked in *The Complete Works of Shakespeare* and at the back of the book, between 'Venus and Adonis' and the Sonnets, there was a poem called 'The Rape of Lucretia', you see, and I looked in it and right at the end it had how she was killing herself with a dagger. I thought that might have been where he'd got his inspiration from to do something like that. I felt a sort of sense of triumph, really! I'd tried to find out just what had been Carel Weight's inspiration for that picture and then when I'd found out who Lucretia was and how she'd really died and everything, it was as though somehow I'd been something to do with painting the picture. It sort of made me feel – well – very close to the picture in a way, as though I knew the picture and as though I knew the artist when I found out who Lucretia was. It made me able to identify with the picture and with Lucretia sort of going back

and finding out who she really was instead of just looking at the picture and thinking, 'Oh, that's called *The Death of Lucretia*. Well, I won't bother with who she is or why she's there, or anything like that!'

This remarkable statement reveals an intense level of identification with the work and the artist: 'it was as though somehow I'd been something to do with painting the picture'!

Jane now wants to go to more galleries. Some would object to groups such as hers being exposed to 'high art', and a touring exhibition of paintings by Carel Weight, accompanied by a glossy catalogue, would doubtless be so labelled by these critics. Jane, however, has no problems with such labels because she is unaware of them. She has responded to Carel Weight and she simply relates the experience to what she already knows. Apart from her two later gallery visits, this means the work of her classmates. Among her reasons for wanting to go to more galleries is that

> I like to see what other people are thinking. Because I think when you're doing Art, then you're putting down the way you feel, because in the art lesson if we're told to draw something then no two people ever draw it the same, because at the moment we're doing our Mock O-level and there are two girls who are working on a still life and they've both got entirely different angles but the way they've drawn it is completely different as well. One girl's been much bolder with her shading and everything. Just looking at it, it reflects her personality; a more confident personality than the other girl – hers is sort of more conservative, subdued, really.

Jane has observed these differences in the work of her classmates for herself. The art which pupils are most constantly in contact with is that of their peers and its significance is part of this book's concern.

Apart from those involved in practical work completing what they had begun in the gallery and the three who had written making copies of what they had done:

> We never really did anything more about the exhibition, but when we were given the lists of the things to do for our Mock O-level, one of the things was was *Hallucination*, an abstract of that, and one of the things was *Fantasy* and I found myself thinking about the exhibition, about some of the things that I'd seen and how they had an unusual element in them, and that's why they were so impressive really. I think quite a few people were influenced by the exhibition.

We have already seen what lengths Jane has since gone to in order to substantiate that initial gallery experience. Even though the groups as a whole had feared that they were going to be bored: 'A lot of people, they said that they'd liked the exhibition and they wouldn't mind going again to another one like the Carel Weight exhibition, because they'd liked lots of the pictures.' We can be reasonably certain that Jane's appetite has been sufficiently aroused for

her explorations to continue, but other members of the group will have been impressed by the Carel Weight exhibition to varying degrees. 'A lot of people' wouldn't mind going again to another such exhibition, and it is important that this need is met. For many of them to develop the necessary motivation themselves, it is important that the school substantiate the experience. This can be done by the right reinforcement of the specific exhibition as well as through further visits – complex matters to which I will return.

Jane, however, perfectly and completely illustrates the impact of the illuminating experience. She expected to be bored and found the event memorably stimulating. Her commitment is now such that she has made further exploratory attempts to follow up the initial experience by undertaking further gallery visits in her own time and of her own volition. She is developing discriminatory powers whereby she is not only gauging other works against those of Carel Weight, but she is also contrasting the bold and bright *Wet Paint* print with the beautiful and delicate embroideries. In addition, she is furthering her knowledge through background reading, having become interested in what other people have to say 'about certain paintings'. It is interesting to note that at the time of her visit to the Carel Weight exhibition she was the same age as Lara, who equally illustrates this determination to substantiate initial vivid gallery experiences through the same kind of stepping stones – Jane says that she liked the delicate embroideries as much ('as well') as the Carel Weight paintings – these first works confronted in an art gallery are her reason for making further visits and the yardstick by which she still judges other works. With the passing of time she may come to regard these paintings as being lesser works than others for which she has subsequently developed a regard, but it is doubtful that she will ever forget them or lose her affection for them – for they were the first!

All that Jane has undertaken has been in the space of seven months (the timelag between the Carel Weight exhibition and my interviewing her), hence my need to qualify my conjectures about her further explorations with such phrases as 'we can be reasonably certain'. My reason for being reasonably certain, however, is that older students and the adults who have given their 'aesthetic autobiographies' give longer-term accounts which reveal a remarkable consistency from beginnings which conform with that of Jane.

Marie also attended her first exhibition in this country at the same age as Jane. For many, though, their first school-organised gallery visit is not made because they are studying art but because they have gone abroad as language pupils. In this capacity Marie had already had opportunity to see some Impressionist paintings in Paris.

(b) Marie's two gallery outings

I have visited the Jeu de Paume Art Gallery in Paris and Drumcroon which is nearer home. At first on both occasions I wasn't very keen to go, but now a whole new world has been opened up to me about Art and its many different forms.[4]

Marie made the two important gallery visits within the space of a few months. The first, to Paris, was during the summer holidays at the end of her third year, and she visited the Tadek Beutlich exhibition of woven hangings and prints while she was a fourth-year pupil. The reason why she 'wasn't very keen to go' to the Jeu de Paume was because

> . . . you get impressions of artists being boring old things who just sit down painting all day. I just didn't feel like going. My friends won't go because they're just not interested whatsoever . . . But you get this impression of artists that are boring, you know, who sit in corners all day just to paint pictures of women and that – no expressiveness or things like that. It's really why I didn't want to go. I regret it now!

Having anticipated boredom, it was quite different in practice:

> I enjoyed going to the gallery. It was good. Some paintings just didn't interest me, but the Impressionist paintings where you stood back and admired them – the colours and the lines, and the blurred outlines and things like that – that was good . . . Impressionist paintings are usually brightly coloured with fuzzy outlines and the real effect can only be obtained when you stand well back from the picture.

But Marie had said that she wasn't very keen to go on *both* occasions. As she had, against her expectations, enjoyed the visit to the Jeu de Paume, why was she still not keen to come to Drumcroon afterwards? 'Well, I thought that Drumcroon was like a school – it was just a case of going and looking at pictures and trying to copy ideas from them.' In the event, the weavings and prints of Tadek Beutlich clearly had a profound effect on Marie:

> I never realised that artists did things like weaving and tapestries and things like that. I always thought that it was paintings, purely paintings, and then when I came I really enjoyed it. I was really taken aback and amazed at the weavings done by Tadek Beutlich. Never having any other previous experience of seeing weavings I really found myself wanting to know how these weird shapes and patterns could be made from materials. The colours and names fitted the weavings perfectly. [See facing p. 34.]

Seven months later Marie still vividly recalls *Bird of Prey*. She gives the following description of this piece without it having been previously referred to in the conversation, so that when she says, 'Oh yes – that one' she is referring to an image in the mind's eye rather than picking up a logical thread of the conversation:

> Oh yes – that one. It was really good! It reminds me of a bird – a bird and a buffalo's head, and it was really long and big and really dark – and really lovely colours. That was really one that I liked. I thought, 'How was it made? How could you make that?' It was knotted and things like that. It was tied down, and you lifted it up and it just had one battened base . . . It was built

up on top of that. I didn't think anybody could do it! It really pleased me even when I went home. I asked the teachers how it had been made and they tried to explain it, but it would be better *seeing* how it was made.

Too often the gallery visit is treated as a self-sufficient event but, as with Jane, this visit has aroused particular interests and raised questions which have implications for subsequent follow-up work. Tadek Beutlich's prints also made a strong impression on her:

> Another thing which attracted my attention was the simplicity of his prints. These were just a few colours and a few abstract shapes blended together to make a beautiful, striking effect which was really inspiring. They were like pieces of fruit cut in half and then built up in different colours. There was pea green in one and there were some that were really violent. They were really good colours; colours like we do at school – but ours are not as good as things like that! You try. You wonder how people can get it, and you want to do something like that at school.

She wishes that she had seen the Tadek Beutlich prints earlier, because she had done some printmaking at school but had lost her way when she could not envisage the end result: 'I did some prints last year and just gave up because it was just sort of putting one colour on top of another and cutting shapes out of different layers. I thought that it was never going to turn out right.' She feels that her own work is 'always a set thing for an exam or something like that' and you don't get the opportunity of 'expressing yourself, as Tadek Beutlich is doing in his printing'. It is for this reason that she wasn't keen to go to an art gallery at first 'because I think you just build up from school an idea that paintings are as boring as you are doing at school'. Marie therefore feels that 'more chance should be given to the child to do what the artists do', because

> Everybody is influenced by somebody else and if you could just start to formulate your own ideas, just follow the guidelines of somebody else's work and not exactly copy, just understand how they have done it, what they were thinking of and how they put it all together, instead of just doing one simple print of just a figure or something like that – and really going to town on things like that. Just to have the chance to tax your brain – !

From the two visits Marie feels that 'a lot is gained from looking at and studying artists' paintings and creations (both traditional and modern)'. She also feels that 'more trips and outings should be organised to help us understand and learn about different techniques used by the various artists and a class should study in depth what effect colours have on a picture or scene, etc.'. 'It would be nice to be able to go somewhere and see somebody at work. Somebody who's really good and who has got an exhibition there as well.' From having been not 'keen to go' on either visit, Marie has obviously derived a great deal of enjoyment, and insight, from both experiences. The impact of the Beutlich woven hangings has been powerful enough for her to be 'really taken aback and amazed'. *Bird of*

Prey has remained vividly in her mind's eye and has aroused in her a curiosity about how 'these weird shapes and patterns could be made from materials'. (This interest in how things are made is a constantly recurring feature in the pupils' responses to what might be termed craft objects.) Many of Marie's sentiments closely echo those of Jane – both were the same age. It is interesting to set part of what Marie says against Jane's diary entry. For example, Marie wrote:

> At first on both occasions I wasn't very keen to go, but now a whole new world has been opened up to me about Art and its many different forms . . . On my first visit to Drumcroon I was really taken aback and amazed at the weavings done by Tadek Beutlich. Never having any other previous experience of seeing weavings I really found myself wanting to know how these weird shapes and patterns could be made from materials.

Jane's diary entry reads:

> We went to an art exhibition today at the Art Gallery in Rochdale. I thought it was going to be really boring but it wasn't! It was an exhibition by a man named Carel Weight and some of his pictures really meant a lot and they've given me ideas for my Art now. Now I feel a lot differently about Art than I did before.

We have considerable evidence that quite young children can be likewise aroused by these experiences which reveal the totally unexpected, and Sir Roy Shaw describes seeing Richard Hoggart 'spend an hour expounding a short poem of T.S. Eliot to a group of middle-aged ladies and I have seen their eyes open – or more accurately have seen their minds opening'.[5] It is worth emphasising again that though great emphasis must be placed on the all-important initiatory experience, many people describe similar moments of revelation occurring at many key points in their 'artistic lives'. Illuminating experiences can therefore occur at any stage in life from young to old. Nevertheless, it would seem that there is something about the intensity of adolescence which makes the Maries and Janes particularly receptive or susceptible to these types of experiences, as Melanie Phillips has already tentatively suggested in relation to her response to *Sons and Lovers*. In the transition from childhood to adulthood, perhaps the individual is particularly receptive to qualities in works of art which strike that chord within him or her which is an essential part of the sense of revelation. Adolescents are discovering something about their own uniqueness as people through this process. Jane makes passing references to her own practical work, but it is in this respect that Marie's testimony is so unusual. She forms quite subtle links between what she has seen and her own work to the point where she even makes some really perceptive suggestions as to what might consequently be done to improve art education, obviously based on her own needs. She is clear that she does not want to 'exactly copy' from other artists, but sees contact with them and their works as an aid which can help 'formulate your own ideas'. The significance of seeing

the artist surrounded by his or her own exhibition she understands – though she has never experienced this herself. What she has seen has been sufficient to give her an insight into a learning situation which might be. What she is suggesting corresponds very closely with Andrew Brighton's recommendation that

> I would make knowing, and knowing about artifacts of Western and other cultures and past and present cultures, the centre of secondary art education. My pupils would know these works by making, that is they would draw, paint, carve and model in a variety of relationships to these works . . . But they would also know about these works by studying their cultural contexts.[6]

Such a course could be both demanding and stimulating, giving Marie that chance which she wants 'just to tax her brain'!

As things stand at present, however, it is only when the examination system dictates that art appreciation be an essential element that it is systematically taught. This means, generally speaking, that until the sixth form, gallery visits such as those experienced by Jane and Marie are treats rather than part of an essential diet. Most teachers regard subsequent favourable comment by the pupils as evidence of a successful visit, whereas the pupils' reactions make it apparent that the need is for follow-up work (unless the visit has been aversive, in which case it might be best to let well alone) affirming and substantiating the visit – otherwise the effects of the experience will dim, for the motivating effects are obviously going to be at their strongest immediately afterwards. Two case studies relating to sixth-form students who are making gallery visits as an essential part of their course illustrate the importance of such substantiation.

Section 2 Critical Studies Courses and the Original Work

(a) 'Oh no, not this for two years'

Jane and Marie had both made their initial visits to galleries as members of school groups. Marie had set work to do in the Jeu de Paume, and at the Carel Weight and Tadek Beutlich exhibitions each was 'introduced', as Jane expressed it, to the works in question by gallery staff. Many galleries are increasingly offering this kind of service, but as this is not always available the art teacher must either undertake such a role himself or herself, or must adequately prepare the students in advance. Some teachers, of course, see their role as fulfilling both. The art history and appreciation lecture is increasingly being replaced by other approaches. It can, however, be demonstrated to have quite an influential effect on students when it is taught with sympathy and with skill, and it can affect students' attitudes in the gallery considerably.

At the beginning of her sixth-form course Anita began studying art history. This is often a completely new subject for students of this age, but Anita had had a brief introduction to the Impressionists at her previous school:

When we did O-level we looked briefly at Impressionism – Monet, Pissarro and Sisley – and we looked at them and I thought we understood what he was trying to tell us about them painting with an observer's eye, and we understood the point he was trying to make about them not necessarily looking like a photograph but still being art, that it did not necessarily have to be traditional, classical, beautifully painted. It can still mean as much in art as anything that had gone before it, but it was a different approach. When we were in O-level we went to see these slides. I understood what he was trying to tell me, but when we got back to the classroom it was back to painting pomegranates, and half a cabbage; and your reflection in a kettle and things like that, so we couldn't use what we had seen. We couldn't use what we had seen unless we broke the rules again, so it was a bit ironic, well hypocritical in many ways. He was telling us what had been and then he wouldn't let us try it out![7]

From the outset, therefore, Anita was aware that an important relationship existed between the looking and doing aspects of the subject.

When she began official art history studies as part of her course, her first reaction was, 'Oh no, not this for two years':

We started with Constable and Turner and to be honest I'd seen them all on the tops of chocolate boxes and postcards and things like that, and I thought, 'Oh no, I'm not going to like this!' even though there were good and valid explanations of why we were doing it. I wasn't enjoying the paintings, and it was only when we got up to Impressionism and I started thinking back over what we'd done at O-level, and I was thinking, 'Yes, they told us this then' but I didn't understand it then and we weren't allowed to go out and look at things in a different way – you know, we weren't allowed to try and put the style into our work. How can I say it now – incorporate it into our work, what we had learned.

As the course got under way properly, though, Anita began to enjoy the lessons and to look forward to the next one with a sense of anticipation:

I got excited over the Impressionist period in class because I liked the way it developed and the way they used Japonism and the prints, and they went against tradition; I liked that, I like anything rebellious. I got really excited about it. I got to the point where it was like 'The next thrilling instalment next Monday morning at third lesson!' I wanted to see what happened next because it just developed. First of all we had Manet and he went against tradition because he used a two-dimensional effect in *Olympia*, and he took from Titian – *The Venus of Urbino* – and he drew from that but he changed it. And just the little changes, the people went mad at this and there were uproars, 'Uh, you can't do that!' and I said, 'Oh, that's interesting, why did they do it?' And then it was explained why; why it was so different. Because when you first look at them and you don't know about them, you look at *The Venus of Urbino* by Titian and you look at the *Olympia* and you can't see the

difference straight away if you don't know, if it's not been explained to you. Why one was great, and the other one was absolutely awful! You know, everyone was 'Sharp intake of breath!' and 'Ghastly!' and all that stuff. It was exciting to think when you saw them that YOU KNEW what the difference was . . .

There is a strong case for introducing works to younger children thematically and in relation to their own practical work, but Anita indicates here that she is looking forward to each week's lesson with the same sense of anticipation that she might have for the next instalment of a serial which has captured her imagination – it is the way the subject is unfolding chronologically which has aroused her interest. However, the teacher began the course with Constable and Turner because of the practical implications which this period and the twentieth century have for students, and so that they can become involved in the art of their own time at a central point in their course, rather than run out of time at, say, Cubism or even earlier.

At the previous school, the pupils had not only been shown slides of the Impressionists, but they had been able to see them in the National Gallery as part of a school trip to London. Anita says, however, that at that time, 'Your drawing must look like a photograph – how real you can make it look . . . it had to be a sort of rather meticulous drawing . . . It had to be standardised. It had to be in the vein of what O-level Art is.' It is hardly surprising, therefore, that she had difficulty even relating to a Monet:

We did go to the galleries when we were in Senior Five, which was last year, and the teacher went mad over this Monet and he thought it was great and I thought 'My God, what's all the fuss about. It's just like a misty painting of the Thames. There's no detail; you can't even really tell what it is.' I thought, 'What's the big fuss about', but when I'd actually learnt about what they were actually trying to achieve and that they were rebelling in colour and form and everything, and you understood what their aims were – I was getting excited!

By the time she went to the London galleries again, therefore, she had become involved in the work of some artists, but others which she did not expect to derive enjoyment from were quite different in the original. By coincidence she met her next-door neighbour in the National:

When we went to the galleries the second time I was thrilled to bits. I thought, 'It's great, this!' We went to the National and even the Turners and the Constables, I got really excited about them, because I thought that they were the first steps towards going in different directions, like Constable with his snowflaking and Turner with his sort of command over the elements – and he wasn't painting what was there, he was sort of turning everything round and his paintings were exalting, they were really exciting to look at. He was making the colours brighter and lighter. It was mainly the colour that turned at first. I was excited because I understood, but there were some people from [an art school] and one of them was my next-door neighbour, and they hadn't

done any History – at the time she hadn't done ANY History! She's doing the Foundation and I'm doing the A-level and we're both the same age and we'd both done O-level and we'd both got the same grades and everything. When she went to the galleries, she was walking round and I bumped into her, because we'd all gone on the same day on a chartered train, and she went, 'Oh God! isn't this boring, me feet are killing me. We've just had a cup of coffee, and we're really bored to tears.' I thought, 'But why?' I'd been looking and going around. I'd been going, 'Oh, look at that, look at that, look at that' as if it was some kind of carnival, and she was going, 'Oh, my God, I'm really fed up with this','and I said, 'But why?' I said, 'I've bought about thirty reproductions!' I went mad, it was really good. I felt good because she wasn't enjoying it, and at the same time I felt guilty because she wasn't enjoying it, and THE ONLY REASON SHE WASN'T ENJOYING IT AS MUCH AS ME WAS BECAUSE THEY HADN'T LOOKED AT THE PAINTINGS BEFORE AND THEY HADN'T HAD IT EXPLAINED, and that was the only reason. She WAS looking at them, but to her it was just, 'Oh, Constable, Turner – big names in the art industry'!

In outlining the characteristics of the conversive trauma, Hargreaves reminds us that there is the opposite – the aversive trauma: the turn-off! Schools can 'from the best of motives, unintentionally induce aversive trauma and reinforce existing prejudices against the arts if it compels exposure to the arts'.[8] Hargreaves stresses that 'It must be a key policy of the school to *persuade* reluctant or indifferent pupils to participate in these activities (as opposed to "compelling" them).' We have seen shades of reluctance already in the cases of Jane and Marie, but Anita has here described in the most vivid terms a situation where two students from identical backgrounds have each responded in quite different ways: one conversively, the other aversively. Her explanation is unequivocally clear. It is because her friend had not had the neccessary preparation beforehand – and yet the reluctance of art teachers to instruct their pupils in matters relating to art history and appreciation arises out of a fear that it will be boring to them– that the classroom lesson itself will be aversive. This attitude is formed by an awareness that the pupils do already regard the arts as boring and it is reinforced (according to many art teachers with whom I have spoken) by the fact that the lectures they had to attend when art students were boring to them. Nevertheless, all the evidence from the pupils and students makes it clear that they feel the need of explanation, they have to 'understand'. What is certain is that where no adequate preparation has taken place and where the teacher or

T is for Tate (see p. 101).

(Left) The teacher introduced his pupils to the paintings of Mark Rothko and Barnett Newman during the 'L is for Liquorice Allsorts' week.

(Right) Having been surprised by the sombre atmosphere of the Rothko Room in the Tate, Jeff painted a 'Happy Rothko' on his return to school.

tutor then assumes a gallery role of 'being around if needed', it is inevitable that a good percentage of students will become bored or, at best, be indifferent.

Having enjoyed the Constables and Turners so much, Anita also looked at the Impressionists, particularly responding to the Monet waterlilies, but she spent quite a lot of time looking at works not yet touched on in the course:

> I had a look at some of the Renaissance paintings and panel paintings. I was amazed at how accurate some of the paintings were. I looked at some of the Rococo and things like that. We had looked at them, but that was before I actually got excited about what we were doing. Actually seeing the paintings, I could remember what I'd done. I thought, 'I know them, I've learnt about them.' But at the time it was just History, we hadn't seen the paintings, and when I went back to look at the paintings I looked at them in a different way.

She not only looked at them in a different way, they actually seemed like different paintings from what had been conveyed in reproductions:

> I could match the works up with what we'd seen in slides and what we'd written about and what I'd spent ages looking in books for, because it's not as exciting when you're looking in books. You see them in the books, but they're really not quite the same as seeing them in real life . . . There was one with a figure going down the beach, *The Evening Star*. It looks pale in the reproduction, but when you go in it's bright orange, it's really strong – I've got a small book on Turner with colour plates, and it looks pale pink. I thought, 'Oh, yes, *Evening Star*' and I looked at it, and it wasn't the same painting to me. It wasn't the same painting at all, because to me it was a lot brighter, and with thick crustations of paint on. I thought they were all smooth and wishy-washy, but you realise just how strong the colours are and how strong the paint is.

In reproduction form the Constables looked too much like the tops of chocolate boxes but not in reality:

> The Constables look like photographs when you see them in the reproductions, but when you get up to them you can see how thick he put the paint on, how rich they are, and they look as if they've just been painted . . . You could get right up close and you could see the meticulous detail in the Pre-Raphaelite stuff . . . You can't see that in the reproductions – you look at the style and the biography of the artist and you think, 'Wow' but when you actually see them you think, 'WOW'! You realise how important it is when you actually see them. When I go to the galleries I – at the moment – go up to the ones I've read about.

People and peoples: The Scream *by Edvard Munch (see p. 116).*

The children's studies were executed very quickly 'because it had all been done in the head beforehand'.

Some teachers have asked why the CSAE Project has put so much emphasis on the study of works in the original when modern slides and reproductions are so good. Anita here gives the most vivid explanation as to why – and the process does not stop on leaving the gallery:

> . . . you were looking at it in a different way – not actually while you were there, but when you came back home and thought back over it. You would be reading back over your notes and you would think, 'She was telling us the truth!' Not that you thought that she wasn't telling you the truth, but you had something to prove it.

She has said that at the moment she goes up to the ones which she has read about. This basis of knowledge is an absolute prerequisite for Anita to enjoy gallery visiting fully:

> I've been to the galleries before that, and I've looked at the paintings and I've thought, 'Oh, that's nice!' But when I actually got it explained and went back again, that was when things started me – and you get a SORT OF A TINGLING FEELING INSIDE YOUR STOMACH and you think, 'Oh, it's really good that,' and I understand.

To emphasise this point further, she draws an analogy between gallery and museum visiting:

> Before I came to A-level Art, I used to go to museums, like the Science Museum, because they used to have a plaque at the bottom explaining the history of things . . . what things were, why they came about, and the Industrial Revolution and all this stuff. You could press a button and try the things and see the workings of things. But when we went to the galleries it was just pictures. O.K., you can look at the pictures; it wasn't the same! Things weren't explained to you before. You see, you've got to connect the two – you've got to draw from the two (for me, anyway). I like to have it explained, go and see it, come back, read what was explained and then think about it. It's connecting the two; it's KNOWING WHY IT HAPPENED, GOING TO SEE IT, AND THEN REALISING. It's just that seeing it – it's proof for yourself, seeing it with your own eyes!

Since that important visit to the National Gallery, Anita has developed an increasing love of art history, and has begun to acquire a collection of art books of her own. She has made a number of subsequent visits to the Tate, Courtauld and the Victoria and Albert Museum and has been to galleries in the North West such as the Walker at Liverpool and the Manchester City Art Gallery, but she would love to visit Paris, and on two counts:

> I'd like to see the very first things that I got excited about like the *Olympia*, the Monets, and things like that. I want to see them – I really do want to see them because [the teacher] stands in the class and she tells us, 'Oh, I saw it, and we walked in and it was just there on the wall and it was breathtaking',

and you think, 'Oh, God!' You can't understand until you've seen it, you really can't. You're tapping your fingers and you're crossing your legs – I chew the inside of my mouth. And when she's telling us I think, 'I bet that's fantastic in real life' and I really want to go and see them now. I really want to get up and get out.

The transmitted enthusiasm revealed here is a long way from the common assumption that art history and appreciation lessons are to do with information which relates only to facts about names and dates. The second reason for wanting to visit Paris is that she has already seen a Monet haystack:

In Edinburgh they have two Monets, one is of the haystacks . . . I really, really would like (fingers crossed) to see some of the Rouen Cathedrals, because I've seen the effects he used in the haystacks, and I really would like to see the way he did the Rouen Cathedrals. I really want to go to Paris. I'm hoping to go (fingers crossed) before Christmas.

We have already seen that Anita felt frustration at not being able to utilise 'what had been' in her own work when she had been shown the slides of Impressionist works as a fifth-former. She describes how she is now becoming more confident about her own work, and she says that 'the more confident you feel the more you want to take from other people's work': 'I'm conscious of borrowing not only from people in the class, but also from the History; you are just more conscious.' The question is posed: 'So you say borrow, not copy!', to which she replies: 'Oh, God, no, you'd get done!' Asked what exactly she means then by 'borrowing' she explains:

Well, we were doing some work on Seurat and Cézanne. We were just going into the Neo-Impressionists. We did Seurat and we are coming to Cézanne at the moment but we had looked at some of the works, and we had studied Seurat in quite great depth – my first oil painting was a disaster, I'll be honest! – I've just done a self-portrait and I did a very little bit of drawing up, it was hardly worth doing, and I based it on a sort of mixture of Cézanne's style and Seurat. I did it in blocks of colour and I used a square brush, and nearly everything is in blocks of colour. It's a sort of pointillistic approach but with blocks of colour, the same as Cézanne used. So it's pointillistic but the blocks are square, if you follow me. I found out where I was going wrong with my oil painting, why the colours looked so muddy and that if I applied the paint in separate blocks and kept the colour more pure without trying to mix it in with other things, it would come out fresher, sharper, and that was the effect that I was trying to achieve. I COULD CONNECT ART HISTORY WITH WHAT I WAS TRYING TO DO IN CLASS MORE READILY, and I found out that you can learn from other people – not just your classmates – but from other people; from the artists of the past, the Great Masters and all that.

Having expressed frustration at not having been able to utilise information about the world around her made apparent through looking at the work of the Impressionists when a fifth-form pupil, Anita at last is able to solve a variety of technical problems through the application in her own work of such information.

From thinking 'Oh no, not this for two years!', Anita has become so involved in her art history and appreciation studies that she has now made many gallery visits and has become an avid student of the subject through further studies and researches from books. It is interesting how many people alter the title of the Critical Studies in Art Education Project to include either of the words 'historical' or 'analytical'. It is possible only after the pupil has experienced the kind of excitement which Anita describes on that first visit to the National for 'analytical' study to follow meaningfully. Anita explains how actually seeing the paintings gave fresh meaning to the work which she had already done, and she describes how the gallery stimulus caused her to go back and cover again with excitement those areas of the course she had initially done out of duty.

The interview with Anita took place in the first week of her upper-sixth course. As part of her A-level JMB examination she wrote a Personal Study called 'The Optical Inclusion of the Viewer in Painting'. Having made a necessarily brief analysis of how the rods and cones of the eye enable us to perceive colour, Anita then makes an analysis of *Yellow Attenuation* (1965) by Peter Sedgley. This illustrates the degree to which Anita is now, seven months on from the interview, both critically and analytically aware. She writes:

The colours are bright and pure each in their own right, though I only appreciated their identity when close to the board itself. At approximately 5 metres from the board I could evaluate the whole, or so I thought. We can come to terms with this need for distance when we consider the biology of the eye. Vision is most acute at the fovea, when close to the picture we can only focus on small areas at a time and surrounding areas are blurred because sections other than the fovea cannot cope substantially with the brightness of colour in the work. A greater distance from the picture widens the span accessible to the fovea, thus resulting in a more satisfactory focus. The effect given off by the Sedgley was an apparent confusion of colour and yet I could see a disciplined format of design, a regular insistence on horizontals, occurring at first it seemed, at predictable intervals. Then the darker bands group together and the intervals become narrower. As you proceed down the picture the bands of light-toned colour open up, yet the dark horizontals remain the same. Proceeding down further Sedgley lessens the width of light tones again widening them out towards the bottom edge of the picture. This emphasis on horizontals is in keeping with Seurat's interest in that facet of design which enforced the relationship between forms and the picture's edge. So the effect of alternating these light-toned bands gives the illusion of alternating space. As a result the wider the intervals the closer that region of the picture appears to be.

If I were to show the illusion of space which appears in the picture in a diagram it would look something like this:

In the past the concern for space has only been used to aid represent-ationalism, in conjunction with the idea that the picture is a box or a window with the scene set within. This particular picture, however, creates an illusion of projection of space, it appears to protrude leaving me unsure as to whether I am standing closer to the canvas than I really am. So I see that juxtapositioning of colours and their interacting tonalities have disorientated my understanding of space. (It is interesting to note that the illusion of protruding space has been achieved with non-representational subject matter.) The artist is not physically building in relief yet he gives that impression. Added to this disorientation by colour is the movement created by kineticism, creating further disturbances as mind and eye strive to collate the illusion to a logical conclusion. In other words, we know the painting is flat, and the added difficulty of moving colours increases the ambiguity. The ground colour appears to be yellow and darker tones of other colours have been placed over the top. Perhaps it is the fact that yellow is by nature a progressive colour that the gyration disturbing my focus occurs. The darker bands are made from individual lines of red and blue which when mixed together produce purple. Close to the work they act as independent stripes, further away they form purple – purple and yellow are complementaries and so when seen together they increase each other's intensity. Also the wider intervals of yellow and red mix to form orange, thus making a complementary for lines of blue which may occur. This makes for greater richness in the two areas where blue dominates the dark band but an interesting subtlety in the middle cooler band, where red dominates blue and yellow stripes. All the lines are of equal width, thus it is the interaction of our eye which produces the effect of colour dominance.

A further aspect of Optical painting is that undetermined effects appear due to dramatic changes in tonality. When looking intensely at the picture for long periods of time, shades of grey areas appear. Their direction opposes the horizontal design. This is a monochromatic after-image, which evolves out of

a saturation of primary colours. The reverse of this happens when observing the stark black and white of *Supa Nova* (Vasarely 1959–61), Tate, when an after-image of colour appears in the white areas and even continues when we look away.[9] [See reproduction facing p. 35.]

Anita needed the help and support of her teacher to be able to relate art history studies to her practical needs, and she has likewise developed an unusual ability to respond to work of arts in an informed and critical manner – but only because gallery visits have arisen out of a systematically structured course. In spite of the examination board's regulations, many students have to write such studies with often only the flimsiest of courses to draw upon for relevant background information. Likewise, where the teacher does run a regular art history and appreciation course, it is often minimally factual with the students referred to art books without their having developed adequate criteria to draw out material in a discriminating manner. Julie gives us some further insights into the nature of these lessons.

(b) 'It just caught the imagination completely'
If Anita illustrates the importance of the right form of preparation and the relationship between the reproduction and the original, Julie makes it apparent that a variety of experiences over a period of time can each open up new facets of the visual arts. As her understanding and awareness increased over a period of time, a number of key experiences acted as stepping stones to accelerate this process. The importance of the initial illuminating experience cannot be over-emphasised, but Julie's testimony illustrates that one individual can benefit from a set of such experiences over a period of time.

Until she began the study of art history and appreciation at the age of sixteen, 'paintings were something that were very nice, or were on the wall. I never thought too much about it, because art to me was doing a drawing or doing a painting.' Where the word 'Art' appeared on her timetable at the beginning of her A-level course she assumed that it automatically meant practical work, and so she simply found herself in attendance in her first art history lesson, but that one lesson had a considerable effect on her:

> It just caught the imagination completely – I was introduced to art history, because I think you can be taught facts and you can churn out the dates and relevant details of it, and it can be boring if that's all you're looking for and that's all they are teaching you. But the way I approached art history they were introducing me to a painting and it was up to me then whether I found any sort of sympathy with it or whether I enjoyed it just for the sake of it being there.[10]

Julie, like Anita, recalls that first lesson dealing with Constable and Turner:

> The first lesson was quite interesting in that it was Constable and Turner. We did *The Haywain* and for years, in one of our rooms at home, we had had a reproduction of *The Haywain* and it had been there for years – I mean, oh, I

must have been about six or seven – and that first lesson was the first time that I'd looked at that painting and seen something in it. It had always been on the wall and – you look at things – but I'd never appreciated what it was . . . It was only then once I'd been in that first lesson and seen it and been introduced to it, that I then went home and looked at it. I suppose that was good, for the first lesson that was great, because I immediately saw something that I could relate to – even though it was only something in our dining room!

She had never previously 'looked at it as being an atmospheric picture – I'd just thought of it as being there!' When she went home she says that she looked at it from a compositional standpoint, also, the way it was built up 'instead of just being on a blank canvas and it was on the wall'. She was immediately interested, 'and as the lectures developed I never lost that desire to learn more about it':

We knew what we were going to do next and I can remember going out and looking for art books to read in advance, which was something I'd never done before. I'd always been interested in History but I'd never actually gone out and looked for something to read on that subject before I went into it – but I found I was looking forward to learning about different things. The thing is you don't realise how much Art you know as a child, seeing certain famous paintings that are on television or famous buildings or sculpture. It's not until you learn about them that you realise how much you do know or how much you *don't* know. I know so many paintings that I think, 'Oh yes!' but I didn't realise anything about it until then.

Julie emphasises that she did not understand everything that she read in books in advance of lessons, 'but once I go into a lesson it's like having a prior knowledge and then it's clarified for you'.

Shortly into the course, another event occurred which she sees as being of equal importance to the lesson on *The Haywain*:

By the time I'd gone to a few lectures my interest was becoming much wider and then we came here and saw Gerd Winner – and I didn't appreciate that exhibition at all at the time. I think I'd had only one art history lesson and, as I said, it was Constable and Turner and, I mean, the difference between a Winner and a Constable and a Turner! I didn't appreciate the Winner exhibition at all, because my exposure to art history – if that's the right word – was just Constable and Turner.

As the weeks went by, however, she became aware that she was seeing everything around her with a new perception:

I began to appreciate art in a much wider way and I began to look at things in a different light. Not only paintings but things around me and books and television – different things I began to appreciate, I began to look at things differently. I can remember looking at buildings on television. Don't ask me why I looked at buildings differently but I'd have to put them into a place in

my mind, I'd have to work out why I liked them or disliked them. I would lose the flow of what was happening on the television because I wasn't watching or listening to the television — I was watching it and I was thinking.

Formal visual qualities had taken over from the storyline. On holiday in Barcelona all her friends remembered the holiday as being great because of the bars and cafés, but her memories are of the height of the buildings eliminating the sunlight. She remembers it as 'just a stark place', and she now found herself responsive to places in this kind of way:

> I started to walk around, even places that I'd been brought up in. I started to go to the older parts of Liverpool – not the shops, but to the Town Hall and to some of the arcades, the business arcades where they've got lawyers' offices. I could feel myself looking at things in a different way and appreciating things. I mean, I don't love every painting that I see and I don't appreciate everything that I see, but I am aware of things going on around me that I wasn't aware of before.

As this awareness increased, she found that something strange was happening in relation to the Winner exhibition: 'I'd looked at the Winners here and not appreciated them – but once I'd done, say, a year's art history or even a good month my appreciation for what they are grew.' 'They are very much' still in her mind's eye. The exhibition was also affirmed when the *Catfish Row* suite of etchings was displayed in the art department as a Picture Loan item:

> When they first came I didn't recognise them as something I could appreciate. Now they were there for quite a few months and there was a Vasarely there and it immediately appealed over the Winners because of its colour – it immediately appealed to me. By the end of that few months, though, I definitely had a sympathy with the Winners. I still didn't understand them and didn't fully appreciate what they were about because I hadn't sort of progressed that far into appreciating things around me, but I can remember saying to my friend Kath, 'I do like those.' I couldn't explain why I liked them but they had grown to the point now, virtually two years later, where watching a programme they're just so vividly in my mind.

She is referring specifically to a recent documentary on Harlem:

> . . . that had brought back the Winner exhibition so vividly, just seeing it. I mean, it was interesting in its own right – but it kept flashing back in my own mind certain things that I'd seen in Winner's prints that had been there, and the next day I rang up Kath and I said, 'Did you watch that programme last night?' and she said, 'No.' I said, 'You should have seen it, it was great, you should have seen it! It was just like those Winners we had at college.'

She feels that, as her general understanding grows, Winner is somehow part of this process:

> In a special way in that he was the first artist I'd seen, actually, in an

exhibition of his work. He is still interesting to me. He is a person I would love to meet again now. I mean, I've spoken to him when I first saw the exhibition but I'd love to meet him again now. There are so many things I'd love to ask him now that I hadn't got the capability of asking him then, and I know that if I ever found another exhibition of his work I'd love to go and see it again and just look at it for its own sake. I always found the Liverpool docks fascinating and I think he's the only artist I really know who also finds that type of landscape fascinating. He is something special, really. I've never thought of it in this way, but he is a person that I'll always remember as being the beginning, really, of my interest in art history.

On her first visit to the London galleries, Julie naturally wanted to look at *The Haywain* but she was particularly interested in the Turners by that stage as well, but 'I couldn't say that I'd looked at anything in particular outside of that room on that visit.' Her next visit, however, began at the Tate. She had gone with the upper sixth six months after that first visit:

We went to the Tate and I hadn't done any modern art by then and I was full of disbelief. That is one thing I do remember, being disbelieving at why that was any good. You know, that a canvas that was painted all red with one purple stripe was any good. I was relating it to works, say nineteenth-century works – I was relating Barnett Newman to those. I can remember going to the Tate in the morning and looking at things but not understanding them at all, not appreciating them really, and then we went to the National in the afternoon. I was back on home ground then, sort of thing. I knew what I wanted to look at there, and of course I went to the old faithfuls – the Constables and the Turners and we went round the nineteenth century, really, and I was back – 'Oh, yes, I recognise that, we've done that.'

Nevertheless, the visit to the Tate did have a very important effect upon her and the Barnett Newman lingered in her mind:

Even though I like the Barnett Newman for its colour – I mean bright red, it really attacks – it really hits you, but I wanted to know why he'd done it bright red and why he could get away with it being just a bright red canvas with a purple stripe.

She couldn't 'fathom it', it quite upset her because 'I stood and looked at it and I just couldn't understand!'

We moved back and then we went up close and we moved back again. It began to affect the way I looked at it and it began to affect the way I thought about it – what I thought about the whole situation of standing looking at a painting that was red basically. I can also remember going after that, I went to look at the Cathedral Room, the Rothko Room.

She went into this room alone:

And I went in there and I was still disbelieving about it all, you know – purple

and black! I sat in there and there was a little lady sat further up on the benches in the middle and I wasn't really looking at these things, I was just sat in there you know and this lady came up to me and she said to me, 'Do they have any effect on you?' and I said, 'What do you mean?' She said, 'Do you know, I'll have to get out, I feel so sad. I'll just have to leave this room. I can't stay any longer.' And *I* suddenly thought, 'I think it does!' So I sat and I looked and I came out and I said, 'I feel so melancholic, so depressed.' And she triggered that off in me and suddenly *I* was *looking at* it. About ten minutes after I'd been sat in there, *I* had to get out. Whether that was a reaction to what she said, or whether it was a reaction to the paintings I don't know. But I had to get out!

It was a revelation to Julie that a group of paintings could affect her in this manner, that they could affect her whole being:

It was a complete eye-opener. I'd never thought of art affecting you in that way. You see paintings that make you sad and you feel all sad. But that affected the whole way I was thinking that day. I just couldn't get over it – not just the painting, but about everything. I began to feel sad and I was going to have to get out of that room, and that was another significant thing – that was really my introduction to 'Modern Art'. Now that's a very sweeping statement, but I hadn't done any modern art up until then and so really that was the beginning of a sort of seed planted . . . I haven't sat in that room again, and I must do that when I go back. When I think of it I think, 'You wouldn't think it would have that effect.' And I came out and I said to my teacher, 'Do you know, that room has depressed me!' I said, 'I know it sounds silly a room depressing me, but it has totally affected me.' I explained to her what had happened.

Julie has explained how her lessons and her preparatory reading towards them was contributingg to an ever-increasing awareness. She has talked about the growing significance of the Winner exhibition at each stage in this process, but the Rothko Room equally has a special place:

I was learning each week and progressing further, but that is another day to remark on in the Tate . . . That feeling they evoked before I learnt anything about them or about colour field expressionism, that will always remain the same for me. I will always relate to that Rothko as THAT EMOTION that it evoked the first time. No matter how much I learn about him in particular that will remain my thought, that will remain my idea about those particular paintings. [See Rothko facing p. 35.]

The preliminary stepping stones leading to the illuminating experience are extremely important – certainly if these experiences are to be utilised from an educational standpoint – but are more difficult to unravel. For example, why does a piece of music or a painting suddenly become significant when the person has already heard or seen the piece numerous times without any effect (as, indeed, Julie had so seen *The Haywain*)? Julie explains how important her art

history lessons were to her, and had this not been the case it is possible that she would not have been in a sufficiently receptive state of mind to respond positively to the lady's remarks in the Rothko Room.

She has now become so involved in the subject that, at the time of writing, she is just embarking on an art history degree course. She has described the unusual route whereby she has come to terms with Winner and the emotional manner in which her initiation into the works of Newman and Rothko took place, and with it a sympathy for modern art in general, but she is aware that the weekly art history and appreciation lessons which she attended provided the essential underpinning:

> I also think that even though I'm going to do a degree in art history, I'll always compare the lectures that I'm going to have with the lessons that I've had. They have a significance, they were the beginning of my interest and they will always have that significance . . . Obviously it's got a lot to do with your teachers. If I'd have had a very boring teacher for the first lesson I'm sure that I wouldn't have had any interest in it, because they do control whether you find that interest or not – I mean *you* can always say, 'Oh, I'd like to learn about that', but if *they* don't teach you or introduce it to you in an interesting way, then I'm sure the interest will not last.

She refers to the experience in the Rothko Room as being 'the beginning of a sort of seed planted' and uses the same analogy again in attempting to put her finger on what was special about those art history lessons:

> I never even knew that there was any art history involved in that A-level that I was going to do, so I wasn't going to do the art because of the art history in it. I didn't have great interest in it before I went into the first lesson. I'd been to a gallery before and I'd seen masterpieces on the television or whatever and you knew that was there in your mind, and it wasn't until I went to that first lesson and it was triggered off for me then the interest grew. It was like a seed that was there – but it has to be triggered off. But I'm sure that if I'd gone to somebody else who had not held my interest, then that may not have been set off! I think that's the difference. I found the whole idea interesting, I found the teacher interesting – I'd never met anybody like her before. She's totally different, she's not like any of the other teachers there either. She has an attitude that is entirely her own – and she set it off for me, really. You can't describe her lessons. You can't say, 'She's good at this and she's really good at that' – because that's not what it's about. It's about being there and listening to her and her ideas and – I just found she set off my interest!

This is an extremely important statement. The impact of the Rothko Room has obviously been a considerable one on Julie – it was an 'eye-opener' – it is a vivid example of the illuminating experience in its purest form. And yet it is apparent that something of an equivalent nature was happening to the student on a weekly basis in her art history lessons, so much so that she must continue to pursue her studies until they have reached their natural fulfilment:

I was talking to my grandad the other week and he said to me, 'A lot of people say to me, "Why is Julie going to do art history?" ' At first I didn't have an answer, I just knew that I wanted to go and do art history, and he said to me, 'Well, what are you going to do?' I said, 'I don't know what I'm going to do, but I know what I want to do at the moment. I want to go and learn. I want to go on carrying on learning until I don't want to learn anymore. That's all I'm interested in anymore. I'm not bothered about a career, which I'm going to end up with, hopefully, eventually. I want to learn at the moment, and that's what I feel I should do. I don't feel I should prepare myself for working for the next forty-odd years, I feel I want to learn something and I just want to go on and learn until I don't want to learn anymore!' . . . He just said, 'If that's what you want to do, just do it and enjoy it.'

Her lessons have aroused in her an appetite for learning more, in exactly the same way that the vivid gallery experiences which I have been describing in this section lead the pupils to want to repeat them or build on them through subsequent gallery visits. Julie's art history lessons, on her testimony, would seem to fulfil all of the four conditions which Hargreaves speculates as being necessary if the teacher is to 'explain' the arts successfully to pupils:

(1) that the teacher successfully communicates his or her own fascination with, and enthusiasm for, the art form or art object;
(2) that the explanation given builds upon the pupils' aroused interest in the art object, or upon the pupils' fascination with the teachers' fascination;
(3) that the teacher is allowing the pupils to make a free decision of their own to move from 'outside' to 'inside' and is in no way seeking to compel them to do so;
(4) that the teacher is inviting the pupils to join him or her on the inside, but is making no judgement against them if they choose not to do so.[11]

In my researches it is clear that those teachers who retain a 'fascination with, and enthusiasm for, the art form or art object' are the ones who, however 'experienced', remain in a state of personal growth. In other words, they appear to maintain a constructive balance between their private and personal lives and the considerable demands of being committed art educators. Such personal growth can take a number of forms. Some, for example, argue that the art teacher should continue to produce his or her own work, but for others it might take the form of avid gallery-visiting. Both must be allied to a desire to communicate and share these experiences with their pupils – for I have heard it stated that the art teacher is entitled to keep some of his or her subject interests private, and there is nothing special about the teacher who pots, weaves or paints in private but teaches the same prescribed course as a non-practising colleague. By whatever means, some teachers continue to 'grow' in their love and understanding of the visual arts through some form of personal and active involvement, as opposed to those who continually attempt to draw passively upon what they derived from their art training. They are more able to help their

pupils envisage something of the full breadth of the visual arts. Without this kind of continuing personal involvement, it is all too easy for the art teacher to appear as the sole arbiter of artistic taste and judgements in the art room.

The CSAE Project has set out 'to develop and clarify a range of alternative approaches' to the art history lecture accepting that it has been rejected by the majority of art teachers. Nevertheless, the effect it can be demonstrated to have had on a number of students such as Julie should be noted, and also the words of Louis Arnaud Reid: 'Courses in "art appreciation" are often held in contempt – but I think more because of the way they have been taught than anything else.'[12]

All the four case studies above feature girls; more opt to study Art at A-level and in higher education than boys – often because of social, school and 'career' pressures rather than because of aptitude and inclination. Consequently, one naturally gathers more examples involving girls than boys. It is also possible that adolescent girls are willing to speak more freely about the experiences being outlined here, but three examples involving boys illustrate that pupils of both sexes can be similarly responsive to and affected by illuminating experiences.

Section 3 Three Male Responses

One of the paintings I remember was *The Bathers* by Seurat which amazed me – the enormous size of it! I'd always imagined it to be quite small, so when I was confronted with a huge painting I was pleasantly surprised.[13]

Though Andrew comes from an artistic home, with books on embroidery and carving reflecting the interests of his mother and elder brother, he did not visit an art gallery until he went with the school. The trip was for the sixth form, but he was one of a group of fifth-formers who accompanied them. He remembers that day two years ago with clarity, in particular because of the effect which Seurat's *The Bathers* had upon him. He already knew the painting in reproduction form, but its scale had the effect of somehow drawing him into the work:

I think because of its size it created an effect of harmony around you rather than it being just a picture in front of you. It almost seemed to be in the whole of your view. If you were looking at the painting you couldn't really see much else on either side, so your attention was drawn to it. That created an almost unreal atmosphere – a sort of escapist feeling. [See facing p. 35.]

He sat down in front of the painting for quite a long time, but moved forward on a number of occasions to inspect areas in detail:

I looked at it closely for quite a while because I was amazed at the very flatness of some of the painting, but actually up close there were so many colours and there was actually so much detail in it. That was one of the things that I enjoyed looking at, the harmonious colours and the way they had been

blended. I tend not to like harsh colours in paintings. I like very mild colours, pastel shades.

His previous knowledge of the painting was not only based on reproductions, because he recalled that he had also read something about Seurat's style and technique in books. Though this gave him the interest to want to see the painting, it did not prepare him for the impact:

To actually see the painting in front of you is a unique experience and it's totally unlike looking in a book. Especially because in a book pictures are always so much smaller and in this case considerably smaller. There was so much detail that you don't see when you look at reproductions of a painting. Although I expected that those qualities were there, I couldn't actually see them until I saw the real painting. There were elements in the reproduction that I liked – but hardly comparable to the actual thing.

He had recently seen the original again, two years later, but having had to live with reproductions between the two visits, he was aware that the impact of the original had enabled him to look at the reproductions differently. Having been initially moved by the work, he had then made a further analysis of its qualities:

I had the same feeling about the Seurat that I had about some of the other paintings in the National. I think it was an emotional response firstly. As soon as I saw it everything else seemed quite insignificant, so I just had to sit down and look at it. Simply because of my liking for it, my response to it, and I think because I liked the painting I made an effort to appreciate the technical qualities of it.

A concentration of attention accompanied by a sense of revelation are certainly intrinsic elements in Andrew's experience, and Anthony illustrates these characteristics further. His first gallery visits were as part of his A-level course. Art appreciation 'was a new thing' to him on commencing the course and he decided to 'treat it with an open mind and see how it went for the first few weeks'. He quickly found himself really involved, especially after the first London visit. Turner, in particular, began to fascinate him:

When you look at the reproductions you can only see the colour, but the application of the paint stood out as well because the techniques were so varied. That became interesting because it started applying to my own paintings as well. It was the glazes on top of rich impasto and the way the paint seemed to shine through underneath. And the various techniques that nobody else was using at the time as well, like using his own hands and fingers and such, instead of brushes and rags. There was evidence of that in the paintings and that was the side – the techniques – that influenced me.[14]

Not surprisingly, Anthony chose to base his Personal Study on Turner, and on a subsequent three-day visit to London he recalls, in particular, the time he spent comparing Turner's *Dido Building Carthage* with the adjacently hung *The Embarkation of the Queen of Sheba* by Claude. An intense concentration of attention is apparent in his graphic description:

I spent a whole morning comparing both. I must have been about an hour and a half, perhaps two hours, in front of the *Dido* and it was enjoyable, it just flew past . . . it didn't seem like an hour and a half – more like ten minutes . . . I was just picking little bits out; I'd travel all over the painting. You'd go from the left-hand to the right-hand side, and you'd do that from the top right down to the bottom; you'd scour every inch. It was the detail coming out again, the techniques. You could actually see evidence of technique . . . I made stacks and stacks of notes. Very detailed descriptions, like I'd start off, 'In the top left-hand corner there is rich cerulean blue phasing into a more yellowy impasted cloud' and that would take the space of, say, one or two inches. I'd probably write about three or four paragraphs on that inch, and it went on for ages and ages, all these notes, until I could actually repaint the picture from the notes because they were so detailed; I won't say accurate, but detailed!

I think I got to the spirit of the painting through the notes. From Turner's point of view, I thought he was searching for the actual source of light. From the distance you could actually see the sun, but when you looked close it was so true to life that he had actually found what he was searching for. You couldn't see the progression – a sun and burning-out light – it was just one glazed wash. [See facing p. 35.]

His 'stacks and stacks of notes' were to prove invaluable when he came to write his study some time later. One short extract from his notebook should suffice to give something of their detail and nature:

Cerulean blue sky, light, clean. Flickered clouds. Warmth of sun coming into clouds. Left to right moving towards warmer, stronger colours. Moves away again but to a more purply blue. Sun is layered in bands of warm and cool. Thin paint, cracking. Sun is white (flake white) on top of yellow. About 12 brushstrokes in orange represent sun's rays. White haze pours down from sun, colours appear to have been rubbed on over thick paint forming a glaze. Atmosphere in background is similar yellow to top – very light. As light colour is applied, more thick. Appearance of sky being painted right down to footbridge, permeates all other colours. Masts and buildings in distance are painted in thin glazes . . .[15]

Of course, Anthony was not entirely alone. The various students were dispersed around the gallery, but the staff spent time assisting each student in turn. One describes the value of this support, recalling that the staff would catch up with maybe three students and they would all get very close to a picture and have a good look and discussion. 'We used to really get inside a painting, and just to see one painting in the flesh and really get to know it!' Anthony benefited from this process during the morning and later, too, when writing about *Dido* in the study he made. He wrote poetry as a private interest, and through Turner he became fascinated by Ruskin's prose in his writings about the artist. Nevertheless, his initial description was matter of fact, reflecting that personal-study tendency to regurgitate book information to the neglect of one's own reactions to the work.

His teacher had read his notes, though, and had spent time in front of the work
with him. This enabled her to make the necessary demands on Anthony. She
could discuss with him his analysis of the work while in front of the canvas and
ally this to his notes so as to recall what he had observed and experienced that
morning. The final version made extraordinary use of the notes, as a comparison
will reveal:

> A cerulean blue sky encompasses the haze of the sun, its light, clear colour
> compares with the flickered clouds to which the sun's warmth clings. As the
> eye stirs towards the centre, an array of glorious, warmer, more intense colour
> develops in the atmosphere. The sun, layered in bands of warm and cool is
> painted thinly, so much that the surface has now cracked, as if caused by the
> swirling radiance of the brilliant orb. The colour of this glaze is translucent
> white, underneath is an impasted yellow. Surrounding the sun are a group of
> approximately twelve brushstrokes, simply painted in unequal lengths of
> orange, which represent the rays. Already, the shimmering effect of eager
> light is reaching the distant architecture, eroding away the solidity of the
> structure, reducing it to a gossamer of wafered marble.[16]

From the detail of his notes, Anthony has successfully produced an equivalent
in words to the Romantic atmospheric splendours of Turner's treatment of the
elements. The study was an informed piece of writing revealing a fusion
between his avid background research, the evidence of his own eyes and
responses utilising criteria derived from his weekly course.

On being shown this example, a teacher researching equivalent student
responses in music said that it was of no interest because similar pieces by a
talented minority could easily be produced. One of the reasons which
Hargreaves puts forward as to why the conversive trauma is important is that
the accompanying arousal of appetite is so motivating. His observation that the
individual concerned only has something to say after the experience has taken
place has already been noted; let it suffice to say that Anthony failed his
A-level English examination!

Anthony's close friend Joe is a successful Rugby League player, having
represented his country, won the Man-of-the-Match Award in a Wembley final
and having recently been nominated Player of the Year. He owns a Gerd Winner
print which he acquired while still an A-level student because, 'Having been
interested in his works for about two months with the Study like an everyday
thing', he wanted to possess one of his own rather than just look at them in
books. Taking it home rolled up in a tube he recalls feeling great with it. It was
something worthwhile that he had almost won. 'I felt that it was like all my
rugby medals; it was something to hang up and look at and respect, in a way.'[17]

Like Anthony he, too, had not visited a gallery prior to the A-level course,
having always regarded art history as boring, 'like any other academic subject'.
However, he began to find it enjoyable 'because it was different' and developed
a particular interest in Degas. The racecourse studies, the lighting effects
achieved in the ballet dancer paintings and the use of pastel in the boudoir

scenes all appealed to him, so he decided to produce a Personal Study on Degas. He was still considering which aspect to do: 'Then I changed completely! I still carried on liking Degas but due to the exhibition here at Drumcroon of Gerd Winner my eyes were opened to the work of Winner. I became involved in his work and I decided that I'd do one on Winner rather than Degas.' The sudden discovery which Joe sees as making him change completely is typical of that sense of revelation, characteristic of the illuminating experience, and he is able to say what it was which so affected him in Winner's work:

It seemed a totally different form of Art. Whereas I was interested in Degas he seemed very much in the past. But coming to the exhibition of Winner I seemed to be here and now. The impact was of the present day . . . To be able to become involved with the actual world that he was working in and also to see his kind of work around with everyday subject matter affected me, whereas with Degas you had to use your imagination as to what he would have seen in his times. Knowing that Winner's world was all around, especially the mills of Wigan, I found it fascinating that such subject matter which you could see every day could be translated into such beautiful Art.

In addition, Joe became conscious, for the first time, of the qualities of contemporary screenprinting:

The presentation of them, just the impact of them, was beautiful, especially stark images like *The Red Bus*. Also, I hadn't seen the printing before as such, the screenprinting – and it was such an impact! . . . I felt excitement. I would love to have a go, really, at this form of Art. It seemed to jump off the paper, it was there in front of you, it wasn't like a painting that anybody could do, and it was very personal to the artist.

He had the opportunity to meet the artist which he also describes as having a big impact, knowing that he was an artist and 'not somebody who was dead in a history book, but somebody whose works you could see next to him'. Winner explained about techniques and discussed how he tackled his subject matter, all of which fascinated Joe: 'Especially his description of the dockland scenes, using a camera, whereas we'd always used a sketchbook in the past. I thought, "This is a new form of Art which I've never thought about; to use a camera as a sketchbook", and as he explained it I thought it was a good idea.' He started to research his subject, and was helped when he visited Kelpra Studio, where Winner's prints are editioned in this country, and Chris Prater gave him a copy of *Gerd Winner, 1970–1980* to assist him. On the same London visit he was able to substantiate the impact of the exhibition by going to the Print Room in the Tate which he recalls, 'seemed like an unveiling':

It was fantastic from my point of view, because I had always looked forward to seeing more of his works. I think it was a better experience than seeing that first exhibition, really. Pulling them out of the drawers you always wanted to see the next one, and each one seemed better than the last one. Although I

was fascinated by the exhibition here in glass frames, I think pulling those out of these drawers, and being able to touch them as well, was a real experience. *Isle of Dogs* I had never seen before, and a new colour sense that he'd put in it – it all stands out in my mind!

Whereas prior to seeing Winner's work he describes his own as drifting along, 'after the impact of Winner I kind of jumped into Art more'. The parallels which he could discern in Winner's work and his own surroundings gave him a heightened awareness of the world around him:

Certainly, back in Wigan, walking round, a brick wall would now be a Winner wall, if you looked at it right, and a lamp post stood out rather than just being something at the side of a road. You came to look as a camera might, you'd walk round and see with Winner's eyes, just walking. Especially when you went to the canals and warehouses, the fire escapes seemed to be more prominent. You seemed to get a totally different viewpoint.

The Winner print which he acquired, the 1978 *Mince Hill*, now hangs framed in his hall. Though he supposes that he takes it for granted a little, walking past it every morning, every now and again 'it hits you and you still think of Gerd Winnner and the exhibition and all his other works flash to mind':

So it's like a framed memory, I suppose, of all his works although it's only that particular one. All the Winner works like *Isle of Dogs* and *Catfish Row* spring to mind and you start thinking of them. Then you drift by again and you don't notice it, but then it'll come out again. It's just like one big memory of all his works, even though it's just one particular work!

Now an art student, he feels that Winner has given him a more open-minded attitude towards Modern Art movements and any art which he confronts without any previous knowledge. However, it did take him three months to get the examination board to agree his topic – Winner is not a painter! Though he found himself restricted by time, he managed to complete a quite original piece of research; like Anthony, he was able to combine background study with his own analysis and responses in front of the works as encapsulated in on-the-spot notes. Three paragraphs from the chapter devoted to the *St Katharine's Way* suite of seven prints, which combine to add up to a continuous dockland façade, possibly communicate something of the overall flavour:

Studying *St Katharine's Way*, we are aware of a feature of picture organisation which is recurrent in Winner's work. Over and over again he shows us the frontal plane of a building. This is the case here where he insists on the structural qualities of verticals and horizontals. Like in Seurat, these aspects give his work not only structural cohesion but create a mood through the rhythm of interval. The notion held by Seurat that verticals represent stability and horizontals calm, is surely borne out in this work. In a frieze which is depopulated the appearance of the subtle diagonals could represent, as they did for Seurat, the element of life. Using a highlight or a totally lighter version

of a colour he persuades the eye to follow them, occasionally placing his diagonals and curves to upset the expected tempo.

Not only do the periodic intervals establish the mood but so does the use of later photographic stencils which are placed over the bolder hand-cut stencils. They comprise to give a rich and beautiful atmospheric quality of shadows and textures as in the inset doorway of print number four. The final statement of hand-cut lettering 'AA1' is placed over the top as if hand-painted, this 'lifts' that region of the work and makes it particularly distinctive.

Winner's brilliance shows in this series as we become aware of the difficult task he has overcome in producing individual prints which function as complete ideas in isolation, yet combine to form a continuous inter-related picture when printed touching. These subtle relationships are applicable to on-going forms and textures but especially to a travelling wave of carefully adjusted colour from left to right. The totality of the conception of this conglomerate print picture is emphasised in unity as eventually Winner printed onto canvas and called it a 'screen painting'. Thus the multiplicity of the printing process becomes a 'one off' (see facing p. 34)[18].

Conclusion

The material in Part II substantiates the theoretical foundation laid down in Part I. The testimonies of pupils and students demonstrate that the illuminating experience can be a powerful and invaluable aid to learning. Their experiences variously illustrate all the constituent elements of the illuminating experience as delineated in Part I.

From the case studies, we can further deduce the importance of the school/gallery relationship as one in which systematic and experiential learning of different types complement and reinforce each other. It is clear that the pupils featured here have not encountered art haphazardly but have been offered opportunities within a teacher-organised structure. The critical studies methods which contributed to that structure are ones developed out of the art history model but which have emphasised pupil response, the significance of viewing art in the original and the natural relationship between seeing and doing.

The pupils' own insights into the nature of education are crucial. Again and again the stress is upon the need for closer integration of practical work with critical studies approaches. Attendant upon the motivating impulses arising out of the illuminating experience also comes the demand for rigour and more taxing courses of study as a means of achieving that closer involvement which the awakened individual desires so strongly.

That such needs are likely to lead to lifelong interest in art seems clear from the evidence in this Part. A minority will have those interests awakened in them by parents and friends introducing them to art; it is the school's responsibility to cater for the majority.

Part III
Practical Starting Points and Developments

Section 1 Home Art
Another strand of experiences is drawn into the book in this section. Relating the explorations of Timothy and Anthony in cartooning and film-making respectively, the author investigates the phenomenon of Home Art. Work done at home is shown as being of vast significance to the individual. The author analyses the pupils' achievements in a way which links this type of activity with the illuminating experience by way of motivational force, concentration of attention, stimulus of external material, curiosity and research.

The possible educational repercussions are sketched in and the connection made between what can be realised through in-depth learning and through in-depth teaching.

Section 2 The Mature Artist and the Illuminating Experience
Here evidence of illuminating experiences affecting artists themselves is used as a basis for theoretical points about continuity and integration in art education. The author draws parallels between the effect of illuminating experiences upon pupils and artists. He moves on from remarking on the interwoven nature of perception, reaction and production in the artist's involvement with art to describing certain educational practices which are in direct contrast. His suggestion for an alternative method concludes the section.

Section 1 Home Art

The kind of aversive experience which Bev had to undergo serves as a warning to anybody who seeks to impose a course without due reference to the point at which the recipients are already – but the case studies, including that of Bev when motivated, are all-important in that they illustrate the lengths to which pupils and students will go once they are sufficiently involved. In the introductory section of Part I, words from *The Arts in Schools* such as 'rigour', 'dedication' and 'discipline' are listed. Carefully structured courses combining practical art activities with art appreciation should and must make rigorous

demands on pupils, but the discipline which is so apparent in these examples is self-discipline, and dedication naturally develops in a committed student who has learned self-discipline. Such illuminating experiences, and the gradual build-up of understanding and awareness which Julie ascribes to her art history lessons, leads to a motivation which is to do with the intrinsic nature of the experience, rather than arising from a fear of examination failure, detention, or whatever. Silverman also attaches great significance to such motivation, and says that from his research (relating to motivation) it can be concluded that motivation will be stimulated when the art teacher:

> (1) knows about his students' aptitudes for art and what is truly meaningful to them; (2) utilises a carefully structured, inductive, and in-depth approach to teaching which recognises differences in the interests in concrete and ideational materials of slow and fast learners; (3) provides opportunities for discussions which attract attention to the complexity of art and, thereby, arouse curiosity; and (4) helps students to identify the criteria by which they can evaluate themselves as they work and, thereby, serve as a stimulus for accomplishment.[1]

In the examples which I have used, the pupils and students are obviously responding to specific works which are 'truly meaningful' to them and which have aroused curiosity. In his list, however, Silverman has priorities which can equally be assumed to relate to practical activity as well as to the 'consumption' of art; for example, evaluating themselves as they work as a stimulus for accomplishment. The close relationship which exists between the enjoyment of a painting, a weaving, or a pot and the desire to be practically involved in A RELATED WAY is illustrated when Jane says that the Carel Weight paintings have 'given me ideas for my Art now' and it is interesting – given that Lara's interests were previously unknown – that 'what is truly meaningful' to her, in a practical sense, is what she does at home. It is this work which she connects to the equally meaningful examples, for her, which she has discovered in the Tate.

Home Art is something which recurs again and again throughout all the interviews, sometimes as an undercurrent but frequently as something which has great significance for those involved.[2] In its weakest forms it would appear to be something which is mildly therapeutic. For a surprising number of pupils it is of great importance because it represents for them their natural form of personal expression – it is 'truly meaningful to them', though it frequently lacks formal qualities. In this potent form it is as strong a motivating force as the gallery-based illuminating experience. Rooted in practical involvement and often beginning way back in early childhood, it has many of the same characteristics as those involving research around their chosen interest. They sometimes become surprisingly informed about quite unusual facets of their subject, and make unaccustomed technical demands on themselves in the process. All the pupils and students interviewed describe having enjoyed drawing and painting from a very early age – as long as they can remember, they

frequently say. We will see later some of the conflicts which can emerge between this form of expression and what is done at school. Lara has already given a clear explanation as to why she works at home. Timothy, a third-year pupil from the same school, started making and drawing his own comics at home at the age of nine. His parents had encouraged him and his two sisters to draw from an early age:

> And I also collect these comics – not like the *Beano* – but they're American comics, I think. And some of them have quite good artists. A lot of them are not very good, but some of them are really quite interesting, and I got the idea of doing my own ones from that, doing my own comics.[3]

Asked how old he was when he started producing these comics, Timothy continues:

> About nine, I think. I used to show them to my teacher in our junior school, as well, and she thought they were very good. I try and do them sort of regularly. I try and get a page done a night if I can, I think that's best. But sometimes I just don't feel like doing it, and I just leave it and then I might do two or three pages at other times. But I average one a night at least.

Having produced the first one, it gave him ideas for further related comics:

> Originally I was just doodling, and then I started doing one and I was quite pleased by it. And also some of the ideas about the people in it I wanted to continue, and my mum encouraged me and so did my teacher and so I just carried on doing it, and now I just do it because I've always done it.

After the summer holidays he will enter the fourth form and begin examination courses which, unfortunately, will affect his own work: 'But I'm planning to stop doing these comics quite soon, because by the fifth year I'll have to be studying for exams so I won't have time to do them. So I plan to have to finish them by the summer.' But for other pressures, like examinations, he would definitely continue producing them, because 'I'd quite like to get into the profession!' He has obviously accumulated a great number now having worked on them so systematically for about five years, and sometimes he naturally looks back over the earlier ones, but:

> Not all the time. Because some of them, like the first one I did, the paper I used had writing on the back so, I mean, I just didn't do it very seriously at first, and really that doesn't seem very good now. When I started I didn't use shade at all – they were just very flat. Now I try to use shade, and also now I try and get my figures done correctly as well – you know, like there are seven heads in one figure and I try and get them to move correctly, like a real person would, which I couldn't really do at first. They didn't look very realistic, and also the writing as well, I try and improve that and get it looking a lot neater than when I started.

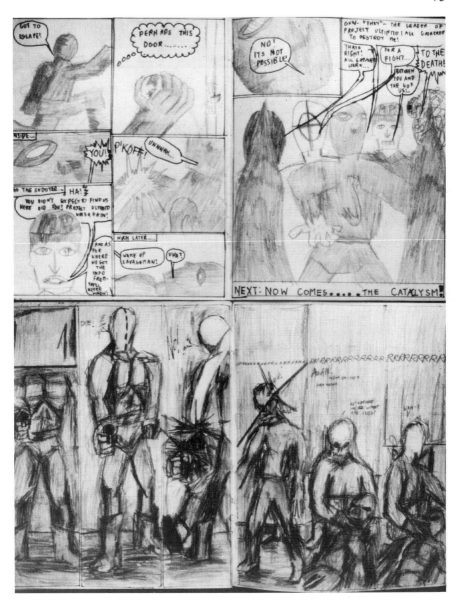

Timothy, pages from two comics drawn two years apart.

Timothy, page from a comic illustrating the use of foreshortening.

It is obvious that Timothy's involvement is such that he is making quite considerable technical demands on himself as he strives to improve the quality of what he is doing. He continues:

> Perspective and things I try and get right. It wasn't until about a year ago that I could get the necks right, because they were just like thin stalks. And then my sister mentioned this and since then I've tried to get my necks looking more accurate. Before they were very thin – and with the more muscular types, I mean, it comes right out, and now I try and really get the heads coming into the bodies – before they were just sort of stuck onto the shoulders.

Another element which he doesn't mention, but which plays a very important part in his drawing, is that of foreshortening and he has obviously worked on this in an equally avid manner. In some of his more recent comics, for example, there are dramatically foreshortened figures in the foreground remarkably reminiscent of Paolo Uccello (an artist he has not yet come across, but there are sufficient clues in Timothy's work to suggest that he would be interested in such paintings of Uccello's as *The Rout of San Romano*, in the National Gallery).

When he is working on his own, he is aware of the comics that he buys and has also become extremely informed about them, deriving ideas from them and studying them in their own right:

I do get inspiration from the ones I buy, but I do try and make them quite original. One of the comics that I buy, the artist is meant to be very interested in the Japanese way of drawing comics, and he does it quite strangely and lays out his page in a certain way, sort of cinematic I suppose. I read something that said the Japanese, because they read from right to left – it seems very strange to us – but they can freeze time and build up tension in their comics. And the person who I really like uses those techniques and others, and does his own stories that way. He's the artist that I like the most, he seems to be about the most original.

In response to the observation that what he does at home is a very different kind of art to that which he does in school, he responds:

If I did it the same as we do things in school it would be a bit pointless. But you see, the sort of things I do in other comics are not the same anyway, because you have to work very quickly, obviously, if you are a professional – there would be a deadline to meet. Also, the way it's done they do it like in films. They have storyboards. They have to lay out the film in art terms and I think it's done a bit similar to that in comics. Like in a film, they have these establishing shots and then it closes in, or something – well, sometimes you get that sort of effect as well.

Not exactly a direct answer to the question posed, but one which shows how obsessive such interests can become. Asked which he prefers doing, his own or school art, he replies: 'Well, I find my art easier. But, I mean, they are very different types.' His own 'is more fun to do' but school art 'can be more interesting, because you're trying out new techniques and stuff, which I don't do much because I just use pencils and crayon'. He is conscious, though, that each does have an influence on the other. He is aware that his own work has benefited in some ways as a result of his art lessons:

I think with colour, for instance, because I used to just colour it in but now I try and get different colours on one thing, because obviously things aren't just the same colour everywhere, so I try and get different colours into one thing . . . In some ways my own work probably helps my work at school as well with figures, because I do so many figures in my comics that when I do figures at school I find it easier – I think this helps a lot.

Many pupils reveal that there is a conflict between the art they do at home and that which they produce at school, but Timothy enjoys the variety and would not be too pleased if the two came together one day. He illustrates his point with a beautiful analogy:

I think I'd be quite upset, really, because it's quite fun having different styles. I mean, a lot of artists have different styles. Like Stanley Spencer with his portraits and his figure work, they're very different because when he did portraits he did them very detailed, but when he did figures they were sort of – it's hard to put them – but they were very broad, bulbous.

He says that as yet he hasn't really looked at much Art, but he likes both Stanley
Spencer and Salvador Dali. Occupying a full page in one of his comics there is a
dramatic, foreshortened drawing of a figure on a cross, very reminiscent of the
famous Dali painting: 'Well I didn't actually copy from it, but I mean I had sort
of looked at it.' He has been to the Tate and the National Portrait Gallery, both
on his own and with his mother. In the Tate, the Mark Rothko was one room
which made an impact on him:

> In the Tate I can remember a lot of the more modern things. I remember
> some really strange rooms. There was one which was just maroon on reds,
> and also there was something by Roy Lichtenstein which was like Pop Art. It
> was a bit sort of stupid in a funny way, because it didn't seem very serious –
> but I liked it!

Asked if it interested him because it related to comics, he replied:

> Yes, in some ways. In the sixties one comic company put 'Pop Art' on all of
> their covers so that people interested in Art would be attracted, and I think a
> lot of hippies and people like that used to buy comics because they were
> actually psychedelic – there was that sort of thing in that sort of era!

Timothy's approach to his comics is similar to that of many youngsters of his age
who have developed an interest in, say, computers. They read around their
subject, often buying adult magazines yet deriving quite a lot from them. They
are frequently interested, not only in operating the computer, but in finding out
how one works, how one operates. Timothy's acquired background knowledge
of 'the Japanese way' of drawing comics and of the relationships between page
layout and cinematic devices such as following initial establishing shots with
close-ups, etc., is quite striking and reveals the mind of a boy who is right inside
his subject. There is also a close relationship between Lara's choice of artists'
works and their link with her own work, and the way in which Timothy has
naturally been attracted to Roy Lichtenstein's *Whaam!* but also to other artists
who are 'usable', and therefore meaningful, in his terms. His comics form the
platform from which his enquiries and researches into other works – including
his study of American comics – emanate, meaning that those which he latches
on to for practical purposes are special to him in that they are personal in some
way.

Ralph Smith suggests that:

> the proper object of study in art education is the study of the work of art. This
> does not imply, and this must be emphasized, that creating or performing
> activities are to help cultivate aesthetic percipience. They are neither
> self-justifying activities nor the principal focus of art education. That is to
> say, they are primarily *learning exercises* and play a role in honing the concepts
> and skills needed to perceive works of art in their complexity . . . This means
> that mature art replaces children's art as the proper object of study . . .[4]

If Timothy's only experience of practical activity was through 'learning exercises' he would doubtless be looking at quite different works in a quite different order, and it is likely that his responses would remain at the level of intellectual interest without that personal curiosity motivating him to the study of further and diverse works – in the manner which we have already seen in action in other cases.

Anthony, by comparison, did not go to an art gallery until he was a sixth-form student, when he went on his first organised college visit. However, his father was practical and did all the electrical and plumbing repairs in the home, as well as his own decorating. Anthony watched and helped his father, and from an early age was interested in making things as well as drawing and painting: 'I remember making things. One of the things that I liked to do was to make mechanical things. That always interested me – things that you could move, things that when you pushed something over here it moved something over there.'[5] They were made out of cardboard 'or anything like that': 'It was working models – the Art was on top of that. That was a thing to enhance the movement . . . I could have a flat moving thing – it might be two-dimensional but it could move through other parts. It was sort of animation in a primitive sense maybe.' An important development came when he was about twelve:

> I started being interested in animation and I managed to get hold of a cine-camera that could take animation. I was always fascinated with drawings that moved. I liked the ideas whereby people can get involved in the thing, whatever it is . . . I think it's a case of them actually doing something to make it operate in real time . . .
>
> Seeing as I was interested in animation, I started finding out how they actually made characters – drawn characters – move on the screen and I understood that there were so many pictures and lines on a long piece of celluloid and all these pictures were slightly different. Now I actually had a go at making something like that, where I got a long strip of paper and drew pictures on it and then pulled it through this little square box – but nothing happened because everything was going blurred, you know. I thought, 'It's a mechanical problem' so then I tried to find out how a camera worked and the way that the camera actually does it. It shows a picture, shuts it off, moves on to the next picture then shows that one very quickly. Then I started experimenting with mechanisms that could do that. You know, it was very primitive but I was beginning to understand how the camera worked, so then I understood that I needed so many drawings. I started doing drawings, hundreds of drawings you know, like of movement, so that when I got a camera I could film them. And when I got my first camera – it was only about fifteen pounds secondhand – I had to take them outside because I had no lights – I had to get the light from outside.

After so much experimentation and work over such a long period of time, it is easy to imagine how Anthony felt when at last he was rewarded for all the effort:

Seeing these first drawings, when the film came back, move on the screen – you know, it was just amazing! Something that you've done – and it was on film! You know, little tiny drawings that are there and when you project them on to the screen they move in front of your eyes! It's a quite remarkable experience. I must have only been about thirteen or fourteen when I did the first experiments in filming.

He had obviously made some tremendous strides and solved some quite complex technical problems. He continues:

Now that was done at home. I couldn't really relate it to things I was doing at school because there wasn't really anything open to me like that in Art. The things I was mainly doing in Art was getting ready for an O-level, at the same time I was experimenting with drawing skills, improving my drawing and painting . . . we didn't have much experimentation with other forms. It always had to be very naturalistic. You felt you were being pushed by the people around you to draw something and make it look real.

He inevitably became interested in a wide range of cartoon and animation films. He came to know the different styles and particularly liked a lot of the Canadian cartoons, 'which were very well realised'. He is conscious that he looked at cartoons in a different way from other teenagers, who would be interested in Tom and Jerry as a story:

I'd be watching the timing – you know, the timing fascinated me. You could tell what the timing was leading to, the timing of an action, when Jerry walks round the corner and then suddenly goes 'Uggghh!' The cat comes flying towards him. You could almost see that timing is going to happen and where it is going to happen. The things flying about – knives – you'd always get, 'Thud, thud, thud, thud, thud,' and then a space, and then – 'thud' – the last one would go as though you weren't expecting it, but you always knew it was coming. It was the sort of timing of a movement that was so perfect in that style of animation and no matter what – it doesn't need to be realistic animation – but as long as that timing is there it makes a difference between a professional and an amateur cartoon. An amateur cartoon doesn't have that timing, that slick timing, that it needs. It's a very, very fine line, but it's all in the timing.

What also meant a lot to him at this stage was that he acquired a particularly helpful book:

I remember now, there was a book which I got and it showed you the way of drawing a character. That was what I was interested in when I got into the animation field. With a character – to see the movement in a character, to get that violent movement – the stretch of a figure – you know, as he is surprised or as he points to something. Now that helps a lot with figure drawing, because I could see an action – say somebody running – and I could see that action how it should be done to get the force in the limbs and the way the

figure and the character should match up together to give the force and the feeling of speed or different moods. So that helped a lot with the figure drawing because I could do it quickly – I could see the line.

To aid his experiments he was continually studying figures around him to sharpen his skills further:

I was experimenting, say, with the walk. The way that a character walks, the way it transfers from foot to foot and the way the body sits over the foot and moves in time – the different movements – you could see somebody walking and then you would use that that you've learned by actually moving the drawings and getting the weight to move in the right way, by looking at a real figure and being able to draw that in the same way. Being able to see the way it is at that specific point to put more force on certain bits.

His interest was obviously of a specialised nature and outside the terms of reference of what was available in most schools, but he did get an opportunity to utilise his animation skills in a school context when he did his CSE Music Project:

In Music I did a soundtrack for a film. I made the film after as well. I was always interested in music, composing music and the piano . . . I made a storyboard first and then wrote the music to it, timed it so it was about five minutes long, then it was recorded. Then since I was interested in audio and sound I put voices on top of it, effects on top of it – little voices and a few bangs and crashes and things and then I had to get it into synchronisation with the film, so I could then make an animated film to it. I had to go through each – well, let's explain it this way! The tape is sprocketed tape, there are little holes all the way along it and all the holes in the tape correspond with the holes in the pictures in the film. Every hole equals one picture. So, say you had a crash somewhere, you had to count the number of frames up to that crash, so that you'd count – 1,2,3. When you were actually filming the film you would press so many times and then the character would do – you know [demonstrates with his hands] – there would be the crash – so it would synchronise with the sound.

He was 'chuffed' to come second with this film in a North-West film competition, because 'I was competing with live action films and it's a lot harder to make an animated film than it is a live action film.' This was a fairly unusual CSE Music offering, so how did his music teacher react?

I was virtually on my own in that respect because the teacher didn't really know anything about animation. It was good enough for the teacher for me to write the music to a film. That would have been O.K. That would have been enough, but I made the film on top of that because the film was the reason

why I was doing the music. You know, I had to have the film there for me to do the music, sort of thing.

Before commencing his A-level courses he made another film:

> . . . another cartoon, three minutes long, which was a full celluloid acetate thing on a special rostrum. I found out all my problems with the rostrum, then when it came up for doing A-level in Design Technology I could, of course, make an animation table for myself, to improve it in some ways. So that was a project that was enjoyable to do . . . It's a special table type of thing for putting all your drawings on and keeping them central and flat and registered correctly, because if they're not registered, your drawings fly about all over the place. They've all got to be in exactly the same position all the time.

Just as the film was the reason for doing the music at CSE, so the problems he was experiencing as an animator were the reason for him making an animation table for A-level Craft, Design and Technology: 'Since I was doing the animation I felt that I needed an animation table! . . . There was a cheap one around for about £130, but if you wanted to get a real professional job it would cost you something in the order of £1,000, which is quite expensive for an amateur.' He could sell his for about £100 and, in his opinion, it was about ten times better than the £130 model. It won a Design Council Award and was shown on the BBC 'Tomorrow's World' programme.

Much of the Home Art which the students talk about is done with second-rate materials on small pieces of poor quality paper. It frequently does not develop beyond a certain point because it is unaided when sympathetic teaching is required. It would appear, from what person after person says, that it is so persistently produced because it is one of the few forms of personal expression open to the pupil, for most of schooling is to do with pupils acquiring, or attempting to acquire, the same examples of external knowledge and facts.

We live in a society which tends to judge people by their paper qualifications, and Anthony is always in danger of being pigeon-holed because his numerous attempts to pass an O-level English examination have all proved unsuccessful – and yet how clearly he communicates when talking and how this example emphasises that we should really judge people by what they have to offer! For Anthony obviously has a great deal to offer. From being a junior school pupil who tried to add moving parts to a drawing, he has developed quite unusual skills through sheer hard work and endeavour. Here, surely, is the rigour, dedication, application and discipline which *The Arts in Schools* talks about. These unusual interests, one might say passions, also call to mind that section of *The Arts in Schools* which suggests that

> . . . it does not follow that because a person is creative in one realm of activity he or she is equally, or at all, creative in others. We all tend to show creative

abilities in relation to particular problems or types of activity which engage our curiosity and for which we have a 'feel'. The creative musician is not necessarily a creative painter or dancer and need not find these other arts personally rewarding. The person who is 'at home' working with clay may feel awkward working with paint and so on.[6]

It goes on to suggest that those children who are described as having no imagination or creative ability are unlikely to be bereft of these qualities; it is far more likely that they have not found – and have not been helped to find – those areas in which their creative abilities lie. This diagnostic problem is a complex one for the art teacher, especially when linked to the point which Art HMI raise. They say that it is not necessary for a department 'to pursue many different activities in order to have a good course. The principal aims can be achieved through a concentration on one or two activities, and wise teachers on the whole work from their strengths.'[7] The teacher who truly works from strength also works in depth. Silverman links in-depth learning to motivation, and the paradox is that it is such teachers who engage children's curiosity and help them to develop that 'feel' for particular activities, rather than the teachers who attempt to give their children a taste for everything, thus denying their own strengths in the process as groups become just a brief responsibility in the shifting from teacher to teacher or from one medium to another.[8] This usually means that even when they are taught by the same teacher, each medium is dealt with for such a short spell that superficiality is inevitable. This problem is vividly brought into focus by the in-depth pursuit of home interests which are so meaningful to Timothy and Anthony. Just as Timothy has become fascinated by the 'Japanese way' of drawing comics, so Anthony gives us a beautiful illustration of how he studied Tom and Jerry when he was in his teens; his analysis of the timing used in such cartoons is for practical application in his own work. The illuminating experience before a work of art has wide-reaching practical implications as well, and the study of relevant art objects by these two practitioners of Home Art indicates how the practice and study of art can mutually benefit each other.

The illuminating experience should be seen as offering a *complementary* approach to learning to the incremental model that is so predominant in schools. What is interesting is that my young informants frequently associate the works to which they have been responsive with the art which they produce at home, as in the case of Lara. In some of these examples of Home Art a pattern emerges of pupils working out ideas and steadily resolving practical problems over sufficiently long periods of time for them to develop logically, irrespective of changes of school or teachers. By working in this manner Timothy, for example, has learned to assess and gauge his own progress both in relation to what he has done previously and through an ever-widening knowledge of his subject stimulated by his interest. He is conscious of improving shading, the proportions of figures, the way in which they move, the perspective (by which he invariably means the foreshortening of figures), the treatment of necks to

convey muscularity and to relate head to body satisfactorily, the overall design and layout of each page by using establishing shots followed by close-up views, and techniques which enable him to freeze action and build up tension. He spells out all these technical means as the check-list which helps him to ensure and monitor his own progress. This check-list could beneficially form the basis of any long-term structured drawing course which would benefit all school pupils – not by their drawing comics, but by the principles being consistently utilised. There is food for thought in such examples of Home Art, which would appear to parallel an approach and working methods not dissimilar to that of many established artists and craftspeople.

Section 2 The Mature Artist and the Illuminating Experience

The ability to work out a problem, or set of related problems, over an extended period of time as illustrated in the two Home Art examples is a characteristic shared with many mature artists who approach their work in a similar manner. Even in cases where the artist has already well-developed career intentions and a professional sense of purpose, accompanied by an appropriate breadth of knowledge about the visual arts in general, he or she can still be subject to the shock or surprise of the illuminating experience. This often has a significant bearing on the artist's work and subsequent development because the illuminating experience, relating so peculiarly to personal individual needs, frequently has, not surprisingly, a direct bearing on that person's own work. It has already been noted that Lara was similarly affected and as heightening of environmental awareness is associated with the illuminating experience, it is obviously going to have a significant influence on the practising artist.

There are many instances of artists' work reflecting the influence of these illuminating moments, with them often being instrumental in the process of the artist 'finding' him or herself. On seeing Constable's paintings for the first time, Delacroix took down his canvas of the *Massacre at Chios* from the Salon wall and repainted the background 'with touches of broken colour to give it sparkle'. Lord Clark describes this work as the first in which Delacroix is truly himself, in which 'he speaks his own particular language, which was not to be greatly modified in the next thirty years'.[9] Eighteen years after the event, Kandinsky recalls the Monet canvas of a haystack which he had seen in Moscow in 1905. He describes having been puzzled, surprised and bewildered by it, but the painting had remained fixed in his memory down to its smallest detail with the intensity of the colour 'a complete revelation' to him. He adds that 'even the subject, regarded as an indispensable part of painting, had begun to lose its importance for me'.[10]

Kandinsky was shortly after to dispense with the subject and to play a major

part in the development of early twentieth-century non-figurative painting. In the same year, 1905, the Van Gogh retrospective exhibition held in Paris was to have a profound effect on the young Fauve painters, but Van Gogh himself had been powerfully affected on seeing a Monticelli exhibition in Paris shortly after his arrival in that city. Frank Elgar writes:

> On entering the gallery he had the sensation of confronting a different world, some garden of fairyland. He was enchanted by all the splendour he saw . . . They were soon to inspire the Dutch painter. No less than fifty flower-pieces are to be found among his two hundred Paris pictures. A comparison of Vincent's *Flowers in a Blue Vase* for instance, with the identically named masterpiece by Monticelli shows striking resemblances between them.[11]

Obviously Van Gogh was also affected by the whole climate of Paris at that time, and a range of influences is revealed through his subject matter, brushwork and use of colour, etc.

Another artist who made the pilgrimage to Paris was Chagall. Arriving there in his youth in 1910, he was similarly fired by the whole climate. The Royal Academy Chagall catalogue observes that '. . . the juxtaposition of St. Petersburg pictures with those painted in Paris . . . makes it equally clear that other specifically French influences joined together to lift the work of an extremely talented young student from St. Petersburg into the first rank of modern European art' and 'After one year he had leapt ahead both in imagination and the scale of his work . . .'.[12] On first arriving in Paris, he was looking for excuses to return home again, but recalls:

> It was the Louvre that put an end to all this wavering. When I walked round the Veronese room and the rooms where the Manets, Delacroix, and Courbets are, I wanted nothing more . . . The most authentic Russian impressionism is puzzling when it is compared with Monet and Pissarro. Here, in the Louvre, before the canvases of Manet, Millet, and others, I understood why my alliance with Russia and Russian art had not worked. Why my very language is foreign to them.[13]

Readers will doubtless recall other examples known to them, and will perhaps recognise similar moments in their own backgrounds which have been instrumental in their becoming art educators. Three British artists and craftspeople, two still working and the influence of the third strongly reflected in the work of each successive generation of ceramicists, describe how the illuminating experience has significantly affected their own artistic development.

Michael Rothenstein has played a leading role in the development of printmaking in this country since the war. He had been dogged by a most unpleasant illness for many years, but recalls that

> I began to become alive after this terrible period and I became much more aware of what was happening with chaps like Piper and Sutherland. And then

of course we knew about Hayter working away in Paris – it must have been about 1957 or something like that. I worked with Hayter for three brief spells and it absolutely altered my life. I had never come across printmaking and he ran such a remarkable operation! There were so many people associated with the studio and it wasn't just what they were doing there or what he was doing, but it was all happening against the great backdrop of what Picasso was doing and what Braque and Matisse were doing, so it was heady stuff. To me it was an absolute revelation. It was as if I'd lived in a particular room and I'd suddenly opened great double doors onto an entirely new glittering landscape – it was a most marvellous thing. In entering this glittering world I felt I could discern huge tracts of untried country. It was through Hayter that I discovered the extraordinary world of print.[14]

His mind full of images, he returned to England but there was nobody who could print an etching in colour or help him to work on the ambitious scale which he envisaged. 'It was hopeless.' He began lino-cutting in an experimental manner, but felt a void because he was no longer working with nature. He recalls that among many experiences that made further development possible, one particular incident stands out:

I was having a picnic with my family here in Essex and we unpacked the lunch and sat in this lovely place, and when I looked round I saw the most extraordinary sight! There were immense offcuts of elmboard which were set up as a great wall around a timber yard and these bits of wood were so marvellous, so strange you know with this grain like the looping tide on a shallow coast. These are the bits of wood which are first cut off the tree – the wild planks before they get into the hard wood and get the proper planks. Immediately it came into my mind, 'Why need we print or engrave or cut – or whatever – on a blank surface? Why can't we conspire with these extraordinary shapes and these magnificent surfaces and start that way?' You know, it absolutely hit me and I went to one of these timber yards and I bought a great mass of these offcuts – a whole truckload – and they came back to the studio . . . This idea of an inheritance drawn from the world of nature was very important to me at this time . . . I started by enjoying things through my eyes and drawing what I saw, and when I moved into this more abstract thing, the withdrawal from nature it meant a kind of emptiness, perhaps it made a chasm in my mind! But the moment I got onto this idea that the materials themselves were drawn from the world of nature – even things like plywood with their extraordinary field of tiny organic marks – once again had the reassurance of nature. One was working with nature.

The vision of a colourful, large-scale world of print which he had formed as a result of the heightened experience of Paris and Hayter's studio was only resolved after a parallel and closely related experience in front of nature some time later.

A second and equally interesting example is of a formative period in Brendan

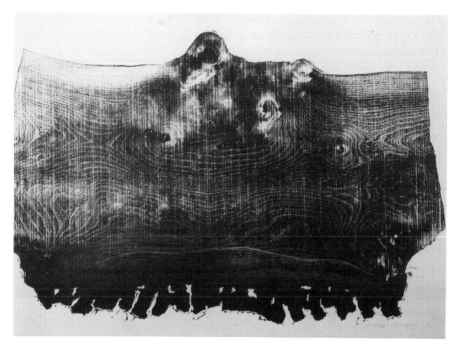

Michael Rothenstein, Black, *woodcut, 1963.*

Neiland's development. Edward Lucie-Smith has described him as being 'one of the few great virtuosi of the British Art scene', and yet he was not studying Art at his grammar school.[15] 'The way the classes were structured you did your chemistry, biology, physics – and of course there's no room for art!' (how many schools might this still apply to today!). It was through the sympathy and support of an English teacher that he eventually went to a Saturday morning class in Art, thus keeping open his 'Art lifeline'. He moved to Birmingham from East Anglia when in his teens, and he eventually went to Birmingham Art College. Few would detect the influence of Léger on Neiland from a study of his recent mature works, but he stresses the importance of this influence when he was a student:

> The interest in Léger was most peculiar. As most students do I looked at work and the books and reproductions – and he is an artist I really loathed. I found his stuff most unpalatable, but quite extremely so, and so extreme that I thought there must be something there to have a look at further, so I approached Douglas Cooper who was living just outside Avignon. I wrote him a letter and asked him if I could speak to him about Léger and perhaps see his collection. He invited me across and really, to be honest, slightly before then but certainly in conversation with him and seeing his collection, my hating and loathing of Léger became one of admiration and loving . . .

but the interest in Léger, apart from feeling rather put off by the ugliness of his paintings and drawings, did arise insofar as he is one of the few machine painters I had ever come across and ultimately I thought that he used the whole contemporary environment, or contemporary to him, very well.[16]

On moving to Birmingham he recalls that he couldn't believe

. . . the bustle, the size of the city and the fact that one of the stores had a roofgarden on top of it. It was so extensive in a sense, and I suppose Léger ultimately did capture something of that sort of environment which was very new to us . . . It wasn't a very pleasant city on the surface and I was trying to think what its life was and it was very much to do with the machine, with the car, with manufacturing industry. And so I received permission while I was there to go into the factories and to actually work from machine parts, drawing bits and finished pieces . . . Having worked in a factory and having done a number of colour studies and drawings, these were then taken back to the studio and to the college. I was fortunate enough to get one or two prints of Léger's and no end of reproductions in books and I posted these up on the walls about me, and from my own subject matter from either the Science Museum or from the factories I'd visited or from a girlfriend who posed for me, I did a series of paintings which owed an enormous amount to Léger's colour and to his structure. In a sense it was like putting on another artist. It was trying to understand Léger, to work through his work, to use his colours – and for a year and a half I worked in this manner.

'Most unpalatable', 'hating and loathing' are strong words indeed! Many of the youngsters interviewed are indifferent to or ignorant of the art form in question prior to the moment of illumination, but some, like Julie, reveal the kind of hostility and antipathy which is so apparent in Neiland's initial attitude to the work of Léger. It is the extent of this hostility which makes Neiland sense that 'there might be something there to have a look at further'. In the Rothenstein example, the Parisian episode precedes the resolution in his work which resulted from seeing the elmboards, whereas there is a complete integration between Neiland's response to Léger and his vision of how the essential aspects of the city might be visually interpreted – each is helping form his attitude towards the other. That many pupils have the potential to develop their work systematically through a clear understanding about its relationship to other relevant objects is clearly illustrated by Timothy and Anthony, making the parallel between them and the two artists close enough to be significant.

Important developments within an artistic process are important but the illuminating experience can sometimes be instrumental in the artist discovering that he or she is, in fact, working in the wrong field. Reference has already been made to the importance which *The Arts in Schools* places on this diagnostic problem: 'The person who is "at home" working with clay may feel awkward working with paint and so on.'[17] Tadek Beutlich, one of our leading and most inventive weavers, trained as a painter and it was only some time afterwards that

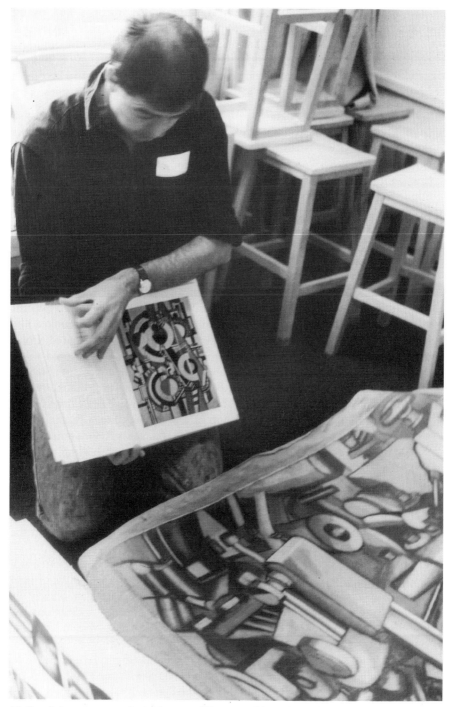

Neiland demonstrates the influence of Léger on his early student paintings.

he saw some French tapestry weavers at work in the Victoria and Albert Museum, as accompaniment to an exhibition of tapestry weaving. From that day on he says that he knew it was his destiny to be a weaver.[18] Similarly Bernard Leach describes visiting a Japanese tea-room with a view to exhibiting the etchings he was then producing – only to discover that he had to become a ceramicist, a moment of great significance in the recent history of ceramics. This is part of his diary entry written at the time:

> In this large most beautiful tea-room, brushes, pigments, and unglazed pottery lay about on small felt-rugs which protected the matting. Someone who spoke English asked me if I would decorate one of them, and for the first time in my life I considered what was appropriate on a pot. It crossed my mind that pattern must be something different from either the landscape or figure-painting to which I was accustomed.
>
> Quite recently I had seen a Ming porcelain dish in the Museum, I recollected, of a parrot balancing on one foot. At the two ends of its stand, small pots contained seed on one side and water on the other. From them at right angles, a framework within the circle of the dish was joined on the fourth side of the square by a handle. Thus a style or formality was created which seemed to have something to do with pattern. This I attempted to paint on my plate, which was then taken from me and dipped into what looked like a pail of whitewash but when it emerged my pattern had disappeared. For a moment I wondered if my work was disliked, but then observed other people's pots being treated in the same way. I came to the conclusion that the whitewash was more likely to be finely powdered glass mixed with water. This was not entirely wrong: after all glass and glaze are of one origin.
>
> The pots were placed around the top of a portable kiln no bigger than a studio stove, to dry thoroughly. This stood on the ground outside the verandah. At the right moment the outer lid was lifted off with a long-handled pair of tongs and we were able to see the inner box with its own cover and red-hot charcoal burning between outer and inner walls. When the inner cover was removed, the colour of the interior was a bright red. The pots we had done were put one by one into the inner chamber, replacing those already taken out. The cover was put back, then more charcoal was added, and the perforated outer cover replaced.
>
> About three-quarters of an hour later the opening process was repeated and the red-hot pots were taken out one by one and placed on tiles on the ground to cool off. The colour gradually changed, the patterns emerged, and as the crackle formed in the glaze, each made a 'ping'. To my amazement the pottery withstood the treatment. (Later I discovered that the reason lay in the composition of the clay, which contained at least twenty-five per cent of pre-fired, and thus contracted, powder clay.) After another quarter of an hour or so, my dish was returned to me, not too hot to handle, in a piece of cloth. Enthralled, I was on the spot seized with the desire to take up this craft.[19]

The rest is now, of course, history!

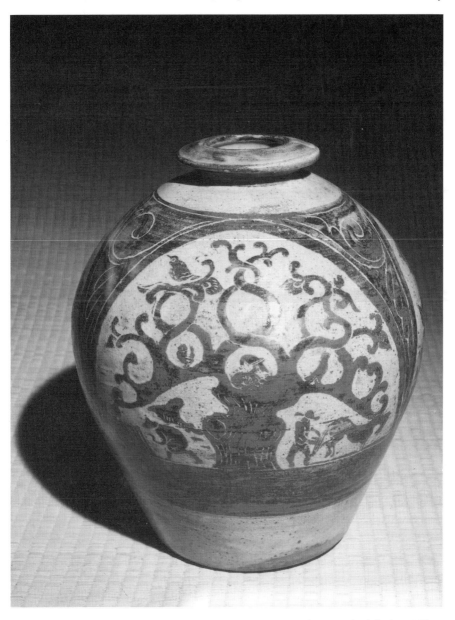

Bernard Leach, a globular stoneware vase, about 1946, decorated with three 'Tree of Life' designs, unglazed, in brown on speckled grey ground.

It will be recalled that in the student examples of the illuminating experience already described, they also draw important parallels with their own work. Anthony found it interesting 'because it started applying to my own paintings as well' and Joe 'kind of jumped into art more'. Jane wrote in her diary that the Carel Weight paintings had given her ideas for her own art. Obviously it is too much to expect of immature young people that they simply resolve these issues unaided; it requires the sensitivity of the teacher to pick up the appropriate clues from the pupil, some of which the pupil does not necessarily translate into practical terms. This was certainly the case when Julie began walking around the places that she had been brought up in and could feel herself 'looking at things in a different way'. Her interest in the history and appreciation aspects had heightened her awareness in the world around her, and had these clues been picked up she would probably have developed an equal motivation for practical work.

These examples suggest that the all too frequent assumption that any deliberate linking of art works to practical activity is going to be boring and unacceptable to pupils is misplaced – it is all a matter of how it is done, as Marie has already suggested. Art departments are practical places, and I have already emphasised that the CSAE Project affirms this, but equally asserts that the enmeshing of the practical work with the study of art objects is an essential aid, and in no way a deterrent to the development of the student's work. On the contrary, given the significance of this relationship between response to art objects and individual practical needs, it is surprising that teaching strategies to draw out these links are not more widely practised. Likewise, engagement in practical work can and should give the student added insights into art objects about which he or she might otherwise remain ignorant. In recent years many art teachers have placed practical work in so pre-eminent a position that such relationships have frequently not been developed, and Witkin's observation that no doubt art appreciation properly integrated with creative work plays an important part for some teachers but was 'non-existent in the work that we observed nor was it mentioned by the teachers whom we interviewed' has already been noted.[20] Hargreaves has recorded many art lessons by different teachers. From recent literature on art education he summarises six main aims in art teaching. These are (1) personal and emotional development; (2) visual awareness; (3) skill training; (4) compensation (the art room as a sanctuary for difficult pupils); (5) education for leisure and (6) initiation in our cultural heritage.[21] Acknowledging that these aims are not discrete and that in practice they overlap and inter-penetrate, his observations of teachers working nevertheless confirm that the first four aims 'appear to be very much more dominant than the last two'. In consequence, the art of the classroom all too often turns in on itself and is taught in a vacuum.

In an article which does not pull its punches, Lauretta Rose argues that most pieces of work which children produce in school relate only to themselves and that there is a form of art, 'School Art, which is in a class of its own':

What does it relate to? Only itself. I hear the argument 'But you have to teach basics.' Basic to what? School Art bears little relation to the Art of the past and none to the Art of the present. There is a curious notion that I have come across recently which is that you mustn't show too much art, past or present, because otherwise they might attempt to copy it and that would crush their originality. But if you want to teach creative writing you will encourage extensive reading without any fear that by reading too much Beckett they are going to write another Godot. Most artists have learnt by copying masters and making pastiches. Much better know what you are doing and use the experience as a springboard than what happens in schools now, which is to copy surreptitiously from sci-fi mags, comics or each other and produce a wonderfully unoriginal turgid piece of work and pretend that it is the Art of the Unconscious – the true individual. It is called Free Expression and is very popular . . . Art is a language and always has been. It is simply one not taught in schools.[22]

That children should systematically be introduced to the art of the past and of the present is the main theme of this book, which also asserts strongly that this should be related to their own practical needs, though whether copying and making pastiches is the best approach is debatable in a school context.

Rose merges together two different extremes of art teaching in this statement. The exercises in the name of 'basics' are more usually taught in the first two or three years of secondary schooling, precluding personal expression – as we shall see later – while what she labels as 'Free Expression' usually emerges after options in years four and five. Witkin is sensitive to these extremes when he observes that 'A not uncommon procedure is to emphasise control of the medium in the early years and self-expression later almost as though the two belonged to different universes.'[23] The DES, in *Art in Schools*, pinpoints another facet of this problem when it observes that '. . . in many secondary schools the art syllabus begins with the first year as if nothing had gone before; occasionally with the result that the teacher's expectation of quality in the work is lower than that to which the pupils have been accustomed'.[24] 'Control of the medium' is obviously important; it is fundamental to any constructive development in art work. But need it be done in isolation from everything else? Lower secondary pupils are rarely taken on gallery visits, and the damage which a course of these exercises can cause is well illustrated by Julie – for they take no account of personal values or interests and the onus then placed on the pupil to be 'expressive' at the next 'phase' is often too great:

I can remember drawing from being a toddler, colouring basically. Then it was always a form of leisure because I wasn't sort of sporty at all outside. I'd rather sit and draw. I used to draw anything that interested me, in a room or outside. It was just a form of leisure for me, I used to love just sitting and drawing and I could spend hours on anything. Sometimes I would draw what was in my head, but often I would sit and draw something that interested me colourwise. I used to love flowers. I can always remember drawing flowers

when I was little. I can remember particularly drawing irises, the long tall iris and the colours, because they were tinged with purple and yellow within. It was like magic, you know, the colour transition from purple to yellow within one inch! That sticks in my mind, I can always remember that. Just sitting in a room and drawing those flowers – but anything interests me. I can remember doing a painting for an exhibition. I was about nine. It was Coalbrook Dale and it was furnaces and all the colours. Anything with colour that interested me I would draw. It was just a form of expression at the time. I used to enjoy it to the point where I would draw for hours and hours and not bother about anything else. And then it became a lesson, which it did when I went to secondary school. That's when I changed. I didn't enjoy drawing any more. Because we were being taught to draw, being taught to draw say a spiderplant. I remember they used to teach us to draw spiderplants or bottles and from then on it wasn't a form of expression for me; it was what I had to draw. It was what somebody had said to me, 'You've got to draw that! Learn how to draw a bottle or a plant!' and from then on it wasn't any enjoyment – I still enjoyed drawing for the sake of it but it wasn't what I wanted to draw.[25]

She still continued to draw at home:

. . . but to a much lesser extent. It was then I would practise drawing a bottle or then I would do something I'd been taught to do. It wasn't just me sitting down and drawing whatever caught my imagination . . . and really I lost interest in it for my own sake and changed my leisure time to more outdoor sports and reading, whatever. It wasn't as much drawing – I hardly did anything – and my family used to remark that I'd changed so much!

She has now left school, having completed her A-levels:

This summer I've finished formal art lessons for three and a half months and I've gone back to enjoying art, to producing work that is just purely for my enjoyment. Now whether that's an indication of because art lessons have finished I've suddenly gone back to enjoying my art, I don't know. But this is the only summer, really, since I began that I've drawn for the sake of drawing.

One could not have a more vivid example of an induced aversive reaction in relation to practical work! Just as Anthony's animated cartoon was the reason for composing a five-minute musical composition, so Julie's sense of wonder at the magical colour transition of the iris petal was the motivation for painting the flowers; this personal awareness and sensitivity is at variance with the task of drawing a spiderplant. Technique has become the sole replacement for all the challenging problems of how to represent something which was marvellous enough to warrant the word 'magic'. Her natural vision could have been supported and extended through reference to, say, a Dürer watercolour, a Leonardo drawing, a detail from a Van Eyck, or a Chinese watercolour or Japanese print. Of course, there is nothing intrinsically wrong with the

spiderplant as an object worthy of attention – it is that such lessons are invariably taught in total isolation without reference to anything else, and as such they are the antithesis of what the CSAE Project is about. And here is the dilemma. Besides changes of emphasis within one school, such as that from control of medium to expression, each change of institution brings its problems if what has gone before is ignored or unrecognised. Richard Hamilton describes his first task as a teacher as being 'to wipe the slate clean'.[26] A foundation art lecturer once described to me an analogy he always used with new students. He likened them to sponges who had been being filled up with 'art' since they began school at the age of five. They were now filled to overflowing, and it was therefore necessary to empty the sponge into a bucket and start again from scratch! Do we really have the right to destroy as worthless those experiences which Lara, Jane, and others describe as being so important to them?

I have suggested that some Home Art is mildly therapeutic, and that it is killed eventually unless nurtured and harnessed through sensitive teaching. In its more potent forms, as in the case of Anthony, it demonstrates an extraordinary form of continuous, almost inevitable growth, as he progresses from establishment to establishment. From making drawings with moving parts as a junior school pupil, we have seen him analysing the timing in professional cartoons, experimenting – undaunted by failures – through making hundreds of drawings and filming, composing in synchronisation with animating, and making quite sophisticated related equipment. Julie's own art was probably too close in type to her set lessons to survive. Both Timothy and Anthony are working in areas which are generally removed from what is done at school, and they have developed an acute and related critical understanding of their subjects. Perhaps they have flourished because, being so different, they are not threatened – but as models of continuous development they are intriguing. Peter Fuller says that what we need is

> . . . a review of art educational practices from nursery to art school levels. We need a continuum of aesthetic teaching, rather than a series of often oppositional systems at different stages of development. (In that continuum, secondary school art teaching would play a peculiarly important role, in extending aesthetic work beyond the 'natural' and purely subjective.) Such a revised system of art education could represent the best chance we have of nurturing a living, widely accepted, alternative tradition to the general anaesthesia of mechanical 'mass culture'.[27]

Almost idealistically impossible, perhaps, but some attempts should be made to start this process, for we have already seen how damaging the transfer from one stage to another can be for some students, and the often unrelated nature of one stage to those on either side certainly leads to fragmentation of experience. The motivations and development over a significant period of time of such individuals as Timothy and Anthony provide one important area of study as to how this might be achieved. Another complementary area of study should likewise relate to how the similar motivations of Jane, Julie and Anita can best

be harnessed and built on through sensitive teaching. Gallery experience is a central feature of these experiences, and it is encouraging to note how many authorities, through the efforts of their art advisers, have organised well-attended CSAE meetings and conferences attended by gallery staff and primary, secondary and higher education teachers and lecturers; an essential mix if the establishment of closer links and greater continuity is to be achieved.

Though the interviews consistently confirm the contention that the art gallery is the natural arena in which the illuminating experience is likely to take place, they also reveal the nature of the essential preparatory work which has to take place in the classroom. Further, they reveal some instances of responses to classroom practice which strongly suggest that it is quite possible for the skilful teacher to induce illuminating experiences in at least some pupils.

These issues have deliberately been viewed initially from the standpoint of the individual. As the recipients, reluctant or otherwise, of the educational process, pupils have numerous schemes of work devised for them which outline how they are going to benefit, but with the underlying assumptions rarely if ever put to the test. My informants reveal insights and capabilities which are surprising to many, but which equally describe with consistency strong aversive reactions to particular types of lessons which are at the nucleus of many school art courses.

This is an opportune stage, therefore, to shift the emphasis to the role and work of the art educator, the examples from now on essentially involving classes or groups. They are drawn from a wide variety of circumstances involving work with pupils of different ages and abilities in both galleries and classrooms. Each example has been chosen because it focusses on a specific facet of art teaching designed to make those pupils concerned more critically conscious. On occasions it has been necessary to describe a particular lesson in some detail, but an attempt has been made to describe how that lesson arose out of, or characterised, an overall approach to teaching practised on a long-term basis by that teacher. The examples demonstrate how involvement and commitment can successfully be developed and built on by the systematic exposure to critical studies teaching.

Conclusion

The main significance of Part III is the comparison between pupils' practice of Home Art and the mature artist's approach. Both are characterised by self-discipline and by problem-solving over a long period. The illuminating experience is relevant to both: the stimulus of interest which produces Home Art results in the same effects; for the practitioner, his or her work can take different form because of such an experience.

The suggestion is that 'Home Art' and 'Mature Art' have more in common with each other than either has with some forms of 'School Art'. We are asked to consider Home Art as a practical starting point and valuable learning model.

In contrast to the involvement of the pupil in his or her work at home, we have been shown how pupils react against types of teaching which concentrate on discrete elements and ignore pupil interests and previous studies. The implications are three-fold. First, learning should be organised in a continuum. Secondly, there are advantages in teaching a narrower range of media in greater depth. Finally, art education should be based upon the intermingling of reflection, response and research, of practice with appraisal and of exercise with expression.

Part IV
Age, Intelligence and Background

Section 1 Critical Studies for All?

Divided into two sections, the first sets out the case for critical studies being necessary and of benefit to all pupils. It then gives substantive evidence in the form of a case study involving children from a special school in South Wales.

The author alights upon one of the glaring omissions from arts and educational debate: the relations between social class and involvement in the arts. He gives art departments credit for compensating in some respects but notes that conventional art history lessons serve to divide the more from the less able.

The argument is put that, though the arts may not appear immediately meaningful to all, appropriate educational experience can help people to become familiar with and find meaning in art.

The school project included is therefore a test case in that it describes the experiences of a group of children who might be judged the most unlikely to benefit from a critical studies approach. It is doubtful that anyone will fail to be moved and enthused by what happened.

Section 2 The Primary School Context

Uniting views already expressed about the applicability of critical studies for all and the desirability of a continuum in 5–18 education, the author turns to what can be achieved in primary schools. He indicates why critical studies are particularly important at this age, suggests that not enough is being attempted and gives his views on what methods are appropriate.

Varied examples are used of actual approaches, culminating in a detailed account of a junior-class project involving Munch's *The Scream*. The Devon working party provides an analysis of how works of art can be employed. Other case studies demonstrate the essential need to relate art to the child's exploration of the natural and man-made world, both environmentally and socially, and to the appropriateness of responsive work in other art forms.

Section 3 Multi-Cultural Issues

The section covers the multi-cultural and mono-cultural school situations, demonstrating the potential for critical studies in both cases.

In the first instance, art education as a whole is seen as especially helpful in

allowing experiment and providing a different climate so as to overcome associated problems. The teachers in the inner-city school featured attempt to start from base-line experiences common to all, stressing the individuality of each child, and to engender confidence so that the pupil makes demands. In this way the teacher does not have to marshal vast stores of information about different cultures in advance. The journey is from the internal to the external instead of vice versa. In passing, the author comments on the desirability of extra-curricular activities, in-service programmes to support multi-culturalism and action research.

The second situation is exemplified by a South-East primary school where one teacher has become expert in group work with children. She provides her own analysis of the value of such work, particularly in terms of social education. Projects on Java, the Kalahari and Japan have added significance which she and the author outline.

Section 1 Critical Studies for All?

(a) Intelligence and background

On that side of the political spectrum to which I belong, the left, the predominant style today rejects the whole artistic heritage of Europe as a 'bourgeois deception', in favour of a call for a new and undefined communitarian art. This would have more value and might well produce some reliable evidence on the potentialities of creativity, if it could be separated from the crude agit-prop terms in which it is always presented. Most people who write in those terms give one no confidence that they understand the working-class life they claim to speak for or those traditional arts they so cavalierly reject.[1]

Richard Hoggart

Hoggart criticises the low level of debate about the arts in 'serious' journals of all political colours, stating that, 'The hardest issues of all, the relations between social class and artistic taste and between social class and artistic creativity, are largely ignored.' Unfortunately, they have also been largely ignored in education, decisions with major implications frequently being made on a crude generalised basis. For example, children regarded as intelligent and therefore academically 'able' often have little opportunity, regardless of inclination, to study art beyond the third year as they are directed into additional science subjects or encouraged to take up a second language. On odd occasions, though, it might be suggested that they do, in fact, study art as relaxation from their otherwise taxing academically orientated timetable! The less able, by contrast, are likely to be timetabled to the art department for additional periods on the assumption that if they are not good at formal lessons they are going to benefit from practical ones. Though many art departments naturally complain about

this state of affairs, and though society should – if only on the practical grounds that people, for example, who are in a position to influence or affect decisions about town planning which have a bearing on all of us should be visually literate – it has to be added that art departments generally do a marvellous job in providing compensatory experiences for children who often feel unwelcome elsewhere in the school.

Nevertheless, the issue often becomes further clouded within the art department itself. Traditionally, if the course has contained a critical studies component this has been represented by art history and appreciation lessons, in which the teaching style is distinctly different to that of the practical art lessons, with an emphasis on learning what are regarded as necessary dates and facts about the subject. As such, these more formal lessons approximate to those in subjects like history, geography, languages, etc., involving note-taking, essay-writing and the memorising of information which is often about, but rarely to do with, the works in question. Not surprisingly, this tends to mean that if a critical studies element is consciously practised in the department, a *further* selection procedure is involved; the study and practice of art are for the more able, but only the practice of art is relevant for the remainder. It is partly this state of affairs which has led to the coining of 'critical studies' as a phrase, emphasising the need to explore the many ways – of which art appreciation lessons are but one – of combining and linking the study and practice of art for *all* pupils, so that the majority might derive lifelong benefits from their time spent in art lessons while at school.

Su Braden is one who propounds the 'bourgeois deception' argument:

> It must be understood that the so-called cultural heritage which made Europe great – the Bachs and Beethovens, the Shakespeares and Dantes, the Constables and Titians – is no longer communicating anything to the vast majority of Europe's population . . . It is a bourgeois culture and therefore only immediately meaningful to that group. The artistic deception of the twentieth century has been to insist to *all* people that this was *their* culture.[2]

The testimonies of the pupils and students already cited make it clear that they often did not find the works *immediately* meaningful by just walking into a gallery, but Sir Roy Shaw observed that this does not mean 'that they must remain outside the reach of (ordinary) people', for, in his own experience, he has seen the range of countless people's appreciation and enjoyment of the arts extended:

> So I reject the views of Miss Braden which I quoted above as politically inspired philistinism at best, and advocacy of a form of cultural apartheid at worst – advocating a sort of Bantu culture for the lower orders . . . These so-called democrats are elitists in the proper sense of the term. They agree with cultural snobs that the high arts should be preserved for the elite, a privileged few and the rest of the population should have something else.[3]

He feels that the schools are sometimes responsible because, if the arts are 'not

immediately meaningful, this is usually because people lack the education experience to "possess" a work of art'. When children do have this capacity, they do not categorise the work as being 'high art' or otherwise; these are adult labels. Hargreaves emphasises that 'the fringes of the "high arts" are extremely fuzzy, with no natural or uncontested boundaries' and, like Sir Roy Shaw, he believes that we should not let the existence of cultural snobs cloud the issue:

> It is surely a mark of the well-educated person in the arts to display both breadth and open-mindedness. To be otherwise is not to be educated in the arts; it is to be a 'high culture' snob. We should not be distracted by the existence of such people. Nor does a commitment to the 'high arts' involve a necessary denigration of working-class cultural forms, which should also be celebrated in school, or of the wider functions of aesthetic education as a whole, which must educate pupils' perceptions of the whole of their environment, both natural and man-made.[4]

John Berger in his *Ways of Seeing* draws upon the work of Bourdieu, demonstrating how the percentage of the population who visit museums increases according to the level of education received.[5] Hargreaves points out that Bourdieu also shows that schoolteachers are the greatest readers of books and the most regular visitors to art galleries, museums and exhibitions and argues therefore that teachers should transmit their own capacities to appreciate the arts to more and more pupils:

> The school should, in short, increase its powers to disseminate cultural capital. If this task of greater dissemination is to be accomplished, then initiation in the 'high arts' must be given more, not less, importance in school. Art is now a low status subject and as pupils get older it becomes an optional subject that 'gifted' pupils are encouraged to drop. Inevitably the aspects of cultural capital that relate to art become progressively less available to pupils, and those who already derive pleasure from 'high art' and visit galleries because of their home environment lose little or nothing by its exclusion from the curriculum. As long as art is an optional and low status subject, it is the working-class pupils who will be denied opportunities for the acquisition of the appropriate cultural capital.[6]

Germaine Greer illustrates the truth of this statement autobiographically and in the most vivid way. As a convent schoolgirl it was her ambition to be a great opera singer performing in a different European capital every night, but:

> Mother Superior would have been surprised to learn that this ambition had been formed in me by the convent itself, for nothing in my suburban home gave the slightest hint that there was such a thing as grand opera . . . At home there was a tiny bookshelf which had held the volumes given away periodically by my father's employers and not so much as a recordplayer. Home was total sensory deprivation . . . School by comparison was a veritable treasure-house of created pleasure.[7]

Two of the sisters were 'the architects of these delights' and she recalls subsequent moments which arose as a result of Sister Raymond's transmitted enthusiasm:

> It strikes me still with a faint shock to realise that although she prepared me for some of the climactic experiences of my life, the first sight of the unmatched towers of Chartres rising above the cornfields, the revelation of the Mantegna Agony in the Garden in the National Gallery, the magnificent wreckage of the Acropolis, she had never seen and never would see any of them . . . Yet it was she who taught me the difference between a picture and a painting. I have listened to my fellow students at Newham discussing 'modern art' and been surprised to find that living in the midst of great art they were aesthetically illiterate. If I am not, it is because a droll person who became quite red in her excitement and punched at the air with stubby stiffened fingers took great care to see that I learned the difference between a Braque and a Buffet.

Many children have the potential to benefit likewise from the arts to a greater or lesser degree, and these are benefits enjoyed long after leaving school. Ken Robinson likens much of school knowledge-based learning to being like filling a tanker with two-star petrol, for it all to spill away on the day the pupils leave school, and yet it is the hold which such subjects have which determines the lower status of art in the school curriculum and option patterns.[8] At a conference in 1980, Hilmar Hoffman, in a discussion about attitudes to the arts in society, said:

> You consider art as an option. But this is difficult to handle in reality because most people have not learned at school the cultural 'techniques' and are not motivated to participate in what is offered to them in the arts. If someone has not learned at school the metaphoric language of the theatre, or to discover the essentials in a piece of abstract art, he will not really participate, for he can take nothing away. The problem remains that even if we try to help such people, we reach at most an additional 5%. So what happens to the other 80%? . . . this can only be done by changing the school system. In schools, literature, music, and so on has to be taught . . .[9]

In this respect it was encouraging to hear the Secretary of State, Sir Keith Joseph, recently give unequivocal assurances that, so far as he and the government were concerned, the importance of the arts in education was beyond question or doubt, and that he was sympathetic to the notion that all children should continue to study at least one aesthetic subject throughout their years of compulsory schooling.[10]

Changes in education come about very slowly, however, and in the meantime, there are many things which arts teachers can do to benefit the children in their charge while demonstrating the importance of their case. A notable example indicating something of what can be achieved is the work of a teacher in a special school in South Wales. He is a classroom teacher, responsible for all aspects of

his children's education, but in outlining this case study, I have naturally concentrated on the critical studies aspects of what was done in a thorough, systematic way over the period of one school year. It illustrates that critical studies in art education has implications for all children.

(b) T is for TATE

'It's moving, it's moving!' shouted John. For some time he had been concentrating his attention on the dominant area of *Eve* by Barnett Newman. In the design of this large canvas Newman has placed one narrow vertical stripe of purple on the extreme right-hand edge of the painting to alleviate an otherwise totally red canvas, and it was this vivid, intense area of red which appeared to be moving as John looked at it. The impact of this optical effect was far greater than any verbal justification could have been and the teacher remembers this incident as the most vivid moment in the day which his pupils spent at the Tate Gallery in May 1983. John was one of a group of maladjusted pupils from a special school in South Wales. They were between eight and twelve years of age, and their visit to the Tate arose out of an extended course relating to the Critical Studies Project which he had undertaken with them. This work came about because he was studying, part-time, for a BEd at the South Glamorgan Institute in Cardiff where he was a member of a working party on Critical Studies in Art Education (see facing p. 50).[11]

His involvement with this aspect of the art curriculum was unusual considering that his pupils have a wide variety of emotional problems and experience considerable learning difficulties. The average intelligence quotient for the school is in the eighties, inevitably meaning that there are ESN children in each class. Some of these children find difficulty in even memorising and reciting the alphabet, and tasks which would normally be regarded as routine can prove to be unexpectedly difficult. An eleven-year-old boy, in attempting to return three '10c' Ladybird books to the bookshelf, could put them after those graded '9' or 'b', but there was no way that he could place them after those marked '10b'. The teacher has to contend with such basic problems on a regular basis. The pupils' concentration spans are inevitably limited and the teacher has constantly to adjust what he is doing in the unpredictable light of his pupils' actions and responses.

A number of teachers have recounted stories at CSAE meetings about taking groups of pupils to galleries and exhibitions, only for them to be in and out in no time at all. To many teachers this is the great inhibiting factor about gallery visiting. In this case, teacher, pupils and helpers travelled to London by train, ate their packed lunches outside the Tate and entered the building at 1.10 pm. They spent about four hours in the gallery and only stopped for a drink at 3.20 pm; an initial uninterrupted two hours ten minutes looking at paintings and sculpture! And yet the teachers mentioned above were talking about groups of pupils who had opted to study art as an examination subject. What, then, were the factors which enabled these children, with so many disadvantages stacked against them, to spend so much time in the Tate without

losing interest? To answer this question it is necessary to return to their classroom nine months before the visit took place.

The children suffer from inconsequential behaviour. 'They can't think further than tomorrow or the day after, and even within the same day they will do something without thinking of the consequences.' Many children will act thus on occasions, but this is a dominant, recurring trait for these pupils. To work out a planned curriculum for the year, or even for a month, is so difficult that many teachers in similar situations regard it as being out of the question. The teacher can be working extremely hard responding to the minute-by-minute problems which are constantly arising – but every day becomes basically the same for both teacher and pupil, incentive and motivation being at an absolute premium. These teachers 'are screaming for a structure' but one which is meaningful for their pupils.

For an underlying structure the teacher took the letters of the alphabet, one for each week, beginning with 'A for Apples'. In the wrong hands, this could have become boringly low-level and predictable but, in fact, it provided him with a basis which allowed for long-term planning and his pupils were able to become involved in short bursts of activity which they could see as being part of a larger whole:

> By the end of the week they feel that they have achieved something and they are moving on to something else, although they are still working within the structure. They know about the alphabet and they know it's going to take so many weeks – but that doesn't matter because they're coming in on Monday and saying, 'What are we doing this week?'

It is easy to sit down and write schemes which offer children novelty on a weekly basis and in which, though the teacher is aware of the link between specific lessons and the overall structure, the children are not, but

> The more involved you get in it, the more accidents you come across – you generate them . . . It is a sequence and it is an extension and a progression from week to week. It isn't just a case of doing A for apples this week and we'll do B for bananas next week, and there is no progress. You have to build on the previous letter and the experience that the children have is built upon from week to week. So you can't really plan it that much in advance, anyway, because it depends on how the kids go because you want to consolidate something or extend the child, or cover that ground again. So you've got to keep within a few weeks. You've got a general idea, but then other things crop up in the work anyway.

In practice, therefore, though what was coming soon had to be carefully planned in advance, it was significant that the children themselves began to pick up and become aware of cross-references which naturally established links between one week and another. B was for the Blue Lady – *La Parisienne*

by Renoir – which the children saw in the National Museum of Wales. A month later, in relation to F for Faces, they were excited to discover a photographic portrait of the aged Renoir and they learnt how, sitting in a wheelchair, he had had to paint with brushes tied to his arms because of the crippling effects of arthritis. Such links became increasingly commonplace, giving added impetus to the later weeks' work.

Some pupils are rarely taken out on visits because of worry about their behaviour, but the teacher took his pupils to see the Renoir on the second week, and their behaviour was exemplary. On subsequent weeks they made comparative studies of pub signs and drew the façade of the New Theatre, for example. The children became quite adept at improvising, using the gallery floor as a work area or drawing in the streets in the public gaze. This often clarified teaching problems in a particularly sharp way. Mary Ann, though twelve, drew the New Theatre exterior by scattering architectural details all over the page in a random manner. It might be acceptable for the four-year-old to 'list' in this manner, but the teacher clearly had to help Mary Ann to record architectural relationships by showing her, and discussing with her, how the columns are all in a line supporting the next level of the building (having initially encouraged her to begin by concentrating on a single column). The problems reflected by her drawing are obviously deep-rooted ones, not solved in any one lesson, but by going out of doors and drawing something as specific as the New Theatre, such problems became more clearly focused.

The children have extremely limited vocabularies, and it is very difficult for them to clarify ideas through constructive conversation. Progress and development in their use of language is extremely slow, and their teacher would not claim noticeable improvement over the school year. Nevertheless, he has adopted a number of strategies to encourage his pupils to articulate ideas more clearly. In describing calendar plates of gardens so that the rest of the class could recognise the example, a child would say, 'There is sunshine and there's a lot of colours' – applicable to virtually all of them, and the teacher would have to add a few words and pose a few questions to stimulate further description. One boy, to distinguish between differently shaped trees, eventually described them as being 'spear' and 'carrot' shaped, but then used the carrot analogy to describe another tree several weeks later. On other occasions pupils have taken it in turns to describe their own work: what their ideas were based upon, what they had in mind, why they used particular colours, etc. Even if it is difficult to gauge what language development has taken place, such strategies have encouraged talk and have concentrated their attention on objects which would otherwise have warranted only a cursory passing glance.

They became able to recognise a Hockney at a glance. H was for Hockney. The teacher 'posed' for the children in the school swimming bath with the pupils standing around the edge making drawings not only of the figure, but of splashes and the patterns made by ripples, one boy even attempting to render refraction. Individual children also took their turn in the water as models, of course. From their sketches they produced paintings and fabric collages, some

of head and shoulders above the water, but others quite unusual with just feet and ankles visible above the water level. It was Hockney's *Splash* in which no figure is actually visible that made them aware of such related moments. They discovered that apparently detailed sketches, of which they were quite proud, did not contain sufficient information for them to carry out their follow-up work adequately, so their teacher had to pose at one stage, minus shoes and socks with his feet on the desk so that David could obtain the necessary data which was lacking in his original studies. Hockney did not just provide the subject matter for their practical work, though, for Hockney became one of the artists whose work held a particular fascination for them.

Throughout the year, the children became aware of an ever-increasing variety and range of works by artists and craftspeople. The teacher felt that they would have difficulty coping with too many names if each week was to do with a particular artist, but he skilfully introduced his material in a variety of ways. L was for Liquorice Allsorts, and in the process of the children making large, bold and simple rectangular and circular paintings and prints, they were introduced to the paintings of Mark Rothko and Barnett Newman. Though they would probably have rejected the work of both if asked to compare them to a Constable, they completely accepted them in relation to their own work based on liquorice allsorts – the point of which they clearly saw. They were asked to compare Rothko's paintings with those of Newman, however, and weeks later, in the Tate, they were also able to recognise the work of each of these artists at a glance. It has already been noted, as with Renoir, that links between the weeks emerged. The New Theatre was just another building because none of the class had ever been to the theatre, so O was for Oliver with the children producing their own special lunch-time play which they eventually performed to the whole school.

Genuine chance, however, led to another substantial link. The teacher recalls that

> There was an Artist in Residence who was working in South Glamorgan and I felt that I wanted to use her services in school. It just happened that she was a potter and I was coming up to the letter P. Now you can call that an accident, but if I had been coming up to the letter Q I might have worked it in in another way. But it worked out that way; she was a potter so I justified it by having her in for a week. She happened to be working on pottery cockerels, and I felt that needed to be followed up, so when I came to R we did roosters.

He acknowledges that this 'sounds corny to a certain extent'. Perhaps not, though, when it is added that he loaned a cockerel from the City Farm and both craftsperson and children worked directly from this live specimen, the pupils' drawings forming the basis for them to make clay versions. Ken lived close to the City Farm and on occasions he helped to look after the animals and poultry, so his teacher gave him the responsibility of looking after the cockerel in the classroom. He was ten years four months old at the time, but the visit to the *Blue Lady* was the first occasion on which he had ever drawn a body – until then

he had only drawn 'big-head' figures with arms and legs coming out of the large head. His drawing of the cockerel was similarly basic, but when he worked on his clay version, constructed by cutting out shapes from a slab of clay, the outcome marked a prodigious leap. The affinity he felt for the cockerel, and the responsibility of looking after it was obviously involving to Ken, but clay was equally a medium which gave him scope for expression and was relevant to his needs. Because of the interest generated, the topic was extended by week R focusing on Roosters. The pupils made further cardboard versions on sticks and were able to use these for cock-fighting at Saint Fagan's Folk Museum the following week, S being then for Saint Fagan's. This had been arranged with the museum, whose facilities include a reconstruction of a cock-fighting pit.

A book of Tate and National Gallery paintings was available for reference in the classroom for several weeks before the visit to the Tate, and any child could look through this book in spare moments. Their detailed knowledge of its contents was quite surprising, for they referred to it on a number of occasions as they recognised particular paintings in the Tate with which their teacher was not familiar. He had carefully planned this visit. Trips to appropriate places in and around Cardiff were now a matter of course, but one to London needed thorough preparation, and he also arranged the help of four additional adults. He wrote to the Tate well in advance, and they asked him if he could change the date, as they could not offer any service on the day in question. As the date could not be altered, I was approached to act as a guide and I naturally agreed to undertake this task.

In a sense this visit was the natural culmination of many months' work. In addition to the artists already mentioned, the children were also aware of the work of Monet, Pissarro, Cézanne and Van Gogh. They were familiar with Seurat's pointillism and the atmospheric landscapes of Constable and Turner, and works like Lichtenstein's *Whaam!*. 'It's probably a very dangerous thing to say, but I was confident in the kids before I went. I felt the work had been done, the ground had been prepared well enough for them to go, and when the time came there was no problem at all.' Like all good preparatory work in this field, the teacher's had been such that he had whetted his pupil's appetites and aroused their sense of anticipation. But he knew that he needed support in the gallery. 'I think, not only do you have to prepare the work in advance, you have to have somebody there who knows about the paintings in the Tate.' Though he was disappointed that the Tate could not offer any help he felt, with hindsight, that my contribution – though not as expert – was probably preferable in that the children already knew me and regarded me as a friend. After about ten minutes, though, he thought, 'What have I done, they've lost interest?' In their initial excitment the children were hurrying from painting to painting in the Impressionist Room; 'But once they began to see things they had seen in books and once they began to have stories behind the paintings, then – well – we were there for about four hours!' Seurat's *Le Bec du Hoc*, a painting of a huge rock silhouetted against sea and sky, was the first work to hold their attention fully and they spent some time moving backwards and forwards observing at what

point dots disappeared and the form of the rock took over. It was necessary to be selective but, equally, the children had come wanting to see particular works, meaning that a balance had to be achieved throughout the day between talking to them as a group and allowing them to exercise their personal preferences, at which point discussion was with one or two at a time. Mary Ann wanted to see Renoir paintings, remembering the *Blue Lady* from so many weeks before. None was on display, but the sculpture of the *Woman Bather* was situated close to the Impressionist Room entrance, and Mary Ann returned to look at it throughout the afternoon, finally deciding to draw it. She sat on the floor, only to be 'moved on' by an attendant. She attempted to continue it from a different angle, her back to the work so that she could lean against the wall. A new drawing had to be started with her too far away, but at least facing the motif. In the Turner Rooms, Nathan tacked himself on to a group of adults with a guide, informing us afterwards that she had been telling them that though *Norham Castle, Sunrise* was painted in oils, Turner had used them like watercolours.

The evening before, a teacher had asked Jeff why he was going to London. His reply was: 'To see the Mark Rothkos in the Tate!' A boy had detained us in front of a Morris Louis canvas in the adjacent gallery, and the main group went into the Rothko Room. They returned, exclaiming, 'They're awful!' After a brief discussion as to why he might have painted them in such sombre, brooding colours they had a further look – but back at school, Jeff insisted on painting a 'Happy Rothko' to redress the balance. Chosen from five preliminary felt-tip drawings using different colour combinations, the final version – quite large – was executed in emulsion paint on hardboard, the main colour areas superimposed over the initially brushed-in pink surround. This 'Happy Rothko' featured in the Tate exhibition which was staged on the school corridor to mark the visit. Ken painted the *Marilyn Monroe Devlin* by very precisely colouring over sixteen edge-to-edge portraits of Mary Ann Devlin which the teacher had photocopied for him. Roy produced a large painted version of *Whaam!* by tracing over a postcard reproduction, enlarging it on to a piece of paper by using the overhead projector and drawing round that image. Both were proud of these paintings. Ken felt that his was probably the best thing he had ever done, but at the same time it wasn't really good because he had cheated! On the other hand, they argued, it was all right for Andy Warhol to use mechanised means because he could get a lot of money for his and you wouldn't know that he hadn't painted it all by hand unless he told you! Cheating was related to time – if it saved time it was cheating because the longer a painting takes, the better it is likely to be. Hockney, they informed me, had been working on a still incomplete painting for four years – that one *must* be really good! Their ability to argue a case was limited, but nevertheless they had arrived at a stage where they were aware of such issues, because their course had introduced them to a diverse range of works produced in a variety of ways. This was reflected in their choice of postcards, bought from the Tate Bookshop for classroom use. Davie, Stella, Warhol and Rothko were naturally interspersed with Constable, Turner and the Pre-Raphaelites.

The *Blue Lady* was the first framed picture the class could recall ever seeing.[12] Most of the pupils come from homes which are devoid of books, and it is unlikely that any of them will ever study for an external examination in their school lives. Often in trouble, most of their feelings are directed towards themselves through their problems, but during this year they have identified with numerous artists through their works; their sympathies went out to these artists through this empathy. They are adamant that they want to visit the Tate again – in some cases to look at the same works again, in others to see the rest because that first visit was so enjoyable. Some would like to visit other galleries. They can recognise a wide variety of artists' works which have special meaning for them, and they sketch fluently within their limitations and handle paint with assurance, as well as other media. They will never aspire to note-taking and art history essay-writing, but they have undoubtedly developed a critical awareness and, most important of all, they have also developed that all too rare gift – the ability to derive genuine enjoyment from simply looking at paintings and sculptures. Their teacher knows that the use of a letter a week 'sounds corny to a certain extent', but his approach has been so imaginative that the weeks eventually all came to inter-relate like some giant spider's web with each contributing to a larger whole. The children – seemingly the most unpromising of material – now have a rare knowledge of art as well as an interest in making art, and their teacher knows that he has been enriched and regenerated as a teacher in the process. This project vividly demonstrates that all children, irrespective of background, can benefit from a critical studies approach to learning.

Section 2 The Primary School Context

(a) A critical approach in the primary school

T is for Tate was considered from the standpoint of a teacher successfully adopting critical studies approaches in his dealings with a group of children who all experienced considerable learning problems. However, his class was also vertically grouped and he had to cater for eight- to twelve-year-old pupils' needs; the youngest children were therefore of primary school age. There is considerable talk at present about how greater continuity can be achieved across the span of 5–18 education, and the problems in art education are particularly acute in this respect. One factor is that many primary teachers have not studied art to any level since they were fourteen, often only appreciating its significance – not only in its own right, but as a general aid to all learning – after they have begun teaching. There are primary teachers who have sought to introduce children to the whole world of art who are aware that this age group can show remarkable insights and be extraordinarily responsive, often identifying with artists and their works with uncanny ease. The application of critical studies approaches integrated with practical activity can relate the child's inner world of sensations and feelings, 'of private space and of the solitary subject', to the

immediate world with telling effect at this stage of education.[13] These examples remain very much the exception, though.

One of the concerns relating to art education in recent years, then, has been to do with the crisis period in the later years of primary schooling. The Schools Council *Art 7–11* document cogently outlines the problem:

> While every area of the country can produce two or three junior schools or departments that provide an exciting and demanding programme of work in art for their children, the overall picture is much less encouraging. There is a genuine belief amongst art educators that the last decade has seen something of a decline in the quality and purpose of work in art in the 7–11 age range. In many schools art is too easily regarded as having only a mildly therapeutic or civilizing function, with little in the work of many junior classes to suggest that it is making a positive contribution to children's learning. Frequently art is seen as offering only a decorative adjunct to the more serious business of learning; in these circumstances it is not surprising that teachers have become over-concerned with simple craft prescriptions and the provision of materials. Teachers are certainly not helped by pressure from the manufacturers of art and craft materials to solve their problems by spending, or from the television 'how to do it' pundits who bedazzle the children with short-term and spurious achievements totally unrelated to the structure and contents of their learning in school.[14]

In my recorded conversations with pupils and students it is significant that when talking about their early artistic memories and development, the vast majority make no reference to the junior school; they refer to infant school lessons and are very outspoken about early secondary school lessons, but recall art done at home during the junior years. When reference is made, it usually affirms the observations above. One student, for example, recalls that 'I did more drawing at home than I did at school. My mum always said that she liked my paintings. I had more time at home as well, and you can draw what you want. When you're drawing what you want you tend to draw better, I think.'[15] One piece particularly pleased her: 'I remember thinking to myself, "It's really good, that." I showed it to me mum and she thought it was really good, but it was no use me taking that to school because I don't think they would have thought it was any good!' This divide between Home and School Art, as revealed in the interviews, has already been emphasised, and this student further illustrates her story by describing a particular junior school project:

> But in school it was different. If we had to do a display for the wall we'd get a title like 'The Three Wise Men' or 'Good Friday'. One Christmas we did 'The Twelve Days of Christmas'. We all got put into groups of threes and fours and we had to do a great big picture of one verse. We got 'Seven swans a-swimming' and they virtually told us what to do. It was good actually making it – I mean, there was a lot of glue and tissue paper everywhere but I think it would have been better, I think the styles would have been more different, had they let us do it on our own.

They drew the swan shape for us and we had to stick the bits of rolled up tissue on – it took us hours doing them, we had to stick all these stupid bits of paper on the shape of the swan. They even drew the beak in for us and everything. We had like a bit of black tissue paper for the eye and all the rest was little white bits of tissue paper, and they did the background for us. I suppose the teachers did as much as they could to make it look respectable. I suppose they felt that when we were left to do them on our own they looked a mess. It was good in the end – but they still organised it all for us.

It is revealing to hear such an immediately recognisable standard-type lesson described from the pupil's standpoint, with the accompanying sense of disapproval that she felt would meet her own work which lacked the neatness ensured in the school work through the teacher's control. In the process, adult art becomes identified with 'neatness', and yet children in this age-range can be encouraged to respond to the world in a sensitive and personal way and be led to an understanding and awareness of the many ways in which that world can be interpreted. The underlying motivations which lead children to produce 'imaginative' work at home could so easily be built upon in school through the combination of the provision and use of adequate art and craft stimulus and through an emphasis on the exploration of the natural and man-made world which the pupil inhabits. *Art 7–11* again sets out these relationships:

> Works of art and architecture and designed forms of all kinds can be used to stimulate children's interest and to focus their attention upon visual qualities in the environment. With children in this age range, it is more appropriate to use art and designed forms in this way rather than as a basis for art criticism or as a means of developing good taste and discrimination. Children can learn much about their own use of colour by looking at or being encouraged to talk about paintings. The richness and variety in other artists' work can help to reinforce in children the notion that drawings and paintings can express ideas and opinions as well as record appearance. Discussions about the way in which different artists have dealt with familiar themes can encourage children towards the self-evaluation of their own work. Observation and discussion of works of art and designed forms should be used in this way to heighten children's understanding of their own work and of the problems they encounter and their possible resolution.[16]

Even though the emphasis might be to use the works as stimulus to increase general awareness, many people who have worked with this age-range are aware that the children can be equally responsive to the works in their own right.

Fuller's observation for the need to establish a continuum in art education extending from the nursery stages through to the art school has already been noted. If use of works of art and craft does take place as *Art 7–11* recommends, it is usually applied infrequently or haphazardly and, though children are quite capable of enjoying and accepting a whole breadth and variety of visual arts objects, children can reach adolescence having been led to believe that there is

only one kind of genuine, 'true' art – that which imitates and mirrors the surface appearance of the world exactly and most realistically. The introduction to, and use of, works of art and craft from an early age can help to dispel or expand these types of notions by showing that a variety of diverse approaches are all equally valid. In the process, children can acquire a greater regard for their own work by seeing that the range of styles, viewpoints and responses reflected in what they do is mirrored in the works of mature artists. Such an approach, begun in the primary school but continued into secondary school, could contribute significantly to that establishment of a continuum because, being relevant and beneficial at both these phases of education, it offers the potential of a unifying thread whatever the overall shifts and changes of emphasis and direction. Many of the great works of art can be regularly used without fear of repetition as different layers of significance are revealed at each stage.

Many of the CSAE Project working parties include primary teachers and Bob Clement, the County Art Adviser for Devon, pinpoints four common threads which run through his schools' use of works of art.[17] These are:

1 Study and appraisal
Children's responses, their likes and dislikes, were used as a basis for discussion about reproductions or original loan works. Children naturally drew their favourite works in support of their written comments, often explaining their attraction to the particular work in the process.

2 Drawings made from descriptions of paintings
A number of teachers used oral description as a means to focus attention upon, and encourage detailed description about, works of art, the children then producing their own versions without seeing the original. On completion the children were able to compare their versions with that of the artist, leading to a great deal of discussion about the original, their interest in it having been thoroughly aroused. The diversity of drawn versions likewise made the children question the ways in which different people respond to the same stimulus.·

3 Direct studies from a work of art
This is the aspect which has aroused most argument and controversy. Clement suggests that

> It seems ironic that teachers at both primary and secondary level who are happy to use contemporary and often second-rate images as a major source of visual information for their pupils still ignore the significance of that rich vein of information and comment that is at hand through the study of works of art . . . Younger children in the Primary schools seem to be cheerfully uninhibited in their 'borrowing' from works of art. They enjoy the challenge of making pictures 'like' that painted by a famous artist.

4 Works of art as focus for things seen
By setting up poses and still-life groups based on the works of Seurat, Matisse, Cézanne, Moore, etc., the children were encouraged to observe things in their

immediate environment more sharply through the cross-references with the artists' rendering of similar subject matter. This process was further extended in some cases by the children being able to compare photographs of themselves posing with the figures in the reproduction from which the poses were derived. Works of landscape and cityscape were likewise used to assist the children to see the wider environment from a variety of standpoints. Clement observes that

> The range and quality of response would suggest that using works of art in these various ways helps to extend the children's understanding of what it is possible to achieve within a drawing or painting. They are challenged by the confrontation with a work of art – even when it is only postcard-sized, and in this challenge engage with a greater vocabulary of possibilities.

Many secondary art teachers are inhibited about using works of art because they feel that their knowledge is inadequate. Their non-specialist primary colleagues can feel this more acutely, but in Devon a number of teachers have come to see the benefits to be gained from using works of art and craft in relation to the children's practical needs.

To like a work of art can be as dismissive as to dislike it. In both cases, many children will look, make an instant judgement and move on. It is the teacher's responsibility constructively to engage the pupil in the looking process. There is often an emphasis on the storytelling and narrative content of works with this age-group, but the children can be extremely sensitive to compositional devices and the ways in which colour and shape can be used to evoke mood. On the occasion of Gerd Winner's exhibition at Drumcroon, a group of ten-year-old pupils met the artist and undertook an extensive environmental project, involving them in practical work, based around the Wigan Pier area. Their recorded observations made four months later reveal how receptive they were to the mood and atmosphere of such works as the 1979 *Inside-Outside* screenprints:

> I liked the reflections in the windows. They look like you are looking through the window and you can see outside of it. It looks like snow – like winter. It looks like a graveyard. It's all spooky and all the shadows are cast all over the place. And the grey trees – it looks as though the trees are outside and then you can see these things that are inside and are reflected onto the window. There's all mysterious shapes – one looks like a face with a helmet on. It looks upside down and you can make a picture out of anything by turning it upside down, side-ways or whatever.[18]

They had also been impressed by the five *Catfish Row* etchings of the same year. There were:

> shadows from buildings. That's good because it tells you what's in front of it, like, or behind it – the shadow, like a fire escape but he hasn't put the fire escape in – just caught the shadow . . . He's interested in all the shadow and the writing, the colour, and the shade. It's vandalised, it's all going rusty. There's cracks and the pattern it makes . . . They're all old buildings with a

fire escape up them, or something. [Old buildings] because that's when man has left his marks on it. Where he's been, like . . . They've got crosses on them – they look as if people have sprayed them on – they look as if they've been vandalised. The crosses are there in case they are derelict, in case they want knocking down – crossed out! It's like trees with crosses on, to come down.

These children recall plenty of detail, but are certainly not restricted simply to listing objects, for they are equally sensitive to the mood and symbolism of the works. Of course, they had done extensive research and practical work of their own and discussed Winner's imagery with artist, gallery staff and teachers, but four months later, it is the mood and atmosphere of the works which they so vividly recall.

The environmental project around Wigan Pier involved these ten-year-olds in a study of the town's industry, housing, roads and traffic, people and the changes which have taken place since the Industrial Revolution. Both in their art work and their writing they demonstrate the effect to which primary children, too, can be subjected to heightened environmental awareness. Three short extracts illustrate the point:

Some buildings have been tarnished by the air, they look very arid, silent, and half-demolished . . . Tracks with buildings lumbering over them, windows boarded up because they have no glass. It looks as if bricks have been hurled through most windows. All of the buildings look so sorrowful it seems as though they are dead.

A railway seeks its way through a smoky cloud. Suddenly a train shoots past making a hissing clicking sound. As we walked it was like a never-ending town of houses, factories, warehouses and a labyrinth of roads. The main road was ominous. We went under a dark dismal bridge that carried trains over our heads. Lots of towering shops and buildings surrounded us. Moving under bridges, over bridges, through bridges. Past broken-down factories, warehouses and mills. Iron bars in the lifting equipment were rusty and the water underneath was carrying away the rust.

Buildings at the side of busy roads that seem to hug the clouds and block out my upward view. Blind alleys with buildings looming over them. Alleys small, dark and desolate. Alleys where buildings have been made higgledy piggledy, all shapes and sizes. Ancient stone buildings with towers, brick semis with boards over windows or bricked up.[19]

Having walked through similar townscapes all their lives, these children are now suddenly acutely aware of their surroundings. Observation tinged with feelings of mood and atmosphere are as evocative here as in their remembered descriptions of Winner's work. (The related environmental responses of Julie and Joe to the same artist's work have already been recorded. Winner relates to Lowry in that both make the viewer sensitive to visual qualities in the most banal landscape.) Just as the contact with Winner's imagery had sensitised the

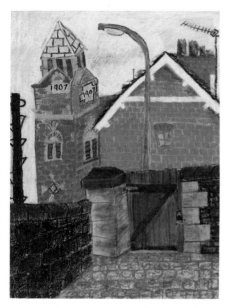

Pupil aged ten, Trencherfield Mill.

Pupil, aged ten,
Industrial
Landscape.

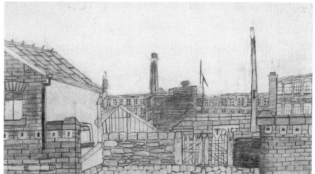

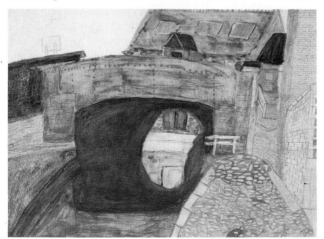

Pupil, aged ten,
Canal Bridge.

pupils to qualities in their urban environment, so that awareness of their immediate surroundings had led them back to further scrutiny of the artist's work. Their first concerns were with his subject matter, but their environmental studies and related practical work, in turn, led to an interest in the formal qualities of his work and a desire to know about his techniques and methods.

Another frequently neglected means of encouraging deeper engagement with art and craft objects is through storytelling. With children of primary school age – but also at the lower secondary level – storytelling can be a most important method whereby they can identify with, and get inside, a work. That the artist can 'reveal us to ourselves' in revealing him or herself is a process which Fry saw as 'an essential part of the aesthetic judgement proper',[20] and this empathy between artist and pupil is illustrated by Karen, an eleven-year-old, in her story called 'Sweet Dreams'. It is based on a screenprint, *Caroline's Cat*, by Martin Leman and was written while the work was on display in her school as an authority schools' loan exhibit:

> As I walked along the beach I could see my tom cat, Sam, sitting proud and satisfied on a bed of damp moss. He looked up at the stormy, dull sky which was occasionally lit up by the twinkling stars. I had never noticed before that my adventurous tom cat was becoming rather plump, he never did bother about anything he was so carefree.
>
> The moon suddenly came out from behind the clouds and lit up Sam's gleaming gree eyes. His snow-white fur and cotton wool front looked cleaner than ever before. I knew now that my contented cat was dreaming lazily of his next adventure.
>
> As I came up to him he purred happily and looked up as if to say 'Good night'. When he did this blue material caught my eye, I then remembered how Sam took his cushion everwhere he went. The calm, silent sea did not crash against the rocks it just slowly crept up to the damp pebbles scattered along the shore.[21]

A beautiful balance is maintained between imaginative response and continual reference to details observed in the print. Few would doubt that the constant examination of and reference to *Caroline's Cat* required in the telling of the story could have failed to establish a sufficiently close affinity with the print for it to have become fixed in her mind's eye for some considerable time afterwards.

That very young children are equally responsive to such intrinsic qualities is

Group work and other cultures (see p. 124).

(Top left) The Japanese print.

(Top right) Having initially refused to participate, a new boy eventually made and added the fish kite.

(Bottom left) The Javanese painting (detail).

(Bottom right) The pigeon made a particularly beautiful additional detail.

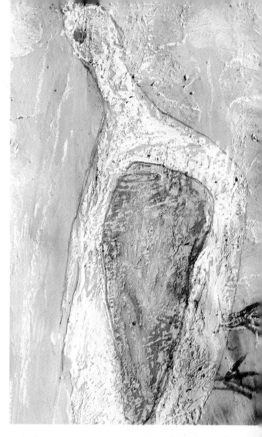

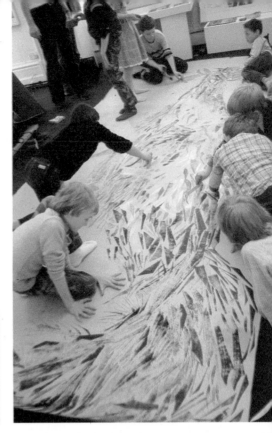
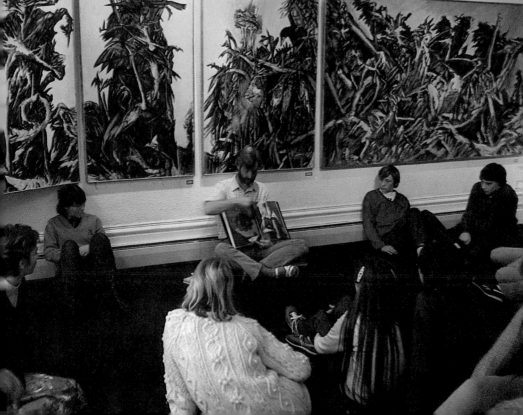

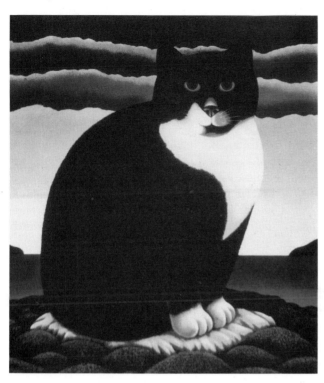

Martin Leman, Caroline's Cat, *screenprint.*

demonstrated by a North Yorkshire infant teacher who used a set of abstract works as her involvement in a project on the use of original works of art (described in Part VI, Section 1(c)), utilising the Wakefield-based collection. Five-year-olds, using the full range of infant school musical instruments, 'played' a Paolozzi screenprint, finding musical equivalents for the lines, gold circles, dark squares, large and small shapes, etc., which make up the design. Their musical composition arose out of extensive discussion as to what was the appropriate instrument, and how it should best be played, to represent a particular shape. Even after they had performed their piece most sucessfully to older pupils, some children were still making suggestions as to how a particular

Drumcroon, an education art centre (see p. 158).

(Top left) A ten-year-old pupil studying the Michael Rothenstein catalogue in the Main Gallery.

(Top right) A giant cockerel being printed by a third-year junior group during the gallery workshop session.

(Bottom) The Gallery Education Officer talking to secondary school pupils during the Robin Bowness 'Ship of Fools' exhibition.

visual effect might be more vividly realised by the use of an alternative instrument.[22]

There are, then, many varied critical studies approaches, appropriate to the needs of primary school children, which can help them engage with the visual arts at quite deep levels. The resulting practice can relate to the work of the artists being studied and also have an important bearing on other areas of the primary school curriculum; the extra insights stimulated by Winner's work gave a far greater depth to the environmental studies/humanities work and the creative writing which flowed from the experience than is usually the case when a pre-determined scheme of work alone determines what is to be undertaken. An added involvement through identification and empathy, allied to study and analysis of the art objects, is the common factor in all the above examples. A further example, involving a similar identification with Munch's *The Scream* allied to the teacher's use of the consequent heightened awareness, is worth studying in greater detail.

(b) People and peoples: *The Scream* by Edvard Munch

Many primary schools build their teaching around a thematic or topic-based approach, and it was out of such a project that a class of first-year junior pupils in a Cheshire school became intrigued by Edvard Munch's painting of *The Cry* or *The Scream*, as its title is alternatively translated. A part-time specialist art teacher taught every afternoon in the school, pushing her trolley of art materials from classroom to classroom. She had worked in the school for some years and was involved in the initial staff discussions about forthcoming projects and themes. A topic of People and Peoples was chosen for one autumn term. 'It was a humanities project to introduce them to different religions and different cultures, showing the backgrounds and effects.'[23] The comparative approach now commonly adopted to make children aware of the variety of religions, and their accompanying attitudes and beliefs, was being extended to enable the children to see also the cultural links. However, it was designed to give the children not only an increased understanding of other people but also of themselves, and different age groups within the school were exploring different aspects of the theme – not only how Icelandic or African peoples lived, but attitudes towards jobs and their availability for various categories of people in this country.

A first-year class had produced sets of drawings of facial expressions. They had observed each other making a variety of faces and discussed the range of expressions and the changes in the features which accompanied them, and how the hands also helped to make a particular expression more explicit. It was arising out of further discussion about how people behave, and particular people, too, that these first years eventually produced a set of figure paintings to do with various jobs – and since these were first-year pupils, the pirate with his parrot on his shoulder featured prominently. The colour in many of these was 'very, very expressive':

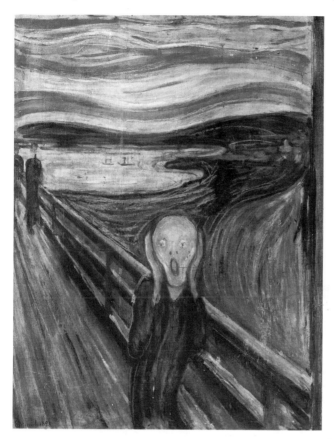

Edvard Munch, The Scream, *1893*.

What they produced in the pirate paintings made me think about the expressive nature of the colour and the vitality and the immediacy of the way they painted, so I thought I must show them Munch's paintings because there is a similarity in the response I get from Munch's paintings and in the response I got from their work. So I showed them the Munch paintings not with a view actually to doing anything from them but really to show them that it had been done before, you know, someone else had travelled the same road – other people had done that and it was valued; to teach them to value their own work.

The teacher brought in her own large book on Munch, and the children found his work fascinating. She would not have specifically drawn their attention to *The Scream* because it triggers off a very emotional response in her, but that was the one the children eventually latched on to:

This seemed to be the one that had got the most interest. They all wanted to know about that one and to spend longer on looking at it, and so on, so it

really chose itself . . . I think they could immediately see – could immediately relate to it – because it's similar to their own work. Similar in structure and similar in some physical way – and it's similar in an immediate impact that it has.

Seeing this painting engendered in the children the desire to produce a related piece of work of their own, and it provoked a lot of discussion: 'We discussed the shapes in the scream and we tried to think why it made us feel like this – whether it was the colours and shapes or whether it was the subject. This figure in the middle was almost like it was a skull!' They had already looked at the way the human face can display varying emotions and the significance of hands, and this process was now taken a stage further in discussing an extreme emotion, rather than the more straightforward examples such as happiness and sadness. The transition from working out why *The Scream* was so horrific and terrible in its impact to a child contorting his or her face into a state of temper or fear was natural and imperceptible. The children then studied the hands and faces of their neighbours as they simulated fear, their focus further sharpened as all the features except for one were covered over in turn so that, for example, 'we looked at how the mouth was pulled back and how the skin was stretched' when somebody screamed or shouted out. When a child achieved a particularly powerful expression, it would be re-enacted for the benefit of the whole class.

> So we did all this and we spent longer, perhaps, on setting it up and talking about it than on the actual drawings themselves. These were produced very quickly and you can see how quickly they were done in the marks that they've made – the drawing was no trouble because it had all been done in the head beforehand. [See facing p. 51.]

Having become so emotionally involved – 'quite terrified looking at each other' – the pupils could not wait to start. Nevertheless, to facilitate the directness which the teacher knew was essential, the class were provided with A2 black paper and used cray-pas so that 'they didn't have the labour of mixing and mixing, they could make it even more immediate so that the response was even more direct'.

The Munch had triggered off this whole aspect of the project, but there was no intention of imitating his painting in which the landscape element is so important. Munch wrote on his 1895 lithographic version of this work: 'The Cry. I felt this great cry throughout Nature', making it clear that the underlying experience expressed in this work relates to nature and landscape, with the 'terrified figure of a woman merely a symbolic expression of it. Panic in nature . . .' observes Otto Benesch.[24] In the event, all the children left the black background of their paper untouched, the whole attention being focused on faces, hair and hands. According to Piaget, 'Child realism, in fact all realism, may be defined as a sort of confusion between the inner and the outer . . . for him nothing is inner and subjective' and the empathetic nature of these studies vividly emphasises this point.[25] The teacher observed that some of the children

had gone back virtually to drawing big-head figures. Others, though, were quite sophisticated in their observations of features and powerful rendering of attitude and gesture. The project in its entirety introduced them to the work of other artists, Henry Moore for example, but it was *The Scream* by Munch which most affected them, and their renderings of terrified figures added to their understanding of how the artist had used expressive shapes and colours to convey a particular emotion, rather than simply render his subject matter realistically.

The work derived from Munch's *The Scream* was but one aspect of a larger project in which the children were not only looking at the lives of themselves, their families, friends and neighbours but were also gaining insights into the attitudes and customs of other peoples and cultures: Henry Moore's work was, in fact, being studied in relation to Eskimo carvings. On some future occasion, a pupil might possibly be led back to the Eskimo carvings by further contact with the work of Henry Moore, or vice versa. Living in a multi-cultural society as we do today, art education can have an important role to play in that it can be a vital means whereby pupils can, at least, gain a glimpse into the traditions and ways of another person, the process maybe leading to an increase in understanding, sympathy and respect. It can equally benefit all pupils by helping them to see that they are part of a larger, diverse community; differences in cultures and traditions are to be enjoyed and there might possibly be constant, universal elements of pattern, colour, order, etc., to be discovered. The next example, though, illustrates how in certain circumstances it can be difficult for a teacher to know just where to begin.

Section 3 Multi-Cultural Issues

(a) Art education in a multi-cultural society
ABDUL, ANDREW, BRETT, DAVID, IFTIKAR, KA-CHIN, KAMALJEET, KELESH, KUMER, MAURICE, RONALD, SHSUSHIL, THAN, THEUNG the boys.

ANGELA, BEVERLEY, FARIDA, FIONA, IVY, JOY, KAMALJIT, MANMOHAN, NARINDER, SUI-LIN . . . the girls.

So reads the class register of a teacher in an inner-city school The majority came from four main feeder schools, several from six others, some came directly from the Language Reception Centre and there were a number of new arrivals. They were city children, with ethnic origins:

. . . from China, Pakistan, Bangladesh, India, Africa, the Caribbean, Poland, the Ukraine, England and Vietnam – North and South. Some born here and some born there. Some with benefits accrued from stable, caring family backgrounds. Some deprived as a result of uncaring unstable family

backgrounds. The superficial difficulty of mastering new names melts away when we start to think about the complexities and the differences brought into the classroom, and if we could coldly apply some mythical multi-cultural art package to respond to these differences – where would we start?[26]

Being aware of individual differences and needs but being sensitive to them, the teacher stresses, requires that one does not go out of the way to emphasise the point as a point of departure – otherwise one certainly runs the risk of fostering racial attitudes. He asks how we start and whose need is the greatest:

Is it the smallest minority or is it the loneliest? Is it the boy from Hanoi? (A double loner because all the other Vietnamese are from Saigon.) Or is it the Bangladeshi girl because the other Muslim girls in the class are Pakistani and nobody is talking to her? Do we start with race or religion? Do we start with ability? Do we start with the average? Do we bore the bright and confuse the less able? Do we start with colour? Do we start with the whites, the blacks, the browns, the half-blacks or the half-whites, depending on where allegiances lie?

He does not think that any of the above are viable starting points because they are all to do with labels, and labels at that which emphasise difference and discrimination.

In order to start, to go deeper, to go below the labels, to help pupils understand cultural diversity and positively respond in appreciation of the richness and the value of multi-culture we have to start on a baseline experience common to all of us – we have to start with ourselves, here and now, together in a school, in a city.

One of his former pupils, Derek, says:

Ever since I can remember, and this is going way back to the early sixties, from being very small I was always very aware of being dark, black, and for a six-year-old it wasn't very pleasant being called 'Darkie' and 'Monkey'. Not just by other kids and other people but by your own brothers and sisters as well, because if you're dark then you're stupid, a fool, and I wasn't stupid, I wasn't a fool – but I was quiet and different. I can remember wanting to be white when I grew up because being black was something bad and awful and in all my dreams I was white and I'd go round in space from planet to planet in my spaceship doing good deeds and rescuing people.[27]

This passage does not only express feelings which are unique to ethnic minorities, it also expresses 'feelings about the individual, feelings all children have, feelings all people have at some stage. Uneducated, these feelings lead to alienation.' The teacher quotes David Best: 'Unless people have learned how to direct their creative energies there will be explosions and violent frustration in some and degeneration into vegetated apathy in others'.[28]

One pupil, a Sikh girl, became desperately unhappy because her ambitions

and aspirations to go to art college as a result of her success in the school were at odds with those of her family. She was not allowed to go on any school visits to art galleries or to London. Her parents were persuaded to attend a presentation, though, at which she received a prize for her work in a competition held for all the authority's inner-city high schools, and they saw her work, appreciated what an honour this was, and so a lucky accident led to her eventually going to art college. The story illustrates, though, that the art teacher's emphasis on the benefits of expression of personal feelings can be at variance with the practices of certain cultures while equally emphasising the value of the arts for the individual pupil in this context. Given the composition of his classes, it would be ludicrous to attempt to devise a course which attempted to focus in equal measure on the cultural backgrounds of all the class pupils – even if the teacher had the capability. His drama colleague in the school poses the question: 'How much knowledge and awareness does the common-or-garden arts teacher possess about such diverse cultural backgrounds, each with its own intricate and distinctive politico-historical and cultural heritage? Most of us, I suspect, would admit to being poorly informed, even disorientated, about our own Angloid heritage.'[29] He says that it may be perfectly valid in the RE lesson to explore and dramatise passages from the Bhagavad Gita 'but as a means of evoking expressive response in a drama session could leave Muslims frigid, West Indians unmoved, whites untouched, etc.'. He emphasises the importance of the individual as an individual, and the arts have a unique role in this respect:

> Shaheen Malik is not Kenyan-Asian, she is Shaheen Malik. Junior Anderson is not West Indian, he is Junior Anderson. The individuality of persons, and the uniqueness of the groups in which they find themselves, needs to be recognised. In practical terms we need to ensure that our classrooms are perceived by pupils as non-threatening environments in which an openness to change can be fostered and in which their attempts to control expressive media are known to be valued whatever the level, or lack, of expertise. I HOLD THAT THE PEDAGOGICAL ISSUES OF CREATING A CLIMATE OF TRUST, SECURITY AND SELF-DISCIPLINE SO THAT AUTHENTIC EXPRESSION BY PUPILS MAY TAKE PLACE ARE MUCH THE SAME WHATEVER THE CONTEXT.

In the art room, therefore, the teacher felt that he was involved in the same basic issues as those which concern most art teachers, whether in a multi-cultural or a mono-cultural school, with the bonus that

> The joy of being in a multi-cultural school is that, as a teacher, the visual reminder is there, it's heightened all the time. There are children with different modes of dress and racial characteristics, there are the different coloured skins, and so forth. So you are constantly aware of individual differences. How many others forget the differences and needs the individual child may bring to us in mono-cultural schools?

To meet the consequent individual needs, he feels that it was through

extra-curricular activities and through community work that the full richness of multi-culture began to come through and find natural expression. He feels that he learned a lot from the school's International Evening, and he refutes the objection sometimes made that events of this kind are merely token gestures. The pupils helped in their organisation, produced decorative pieces of works related to their mosques and temples and contributed ideas about what was visually interesting within their own culture. The evenings were, in fact, celebrations at which people shared in each others' backgrounds 'through food, through dance, through the visual arts' in a festival atmosphere. He believes that these evenings contributed significantly to greater sympathies being formed through mutual understanding.

It was likewise at a lunchtime art club that an Asian girl came up to him and said, 'You know that silkscreen printing that Freda's doing over there, can you do that on cloth?' She was informed that this could be done, but the school used paper because of the capitation restraints. 'Can I do a sari?' She was told that of course she could:

> . . . and so this is where it is the child coming up to you and making a demand on you with confidence gained through the working atmosphere. In comes a bolt of cloth the next week and Kamaljit does some drawings and says, 'Look, there's a design here. I'll make a screenprint. I can make my own sari.' When you've got a class of twenty-five you can't set it all up for a sari session but at lunchtime, then you've got a girl making a sari. Then in comes another child and says, 'Who's doing that, Sir?' and you say 'It's one of the fourth-year girls,' so therefore something else follows on from that and before you know where you are . . .

The way in which multi-cultural issues in education have sometimes been presented has led to some teachers feeling that the skills which they already possess are of no consequence; they have to start all over again from scratch. The process outlined above, though, is one that recurs throughout this book and is a chain response to the children's interest in each others' work, then modified to meet an individual's needs. Many teachers skilfully encourage this process to increase understanding through the cross-fertilisation of ideas.

The example is in marked contrast to another which the teacher cites against himself, recalled in conversation by one of his sixth-formers. In talking about his experiences in the art department he reminded his teacher of when he had tried to wheedle out of the boy what he knew with regard to his own cultural heritage in terms of the visual arts:

> It wasn't me applying my knowledge to say reading a book on art, it was me trying to get him to tell me and he did me a painting of a statuette, the dancer with the arms coming out, and when he had done it he virtually said, 'There you are Sir, this is my painting of Shiva. Now can I get on with my own work?' because Van Gogh, to this lad, was the way paint was put on and was the way he wanted to paint.

The boy recalled that he loved working in the art department and it was seeing an older lad's paintings that had initially inspired him and he had thought, 'That is fantastic. I want to be able to paint like that!' This had been the trigger that had led to him feeling a closer affinity for Van Gogh than for the Shiva. The example pinpoints the ambivalent attitudes which can exist within any group in the multi-cultural school, emphasising the need to treat the art department as a place where individual needs and requirements can be met.

It is interesting to relate this emphasis on the importance of extra-curricular activities to the observations by the black head teacher of a primary school, who recalls his own education in a Luton school:

> I was very fortunate in my education because I felt really that the interest that the teachers actually paid to me outside of the classroom was very important. This happened in various ways. For instance we found that with this group of teachers that were at Luton, they involved us in things like the choir, both in and out of school, artwork and productions. They always worked alongside us and we were frequently invited to their homes. At school they would pay other forms of attention, not only to the child who came from another country but also to the interested child of this very country, and what I felt happened then was that there was always an unconscious guidance that they were giving.[30]

There was a naturalness about these extra activities 'so that what then went on in the classroom was equally natural': 'It never seemed forced because frequently the things that started in the classroom went outside it and then came back into the curriculum. In other words, there was a constant feeding of both sides.'

Throughout this book, the reader will note a number of references by art teachers to the importance of this extra-curricular work and how it feeds back into and revitalises timetabled lessons. Many art teachers accept the timetabled provisions of time as a necessary evil, but one which is particularly unnatural to the teaching of their subject. The extra provision which these art teachers make frequently begins to meet some of the same needs which are the underlying motivations for much Home Art. The specific skills of the art teacher allied to the multiplicity of individual needs which the children bring to the art room are as relevant here as in any other school context. Obviously the issues are vast and complex and, having worked in a multi-cultural inner-city school, this art teacher believes that: 'What we need here is a massive in-service programme with leaders of ethnic communities taking part in this programme to discuss and to share with each other the differences.' This would be an important development, and there have already been a number of area initiatives with information to contribute. The Birmingham-based *Changing Traditions* and Ethnographic Resources for Art Education have already made an important contribution.[31] It is also noted with interest that a project called AIMS (Art and Design in a Multi-cultural Society) is being established in Leicestershire under the auspices of the Centre for Postgraduate Studies in Education at Leicester

Polytechnic with the support of the Leicestershire Education Authority.[32] The AIMS project is initially planned to run for three years and will include a considerable amount of work in schools and the local community. It has been established 'to consider how art and design education can contribute to the ways young people in schools can be helped to understand, practise and enjoy the art and design forms of their own and other cultures' and it 'will seek to learn from the different cultural groups in the city and county about the nature, significance and meaning of their own distinctive visual images as well as about their attitudes and hopes for cultural identity, development and tradition.' A newsletter will be published periodically, and many teachers will look forward to what emerges with anticipation, given that a research and co-ordinating project of this nature is long overdue.

(b) Group work and other cultures

Many children, of course, are still taught in essentially mono-cultural schools but will nevertheless lead their lives in a multi-cultural society. The school therefore still has an important role to play in this respect. One deputy headteacher in a South-East primary school was responsible for her children producing a series of exceptional group works, often painted but sometimes printed.

Silverman attaches considerable significance to the role of art in its contribution to social education and says that

> . . . it is necessary to provide experiences which have been specifically organised to develop abilities for acquiring and applying knowledge while learning to be skilful at such tasks as abiding by consensus of opinion, respecting the rights of others, and, most importantly, retaining one's own identity when faced with pressures for social conformity. When the educator structures such learning experiences he is expressing a concern for social education.[33]

These aims are fully in accord with this teacher's intentions in relation to group work, which she sees as being not dissimilar to the interactions which are worked out through drama: 'I suppose it's like producing a play – a very similar sort of thing. If people have to work together they have to work out their differences',[34] and

> Although large group pictures can be an end in themselves they seem to me to have a wider social and educational value. They should be a record, or at least an indication, that a study-in-depth has been made by a group of children working together with interest and involvement. It is doubly satisfying when the involvement and co-operation necessary has contributed towards an attainment of artistic merit.'

As is often the case, a coherent personal philosophy evolved out of what was initially a teaching device to deal with a particular problem which confronted this teacher. She had a class of twenty-three girls – mostly very backward and

with a record of very bad, unco-operative behaviour. One child who was ESN and came from a children's home was greatly disparaged by the other children so it was necessary to do something that would bring them together as a class. It was decided that painting a large group picture depicting the excitement of Christmas might be the necessary incentive to boost their collective morale. Happily this proved successful as children from other classes became interested in the project too and their admiration and interest was the source of much satisfaction contributing to a successful outcome. The educational and social benefits were apparent and not lost on their teacher.

As has already been noted, much of the potential of group work is often dissipated because of a lack of confidence in the children on the part of the teacher who, as a consequence, might draw outlines for the children to fill in, give each child a regular shape within the whole to work on, or get the boy or girl who can 'draw' to be in charge, the others demoted to being technical assistants. It might be this which has led to a noticeable decline in this kind of work being undertaken.

A more fluid and complex working approach has to evolve in the classroom. The first principle is that the children should not come to the work 'cold':

> Group work has to be preceded by class discussion, observation and some preliminary individual work to get ideas flowing . . . Ideally group pictures should grow from other work that the children are doing, become a compound of their ideas, a pictorial record of their collective knowledge, even perhaps a poetic expression of their own attitudes and feelings.

Often a school holiday caused the termination of the work, rather than it being 'finished' in a conventional sense, but individual children would frequently be most particular about fully resolving a specific area. One such work could easily take a whole term to develop.

Arising out of this democratic framework the children worked at their respective levels – for all ranges of ability and stages of development were apparent in the completed work – with great intensity.

> This kind of picture can rarely be completed in a hurry. At every stage there should be thought and discussion. It is impossible for children to produce work of any depth, unless they have sufficient background material from which to draw their inspiration and capture their imagination. It does not matter from where the inspiration comes: a poem, a story, an historical event; a geographical, anthropological or mathematical study; all these have potential, provided the teacher is aware of it and has the confidence to allow the children to retain their own vision.

Though the whole class would participate, the number working on a picture at any given time would rarely exceed six. With the work usually situated on the back wall of the classroom, the children really got to know it by living with it on a daily basis. The teacher accepted that two or three fallow days, on occasions, were a natural time for contemplation and appraisal by the children; casual

discussions – sometimes arguments – among the children were as important as the whole class talking and discussing.

At the commencement of a project, decisions were made about the most appropriate backing paper to use – choice being limited to what was available in school – the size of the picture and its probable composition.

> If possible the picture should be large enough for the children to paint life-size figures. This will allow enough space for every child to do some work of their own. They may permit other children to stray into their space to help them or extend part of their drawing, but they should be given the privilege of insisting that no one should invade their territory. Indeed no one should be allowed to paint on someone else's part of the picture without permission from the owner. This is very good training and should be insisted upon by the teacher.

The placing of the various characters in the picture having already been decided by initial discussion a child would work on the character he or she had developed with, for example, a friend working on the surrounding area, a sympathetic background being as important as the figure itself.

> The initial layout of the picture can be done with charcoal or chalk. Pencil is not generally a good idea, as the work tends to get too fiddly. If the children wish to work in pairs, or in groups of three or four on one particular part of the picture, so much the better. Any disagreement can be settled by discussion and if necessary a vote taken by the children. All children need practice in making decisions, even if, at times, these seem to the teacher to be the wrong ones. The opportunity to make their own mistakes and to feel free to reject the teacher's ideas and/or suggestions helps the children grow in confidence. This attitude does not of course mean offering the children licence to do just as they like, regardless of the consequences to others. It does mean presenting children with a choice of actions commensurate with their individual abilities and maturity, within a situation where they feel secure.

The level of involvement was normally extraordinarily high and sustained over long periods:

> When fine detail creeps into a picture or a piece of written or dramatic work, it is a sure sign that the children are becoming deeply involved, and are in a relaxed and receptive mood. Care should be taken to maintain this atmosphere and use it constructively. Another indication of involvement is the repainting of certain parts of the picture. Children should be allowed to do this even if the teacher fears the work will be spoiled. In such a situation it helps to remember that it is the involvement that matters more than the finished product. Strange as it may seem, pictures are rarely spoilt by this overworking. More paintings have been ruined by the teacher taking up the brush in execution.

As the children worked into the first layers of paint, sometimes painting over

but often drawing with cray-pas, an extraordinary richness and ordering of colour developed:

> Children who are never encouraged to look for themselves at the objects they paint will tend to paint only in clichés. 'Brown-from-the-pot-tree-trunks', or 'green-from-the-pot-grass' are examples everyone will recognise. There is an abundance of colour, light and form, whatever the school environment, for the children to investigate creatively, and translate in their own terms. This investigation should be as scientific as the teacher is capable of making it. Oral, written and pictorial observations are of equal importance. Learning to make accurate observations is a fundamental part of the learning process and their importance cannot be over-emphasised.

On completion, the painting would be carefully and attractively displayed in the school hall or on a large expanse of wall opposite the main school entrance, often supported by the accompanying individual pieces of painting, print or ceramics and written work:

> It matters not that a whole term may be spent on one picture. As long as the children are involved their interest will be sustained. The development of their written work should be related to their painting; the development of the painting to their written work. Both can, and should, be related to their reading . . . They are a source of pride and satisfaction to all, for the completeness of the whole has only been possible because of each child's contribution. Everyone, therefore, is valued and feels accepted because of it.

Many teachers claim that the social benefits which accrue from their work are an essential aspect of arts teaching but Silverman emphasises that, in fact, if the teacher has a real concern in this respect the learning experiences have to be accordingly structured to facilitate this end.[35] This teacher's work was so structured, with no short-cuts taken; the children often became engrossed in their specific tasks but were always conscious that they were contributing to a larger whole made up of all their colleagues' work. Though two friends might naturally work together, children from varying home circumstances and backgrounds came to understandings and reached agreement in ways which would not have taken place if each had been working on individual things or if the group work had been over-structured by the teacher.

Much of this teacher's methods involved the children in close, direct observation and the study of their immediate environment but she felt that it was equally necessary for the children to know that there was a world outside – in an age when children can see things on television that happen on the other side of the world, they cannot be shut off from what is happening anyway:

> I feel strongly about the necessity for children to understand that whatever the nationality or religion, the saying, 'If I cut you, you bleed', holds good. There's a tremendous amount of prejudice about still . . . and I think the only way we're going to overcome this is to get children somehow or another to

realise that people are people and it doesn't matter where they come from – they might be different in their approach to life, they might have different religions, they might have different ways of using a knife and fork, wield chopsticks or use their fingers – but they're still people with feelings, with ideas and attitudes to be respected.

She sees this as an essential aspect of education but is aware that whatever is achieved within the school is likely to be nullified by the counter-attitudes to which the children are also subjected and she wouldn't pretend to gauge whether anything had been achieved or not. Nevertheless, another reason for the figures being life-size in the group paintings is that, when painting the panel to do with the Javanese for example, the children are simultaneously painting the figure which they are representing and themselves: 'When an artist paints a portrait of someone else there is always something of the artist in that picture anyway. The children are that size – that's their size – and it's quite good for them to see their own size on a painting. That size is to do with identification, isn't it?'

The social value of children working together was undeniable but another aspect, equally important, now emerged: the child's identification and involvement with the character portrayed. An incident concerning a five-year-old was of particular significance to the teacher, enabling her to recognise 'what was going on at an imaginative level'. A large coloured photograph of an astronaut walking on the moon with a beautiful blue earth in the background was displayed on the classroom wall. Its caption read: 'The astronaut walked and walked and what did he see?' The teacher asked Robert what the astronaut saw and he replied that he saw the moon. 'Where do you see the moon?' asked the teacher. He pointed beneath the astronaut's feet and the teacher asked what else he saw. At this point Robert appeared to be very frightened:

> He, with his friends, had been playing at being astronauts so he was already sensitive to the idea of space and its loneliness. My question, 'What does the astronaut see from the moon?' must have jolted him momentarily into empathy with the astronaut, to be alone, insecure on a dead planet looking at his far world. Robert had gone to the moon . . . he came down to earth almost immediately but that fleeting instant of empathy did emphasise for me the depth of involvement reached by children as a result of creative play and discussion. I think we do not often recognise this when it happens in the classroom, its power, or its importance in a child's development.

When the children were painting their life-size figures, then, the teacher was now aware that 'they are simultaneously on the moon and here!', with the two elements of mutual co-operation and empathy seen as important factors in each successive piece. Her convictions crystallised through the process of doing such work over a period of time rather than working this way initially because of a ready-made set of beliefs. Three of the panels illustrate the fusion of these two elements particularly well.

The Javanese (See facing p. 114)

Initially this project was based on a music and movement theme. Javanese gong music was chosen because of its beautiful sound; also it was intended to give the children an evocative and different musical experience.

> We did a lot of movement to the music and then we started to talk about that country, the area of the world that that music had come from. It arose quite by chance – it's funny how these things happen – that a girl who was in school as part of her university course came into my class to do some observation. Her sister had been learning some Javanese dances and so she came in one day and did the Candle Dance for the children, wearing her Javanese costume.

This experience stimulated everybody to start hunting around for books on Java. There was very little material available unfortunately but enough for the children to find out about the vegetation, the animals, the kind of a country it was, the way the people lived.

The resulting group painting was of a Javanese market stall. An upright picture, it depicted families getting their fruit and vegetables, so the foreground was of tables laden with bananas, mangoes and all the various fruits and vegetables they discovered were grown in Java. Over the weeks, as more and more information came to light, indigenous birds and insects were all incorporated into the painting, after careful consideration over their placing. 'That's why the pictures take so long to do . . . so it doesn't seem to be out of the way to have a picture on the wall for a whole term.' As these additional details were grafted on, the picture surface became richer and some pupils, as part of their studies, individually produced batiks using dye on cloth, and some beautiful areas of pattern were introduced into the painting as particular figures' dresses were enlivened with batik patterns. Two particularly exciting discoveries, both of which surprised the children, were that the wood pigeon and the cabbage white butterfly were to be found in Java. A stuffed bird from the local museum and a pinned specimen of a cabbage white provided the models from which two particularly beautiful details were added to the work.

This teacher would never paint on a child's picture, feeling that to mix, for example, flesh colour for a child is a counter-productive short cut, but

> What I would explain to them, for example, was the way to mix up various skin colours. I would show them the different paints it was possible to use, get them to experiment with different combinations, match their own skin colour, look at shadows and the way these defined features . . . there is another aspect to this colour mixing – that of judging the quantity needed for a particular job – 'Do we need a litre to paint a centimetre square?' I would sometimes have to ask!

They would be encouraged to experiment so as to get the colour that they were seeing inside their head, 'because, after all, that's the only way they're going to learn'. In consequence, a wide range of flesh colours were used in the picture. Likewise, there was evidence of many different stages of development in the

Group work, third-year junior, Tribesmen of the Kalahari *(detail).*

rendering of the figures, quite immature images juxtaposed with much more
sophisticated ones. Far from detracting from the whole the various figures
naturally took their place in a painting which was fascinating in its detail but
which added up to a cohesive whole, the various colour variations similarly
giving an extra subtlety and complexity to the work of these nine-year-old
pupils.

The tribesmen of the Kalahari
A third-year group of ten-year-olds produced the painting of the tribesmen of
the Kalahari Desert, though the teacher had not intended this to be a project
initially. She had read to the class some extracts from a book (the author had
lived amongst the tribesmen for a year) so it was a very accurate and fascinating
description of what they had had to do to survive. The children really
understood and sympathised with the hard life that these people lived. She had
used the book because 'I feel very deeply about the way perfectly good cultures
are being destroyed. It is happening all over. They are being destroyed by the

Drumcroon, an education art centre (Degen workshops) (see p. 161).

(Top left) Degen wearing his Banner *on his visit to Drumcroon.*

(Top right) Degen making an adjustment to Yvonne's War Banner.

(Bottom left) A ten-year-old wearing an elaborate Personal Environment.

(Bottom right) A junior pupil wearing his smaller-scale adornment piece.

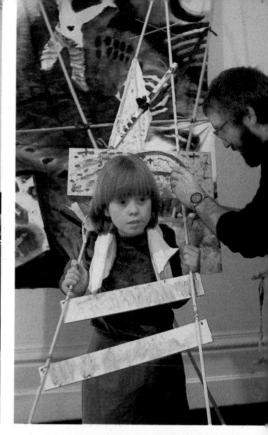

way we are using our Earth. Children need to know what is happening and hopefully, since they are our future, try to do better.' The children understood that even while this project took place, things were changing for the hunter-gatherers. The tribesmen's old ways of life, so enthralling to the class, were rapidly changing to a more settled existence. This knowledge helped develop the project and the resulting large-scale group panel was as anthropologically accurate as a group of third-year juniors could reasonably be expected to achieve. 'It was really a record of what they had learned because everything in the picture was as accurate as they could make it. We researched on the sorts of plants, animals and insects, and various things that were around, and the kind of scenery – the geography of the area.' Having lived in South Africa for some years, the teacher could add something from her own experience. She had seen a number of cave paintings there: 'We found out how these were made and so some of the picture was done using the same materials; the charcoal, the chalk and the animal fat and clay – but we had to use some poster paints.' The children found an extremely wide range of clays – yellow ochres, slate greys, dull reds and browns – and these were mixed with animal fat which the children cadged from the local butcher to provide the main range of earth colours which characterised this painting. Some bright notes were provided by berry juices and by the chains of real beads which the children added to the central figures. These were selected from a wide range brought in by the children, and were chosen to resemble most closely those used by the tribesmen. This work was one of subdued colour harmonies heightened by small bright notes of colour and the bold, vigorous handling of large areas contrasted with the refined drawing of figures and background animals. The demanding background research belied the initial impression of it being just a spontaneous, imaginative work by ten-year-old children – executed almost entirely out of home-made art materials.

The Japanese (See facing p. 114)

The teacher's preparation was always thorough, and she conducted her research for the Japanese project during her summer holidays prior to becoming the teacher of a fourth-year class. In contrast to Java, there is a wealth of material about Japan and she acquired an impressive array of books from her own home and from the county and local libraries. There were numerous books on Japanese art and folk lore; posters and reproductions were displayed around the classroom and these had a pronounced effect on the children, influencing the

The practical use of loan material (see p. 185).

(Top) Bonnard's work provided the initial impetus for a group of still-life paintings in the second phase of the project.

(Bottom) The teacher approached the next project, dealing with the figure, in a similar manner and the resulting work was commensurate in quality and interest (details).

choice of materials and processes used in their resulting group picture:

> We printed it because we had been looking at the Japanese prints and
> woodcuts. There seems to be a lot of light and air – a sort of mysticism – in
> Japanese pictures and they must have felt some of that, too, because of their
> choice of doing it on coloured tissue paper rather than perhaps on sugar
> paper. It gave that feeling of lightness to it . . . They weren't just pictures I
> think. They very often record their feelings about the subject as well as
> making a plain statement.

The tissue paper was worked over a large piece of plastic sheeting, and when
completed and dry, it easily separated from this backing. The classroom wall
looked attractive from the outset because a group of children used a variety of
red, blue, purple and green sheets of tissue paper for the base, and these being
transparent additional colours formed where they overlapped, giving the effect
of a ten foot by six luminous abstract picture. The basic colours of figures and
costumes were established by additional layers of tissue paper being added and
then everything else was printed.

Print-stamping blocks were made out of lino mounted on small bases of wood
and from these, many of them intricately decorative, patterns on dresses,
necklaces, leaves and orange blossoms were depicted, the same block sometimes
used many times to great effect. Other important passages, such as clusters of
peony flower heads and plants, were screenprinted using paper cut-out stencils.
One child made a rectangular lino block, cut so as to resemble fur, and he then
printed an area of this texture on to separate paper, cut out a dog, and stuck it
onto the large print.

I witnessed the development of a number of these group works, but the only
child I ever saw opt out was a new boy who said that he did not want to
participate in the Japanese print:

> It was very unusual because normally there was a great clamour to do things.
> He wanted to be part of it eventually and the only way he could think of
> coming back in again was by adding a fish kite. I think it was a statement of
> his own individuality, really, because the kite was done separately and stuck
> on afterwards.

The kite was stuck on at the top corner of the group print, and attached by
string to the hand of a black-suited Japanese boy to indicate that it was being
flown by him. Before making the kite the boy had first carefully observed and
made sketched notes of a particular fish in the school tank. Working on his desk
top, he made the fish and printed its scales from one simple block.

The completed work was refined and elegant and full of light. Clear pink,
green and purple colours and the notes of white blossom gave an impression of
freshness and clarity heightened by the original selection of tissue paper.

This work and the supporting visual material created such an evocative mood
that a pupil from another class, attending an art club, produced a screenprint on
tissue paper of two birds in flight; the oriental flavour was quite uncanny.

The mutual co-operation and sense of responsibility which developed in the children engaged in these group panels was unmistakeable, and the resulting works – of great impact – were an obvious source of satisfaction and achievement to the whole class. The teacher's belief that it is essential for children to look beyond their own immediate environment to the lives, traditions and values, and circumstances of other peoples was put into practice in a vital and enriching manner – but she would not claim that the values engendered were lasting ones. There is only so much that any one primary class teacher can do in a year and, invaluable though these learning experiences obviously were, they need to be further substantiated and built upon at the next stage – and throughout schooling – for any lasting benefits to be achieved.

Though critical studies approaches might be generally applied in a haphazard manner in the primary school, group projects like those above are typical of the best work undertaken at this stage, utilising to the full all the benefits of the more flexible primary school day. In the secondary school, the timetabled separation of cultural studies undertaken in, for example, humanities lessons from any use which might be made of those cultures' forms in the art lesson is usually fatal; one subject area frequently resorts to teaching the learnable facts while the other reduces essential qualities to the level of exercises. The empathy for, and identification with, the peoples being studied through a natural fusion of the two aspects ensures that these group projects are an intriguing model.

An essential aspect of the Japanese project was a visit to the Victoria and Albert Mueum to see Japanese prints in the original; the importance of seeing works in the original, as well as in reproduction form, has already been fully established in the students' testimonies. The partnership between gallery and education services is, therefore, a vital one to which further attention must be paid.

Conclusion

The findings in this Part can be summed up briefly. Critical studies are crucial and possible irrespective of age, intelligence or background. They are appropriate for the least able, significant for young children at a particularly telling stage of their development, relevant and applicable to pupils of completely varied cultural backgrounds.

Critical studies can do much to allow the majority to gain 'possession' of the arts, to assist primary school children in making sense of the inner and outer world, to generate sympathy with other peoples and to go beyond superficial cultural differences to provide common experiences and enthusiasms.

The Part, as a whole, brings together an immensely wide variety of critical studies models, many of which arise from the practical and feed back into it. The message for the teacher is that critical studies is a general approach with a diversity of possible models that can be applied in different combinations and modified to meet children's needs.

Part V
Going Outside the Classroom

Section 1 Gallery and Workshop Practice
Serving as an introduction to Part V, Section 1 makes some general points about the nature and function of education practice in galleries and art museums. The author indicates factors essential to ensure effectiveness and stresses the complementarity of school and gallery work. Comments are illustrated by the use of a case study featuring educational activities in a large provincial gallery. Finally, the author draws out from problems and difficulties encountered further suggestions on teaching methods and teacher attitudes.

Section 2 Combined Gallery and School Approaches
The two case studies which form this section are put forward as graphic illustrations of integrated school and gallery practice. The first is a joint venture between a town art gallery and a local education authority spearheaded by the research and inspiration of a seconded head of art. Its importance arises from the richness of approaches and the energy applied in preparation. The second case study, of a new town gallery, shows how a liaison structure was conceived and what type of projects developed. In both cases, the author analyses why each was successful.

Section 3 The Role of the Education Art Centre
The section describes two educational centres which offer different kinds of opportunity to schools in their authorities. Drumcroon Education Art Centre, the first of these, has served as a base for the CSAE Project and so could be expected to exemplify the positive aspects of critical studies covered in this book. The philosophy and types of provision are outlined and a particular project described to illustrate the inter-weaving of centre and school work. The second centre hosts residential courses of an intensive kind. The author concentrates on a specific series of courses, pinpointing the contribution both such a centre and means of teaching can make. Parallels are drawn between this and possible practice in schools.

Section 1 Gallery and Workshop Practice

If you are going to take children a long way to the art gallery, if you are going

to disrupt timetables, I think it has got to be an experience that they'll remember – something that is valuable to them, something which they can recall with some pleasure and feel that they really have made some breakthrough in their perception of art works. It's taking children to an art gallery for the first time that really is of great importance – and it can often be quite disastrous.[1]

Head of a Secondary Art Department

This head of an art department has been taking his pupils on art gallery visits for a number of years. He obviously attaches considerable importance to these visits, and yet on occasions he is aware that the experience has been aversive for his pupils when he could legitimately feel that he had taken the necessary steps on his part to make the visit a success. Sometimes, he says, 'the whole system has broken down because someone [the gallery lecturer] hasn't been there at the right time or a party of children from another school who haven't booked in come whizzing through the Surrealist Gallery and the lecturer is drowned out completely.' He regularly takes his pupils to the Tate and is very appreciative of the service he has received there but, inevitably, because of the tremendous demands on the gallery staff, 'at the end of the hour you are away from the lecturer'.

While seconded from his post, he therefore chose 'to look at the way in which art education and art museums worked together'. As part of his researches he says that he observed practical workshops in which there had been no preliminary contact with the schools involved, other than that necessary to facilitate the advertising and booking processes. He did observe situations where only one group a day was booked into a gallery, but closer examination revealed a great deal of talking 'mostly emanating from the lecturer rather than the children' with 'quite a lot of physical and conceptual distance between the two parties'. Again, these visits were not preceded by preparatory work and when he spoke to the teachers they informed him that they did not anticipate doing any follow-up work on their return to school.

He stresses the importance of that first gallery visit, and this book records many positive responses – some from children who were reluctant visitors expecting to be bored. Bourdieu's researches reveal that museums are associated most closely with churches in many peoples' minds, the association varying according to social class – but rising to 66 per cent of manual workers.[2] Many galleries and museums date from the nineteenth century and were specifically designed to emphasise this link, buildings deliberately incorporating architectural features reminiscent of churches and classical temples. It was part of an aim to arouse in the visitor a sense of awe – and hence respect for the art works on display. The fact that exhibits must not be touched, often underlined by uniformed attendants who can carry out their duties in an authoritarian manner, affirms the sanctity of the gallery and the feeling that the conservation of its priceless treasures – what Berger terms 'holy relics' – must over-ride such immediate ones as participation and enjoyment. Children, through their

ignorance of gallery 'rules', often become the obvious targets in this safeguarding process, and many of the critical studies teachers' meetings have revealed their crop of 'horror stories' in relation to the treatment of pupils – and on occasions teachers themselves – when gallery visiting. (These are equalled, though, by gallery staff who express concern about uninterested children 'dumped' on them by teachers who have done nothing to prepare their pupils for the visit.)

Nevertheless, it is important to emphasise that a quarter of a century ago galleries did not offer education services and a typical day spent in a major gallery today reveals far more contact with children than was the case then. Many galleries have made efforts to take account of their educational role and to accommodate children, accompanied by the appointment of increasing numbers of education officers – in the present financial climate, too many of them admittedly only funded on temporary twelve-month posts. One of the problems confronting the busy gallery is that of what kind of contact is possible. The use of worksheets has proved to be of limited worth where they have been devised to encourage children to use the gallery in a completely independent manner; many worksheet questions of this kind have sought to keep children occupied but have failed to lead them to a broader understanding or contemplation of the works in question. Likewise, many galleries have on occasions produced admirable tape-slide sequences, but without the necessary personal contacts to substantiate the points made, their content often remains of a factual 'out-there' type.

The necessity for this essential personal contact has ensured the continuation of gallery lecture services, in spite of the reservations expressed by some teachers about them relating to the transmission of a set body of knowledge to do with the chosen works. Many schools and colleges making regular visits to galleries pay the warmest tribute to gallery staff whose detailed and pertinent knowledge of particular works they respect – particularly when it is transmitted by an obvious enthusiast. Gallery guides come to know and look forward to working with teachers and students from particular 'regular' institutions and become aware of just what demands they can reasonably make upon the groups in consequence. Though there is now considerable emphasis on group participation, as opposed to the lecturer giving out from his or her knowledge, great sensitivity is needed when dealing with adolescent students who are naturally shy and reticent – though the problem can sometimes be of a reverse nature. A number of teachers have talked to me about the day which the National Gallery held in 1983 for the benefit of schools outside the London area. They expressed admiration at observing other professionals working with expertise in their particular field. The morning having been concerned with basic organisational matters and data about the nature of the education service, due stress being laid upon the fact that the gallery will tailor its services to the requirements of the school, the afternoon work took place in the galleries:

We were all teachers that were there and the thing we found extremely

valuable was that they then took us to see the gallery staff in action, demonstrating a talk to a group of children that had booked for that day, and it was absolutely superb. They had a very, very uncommitted group of children who had obviously not come to enjoy themselves and they made that abundantly clear. Within a quarter of an hour those children were absolutely fascinated. They had them modelling the poses of the painting that they were looking at, drawing from it, and the general discussion was at that age-group's way of talking. That was the thing that was so good – they could bring themselves into discussing it at fourth-year level.[3]

The painting in question was *The Martyrdom of St Sebastian* by Pollaiuolo which the teacher felt might have seemed

> . . . the most inappropriate painting for a fourth-year group of initially uninterested children and yet at the end they were loving it – couldn't go away – and that was most impressive. We saw two or three examples with similar reactions with different groups of children and I would certainly want to go back and take my pupils to the National.

This teacher's testimony illustrates the importance to the classroom teacher of knowing that the gallery staff have an inside knowledge and expertise which is *complementary* to their own and which is therefore going to further their children's awareness of particular works in a memorable way through contact with a committed and informed specialist. Good gallery practice arises out of a partnership and through understanding between teacher and gallery lecturer. Of course, the word 'lecturer' is a loaded one and what the teacher has described in relation to the Pollaiuolo extends well beyond the kind of talking at pupils which has already been noted, and comes close to a fusion between lecture and workshop activities consciously designed to make the pupils into active participants rather than passive recipients. The significance of drawing to aid looking is well understood by Renée Marcousé, talking about children's use of museums:

> The requirement, that 'they look carefully', is not only the most important, but is also the most difficult to achieve. In our experience this is done best by sketching; the children are required to choose from among the objects related to their theme any that they prefer, and to make notes about them in the form of charcoal or pencil sketches. The selection of one exhibit in preference to another is already a step towards visual awareness. It is not a question of how well they draw; the drawings may be quite slight, even some detail which has interested them. The aim is to give them an opportunity to stand and stare, to become aware of forms and colours of which otherwise they are but dimly conscious; for these aesthetic impressions are difficult to define and as personal to the child as to the adult. Such impressions can at some stage be strengthened and intensified by discussion or explanation, but initially they can be acquired only through visual contact with the object.[4]

It is the increase in workshop practice which is probably the most marked development in children's use of galleries and museums in recent years – particularly significant when one considers the many inhibiting factors: lack of running water, worries about noise and dirt, concern for other gallery users' needs, care of works and conservation requirements, etc. Yet many gallery staffs have gone to great lengths and overcome considerable obstacles to arrange workshops in which the activity is in direct relationship to the exhibition content, in the sure knowledge that the personal involvement which can be engendered by such activity is an essential factor in helping pupils to relate to, and come to terms with, the art works of others. This is fully in accord with Andrew Brighton's observations that:

> I would make knowing, AND knowing about artefacts of Western and other cultures and past and present cultures, the centre of secondary art education. My pupils would know these works by making, that is, they would draw, paint, carve and model in a variety of relationships to these works . . . But they would also know about these works by studying their cultural contexts.[5]

Brighton is recommending a whole approach to art education which ceases to segregate art history teaching as a knowledge-based entity from the personally expressive work which much secondary art teaching claims to foster. In practice, each can be seen to enrich and affirm the other, and the gallery is the central resource in this process.

Whereas the gallery workshop was a relative rarity until recent years, there are many art galleries all over the country who periodically organise practical sessions in relation to specific exhibitions or during school holidays, etc. In addition, though, there is an important nucleus who are increasingly accepting that their educational role requires an ongoing, and not merely a spasmodic, commitment to the children in their area; workshops inevitably become an important part of their thinking. When these are well organised and run by staff who are both knowledgeable about the exhibited works and with appropriate practical know-how, the resulting practice can be a means of leading pupils to a further level of insight into the exhibited works than was achieved in talk and discussion sessions; there is no more rewarding moment than when individual pupils quietly go over to study and contemplate specific works as a workshop reaches its climax, or on its conclusion. Gallery workshops can also be dramatic in that teachers often express surprise at the sheer amount of work which their pupils sometimes produce in often quite concentrated time allocations. Under the impulse of identification with exhibited works, their work can take on unusual directness of vigour, treatment and concentration in contrast to the more regular routine of the classroom. The gallery workshop is, therefore, one more extremely important means whereby pupils gain insight into working possibilities relevant to their needs about which they were previously unaware.

The responsibility which gallery staff have is an onerous one when one considers that they rarely get a second chance with children, their contacts being essentially of a one-off nature. When they are unsuccessful and have an 'off day'

the child – or indeed that school – simply does not return. This emphasises a further need for preparatory work in the school through liaison. The National Gallery's offer that they 'would organise talks for us round any subject that we wanted', suggests that they would welcome initiatives from schools to enable the gallery visit to be more effectively integrated with the classroom work. Where children make such constructive use of the gallery, having come with related prior knowledge, the combination invariably leads to follow-up work in the classroom as well.

In emphasising the importance of this relationship between gallery visiting and ongoing classroom activity, the gallery role has inevitably been viewed from the teacher's standpoint, but it is important to emphasise that gallery education services frequently cater for whole communities. An education officer and assistant, for example, work together in a large provincial gallery.[6] They cannot conceivably make personal contact with all but a minority of visitors, but the tape-slide sequence they have produced means that gallery visitors can press a button and get, in about twenty minutes, a potted history of the permanent collection. In addition, there is a programme of temporary exhibitions, sometimes two or three simultaneously on display; when there is a major temporary show, tape-slide sequences are likewise produced for these. Notes are normally prepared for all exhibitions and are generally available. Though they are for any visitor, they are usually labelled as student notes ('actually, it's a sort of defensive thing, but by entitling them student notes you keep the control of what's in them though you let everybody have them'). The education staff confess that some are 'not so brilliant' because they have to be rushed, but others are thoroughly produced with care. They normally consist of three to eight type-script sheets, aimed at imparting information in the gallery and at being of subsequent value. If a primary school intends visiting, a copy is sent to the teacher in advance but an appropriately worded worksheet for that age group would then be prepared, and would be of further use with any similar groups. Sets of notes are also produced on particular aspects of the permanent collection, and of works housed in another associated gallery some miles away.

In addition, both gallery education officers work with groups of pupils in the gallery, normally spending an hour to an hour and a half a session, but with some time allowed for children to look around on their own. This is important because most of my young informants refer specifically to the works they have responded to in this context, though it is gallery staff and teachers who have aided them in the looking process during the more formal session. Once a term the gallery prepares material about any planned talks and the exhibition programme, and this is sent out directly to between 800 and 1,000 schools and colleges. Particularly popular are conferences for sixth-form students. At each one, the teachers are canvassed to find out what they most want, and up to 200 students attend when the theme is, say, late nineteenth-century French painting or twentieth-century 'isms'. When it was 'Women Artists', though, 'it had less appeal to schools because, of course, it's not on the syllabus – it doesn't say "Women Artists" anywhere', but the combination of school and college

students and adult education groups, etc., made for an interesting mix. In addition, numerous students come to the staff every year for support and assistance with their A-level Personal Study topics.

The education officer assumes that most of the children who visit will continue to live in the city, and he feels that they need to know the gallery is accessible and a little bit about the permanent collection pictures so that they can say, 'Yes, there is that picture there' and know that it will also be there when they come again. In addition, the changing exhibitions add to the notion that 'the gallery is a great place'. He can tell when a group of children have enjoyed a visit to the gallery:

> They have enjoyed it and they have gone away again. Now they are not going to say an art gallery is a dusty, boring place. I've had this prejudice put across so often that art galleries are a mausoleum, and it's something that comes from articulate adults who never go to art galleries, and it's their prejudice that they are expressing; it's an excuse that they are putting forward.

This outline of some aspects of the work illustrates that a service is being offered to schools but that the job is an invaluable one in its own right. It demands commitment, and the particular education officer referred to here can still vividly recall the moment when the desire to work in this capacity was formed:

> I know when I saw the light. I saw this teacher in the Tate Gallery about eight years ago, talking to a group of eight-or nine-year-olds in front of a Turner and he was saying, 'How do you know it's a Turner?' And this little kid said, 'Because it's got a great blast of light in it!'

Given the diverse aspects of the work and the range of demands made upon them, gallery staff sometimes feel frustration at what they see as lukewarm responses from schools and some have reluctantly decided to concentrate their efforts in other areas, their attempts having met with general apathy. One gallery voiced this frustration:

> Our perennial difficulty of interesting schools in museum projects is the question of syllabuses and curriculum. When museum work would be most effective the schools cannot spare the time out of the scheduled work. Is it possible that the syllabuses are not broad enough to allow for museum-type study in the higher age groups?[7]

Brighton touches on a crucial matter relating to this query. He makes a comparison between the way art history is taught in periods, as history, whereas English is much more concerned with individual works. He would apply the English method to the study of art, artefacts and architecture, 'that is, the relatively in-depth examination of a few objects.'[8] If this was done, it would be possible to study works from any culture, because the enquiry would proceed outwards from those works, rather than the majority of art past and present remaining irrelevant by being outside the immediate terms of reference.

Similarly, particular treasures from the gallery in the vicinity and temporary exhibitions, including those of contemporary works, could be readily utilised because the course would no longer, by definition, deem them irrelevant.

This is important when it is remembered that the illuminating experience is to do with the broadening of the individual's understanding of what art is, and this sometimes involves feelings of hostility. When a provincial gallery staged the Gillian Ayres exhibition, some of the teachers as well as pupils were hostile to them because, according to one, they were not 'Art'. Pupils' attitudes modified during the accompanying workshop, with many positively enthusiastic by the end of the session.[9] To one teacher, though, the work was 'a con', and she intercepted pupils who were washing their hands or brushes to get them to put on their coats as a means of terminating the session. In effect, she felt the need to censor the displayed work even though pupils' reactions indicated that a fertile learning experience was underway. The 1972 DES *Art in Schools* observed that

> Many art teachers, and particularly those trained in a different era, wonder what in the contemporary art scene is relevant to their work in schools. Nothing would be less desirable than an attempt merely to keep up with whatever professional artists are producing at the moment; but it is equally dangerous to remain fixed and isolated in one period of time, perpetuating its fashions in opposition to the realities of the outside world and the pressures of a changing society.[10]

As a teacher-training student, I can remember at one stage being informed that I had now finished with art, from now on my concerns were to be with art education. Many teachers will recall similar exhortations and will indeed be aware of how absorbing and fascinating their involvement with education has subsequently been. It is the contention of the CSAE Project, however, that the enmeshing of the study and contemplation of the visual arts with their practice should be a central activity. The many positive responses to gallery stimulus already outlined indicate the school gains that can be achieved through collaboration between teachers and gallery staff, but equally reflect the vital learning which students can experience when those who teach them are also aware that they, too, are still growing through making new discoveries. In addition to school gains, children can also bring something special to galleries. A design lecturer recounts how a workshop, in relation to a touring exhibition, was held in the temple-like foyer of a city museum. It created 'noise, dirt and excitement' but other gallery visitors temporarily stopped walking on tiptoe and spoke in an animated manner instead of whispering. There was 'a momentary glimpse of museums as they could be'.[11]

Section 2 Combined Gallery and School Approaches

(a) 'A Closer Look'

A seconded head of an art department, as part of his studies, had to make a

study of drawings of his own choice. He went to his local art gallery and asked what drawings they had in stock. 'They brought out cardboard boxes full of old sketchbooks that had been underneath a cupboard for the last twenty years. I started to sieve through them and found them quite interesting.'[12] This was the beginning of a fruitful collaboration with the gallery, because the sketches were by a local artist he had never heard of before, a Thurston Shoosmith. Interestingly, though, there was a Shoosmith Room upstairs, and it was one of the major rooms in the art gallery. None of his paintings was on display, though. 'They were all downstairs in one of the rooms beneath the galleries, all seventy of them.' Two essays resulted and 'the whole thing began to jell together, both the interest in art galleries and their education programmes and the Shoosmith idea'.

He suggested to the curator that an exhibition be held. Coincidentally the next year would be the fiftieth anniversary of the artist's death and the gallery had had a Shoosmith exhibition written into its programme for two years. As a result of the studies which the teacher had made of the sketchbooks, however, the plan of the exhibition was drastically changed, and it developed into a combined venture of considerable educational significance. (Having shelved the exhibition as originally planned, the gallery is intending to revert back to its idea of a T.L. Shoosmith retrospective to bring him out of the wilderness.)

The revised exhibition, in the meantime, had become something quite different. The teacher 'thought that a whole gallery full of seventy Shoosmiths, pleasant as the paintings would be, would be pretty much an "underwhelming" experience because *en masse* they are not exciting. None of them really has a sort of bravura approach to either colour or paint handling. They're subtle things, really, often very subdued in colour.' He felt that the number of paintings to be displayed should be restricted, but that the sketchbooks had considerable potential. 'They're worth actually showing to people because it's not just the images, it's the method of working that was important, so that whole lots of things began to join together. I realised that in the middle of this art gallery there are quite a lot of rich possibilities.'

The sketchbook idea began to take off in its own right. With funding from East Midlands Arts, 2,000 sketchbooks were distributed to pupils in local schools and a sketchbook project begun. 'The firm of lawyers, Shoosmith and Harrison, still related to the artist, provided some money for some little sketching watercolours for prizes.' Some of the sketchbooks began well and then 'tailed off into ET and Toyah and the rest' but others had really developed and there was evidence of excellent teaching in some of the schools.

We've had a number of very positive comments back about using sketchbooks of that kind. Essentially they are a working tool, they're not for presentation work. They're for making quick notes in, and that's just how Shoosmith used them and what we are hoping is that when people come into the gallery, having had that kind of experience, they'll be able to pick up on what he did and enrich their own way of working.

To encourage this kind of cross-fertilisation further, the final layout of the exhibition incorporated both Shoosmith's and children's work and the title 'A Closer Look' was chosen for the whole exhibition. The gallery has two levels, and so the Shoosmith exhibition occupied the upper one, and on going down some steps one was into an area devoted to the children's work. On the back wall, rows of their sketchbooks were displayed on pieces of string passed through their spiral binding enabling visitors to turn over the pages at their leisure. The Shoosmith sketchbooks were displayed, open at particular pages, in glass cases, but to show 'his method of approaching a particular locality' photo-facsimiles had been made and all the pages, in order, of some sketchbooks were consequently displayed on the gallery walls.

> You might find eight drawings of Pembroke Castle worked from different angles. You might find, if you look carefully, that he's taken two or three sketchbooks out with him and done drawings in those different books on different scales, some with greater detail and some done more quickly. So he is finding a way through to the subject through his drawing, through different scales of drawing and different amounts of detail. That's tremendously interesting.

The reason for the children's work also being on display was that

> if you want to get children interested and excited in a gallery project, then what better than to have their own work there to compare with. One nine-year-old boy was yawning all the time, not because he had gone to bed late but because he couldn't sleep. 'I was so excited about coming into the gallery today. I've got a picture down there and I couldn't get to sleep for thinking about coming in.' That really illustrates the kind of cross-pollination you get from having children's work and artists' work in the same gallery. The children were dying to get in to see their work – at the same time they were very interested because they had been doing watercolours and they wanted to see how Shoosmith had done them. They'd seen the slides – but slides are in no way the same experience as seeing the same painting a nose distance away. I don't think they are great art by any means, but minor art seen close to seems a great deal better than great art seen through reproductions and slides or seen from a distance.

He feels that the problem with this particular gallery is 'that it is a little art gallery down a sleepy street. It rarely draws people in outside of its normal visitors who just pop in during their lunchtime.' This was the teacher's perception but the gallery considers a medium-sized attendance to be one in the region of 1,000 per week – which is high, about twice the national average in fact. However, there were 200 pieces of work by the children on display and well before the gallery was due to open for the preview, a queue of over 400 children and adults extended round the art gallery, an unusual sight. The majority of the Shoosmith Gallery exhibitions tend to be by local artists or local art groups, or they are from the gallery's own collection and its normal visitors

A gallery workshop drawing.

Children using a recorder while describing a painting.

are therefore drawn from a particular group. During the Shoosmith exhibition, by contrast, quite a lot of people came in, went straight to the school's exhibition to find a particular piece of work, but would then stay and look around the exhibition as a whole. Likewise, adults who are maybe in a watercolour class, having come in to see the Shoosmiths, would also spend time looking at the school work. 'So I think there is quite strong empirical evidence for saying that people really are picking up on both exhibitions if they are coming in to see just one of them, which I think must be good for the gallery.'

These links were more substantial than just the coincidence of the two sets of work being in the same room and the sketchbooks having been sent out for use in schools, starting a year in advance. Teachers' meetings were held at the various teachers' centres – some of which were not well attended. Sheets about the sketchbook project, the collection of work and about the proposed workshops during the exhibition were also distributed to schools. The twenty or so schools who booked in to the workshop sessions then received an excellently produced 'A Closer Look' folder. This included three postcards of Shoosmith watercolours and a set of twelve slides with accompanying notes dealing with biographical information and his working methods. Attention was drawn to their local environment, as well, because though Shoosmith travelled extensively, sketching wherever he went, he also left a record of Northampton in such works as *Canal at South Bridge* (1920), motifs, many of which can be seen to this day. In addition there were sets of historical notes, 'Shoosmith and His Times', a paper by a local watercolourist called 'What is a Watercolour?' and a set of notes for the non-specialist teacher called 'Practical Work in Schools'. These were prepared by the Advisory Teacher for Art, and included materials list and recommended reading. He had been involved in the project from the outset and had worked closely with the teacher and gallery. His organisational skills proved invaluable, partly because of his knowledge of the education authority's administrative system.

The room above the Shoosmith Gallery afforded some excellent views of Northampton, some of vistas, others of interesting architectural details. Some of the buildings which Shoosmith had recorded in his time were visible, and the pupils made some excellent sketches through these windows during the practical workshop sessions. Prior to the commencement of the practical work, though, all the groups spent time in discussion in the gallery and studying the exhibited works in small groups. A particular feature of these sessions was the use of an extremely well-made tape-slide sequence analysing the artist's work. The teachers I spoke to on my visit were non-specialists but were talking enthusiastically about the environmental possibilities in and around their school. Some teachers said that they had already based a whole term's work on the project, and some have commented on the interest in watercolour which had been aroused, it being a medium they had never previously thought of using. Others appreciated the historical and geographical material, and many children became quite excited as they recognised paintings in the exhibition which they already knew from having seen the slides and postcards previously in school.

The Shoosmith exhibits showing the sketchbook contents displayed alongside watercolours.

A pupil studying a Shoosmith painting.

Pupil sketchbooks were an integral part of the school exhibits.

The schools' exhibition.

Every effort had been made to engage the children's interest from a variety of standpoints both in the school and the gallery. There were, of course, problems. The organisers were disappointed at the small numbers who attended some of the teachers' centre meetings and, though they felt that the whole project with its emphasis on sketchbook work was particularly valuable for pupils at the examination level, the response was relatively poor here. Equally though, the school exhibition was of a high standard, the 200 works were chosen out of 1,000 entries and an attempt was made to represent as many schools as possible. It had been publicised as an environmental project for a whole year, but still some sets of ET, etc., came and meant that it was impossible to represent some schools. There were also some quite small frustrations of a practical nature. The gallery did not contain any seats, for example, and there was a definite need for these once pupils were in the building for hours rather than minutes.

It is pleasing to note that the exhibition will not remain a one-off event. The teacher is a printmaker himself with quite an extensive knowledge of contemporary printmaking. Plans are now well under way in the formulation of a second joint venture, an exhibition with this emphasis. Trevor Allen, the relief printer, has agreed to spend a fortnight in the gallery during the exhibition as a printmaker-in-residence. Both teacher and advisory teacher have already visited him at his East Anglian home and studio to collect photographic and recorded information. His linoprints utilise the subject matter to be found in his immediate home surroundings, but it is also the intention to impart information about other printmaking processes in addition to displaying notable examples; to this end, there has already been a teachers' meeting at the gallery at which sets of loan scheme prints have been selected for preparatory use in schools.

The completeness of the 'A Closer Look' project – its exploration from so many standpoints – makes it a valuable case study, with an important part played in its conception by a seconded secondary teacher in close liaison with his local art gallery and a committed advisory colleague. Both the gallery and the local authority education department made the necessary financial contributions to enable the concept of the exhibition to be realised, and schools were kept well informed of developments. Even so, there was disappointment that more schools did not respond, though, in practice, there were as many as the gallery and project could reasonably cope with. Shoosmith is a minor artist, perhaps, but his work was well worth commemorating and contained many elements of considerable educational significance, and these were brought out and utilised to the full. A venture which sought to draw parallels between his sound working methods and those of the children who participated was beneficial to their approach to school work – leading as it did in some cases to term-long projects – and enhanced their understanding and enjoyment of Shoosmith's sketches and paintings.

This collaborative education and gallery service venture has been looked at in some detail because considerable energy, prior planning and preparatory work undertaken in the schools were all part of a special in-depth project; the level of intensity and effort could not be maintained on a daily basis. Here, therefore, is

a system where periodically the combined skills of school and gallery staffs ensure that worthwhile gallery experiences are offered. In the next example, the focus is upon a gallery determined to establish an education policy out of a belief that galleries are marvellous, but elitist, places. To counter this problem, the gallery staff decided that they must have an ongoing commitment to the school community. Nevertheless, they experienced a great deal of frustration before succeeding in this aim.

(b) A gallery education policy in action

I'd always felt that galleries were wonderful resources and I'd been enjoying them for years and years. I was very conscious that most people didn't go into them – were frightened off by them and felt that they were for an elitist minority – and I felt that the sort of gallery that this should be should be very popular and people should feel that it was easy to come into and work on that sort of level.[13]

Neither the problem nor the sentiments are new ones, but the appointment of an Exhibitions Officer to a new-town exhibition gallery in early 1982 was to a newly opened gallery. She was therefore in a position to determine policy from the outset. 'It had opened with some fairly prestigious exhibitions and it was still in a state where it had to find its feet . . . I was really given a free rein in what I wanted to do, and that is fairly rare. Normally you've got precedents set by somebody else and committees to go through. I didn't have any of that.'

An important aspect of her thinking was to do with setting up an education programme. She had previously worked for a Manchester print dealer, and in that capacity had visited Drumcroon (the Education Art Centre described in Part V, Section 3(a)) on a number of occasions:

I'd never seen anything like it before. The fact that it was all worthwhile, there was always something going on, it was welcoming, there was ready information on lots of different levels and loads of things going on – that seemed to me to be a wonderful model in a lot of respects, and I wanted to pick things off that and give this gallery the same sort of activity and reputation and atmosphere.

She expresses embarrassment now at her naïveté then. She thought that it would be very easy to set up an education programme. Children were a captive audience at school to be educated and therefore it should be easy to educate them into art, she thought. She spent about six months regularly writing to all the teachers in the town inviting them to the gallery, and their children as well, with some proposals as to what might be done. All the letters asked the teachers either to phone or just to call into the gallery: 'Nobody wanted to know about us and I think if I hadn't known Drumcroon at that stage and hadn't seen what could be done, I would have given up. I would have just thought schools are a lot of hard work with no reaction and I haven't got any more time to spend on that.' Having seen what was possible she knew that it could be done and so she

persevered. With hindsight, she feels that saying 'I'm here' to the teachers and then putting the onus on them to come back to her 'was a very arrogant thing to do'. She now realises that the teachers' preconceptions were probably as bad as hers with no common ground between them. The schools did not know what the gallery was offering and she had no understanding of the problems in schools to do with timetabling constraints and the like. Also some of the teachers, when they had been at school, had probably been subjected to extremely boring guided tours and assumed that this was what was on offer. 'Teachers were at one side of the fence, the gallery was on the other side, and neither of us knew what the other one had to offer or wanted so obviously there was a problem.'

There was no authority art adviser to whom she could turn for help and support, so it was decided to hold an inaugural meeting, with all the teachers invited to attend, under the auspices of the CSAE Project. She wanted a practical evening which would open up a picture of what might be and how that might be done in their context: 'It wasn't a question of getting the audience, it was always trying to prove to them the benefit of having an education programme linked to the gallery, of using the gallery as a resource.' In the event, the meeting was very well attended and a great many questions, some of a practical and organisational nature, concluded the evening. An important member of the audience was her new assistant (officially as the gallery attendant!) appointed two days earlier meaning, of course, that she was not officially in post at the time. Her sculpture degree meant that she had valuable practical expertise, and at the time of her appointment she knew that the Exhibition Officer had ideas about doing educational work but only fully realised what she had let herself into during that evening. 'I was quite excited about actually starting a job but this was another dimension that I hadn't envisaged quite so clearly. I found it extremely fascinating.'

The major outcome of that meeting was the formation of an Art Teachers' Forum. Exhibitions change approximately every five weeks and in addition to the traditional preview there is an evening specifically for teachers three or four days later – though, of course, some of the teachers attend the other preview also as members of the general public. Like that preview, the one for teachers is a social occasion but with a formal component to it in which there is discussion about the exhibition content and the nature of related workshops which might be relevant for different age groups. Some of the teachers who attend travel quite considerable distances; the gallery is situated in a large county, and in addition teachers travel from neighbouring authorities. It is obviously impossible for these teachers to attend every preview, so the officer and assistant have devised a system where they will not only discuss the current exhibition's possibilities, they also make the teachers aware of the next two or three exhibitions and indicate some of the practical possibilities which they are envisaging at that stage. The Exhibition Officer observes that

We tend to talk about what our plans are for every exhibition. The exhibition

is hung and we sit down and we decide what we're going to say to the teachers and what sort of workshops we're going to have or if the artist is going to come or whatever. So when the teachers come to a meeting we tell them what our ideas have been.

She adds:

> Quite often we have a number of different ideas and we discuss them and say, 'We could do this or we could do that! It's never, 'This is what we are going to do unless you stop us.' It is always negotiable and it's also asking them if they have any ideas, and obviously we want them to contribute but now they know the way we operate and how we come to gear the talks.

These forum meetings are therefore extremely important for the reciprocal exchange of views which now takes place and also because during the evening the teachers will make specific bookings for groups of children with an agreement reached between teacher and gallery staff as to what will happen during that visit. Through their initial discussions together, therefore, the gallery staff envisage a range of possibilities which are then discussed with the teachers. The comeback from the teachers then further extends these possibilities and, in addition, the teachers react to each other's responses. As a result of this process, the work done with each group is mutually agreed beforehand. Obviously there is a strong nucleus of teachers who attended the inaugural meeting and they are 'also teachers that feel they can be outspoken with us in criticising what we're doing and giving us feedback and that sort of thing.' At the earlier meetings, though,

> They didn't really want to talk and they sat very quietly and felt unsure of us and unsure of being in a gallery environment. They were fairly inhibited because I think they thought we knew an awful lot about art and that they ought to. And so they weren't going to open their mouths in case they let on that they didn't know all that much.

The gallery staff emphasised that they, too, often didn't know anything about 'these artists and this art until we start working on the exhibitions, so we don't expect you to know'. The teachers gradually became more confident and now many naturally and positively speak their minds and express their opinions. There are still a lot of new schools becoming involved, partly through word of mouth and partly because if a teacher happens to come into the gallery, he or she is invited to have their name added to the mailing list for teachers. This list is proving very important, because the invitations and information are then sent to their own homes. Besides the crucial importance of getting on a first-name basis with teachers, this ensures that some of the communication problems between gallery and school are overcome. Sometimes they discover that batches sent to an education office for general circulation have got 'lost at the bottom of a pile of communications and the teachers don't get their invites':

> Quite often they'll come and say, 'What's happening? We've been waiting for

invitations and haven't got them.' So they are interested enough to come and find out if they don't get them through the post. That's a key thing. So what we've started to do is, whenever teachers come to meetings and we don't know their faces we ask them for their home addresses and it goes in the back of the file, so they get one batch of a poster and an invitation sent to the school and another batch sent to their home address. That way, we are absolutely sure that they are getting to them and we do that whenever we can.

Some exhibitions are particularly popular with schools. One on kites and a toy exhibition are obvious examples which teachers assume will be readily accessible to their pupils, but the number of visits and workshops for most exhibitions are sufficient to be demanding on the gallery staff. Nevertheless, the gallery staff are still keen to establish contacts with additional schools, and a particularly imaginative approach relates to a sculpture exhibition which the Exhibition Officer is preparing for the Arts Council. It will consist of fifteen pieces but in addition there are numerous pieces of sculpture dotted around the town which have been publicly sited, very often on the housing estates. The gallery is therefore going to approach the school local to each piece of sculpture to invite them to the exhibition but if the teacher has no interest and does not want to know the matter will not be pursued because 'you can't throw things on to people's plates' but where a teacher becomes interested by the proposal then perhaps the assistant officer

. . . would go into the school and talk to them about the sculpture, get them to go out and visit the sculpture, do practical and written work with them and so on. She would want to know how that would fit in with the teacher and what he or she would want to contribute, so between them they would work out a package for school work around this piece of sculpture.

By linking the gallery's exhibition to the town's sculptures the gallery would make new school contacts through a positive approach which would have lasting benefits for the school in relation to increased awareness about an immediate resource – the local sculpture.

After that first six months of frustration, the gallery now has the confidence of many teachers, a number of whom will take them up on any exhibition. Children are going home and telling their parents about what they have been told, bringing their parents in in turn. The Exhibition Officer feels that their educational approaches have been generally beneficial to the whole gallery community since

We've found that working with the schools actually develops our way of presenting the exhibition because we consciously start thinking about it in that way. We get together and walk round the exhibition and discuss it educationally. We explore our own ideas on presenting the exhibition and that naturally flows through into the adults coming to the gallery because when they come and ask questions we've already thought about it all. We are pleased to tell them because we've already had the experience of telling the

children, so it started feeding back into adults as well – and in a lot of different ways; adults would come in when the children were in the gallery and they'd be intrigued by what the children were doing and they'd listen to [my colleague] talking to the children and the children talking back, so there's sort of feedback.

They now firmly believe that there is no point in staging an exhibition, however good it is, unless they can present it in such a way that the adults and school populations can both derive understanding and enjoyment from it. Their educational work, they feel, has given them added confidence and commitment to the whole spectrum of gallery work.

From the communications problems that the gallery has had we now move to the work with children.

Yesterday half of our class went to the art gallery to look at some of the pictures and models that were on display. The first thing that we saw was a very funny thing called an arm chair paraffin heater it [sic] was like a chair on the ceiling with a pretend fire underneath it but the thing I liked best was called a wardrobe it was not the kind of wardrobe you hang your clothes on. When you pulled a thing that looked like a lot of sick it felt like a baby's dummy. I also liked the model called bye-bye the elephant because when I looked at it it looked like a car to me the square in the middle could be the window the pieces of wood could be the wheels and all the sand could be some sawdust.

Amele Shafig, aged six, wrote this at school after visiting the 'Through Children's Eyes' exhibition at the local gallery. It was a touring exhibition that had originated at Southampton Art Gallery and consisted of the responses of two classes of seven- and eight-year-olds from one school to fourteen original works of art, all of which – with one exception – had been completed during those children's lifetime. They had worked in relation to the fourteen exhibits for most of a school year, and later described the event as their 'good adventure'.

The exhibition 'was a way of letting adults look at pictures in the way that children do' so the Exhibition Officer felt it was vital that the appropriate panels relating to the particular works of art were displayed so that visitors could stand and read and look from one to the other. When the children came in, though, gallery staff deliberately concealed all the Southampton children's writings, otherwise, in response to a question, they just 'spat' back information from the panels without thinking for themselves. Some children came into the gallery 'cold' but others had done work at school in advance. One teacher 'had taught his class the titles of the works, only the titles, and asked them to think beforehand what these works of art might be', a simple enough ploy but one which ensured that the children looked at the works closely not only in relation to the titles but for clues to match their imagined images.

Boyd and Evans were resident artists in the new town and their exhibition was the first one to be used by schools following the inaugural meeting, about two

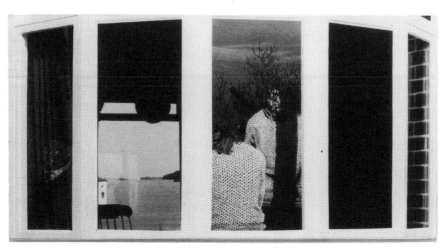

Boyd and Evans, Bay Window.

dozen pre-booked parties visiting. Boyd and Evans do not like talking about their work which is very realistic but with a most ambiguous quality (compositions are derived from images taken from numerous slides) and they feel that their explanation would detract from the work. However, they agreed to an interview with the gallery staff about their techniques and working methods and as the information was for children really basic questions could be asked: 'How they did it and why they do it like this – and how long did it take and how long did they spend on each painting. All sorts of questions that gallery directors are actually very nervous of asking. You feel that perhaps you ought to know that.' Many of the visiting groups were of secondary-aged pupils who found this kind of background information fascinating, but with the younger pupils they put the emphasis on subject and content because there are a lot of clues, little secret things, in Boyd and Evans' paintings:

> There's a window scene with a figure standing on the outside of the scene. On one of the bay windows there is a reflection of a little fat schoolboy or a cricketer, or something – you just can't work out where he comes into this composition and he's quite a sinister figure. There are curtains and it's very decorative. He blends into the general decoration and a lot of adults walked past that picture and never spotted it. We thought the children were going to be as unobservant – well of course they are about five times as observant! The first group we decided to do this with, they ran rings round us because they were so much quicker.

They found things that the gallery staff had not noticed, and all sorts of little, obscure details which one would not normally have expected them to notice. For example, in the window painting already referred to:

> There's a cricket field and it's quite strange. It's painted in different tones of a

colour and different brightness – a cricket pitch, a perspective view. The children were looking right into that picture, they were noticing that, their eyes were looking all round and were focusing onto that square and saying, 'What's that? that's odd! That's a reflection of the window. Why is there a cricket pitch there?!' and really wanting answers and questioning all the time. I didn't expect quite so much as that, and the feedback from them has been a help to me in looking at painting as well and has given me an insight into how they saw it.

Much of the work has taken the form of practical workshops. The constructivist works of Anthony Hill led to some children pointing out the resemblance with much of the town's architecture. Cutting, bending, curling card resulted, some was stuck on to paper, making relief images of a type that could be seen in everyday objects and this eventually led to making kites. The exhibition was staged during the summer holidays and so the kite workshops were a means of attracting individual children into the gallery. However, the next exhibition was of kites made by David Prentice, so there was a conscious link up, and some of the same children returned with their schools. Kate Prentice ran workshops for older children on three consecutive days during which 120 kites were made and successfully flown.

Because the Matthew Smith paintings were unglazed – with in some instances the paint surface cracking – it was decided not to have practical workshops in the gallery for safety reasons. It was also a large exhibition for a single room gallery and there was a crowded effect. The assistant officer therefore devised a worksheet. 'I don't really like using them because I think they can be a bit restrictive but I thought that it was one way of getting them to concentrate on maybe two or three paintings as opposed to being absolutely baffled by the amount they were seeing.' Actual still-life objects which Smith had used were part of the display, and from initially quite simple questions (such as 'How many times does the blue jug appear in the paintings?') it went on to quite complex ones involving the children in making comparisons between two paintings: one in very bright, exciting colours – yellow, red, orange, purples – creating the atmosphere of hot sunshine; the other, *Cornish Church*, a complete contrast though still with a lot of red and purple but a lot more green: 'What I was trying to get the children to see is that by the use of these similar colours but with one introduction of a colder colour the atmosphere was changed.' There were contrasts in paint application, one free and the other deliberate. The loose forms in one contrasted with a neater more geometric rendering of architecture in the other. The differences in architectural style led the children to conjecturing that two countries were involved. The exciting mood of one was quite different to the cold and miserable feel of the other. They realised very quickly that mood and atmosphere could be strongly evoked by the use of colour and that colour was not a purely descriptive thing.

Because of the constraints about workshops, the assistant officer went into a number of middle schools and worked with eleven- and twelve-year-olds on

A kite workshop.

still-life paintings. The visits were arranged at the teachers' preview, the invitations coming from non-specialist teachers. She took in posters, catalogues and some books on French artists, such as the Impressionists. The children painted out their objects directly, working from the outset with a brush, but she didn't have sufficient time to finish them. However, the teacher took over and brought the completed paintings to the next teachers' preview, with a subsequent set of work in which they had used

. . . thick, thick paint and the landscapes that they did were tremendous and the colours they used – they were incredible. There were lots of reds, purples and dark greens that you just don't see in Milton Keynes. Matthew Smith had influenced them. Whether they were conscious of that I don't know but it came out in their work.

Secondary teachers at the meeting were surprised that so much work could emanate from what was only a six-hour project – including the time spent in the gallery.

Similar work has been undertaken in relation to every exhibition staged from Boyd and Evans onwards. These few random projects have been described in an attempt to communicate something of the flavour of the work.

One reason for the particular choice of this example is that, being a new gallery, the decision to implement an educational policy can be clearly pinpointed. Once decided upon, the practical problems of just how a gallery communicates with the schools – even to such basic issues as to how one even gets the information to the relevant teacher in the school – can be daunting and completely off-putting. The gallery can feel very isolated and exposed and the best of intentions can dissipate. In this example the staff eventually adopted one or two simple but effective strategies which have enabled them to build up an effective and fruitful partnership with a still-increasing number of schools.

The main steps which they took can be summarised as follows:

1 Having initially met with no success, the gallery put a great deal of effort into getting as many teachers as possible to an inaugural meeting. This set out the values of gallery usage and pinpointed relevant approaches.
2 The meeting concluded with the formation of an Art Teachers' Forum. This comprised a group who were keen to meet on a regular basis under the auspices of the gallery.
3 These meetings took the form of a special preview for teachers. Though also social occasions, there was discussion about school visits and workshop possibilities. Bookings were made during these sessions.
4 Because of communication problems with schools, a special mailing list specifically for teachers was started. To ensure that information reached the relevant people in time, information was sent to their schools and directly to them at their home addresses. The list is still expanding.
5 The commitment to school visits and workshops was a regular one so that schools knew there was a service always available to them. The format for visits and workshops was negotiable, ensuring additional school involvement.

For galleries to offer a worthwhile education service, a regular commitment has to be matched by commonsense measures to overcome quite basic problems, as in this example. The Exhibition Officer acknowledges her debt to Drumcroon, which strongly influenced her thinking. The Drumcroon Education Art Centre is an education authority initiative set up consciously to introduce its pupils of all ages to the visual arts.

Section 3 The Role of the Education Art Centre

(a) Drumcroon, an Education Art Centre

I enjoy Drumcroon; I like the friendly, intimate atmosphere of the galleries,
the care and attention that goes into the selection and hanging of the
exhibition, the facilities for workshops that I may be invited to use, the
library in which I can study the best art books or look at artists' limited
edition publications. Perhaps I'm very like the nine-year-old who, after his
first visit to Drumcroon, pronounced that he would like to live there. Not a
common response to a gallery this – imagine bedding down in the Victorian
dignity of Manchester City Art Gallery, but one that subtly attests to a
growing awareness of art as a more accessible, more intimate experience.[14]

Jill Morgan

Drumcroon, the host centre to the Critical Studies in Art Education Project, is
Wigan's Education Art Centre. The Edwardian building, originally a doctor's
house and surgery, was purchased by the Education Department in 1978,
modified to meet its present needs, and opened in late 1980. Until then Wigan,
unusually for a town of its size, had no art gallery so it was natural for the
building to be open to the adult community as well as catering for the
educational needs of pupils and teachers. Morgan refers to the children's
illuminated letters of thanks pinned up on the notice board and the twenty cups
of orange juice set out in the coffee lounge in anticipation of the children's
break; 'the presence of children permeates the gallery':

> This emphasis, far from antagonising casual visitors to the exhibitions adds an
> extra dimension to most adults' appreciation of art. Visitors may sometimes
> have to step over children sprawled on the floor trying to get a close-up look at
> a Ted Roocroft pig sculpture . . . but perhaps surprising to many curators
> convinced of the sanctity of the art gallery is the fact that most people
> actually enjoy this kind of contact.

As Morgan's observations indicate, Drumcroon consciously blurs the
boundaries between what is generally termed 'the general public' and its
educational work; all too often each is segregated from the other in the belief
that children are going to impair the concentration and enjoyment of the more
mature gallery visitor. Drumcroon was conceived as a centre for the visual arts
designed to extend, complement and enrich the teaching already taking place in
Wigan schools; children, pupils, students, teachers and parents, as well as
adults who already visit art galleries by inclination, therefore constitute its
'general public'.

The main gallery spaces are in ground-floor rooms, so that exhibits can be
seen from the street, and there are six exhibitions a year, each one
corresponding approximately to the school half-term. Only rarely does the
Centre take ready-made exhibitions; the conception of each exhibition and its

educational potential are synonymous. Gallery Education Officer and art adviser liaise directly with the prospective artists, craftspeople, studio or group involved, building up an extensive record about the artist in the process. This information is later utilised in catalogues and transmitted to pupils and gallery visitors in practical sessions and through discussion. Arising out of this liaison, Michael Rothenstein loaned childhood drawings, including one of a cockerel when he was seven. Brendan Neiland made available early art college paintings done before he acquired an airbrush and showing the formative influence of Léger. In addition to the frequent loan of printing blocks and etching plates, artists like Lynne Moore and Richard Crabbe loaned sketchbooks showing developments in their work and the formation of specific ideas. All of this supporting material makes exhibited works more accessible to visitors of all ages. In addition, the artists visit the Centre to discuss their work, to demonstrate and to lead workshops with groups of pupils, for periods of up to a week or on a day a week throughout their exhibition. For all of this to be possible, exhibitions have to be envisaged a long time ahead.

A balance is also sought between exhibitions likely to arouse an immediate response in children – the sculpture of Ted Roocroft, the colourful off-loom hangings of Tadek Beutlich, the precise cardprints of Lynne Moore – and those which are thought-provoking and which will extend children's awareness and thinking about the visual arts – the systems paintings of Crabbe and the personal environments and adornments of Pierre Degen, for example. The prints and screen canvases of Gerd Winner, depicting the façades of disused warehouses and tenements, and the airbrush paintings of modern reflective glass buildings by Brendan Neiland heighten many children's awareness of their own surroundings. When the Horse and Bamboo, a community group, took over the Centre the children became the active participants creating their own gallery environment. To encourage them to relate what they do to the work of mature artists, a balance is sought between exhibitions and the display of pupils' and students' own work; an art department might display its work, or a selection from the workshops done during a previous exhibition. At other times, their work might take over the whole Centre as when an aspect of children's work is explored in depth – 'Sculpture in School' and '16 Onwards'.

Besides welcoming visiting artists and craftspeople, the Centre also houses its own resident artists. Each school year Wigan seconds one of its teachers to work at Drumcroon as an Artist-in-Residence, an exhibition in the gallery concluding their term of residence. John Roberts, the fourth teacher to hold this post, was acting head of art in an 11–16 high school the previous year, and his ceramic sculptures are characterised by their exaggerated perspectives and the precision in the treatment of figures and architectural detail. The Centre also has a Craftsperson-in-Residence, Frank Egerton, a toymaker of extraordinary inventiveness and ingenuity. He works in wood, which is finally painted and varnished, and many of the small-scale pieces are articulated, operating on simple principles by dowel rods linking the separate parts, so that by pulling a fish's tail its mouth opens and it puts out its tongue on which a fisherman sits.

David Labrum, an American in this country for twelve months, is Drumcroon's third Artist-in-Residence. He is a photographer and in the States he spends part of each year living amongst the Cheyenne Indians of whom he has produced a series of impressive portraits. While at Drumcroon he has embarked on an equivalent project of local people. In this context, he has worked for periods of up to a fortnight in schools and colleges, extending their technical knowledge of photography in the process. Each of these artists, in fact, has spent time working in schools arising out of contacts initially made at Drumcroon.

Artists have also worked for six-month periods, as when Elizabeth Stuart Smith came on a North-West Arts Fellowship. A papermaker and printmaker, she involved many children in the actual making and embellishment of hand-made paper. Drumcroon's financial commitment to this Fellowship involved the purchase of an agreed amount of Elizabeth's work on the completion of the six months. These works now belong to the Wigan Schools Loan Collection, which is extensive and varied, including in its contents ceramics, glassware, jewellery, embroidery and textiles works, models as well as drawings, paintings, prints and sculpture. Work ranges from that of such well-established artists as Paolozzi, Hoyland, Denny, etc., to purchases made from students at various stages of their training. Many teachers choose and collect their own works for use in school, arising naturally out of their visits to the Centre, but sets are also delivered periodically to other schools. School loan works have formed the nucleus for the majority of Drumcroon's exhibitions, for the collection contains sufficient numbers of many artists' work to emphasise the variety of their work, or consistency of vision, etc. Through catalogues and other supporting material, therefore, Wigan teachers are increasingly acquiring a valuable body of teaching material as relevant loan examples come into their schools; the Loan Collection is not just a service that coincidentally operates from Drumcroon, it is inextricably interwoven into the philosophy of the Centre.

Taped interviews form the basis of the information used in the catalogues which are illustrated, in colour if funding is available. Adults and children alike have direct access to these catalogues, free of charge because of a belief in the need to disseminate relevant information to young and old alike. Catalogue content, as Edward Lucie-Smith suggests in a recent exhibition review, is often unfortunately predictable:

> The glossy catalogue which accompanies the show abounds in essays, interviews, evaluations and explanations, but it is also a closed system, so busy making the right noises to the converted that it does little to clear up the mystery of what contemporary sculpture is. It is as self-absorbed and self-regarding, as obsessed with the minutiae of who went to which art school (St Martin's or the Royal College? Eton or Harrow?) as most documents of its kind.[15]

This is why most of the Drumcroon catalogue space is devoted to statements dealing directly with issues relevant to the nature of the artists' work,

extensively using his or her own words – how their work has evolved, the relationship between the technical means employed and content, the artist's working methods and patterns, future directions, etc. All children are encouraged to use the catalogues as part of each visit to Drumcroon; understanding at least something of the information they contain in relation to their study and enjoyment of the exhibited works is seen as part of their induction and training in the use of art galleries and exhibitions. Each child can take the catalogue home, and it is rewarding to see the children return on a Saturday morning accompanied by their parents. The Gallery Education Officer has become skilled in helping children to utilise the catalogues, working with whole groups but in also giving them the necessary criteria to use such publications to 'explore' the exhibitions individually. It is also as part of this process that children are encouraged to visit and meet the resident artists, which they do in small groups of two or three in contrast to the more formal contacts.

Exhibition content is one of the criteria by which the library is extended, so that children can find reference material additional to that in the catalogue. This material is usually displayed as part of the exhibition. The main principle when initially setting up the library, though, was that its art books should not duplicate those which are normally found in school; it should start where the school library leaves off. It now contains an impressive collection of books covering all aspects of the visual arts and art education. A further factor is that the library is well used by sixth-form A-level students. Those who are submitting the 3,500 word JMB Personal Study on an art history and appreciation topic naturally look to the Drumcroon library for extensive background material, and most needs can be met. Nevertheless, the Centre staff use knowledge of their topics as a basis for further developing the library, immediately benefiting the particular student in the process. A wide range of visual arts magazines are acquired on a regular basis – *Arts Review, Design, Crafts, Ceramic Review, Artists Newsletter*, etc. These build up into valuable bound reference volumes, having served an initial life as topical magazines dealing with current exhibitions and events. The library is for reference purposes only as it is important that students and teachers know that the material they seek is always available, and there are few days in the week when this resource is not utilised.

When it is added that teachers can meet informally, that it also doubles as an in-service centre for art and that there is an extensive slide and video library, it will be seen that Drumcroon is a rich central resource for the visual arts in Wigan. Patterns of usage are inevitably many and varied, reflecting the wide range of needs which have to be met. Schools are becoming increasingly skilful not only in their use of the Centre, but in the way in which they integrate visits with their work in the school. The use made of the Pierre Degen exhibition by third-year junior pupils illustrates the extent to which some schools utilise the potential of Drumcroon. It is worthwhile considering the workshops in detail.

Pierre Degen trained as a jeweller. Swiss by birth, he now lectures and practises his craft in this country. This exhibition was untypical in that the work

Pierre Degen, Personal Environment, *1982*.

was not brought together through Drumcroon's normal procedures. It was initially shown at the Crafts Council Gallery in London and it came to Drumcroon once it started touring. Called 'Pierre Degen: New Work', the exhibition showed how far Degen had moved from being a conventional jeweller, for he was exploring aspects of personal adornment in a very free manner, to the point where a number of the displayed pieces were called 'personal environments', large-scale works incorporating life-sized dummies. On visiting the exhibition at the Crafts Council Gallery, the Gallery Education Officer immediately saw the value of showing an exhibition with such a wide variety of work made by someone with a very strict and straightforward training because 'I always thought that jewellery stopped at earrings and brooches . . . and even if the materials are not precious they are presented in a precious way. Even though they might be made of perspex and plastic or something like that, they are still little precious objects beautifully crafted.'[16] This exhibition

obviously contradicted such preconceptions and would be thought-provoking and stimulating to children as well as presenting many teaching challenges. Displayed in Drumcroon's domestic-scale rooms, the exhibition had a different impact than when it was shown in the spaciousness of the Crafts Council Gallery, but the concentration and scale of the objects made the Wigan exhibition strikingly dramatic.

There was a standard catalogue accompanying the exhibition which, though attractively presented, was too expensive at £1.50 for the vast majority of children and adults who would be visiting. One of the clear findings of the CSAE Project, from the outset, was the fairly predictable one that most teenagers and young adults feel the need for additional information as an aid to gallery visiting. However idealistic some gallery staff might be about the work 'speaking directly to you' we ignore this need at our peril. Though the standard catalogue was therefore available for the 'connoisseur', the individual *already* involved in the visual arts, an additional broadsheet was produced for the benefit of *every* visitor. This dealt specifically with the exhibited works, for another reservation about the official catalogue was that it was essentially to do with Degen's work produced *prior* to that in the exhibition.

In preparation for the workshops, there had been three long telephone conversations with Degen, this being the one instance where liaison had not taken place from the outset. It was arranged that Degen would come to the Centre for two days and conduct a workshop with the children, talk to other groups, and attend the Friday evening preview; an event to which all Wigan art and primary teachers and others on an extensive mailing list are invited. As a lecturer working with polytechnic students, Degen was a little apprehensive at the prospect of working with ten-year-old children, but the Gallery Education Officer was confident, 'I knew he would be able to talk to children by the way he talked to me on the phone – you get this idea about people don't you?'

'You knew the minute he arrived as well, because I said "They've been asking questions about you" and away he went.' Two of them asked him about *Banner*, a large piece leaning against the Main Gallery wall. He immediately picked it up, hoisted it over his shoulders and walked about wearing it, bringing it vividly to life, for all his work is to do with the body. In talking to the children he also emphasised the immediacy of his approach – the 'throwaway' element in his work surfaced. 'One of the things I liked when he was talking to the children was that he didn't put his work on a pedestal.' Indeed, he constantly emphasised to the children that 'Anybody can do this, it doesn't require any craftsmanship or any sort of talent, it is just getting things together and joining them and seeing whether you like it or not . . .'. He stressed that the idea developed by the act of joining materials:

> You wouldn't think of it maybe if you draw . . . It sometimes is very difficult to find how to follow an idea, but if you don't have a precise idea of what you are going to do you can be more spontaneous, you can just do it as you go along . . . You just decide at this moment, you decide O.K.![17]

The Gallery Education Officer liked this 'transient idea of his art not being something to be marvelled and stared at, waiting till the end of time, and I think the children related to that as well'. But it was disquieting to their teacher. She admits to having been frightened by the work, and to having felt that the children would react against it and be negative, reverting back to 'their own tradition'. In practice things were quite different:

> Then when we got there . . . seeing the kids absolutely throw themselves wholeheartedly into it, helped us adults to become so involved in it. Because they were so uninhibited about the whole thing, I think we lost our inhibitions as well. I think this was one of the great things about it.

The teacher's preconceptions about art were severely tested, though, and she found some of the implications of the exhibition threatening:

> But I had no terms of reference. I mean, the coffee bag on the stick, for example, I could see what it was, but I thought, 'What on earth will they make of it?' We try to tell them that art is, in a way, not sacred but it's something that's beautiful and rather special – I mean, and then a brown paper coffee bag on a stick! I thought, 'Oh, it's destroying what we're trying to imbue as artistic values – concern for detail, care, etc. . . . But Andrew said after a while he could see what it was about, that you had to put your hand inside this coffee bag, and the coffee bag was to protect your hand like a glove. And so the whole symbolism of the whole thing was fitting into place so easily for them, whereas for me it was – they taught me![18]

This use of utilitarian objects made sense to the children, and it helped them to see everyday objects afresh. Amongst an arrangement of sticks, including the coffee bag, Degen had added a broom which Sandra liked because, 'You don't really see many brooms around and I like antiques a lot . . . They used to use them in old times to sweep floors, but now we've got vacuum cleaners and things like that. That's why it was good.' Perhaps because they do not bother about categorisation, as do so many adults, the children were more immediately sensitive to the symbolism, as the Gallery Education Officer observed:

> All this business of the cross . . . It's everywhere. It's all to do with his ideas on marks which people make throughout history and which never change . . . There is that fascinating one where he has the cross in very rusty wire and there is the shadow of the cross because it stands proud and there is even the print of the cross where the wire has been pressed against it. The children noticed things like that.[19]

The teacher's honestly expressed doubts and her enthusiasm nevertheless for the whole enterprise suggest that it is maybe such people who are the natural avant-garde of the teaching profession; they utilise these situations to the full because they are so sensitive to the needs of their children, extending themselves in the process, whereas some who cannot categorise the work consequently 'censor' it for their pupils by refusing to allow them to see what, to them, is not

'Art'. The children undoubtedly did discern skill in what Degen did, however. Rodney thought there was:

> . . . an amazing use of the material together because when different things are put together they make different solutions each time you move them . . . I noticed that the materials were carefully bound together with strings and elastic bands because if Pierre Degen didn't do it carefully it would all go wrong.[20]

The teacher's preparatory work had been thorough. She had dealt with the vocabulary aspects and the children did work on materials, both natural and man-made. They talked about types of sticks that people carried around, and adornment – how it can be used for giving off messages such as 'Keep away from me', 'Come closer to me' or 'Do you think I'm nice?' They also discussed such issues 'in relation to African warriors and how they paint their faces and how women wear make-up, and this is a different form of attraction', and of course they got round to the local punks. The teacher had seen the exhibition in advance, had the catalogue and preparation sheet from Drumcroon and had discussed in detail with the Gallery Education Officer what she was going to do with the children prior to the visit – in his gallery involvement with them, he would pick up and develop many of these points. The teacher tried 'not to tell them anything about the exhibition in advance', though, and she didn't want them to have any bias of hers. The children's written work reveals that a number thought they would be bored, and once in the exhibition Sandra had worries:

> In Pierre Degen's exhibition there was this Personal Environment No. 3 . . . I spent a lot of time talking to Pierre about Personal Environment because I liked it. When I was looking at this Personal Environment it was shaped like a little world of your own. It had red cloth, yellow dowel, black cloth, blue and white string, and white cloth. First of all I thought this is going to be hard to understand and then I found out that the red was for sunset, yellow dowel was for the sun, the black cloth was for night, the blue and white string was for the sky and last of all the white cloth was for morning. Pierre Degen did not think that until I told him.

She is more than happy with an explanation entirely of her own making and quite unperturbed that Degen 'did not think that' until she told him. Her teacher recalls Degen saying to Sandra, 'I never looked at it like that until you told me':

> . . . because she'd got the whole thing of the sky and the clouds, and the windows and the curtains, so that you drew the curtains when you were fed up of everybody and you opened them up when you were feeling happy and you wanted to meet people. She really had got the whole thing there, even down to the colours . . . she was quite taken by these Personal Environments, she was right into it.

The children were in the Centre for the day, with the workshop scheduled for the afternoon – the whole morning being spent in discussion. Degen had suggested a list of materials over the phone, and as wide a range of these as could be obtained were available when he arrived on the Thursday. He met the children in the morning and had established a natural relationship with them by the time the workshop began. This session had to take place in the Conference Room upstairs, but two of Degen's pieces were on display there, anyway. In introducing the workshop, Degen clarified points by actually joining materials together while he was talking, and what he produced was eventually incorporated into Dale's construction. The gallery staff described the workshop as 'frenzied'. The children worked without respite until they had finished their pieces, and all the Drumcroon staff gradually became involved. 'I think this was because it was to do with the body, a lot of it. They needed help because they just couldn't fasten things on.' Their teacher found these constraints beneficial because of the way in which the children began to work together: 'They had this experience of working together. They really depended on each other. They had to, because you can't fasten an elastic band around something when it's sticking out here!' Equally, she saw the elements of spontaneity and improvisation to be an important aspect of this day, and in contrast with much of school learning on a day-by-day basis: 'It was a valuable exercise for them to be involved in a situation where the adult interaction came after. The ideas came from them. Them having the spark, and then us following their instructions, virtually, was very worthwhile for a lot of them.' This improvisation is reflected in many of the subsequent written statements. Gareth wrote about his piece: 'It is made of wood and wire. It is coloured in paint. I thought of nothing but joining wooden pieces together . . . ', and Yvonne says that she made her *War Banner* 'out of my imagination and I didn't know what it was going to look like in the end'. Many of the children describe the actual making of their pieces but Sandra, when talking later, touches on the problems involved in making such a construction. She naturally related hers to *Personal Environment No. 3*:

> I wanted to make mine a bit the same, but I didn't want to use a lot of cloth hanging down or else I wouldn't be able to see where I were going, so I just thought I'd make it down one side instead of all round me. It was a bit sore on my shoulder when I wore it because of the harness. It was just plonked on there, and I had to hold a stick at the front of it, and it was hard to keep hold of that and keep it on my shoulder. I had to turn sideways going through a door or my environment it would have just gone splat, and the wood would have broke at the sides. I were a bit worried in case I banged somebody in the back. It was a bit too big, you see.[21]

Degen's work makes us conscious of the 'pocket of space' which we occupy, and the spatial implications involved in constructing their own personal environments were new issues to the children. When Sandra referred to Degen's *Personal Environment No. 3* 'being shaped like a little world of your own' she had actually gone inside it and been shut off from the outside world by a screen

of surrounding semi-transparent material, creating an unusual cocooned space – elements she had attempted to incorporate into her own work.

The workshop was intensive, the children producing quite complex and elaborate structures in an amazingly short time, and many proceeded to decorate their faces with paint in keeping with the characters they had now assumed through the addition of their environments. (Their deputy head teacher still recalls the sight of them returning to school at the end of the day, still in character.) Degen had said to them: 'You use fantasy and you decide', and a fascinating aspect of this workshop was in the relationship between the release of fantasy and the imaginative freedom on the one hand, and the practicalities of joining, tying and constructing which of necessity had to take place. In later workshops small-scale pieces, like non-precious jewellery, were made as well as larger, more-considered constructions over longer periods. These were effective off the body as sculptural pieces in their own right. The main characteristic of this workshop, though, was the inspirational nature of the work produced with each piece seen to the best advantage when worn. Many of the children commented afterwards how they felt as if they were different personalities while wearing their structures with their faces painted. These feelings were later affirmed at the Royal Exchange Craft Centre in Manchester where they participated in a mask workshop run by George Waud as part of a joint venture relating that Centre's mask exhibition to Drumcroon's 'New Work' by Degen. In the follow-up work at school, about different feelings and emotions arising out of this experience, Dale wrote a piece called 'Anger':

When I get angry I kick and I yell
But I am happy when all is well.
If I am sad I am furious inside
When I get sent to bed I kick and I cry.
When I have a fight I punch and bite.
When I am angry, lines come to my face
Then I go home and shout and moan.
My face goes red with rage, and my neck muscles stick out and I stamp and
 roar about.
My fists clutch together: I stamp my feet with rage and fury . . .

But one thing is for sure . . .
When I am angry . . . *I AM TERRIBLE!*

Degen's exhibition was called 'New Work', so when the class decided to organise an exhibition of their own in the school library they called it 'Our New Work'. The Drumcroon staff received a letter from Class 7 which read:

Dear People at Drumcroon,
 Thank you for working with us and for showing us around the Pierre Degen exhibition. So that we would know how to put up an exhibition we decided to make one out of the work we did with Pierre and George. We think we have done all the things that you have to do at Drumcroon when

you put on an exhibition. We thought of a catalogue with exhibition numbers and identity badges with our names on too. One of the fourth years typed out the descriptions of our work and we will be holding a preview on Friday 28th January. There will be refreshment the preview will be at 4.00 p.m. We would like the staff from Drumcroon to come because you are the people who gave us the idea to do the Exhibition when you asked us to come to meet Pierre Degen and George Waud. We have Special Permission from our mums so that we can stay and talk to people after school.

The preview was very well attended by parents, teachers from other schools, adults from Tyldesley, etc., and each of the pupils had responsibility for taking these adult visitors around, explaining and discussing the work with them in the most responsible manner. Their teacher commented: 'A lot of them mentioned the feeling of being very grown up when they were actually involved in dealing with adults. They were being the guides and they had got the information.'

A final interesting point is the considerable amount of correspondence which developed between the children and both George Waud and Pierre Degen. Waud wrote to every child in turn and a beautifully 'illuminated' letter from Degen, decorated with a design in coloured chalks, inspired equally elaborately produced ones from all the children. The motivating effects of many key formative moments are recorded in this book and in one of these letters Melanie informed Pierre Degen that 'Ever since we went to Drumcroon we have made a vast improvement in all the Art we have done.'

Each Drumcroon exhibition has a different emphasis and each one can lead to a variety of workshops and school involvements. The use of the Degen exhibition by this class illustrates the type of fully rounded experience which can develop when a relationship between classroom activity and gallery visiting is achieved, though for this to happen, it is necessary for the two parties – school teachers and gallery staff – to be consciously engaged in a partnership with each making a positive contribution. Too often teachers and children arrive for gallery workshops with little or no awareness of exhibition content or of the nature of the work about to be undertaken; there is a correlation between the preparatory work done and the amount of follow-up work which ensues, the exhibition and gallery work being at the fulcrum, though, because it exposes the children to unique stimulus. In fulfilling its role to complement and extend the work of Wigan's schools, it should lead children to involvements which they might not experience, at least to the same degree, otherwise. In this instance, these can be summarised as follows:

1 The children derived a great deal from the Degen exhibition, getting 'inside' work which was unacceptable to many adults because it was outside their normal terms of reference.
2 A spontaneous and improvised manner of working was in contrast to the more logical approaches to which most children are accustomed – important for future adults who are going to have to be more adaptable than has hitherto been the case.

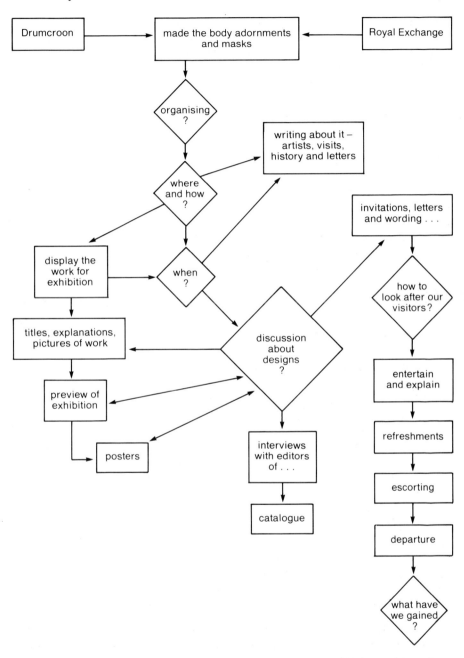

A school diagram listing all the interactions and involvements which arose from the Pierre Degen project.

3 A frenzied workshop nevertheless retained a working order, largerly due to the responsible way in which the children assisted each other; the teacher felt that this unsolicited mutual co-operation was of great importance.

4 The reversal of the teacher informing pupils to adults carrying out the children's instructions, followed by the pupils taking adults round their own exhibition, resulted in fairly uncommon interactions with adults.

5 The children's staging of their own exhibition gave them valuable insights into the judgements and decisions which have to be made when choosing between possible options and alternatives.

Drumcroon grew out of one education authority's diagnosis of its local needs. The percentage of the population who already visited Preston, Liverpool or Manchester galleries and were committed to gallery visiting was a small one. Drumcroon has brought the visual arts to Wigan's pupils and students and laid down ground rules to facilitate active participation. The total concept has naturally aroused a lot of interest and numerous individuals are attempting to establish similar centres in various parts of the country. In the present climate many of these will inevitably fail to materialise. Nevertheless, some of the underlying principles which underpin the philosophy of Drumcroon are applicable to many of the galleries and centres which are already in existence and there is already considerable feedback indicating that some quite major galleries have made modifications based on the Drumcroon experience. The residential art centre, in which groups of pupils can work at problems in a sustained manner over a number of days, provides another model worthy of consideration (see opposite p. 130).

(b) A Residential Arts Centre

The course has now widened my knowledge and opinion of abstract and modern painting. Before the course I looked upon the abstract painting as being very simple, and that no real thought or time had gone into the paintings. Now due to having experience and looking at this type of art work [I realise that] colours and shapes can all work and complement each other to make very effective paintings and collages.[22]

Fourth-year secondary pupil

The Residential Arts Centre opened in 1975 and is quite different in type from the other examples cited above. Situated in a village in the heart of a rural county, it is a converted secondary school now used for educational work in all the expressive arts. It does not have an art gallery, but works have been purchased from visiting artists and these are displayed around the building. What it does have, though, is residential accommodation which allows for a programme involving the children in visual arts studies for a whole week, with pupils and teachers 'living in the Centre'. Meals are provided and there is a lounge area with coffee-making facilities and a collection of books which are often used to affirm workshop points as well as for browsing. A former science lab is now a lecture room and the main focal area is the former school hall where all the

practical workshops take place, the scale of the work often ensuring that the floor is the major working surface.

As part of the authority's involvement in the CSAE Project, five related one-week sessions were held over a fourteen-month period, all of them well documented. Trevor Jones led the first week which was for schoolteachers and college lecturers, and there was inevitably some hostility brought about by the role reversals, with the teacher now the taught, that this process necessitated. Both the practical sessions and lectures focused on the spatial qualities of colour and stressed the differences between objective and creative drawing. Considerable demands were made on the teachers, some of whom had not produced their own work to a serious level or been 'instructed' for many years. By the final critical appraisal session, though, the general feeling was that the week had definitely been beneficial, one teacher summing it up dramatically when he said: 'You have managed to undermine everything I have believed in for the last twenty years, and I am grateful.' One of the recurring features of the subsequent weeks was that teachers worked alongside their children – not necessarily as equals because their teaching skills were still being utilised to discuss, coax and encourage pupils – involving themselves in the same practical problems. The first week was therefore of considerable importance.

Each of the weeks had a specific focus: one was concerned with the face and the figure, another with the investigation of space and its rendering through colour, for example. The Centre deals essentially with the upper secondary age-range, from the fourth year onwards. A typical week would follow the pattern of that run by Oliver Bevan for twenty-five fourth-year pupils. The project was called 'Colour in 20th Century Art'. The initial introductory and discussion session on the Monday morning also involved the pupils in optical mixing using discs, and in the afternoon tiny paintings of small still-lives were executed, the pupils working three to a still-life group. After tea, the first day concluded with a slide show and a film on Matisse. The next was spent in painting, some of the paintings being 30" × 25" with very colourful, optical dots being applied with decorators' brushes. A slide talk by Bevan about his own work concluded that day. On the Wednesday, the pupils were introduced to the collages of Schwitters through slides, and they eventually made paintings from their own collages constructed from coloured scraps collected in the village. The day concluded with a talk by Stephanie Bergman about her own work of dyed and painted canvas pieces stitched together to make paintings or 'hangings'. Thursday commenced with a brief slide show, in which the staining, layering and scratching techniques of Morris Louis, Helen Frankenthaler and Paul Klee were emphasised. That day collages, many of them irregular in shape, were built onto coloured grounds, 'beautiful' in their own right. The day was rounded off by the pupils giving a slide presentation of paintings which they either particularly liked or disliked. After the necessary cleaning-up session on the Friday morning, the week concluded with a quite intensive criticism by Oliver Bevan of all the work produced which was displayed around the hall, the pupils often vigorously justifying what they had done even though aware that a

particular piece might not have been satisfactorily resolved.

In addition to the evening film and slide shows, on occasions pupils would work on a particular painting or collage until bedtime, so the three session days over the course of a week led to intensive and concentrated experiences. One teacher makes the point that the 'five-day course is equivalent in hours to a term's work' but, unlike the school term, 'it is made up of concentrated, uninterrupted time', meaning that the course could give the pupils 'so much that we cannot'. The contrast with the teachers' perceptions of some school situations can be quite striking. One, for example, contrasts the 'relaxed informal atmosphere with plenty of work space, materials and time together with a good pupil/teacher ratio' with the less conducive school circumstances in which practical, financial and motivational problems are not always viewed sympathetically. 'Teaching methods are determined by these factors.'

Not surprisingly, by contrast, this teacher's pupils who had attended returned to school with 'an added enthusiasm and commitment to art'. Fourth-year pupils from three or four different schools often form the group for one week, and many of them finding themselves facing unusual demands in a strange place amongst new faces, admit to an initial disorientation: 'As to Monday, the first day – puzzling and confusing as to why? and what? . . . The film on Matisse left me with an even bigger grudge to Modern Art, though I was trying very hard to understand and enjoy this work.' By the middle of the week, new insights and understandings were forming through the Centre's particular balance between the input of the film and slide sessions and the working out of the related problems in practical workshops:

> The Artist-in-Residence, Oliver Bevan, showed some slides of his work and explained them to us. I did enjoy some of his pieces. There was a reason for its existence . . . it was not just some phoney Modern Art as a whole . . . The days after were terribly hard work with lots of painting . . . I went to work like a mad-man with extreme enthusiasm to finish pieces of work. The problem I experienced was painting my last still-life 'sight size'.

New friendships had been made by the end of the week and the newly formed attitudes were inseparable from an accompanying, uncomfortable questioning of previously accepted assumptions:

> I now felt more secure with the people from other schools . . . The old negative attitudes have gone and I am much more sympathetic to Modern Art . . . I could not help to feel depressed in that our work had finished at the Centre, and that we could not carry on this work for the O-level syllabus cannot accept this type of work. This O-level emphasis on dull drawing saddened me. Why cannot there be a new reform in the O-level syllabus that could accept this type of work?

This problem of the dichotomy between the values derived from such a concentrated week and the assumptions about examinations leading to predictable methods of working on a week-by-week basis is stressed by many of the pupils and also their teachers:

Schools are increasingly concerned with 'accountability', which invariably means success with examinations. In most subjects there seems to be a difference between what is required to pass an examination and what constitutes an education in that subject.

In the Critical Studies in Art Education Course it was most refreshing to be involved with a course which was more concerned with an educational process rather than the production of an artefact for assessment.

This is a not dissimilar statement to that of the pupil, but while the latter can only complain, the teacher has the responsibility of attempting to reconcile these two factors in the pupils' interests. There is considerable evidence to suggest that those art teachers who run courses determined by their beliefs about art education are as successful – if not more so – as those who set out to prepare their pupils for examinations. Particularly when one considers the increasing participation in the 16+ art examinations, with their emphasis on exhibitions of course work like those which characterise the CSE, is it really necessary for there to be an emphasis on *dull* drawings? Fortunately, such weeks will continue beyond the life of the CSAE Project, but the reconciliation between these two seemingly diverse approaches will have to be worked out and resolved in the classroom. The practical involvement of teachers as well as pupils at the Centre is already contributing to this necessary reappraisal of existing classroom practice.

Though a number of artists have made significant contributions at the Centre, Oliver Bevan has been one of the anchors, participating in the initial sessions run by Trevor Jones and leading three subsequent weeks. The Centre chooses its artists carefully, for their responsibility towards the pupils and ability to work with their teachers is essential. Oliver Bevan normally teaches Foundation students and is a hard-working, committed and articulate art educator. His effect on a number of pupils has been considerable, as illustrated by Andrew, an A-level student:

I've enjoyed the week a lot. Being with the actual working artists, a person who is occupied by producing Fine Art – that's been quite a unique experience for me because I've had experience of meeting teachers who do paintings in their spare time as a hobby, but to meet somebody who experiences that all the time! . . . His whole attitude to life is through the eyes of an artist.

Working with fourth-year pupils, though, Bevan found that he had to reappraise what he had planned because 'most of the group regarded "Modern Art" as something of a put-on'.[23] There was a lack of information in the Matisse film shown on the Monday, and he knew that the pupils were unhappy that evening – 'I anticipated a difficult week and the probable failure of the course.' To rectify this he had to rethink the second day so as to substantiate some of the theory from the Monday and he describes putting 'an unusual amount of effort' into the evening talk about his own work. The balance between careful planning

and the modifications which have to be made while thinking on one's feet is essential in ensuring that the week develops the necessary momentum; important social interaction inevitably take place between pupils from different schools and with teachers in this more informal context, but a week can still seem an awfully long time when the planned course falls flat.

Being used to dealing with older, more mature students he was struck by the recurring difficulty of pupils dealing with objects first and leaving large areas of empty background until the end, when they were invariably painted in flat colour. Nevertheless, he found that 'the standard of work reached was remarkable', and any doubts about four and a half days of solid art proving indigestible were dispelled – 'Students I spoke to seemed as excited as I was about what was going on.' It depressed him to think of them 'returning to the O-level syllabus with its emphasis on neatness and pencil technique': 'I hope many more children will experience this atmosphere, and in consequence feel free to become artists or designers or even members of a critical and informed audience for the visual arts.' Only one of the group had previously heard of Matisse and 'very few' had been to any exhibitions – they were prejudiced against 'Modern Art' at the outset. Bevan believes that two experiences helped to overcome this attitude. One was being guided towards making works of their own that they could identify as 'Modern' and the other was meeting two practising artists who, one hopes, came across as being likeable and honest human beings. By the end of the week he believed that he had realised his main aim, which was

> . . . to lead the students into the modern period and make for themselves some of its discoveries relating to colour and composition . . . even if at a relatively simple theoretical level. I concentrated on respecting the object being made, as an experience in itself, and led them towards this by showing how mixtures could generate abstraction by pulling the colours out of the objects set up.

He would like to see this kind of course paralleled by the schools, but recognises that this would necessitate work-units of no less than three hours. He is a strong advocate of artists working in schools and teachers taking groups on gallery visits. Teachers should also show their own work to pupils since that put them on the map as creative people, and he thinks that their fear of influence and imitation is quite unjustifiable 'because other influences are at work in magazines, science fiction, record covers, comics, and we have all learnt through influence how to locate ourselves relative to our culture':

> The teaching of art has two aspects – Janus-like – looking outwards towards the visual language evolved by the culture we share and looking inwards towards the individual student's expressive needs . . . Traditional classroom art, of the kind guaranteed to please the examiner, ignores the history of art in our own time and substitutes a form of illustrative realism as an unquestioned assumption.

This duality of approach is the essential feature of these weeks. Because art history and appreciation courses have traditionally been taught in isolation from practical art lessons the assumption is often made that time devoted to critical studies issues means a denial of the expressive aspects of art education. Oliver Bevan's work at the Centre emphasises that the vast world of art is a rich treasure-house to be plundered and enjoyed. In the process, insights are developed and the imagination fed; it is hardly surprising, then, that much of the work produced during a typical week is of a very personal and expressive nature developed from a basis of knowledge and understanding as opposed to so much of children's art which, in the name of 'expressiveness' is often emptily derivative.

Only a relatively small percentage of pupils benefit from what education arts centres can offer, though; such resources are simply non-existent as far as some authorities' pupils are concerned. There is, therefore, an equal need to improve the resources available in the classroom for the benefit of all school pupils.

Conclusion

The theme of Part V is partnership. The argument for pupils having experience of art in galleries is taken a stage further to the point where the view is put that gallery staff have knowledge and expertise which should be used to complement that of the teacher. It is also developed in another direction to put the case for visits to specialist art and education centres. The author has employed a range of examples to stress the need for liaison, preparation, communication and for frameworks which make this possible, including continuity of opportunity, appropriate exhibition policies, and dialogue on a common ground.

Secondary to the theme, the question of pupils' related practical work has been taken up once more. Gallery workshops are seen as allowing a personal involvement which helps children come to terms with the work of others and gain insights into practices relevant to their own needs. The display of children's work alongside that of mature artists is another way of achieving this and also of assisting adults to approach and engage with art. The point is made that gallery education for children and the wider availability of accompanying materials can play a part in making art more accessible to the whole community.

Turning back to the schools, the author suggests that the mainstream curriculum should be broadened to include gallery and centre visits and that, instead of sequential appreciation, there should be in-depth examination of a few objects so that enquiry would proceed outwards. He describes a key criterion for effective art education: the teacher should be open to new experiences and able to grow through discovery. Other aspects of an ideal situation would be three-hour time-units, contact with artists willing and able both to plan and adapt, and a willingness of teachers to show their own work.

Part VI

Original Works in the Classroom

Section 1 Original Works for All
This section approaches the matter of original works in the school from three different standpoints. It views present provision descriptively and analytically in terms of how loan collections could be employed educationally and their use supported. It considers the educational context for those pupils whose need for exposure to loan materials is greatest; the author argues it is those in secondary years 1–3. It describes a project in a Yorkshire middle school which demonstrates how borrowings from loan collections can be the fulcrum of sustained, diverse and inter-linked learning.

Section 2 Unusual Classroom Initiatives
Developing from Section 1, this section comprises two case studies: one of a grammar school which has built up its own ceramics collection, the other a comprehensive where weaving began as an extra-curricular activity. They share certain characteristics, particularly that of the originating teachers being practising artists in the respective craft who have comparable educational philosophies. Both examples show what can be achieved through appeal to external providers and through the natural pursuit and example of teachers' own interests.

Section 1 Original Works for All

(a) Loan collections as a teaching resource
I have always thought schools, where children can spend at least five hours a day, five days a week for thirty-six weeks in the year, ought to be places which offer experiences of contemporary art, not just in the art rooms, but in different parts of the buildings and outside in the grounds themselves. So often, however, schools are bare places, occasionally relieved a little by rooms with different colour schemes, which reflect more the atmosphere of a barracks . . .[1]

Andrew N. Fairbairn

A school corridor – so often schools are bare places (photograph by Ian Macdonald).

Fairbairn, the Director of Education for Leicestershire, goes on to say that 'Where schools are also used by the community for adult education purposes, the bonus of adult introduction to contemporary art is achieved. If this is not on offer then, except in art galleries, children will seldom, if ever, be in touch with works of art by their contemporaries.' The impact which seeing works in the original can have is reflected over and over in the statements of individual pupils, and the CSAE Project has therefore inevitably put great emphasis on the need for gallery visiting. Even where an art department staff shares this commitment, though, and where the obstacles so often put up by the school to maintain the daily routine of its timetable can be overcome, only a relatively small stratum of the school population can ever benefit from such visits. In the majority of secondary schools such visits commence at fourth-form level and it is only rarely that first- to third-year pupils are so involved. A graph of art-gallery-visiting by school groups would reveal that the main usage is by older junior pupils and older secondary pupils, but to all intents and purposes eleven- to fourteen-year-olds do not visit art galleries and museums unless taken by their parents or as the statutory visit to the Louvre or wherever as part of a school trip abroad – unless they are in a middle school, for *their* older pupils, too, get taken on gallery visits if the school is so inclined. Accepting the

constraints and strictures of school-timetabling as they currently exist, only so many groups can be taken out of school in any given period and teachers choose their older pupils, no doubt on the assumption that they will behave more responsibly and derive most benefit from such ventures.

It is therefore essential that works of art and craft, preferably in the original, are systematically and thoughtfully presented to pupils within the school context. Equally important, pupils of all ages can benefit enormously from living with such works on a daily basis over an extended period of time. This kind of daily contact can contribute to a sympathy and awareness for the objects in question of an order other than that arrived at through specific explanation and logical understanding. (We have already seen that though Julie did not initially relate to the Gerd Winner exhibition which she had visited, she 'definitely had a sympathy' with Winner's *Catfish Row* etchings after they had been on display in her art department 'for quite a few months', and she describes them as still being vividly in her mind.) There is a strong case, therefore, for works of art and craft to be a carefully considered part of the school environment, working their effect by virtue of being there.

Some teachers show extraordinary initiative in acquiring original works for display and use in their schools, staging small exhibitions by local artists and craftspeople or through the loan of portfolios from former students who have gone on to study the subject in higher education, or by the loan of selected works from the local art school, etc. In one or two exceptional cases it has been possible to establish small galleries within the school utilising teaching areas made available through falling rolls. One example has recently been opened in a community school. Staffed by adults from the local community, it runs a programme which was inaugurated with an exhibition of sixty Henry Moore etchings and lithographs but which equally draws on the work of the local community and of regional artists and craftspeople. Such instances are obviously rarities, but there are places in most schools which, with a little imagination and effort, can be modified to create valuable exhibition and display areas so that both the pupils' own work and that of other artists and craftspeople can be seen around the school as well as in the art department – particularly important for those pupils who are no longer studying art subsequent to third-year options.

One or two authorities periodically organise sales of original works so that schools can purchase items at reasonable prices, and a number of schools have successfully built up permanent collections of impressive quality. Given the will, any school can begin to build up its own collection; many print dealers, for example, will offer educational discounts of up to a third, meaning that the works of well-established artists can be obtained at extremely reasonable prices. Ceramic pieces of good quality can likewise be obtained, and college diploma shows are a source of greatly varied works of quality at often absurdly cheap prices. However tentatively a school has to purchase in the first instance, the effort will prove worthwhile within a few years. For the majority of schools, though, LEA-administered Museum and Picture Loan Schemes are the best

Before: a typical secondary school classroom.
After: the same classroom converted into gallery. Henry Moore prints are on display.

means of ensuring that children have access to an adequate variety of original works; every authority should run such a scheme. Some collections, like that of Leicestershire, have acquired justifiable reputations but others, in recent years, have fallen victim to expenditure cuts (even though they represent one of the rare areas of education spending which might be regarded as an investment!). Some are currently funded at a level which only allows for repairs and general maintenance of existing works and others are being run on such a shoe-string that the necessary back-up to administer the service adequately is not available. It is surely false economy to have valuable resources out of use as a result of the withdrawal of the relatively insignificant sums which were previously available to enable them to function properly.

Though loan works can be under-used to the point where they are little more than corridor decoration, their benefits can be such that it is essential that loan collections are adequately funded. In recent years, the Regional Arts Associations have supported many schemes and specific purchases by financially matching the LEA funding, and many art advisers and museums loan officers have done excellent work in making interesting and varied purchases within the constraints of their budgets. The older established collections often contain notable examples of painting and sculpture by British artists who have gone on to establish considerable reputations, but newer collections (such as that of Wigan, begun after local government re-organisation in 1974) have had to use the many excellent examples of contemporary printmaking as the nucleus of their collections, though selective painting and sculpture purchases are still possible. Some of the more imaginative schemes are extremely broad-based, and include ceramics, glassware, embroidery and textiles, jewellery, examples of modelmaking, etc., as well as prints, paintings, drawings and sculpture.

One of the criteria by which loan purchases are made is that they will provide the art teacher with teaching aids. In consequence, many of the works purchased are examples of sound draughtsmanship and there is a marked tendency towards figurative work in many collections. However, there is an equal need for purchases to be thought-provoking in the sense that they have the potential to make children aware of values additional to those which underpin their own practical work. In this respect it is desirable that loan collections should be rich and diverse in their content, as well as in the variety of processes represented. For example, a set of Robyn Denny screenprints – non-figurative and consisting of rich rectangular areas of colour – was recently displayed in an area adjacent to a college library entrance, provoking responses from numerous non-art sixth-form students and general subject teachers; whatever practical use art teachers might make of them, works of art and craft should also be enjoyed in their own right.

All too often supporting information with loan objects – if any is available – consists of little more than a list of where the artist or craftsperson in question has held exhibitions, where he or she trained, and in which other collections their work is to be found. This kind of information is of little interest to pupils and is therefore unhelpful to the art teacher, but when even that minimum

information is not available it is likely that nobody in the school even knows who the artist is, minimising the use which might be made of the works in consequence. In an attempt to deal with this problem, some authorities are exploring ways of developing appropriate supporting data, sometimes even including pertinent children's responses. Four fundamental areas all have teaching potential and should beneficially form the basis of any accompanying supporting information. They are relevant to all art and craft objects, though the emphasis on particular aspects will inevitably vary from work to work. The four areas are:

1 The techniques, processes and methods involved in the making of the work.
2 The formal qualities of the work; its arrangement into shapes, its form, the colour scheme employed, etc.
3 Its content in terms of subject matter; its significance, how the artist has accumulated the information, etc.
4 The mood, atmosphere or feeling evoked by the work.

Though the task involved in producing such material is a prodigious one where the collection is of any size, specimen examples chosen to represent a reasonable cross-section could form the basis of a series of invaluable in-service courses. Designed to achieve agreement between teachers and those who administer the collection, these would elicit what basic information was necessary for teachers to feel confident enough to be able adequately to respond to pupils' questions and to make full and positive use of the works both in their own right and in relation to the children's own practical needs.

(b) Some trends in secondary art, years 1–3, which affect critical studies

Pupils and students of all ages can benefit from the introduction to and use of museum and picture loan art and craft works in their schools. As there is strong evidence to suggest that children in the early years of secondary schooling are the least likely to be taken on gallery visits, though, it is logical – and important – to illustrate the practical use of loan material with a case study dealing with this age group. It might be of value to look first at some aspects of art education in years 1–3 of secondary education. This is the only point at which virtually all pupils are taught art and craft by specialist teachers in specialist accommodation. It is one of the anomalies of the education system that the option schemes at the end of the third year ensure that about 60 per cent of these pupils drop art – one of the rare subjects that form a major touchstone of our civilisation – invariably in favour of yet more 'academic' subjects. Unless their home circumstances are particularly favourable, or they experience the right breaks, by chance, while in higher education, the majority of these pupils' attitudes, values and insights in relation to the visual arts will be largely determined by their art 'diet' up to the end of their third year. These, then are vital years.

Unfortunately, the picture of these years which is reflected in the interviews with students is a truly depressing one. The majority of these students had

developed a motivation and commitment to art education, but were unanimous in their condemnation of their art lessons in years 1–3. The effect which being taught how to draw a spiderplant or a bottle 'correctly' had on Julie has already been noted, but student after student tells a similar story. The main criticisms relate to the undemanding nature of the work, the compartmentalised exercises, and the conformity:

> Everybody was doing exactly the same thing . . . we found the middle of this piece of paper and all we had to do was draw lines to the centre of this page and then draw vertical lines going in towards the centre, and they got smaller, smaller, smaller and then we had to colour them in, and it was so boring – it really was! Everybody's was exactly the same and we had a whole wall full of these pictures – different colours, but they were all exactly the same.

> The first few lessons at secondary school I didn't like at all. I remember one of the first things we did was we had to draw squares and then a squiggly line across the squares and then we'd do from light to dark in two colours. It was a nice effect when you had finished – but it was tedious doing it, we were doing the same every lesson . . . Everybody was doing the same, really, and I sort of felt though that everybody should have got the chance to do different things. If she'd explained and showed us pictures of what she meant by the gradual tones and the lights and shades of colours, we would have understood just as well as by doing a picture that took about six weeks to do. I remember that taking us ages, and I never thought that I'd opt to do O-level Art in a million years!

> There were more exercises in the first and second year. They were exercises in mixing your colour, and exercises in understanding the colour and colour circles – yellow and blue make green, and red and yellow make orange. You knew that anyway. I knew it anyway, and I think most of the others did. You knew what it was going to be like from the beginning, but you had to spend weeks and weeks doing it!

> In the art lesson you just had to draw objects like electric light bulbs and bricks that didn't really interest me a lot. We were being told more or less what do do. You had to follow certain guidelines all the time and you didn't have any freedom, you just weren't allowed to put yourself into it, really. They took weeks to do, and then you'd go on to another thing when you'd finished that. The only time I ever went out really was to draw some houses for pottery. That was good. They didn't turn out very well, but I liked it. I liked going out because it was different.[2]

Most art teachers will immediately recognise the exercises which these students describe – set lessons of which there are many other immediately recognisable variations. For example, the silhouetted townscape against an evening sky is a 'twin' to the perspective lesson described, neither having any roots in actual observation, and many 'basic design' permutations on the square and squiggly

line and colour circle lessons immediately spring to mind. All are prescriptive and allow so little variation that the pupils feel that 'you just weren't allowed to put yourself into it'. This last student describes 'objective' drawing lessons, and there are many sound reasons for pupils of this age undertaking a course which has objective drawing and observation at its core, but again the lessons have become isolated exercises, unrelated to any broader experience, and as such are a chore. The unpalatable truth is that in their descriptions of these lessons the pupils express an accompanying sense of boredom. They affirm Witkin's observation that control of the medium is emphasised in the early years and is so at variance with later art lessons that it is 'as though the two belonged to different universes'.[3] The aversive effect which these lessons have, with their built-in detachment, sets them at the opposite end of the spectrum to the kind of motivating heightened experiences already outlined in this book. The irony is that these lessons are undertaken in the belief that they develop basic skills (often on the assumption that children come to secondary school with no valid previous experiences). Yet the skills which are supposedly being taught remain as 'locked' experiences. All the evidence is that pupils fail to utilise these lessons in any future situation where such information could be relevantly applied – witness the number of pupils, for example, who are taught to coil clay often at, say, junior, middle and secondary levels but who, in practice, only repeat what they previously did rather than build upon and extend that experience at each subsequent stage.

Of course, if such exercises do have a part to play, it may be that they need immediate substantiation in subsequent lessons rather than assuming that the pupil has now acquired a new skill and will be able to apply it adequately in whatever relevant future situations. One fifteen-year-old pupil gives this lack of opportunity to substantiate the previous exercise as being the reason why she dropped the subject, even though basically she liked art. She describes one exercise in which the class had to 'design' a letter within a square, but copied from the teacher's example. She continues:

> As soon as we had done that we went on to something else, and I did not really know what the point of the previous lesson was. We went on to something different, and it just didn't relate to anything else that we did before or after – as soon as we had finished it, that was it. I remember doing a topic where we had to design a record cover and then we went on to observational drawing immediately afterwards, and the two did not relate at all. The topic did not have much by itself, and I would have thought that it was leading on to something, but it didn't. That was just what we did, not knowing why we did it really. I didn't see what it had to do with anything!

This pupil, too, did not like lessons where she was told to draw a shoe or a pencil sharpener, but recalls one enjoyable lesson when they went outside to draw, 'because you could choose the view that you were going to draw. You could choose the bit that you found interesting.' Most of the students made reference to some such lessons which stood out as having been enjoyable because some

form of personal involvement was possible, but many state that there was only one such occasion in three years!

If anything, the picture is gloomier now than when Witkin's observations were made. Design faculties have become the predominant form by which practical departments are organised, and many of the schools involved have adopted a 'carousel' or 'materials-roundabout' system whereby children rotate from teacher to teacher, and hence from process to process, often as frequently as every six or ten weeks – sometimes spending a whole term, or even two, away from the art department altogether. Such isolated pockets of time have inevitably led to an emphasis on producing an end-product by whatever means in the allotted time, and quite imaginative and committed teachers have resorted to prescriptive teaching, inevitable when one considers that the pupils will move to another teacher before he or she has even had adequate opportunity to learn all the pupils' names, let alone get to know them as individual people. The DES's *Curriculum 11–16* book states that 'The quality of experience is far more important than the quantity of time, though less than about two hours a week will make the achievement of reasonable standards very difficult at any age level'.[4] In practice, these two elements are interwoven in a very complex way in many secondary schools. The introduction of the materials-roundabout has coincided with a reduction in time-allocation for practical subjects – the two issues rarely unrelated – to double periods of seventy minutes, sometimes even less. When it is added that lower-school art group sizes have been increasing from twenties (one of the initial positive benefits to art departments of practical-subject integration) to thirties as a result of falling rolls, it is small wonder that many art teachers have resorted to prescriptive and standardised approaches to lessons in years 1–3. The situation can only begin to be rectified by a return to timetabling which encourages regular weekly contact with each art group throughout the year. (This could also do more for a raising of design-consciousness in pupils than has been achieved by the materials-roundabout in the name of design education; rather than leading to integrated courses, all the evidence is that rotation has resulted in short, fragmentary courses.)

Nevertheless, it seems ironical that the students interviewed – from many varying secondary backgrounds – should be so critical of the only phase of art education when all are taught by art specialists. These isolated exercises, with their narrow self-sufficiency, are the antithesis of anything to do with critical studies, and do little to broaden understanding and develop insights – as is illustrated by the fifteen-year-old feeling that there should be some reason for the lessons she was doing but being unable to discern what it might have been. Such lessons do little to develop pupils' attitudes to their own work and are unrelated to the world of art in general. One of their underlying assumptions is that children have to learn the basic vocabulary of colour, line, tone and texture as a pre-requisite to all subsequent work, particularly of the problem-solving type seen as a relevant part of many Design faculty philosophies. Unfortunately, the approach is parallel to that which led to many of us reciting French verbs and learning grammar by rote without the development of any

subsequent ability and fluency to communicate in French at any but the most basic level. (It is interesting to note that the other phase of art education of which the students are most critical is the art college foundation year when there is frequently a return to a similar kind of basic exercise and materials-sampling to those encountered in the early years of secondary schooling.)

There is a lot of evidence, then, that in addition to not going on gallery visits, this age group is the most likely to have lessons which are self-contained in a manner that is unlikely to lead to a broader understanding of the visual arts; a particularly serious matter when one considers that more than half will not study the subject any further. The practical use of schools' loan art and craft works is one immediate means of doing something positive to improve this situation.

(c) The practical use of loan material

An example of good use being made of original works took place in a Yorkshire middle school which is set in, and draws its pupils from, a large corporation housing development. The first view of the school is of a monotonous and drab-looking grey concrete exterior in keeping with the depressed mood of the estate. Such feelings are immediately dispelled, however, on entering the building. Floors and walls reveal a well-maintained interior but the dominant impression is created by attractive arrangements of children's work – paintings, drawings and models – displayed in and around the main entrance area. Passing along the corridors this care over the presentation of work is maintained until one arrives at the door of the school's only art room. Outside this room there are two framed drawings by the art teacher which the school has purchased, and she has loaned two more which are also on display. They are studies of people and of young children and are delicate and sensitive in their treatment.

The teacher is one of a group of Yorkshire teachers involved in a project about the use of original works of art in school. The project was designed to explore ways in which museum loan art and craft objects might be fruitfully used in schools to extend beyond their often minimal function of brightening the corridors. The teachers attended an initial meeting at which the scheme was outlined to them, and they were shown slides of the collection from which their choices of works to be loaned were made. 'As I looked through, certain of the paintings I liked particularly seemed to suggest a theme to me. A theme of looking through into or through out to something.'[5] Her initial choice was therefore based on personal preference, but then subsequent works were selected because they related thematically to the earlier choices. She had to make quick decisions, 'Ah, what do I like, what could I work with and what would be useful in school? What would the children respond to?' She retained the appropriate slides and these proved to be very useful in arousing the children's sense of anticipation. The children saw these in a single lesson and as part of the resulting discussion, the teacher encouraged the children to keep their eyes open for examples of 'framed' images around them. They knew that the original works would be coming and that they would be making use of them:

Richard Platt, Matt Ussler's Pigeon Loft (*detail*). *The painting was one of the original works to which the children were most responsive.*

'So when the pictures did arrive they were quite excited. They knew they were coming and they almost built themselves up to them coming. They were looking forward to seeing them and the slides, of course, are quite small upon the screen and some of these pictures are enormous, absolutely huge!' Equally, of course, some of the paintings and a couple of etchings were extremely small, and the slides made them all seem equal in scale. The teacher took pains to arrange the works attractively on their arrival at the school, and the art room took on a novel and distinctive appearance because she had also loaned a set of photographs of local windows from Bradford Museum and had collected and displayed a wide variety of postcards and reproductions which related to her theme. These ranged from Gallery Five examples to reproductions of Cézannes and Bonnards, because, 'Of course, when you're involved in something like this, whenever you go into a shop it's "Oh, another window frame, I'll have one of those!" and there are some pieces of work that I've brought from home.' The teacher, therefore, had an extensive range of back-up material to affirm and extend points which arose from the use of the original works which, because of their varying scale and because they were original, dominated the room. She had prepared a list of all the works with their titles, the name of the artist and the medium used, and all the works were numbered accordingly:

I asked the children if they would treat the room almost like an art gallery, and they would walk around and look at the pictures and comment on them,

talk to their neighbours about them, come back and talk to me about them
. . . The nice thing about it was the kids would rush over and grab the arm of
a friend and say, 'Come and look at this!' and some would say, 'Oh, I don't
like that because it's messy' or 'It's horrible!' They would actually take
somebody from somewhere else to come and have a look at the picture they
were looking at, things like that . . . It wasn't quite like an art gallery – it
wasn't all hushed whispers!

To conclude this first lesson they wrote about their two favourite works and the
one they liked the least, giving the reasons for their choice. They were then led
to a study of their immediate environment, but related to elements within the
original works:

We started then taking the theme of looking through windows ourselves. We
are surrounded by some lovely industrial landscape, I suppose you would call
it. Some of it is industrial, some of it is sort of rural. We have quite a wide
spread, actually, and whilst we were looking at our own landscapes through
the window we looked at the pen and ink drawing by J. Alec Pearson called
Circuit Fields and Bubble Trees which has a landscape through a window but
also has some element of fantasy in it.

A black and white study drawn in pen and ink, this example was used by the
teacher not only for its imagery but for the technical points she could make
about the variety of ways in which the artist had exploited his medium. She
chose pen and ink for them to draw in because of this picture but also because
she feels that children of this age (the equivalent of first- and second-year
secondary) tend to be a bit tentative with their drawing:

They are terribly worried about getting it right and getting it precise, of
course, and they like to draw when they are drawing in pencil with a rubber in
their hand, and they don't trust themselves to make a mark. I think drawing
in pen and ink tends to make them more confident in their drawing, certainly.

The photographs of windows from Bradford Museum revealed a fascinating
variety in the shapes of the frames, and so, resulting from a study of these, the
pupils made their own window frames, cut out of card, and carefully located
them on the art room window so as to make interesting compositions where the
landscape inter-related with window-frame shapes. There was a great diversity
in the window shapes they made; some had rounded or pointed arches, others
had a large central window flanked on each side by smaller narrow sections. The
resulting drawings equally reflect this variety, for some form triptych designs
while others are striking in their pattern effects because of the relationships
between panels within the basic window frame and features in the landscape,
and the irregular outer shapes of the windows likewise added to the distinctive
compositional effects achieved. The children's observations of how an object
might relate to a door or window frame, or even be partly obscured by such
foreground forms in the original paintings, drawings and prints, gave them a

Pupils' ink studies of window views.

heightened awareness of such relationships in their own landscapes. In some a cloud, or even the hillside itself, eliminating all horizon, might pass behind the frame and the tension between, say, a tree and the frame gave a distinctive tautness to the compositions in many of these drawings, for effects of space and distance were consistently achieved and yet these relationships between near and far constantly reasserted the picture plane. Sustained effort and concentration, and a concern for the tonality and textural quality of specific works, was evident in study after study. These qualities were maintained throughout the work of whole groups and were not only apparent in the drawings of those pupils who allegedly had 'a gift for drawing'. It was clear that a great deal of work had gone into these studies and that this had been sustained over a number of weeks; the children's understanding of the mature works of art they had studied was as vividly reflected in their practical work as it was in their writing or through what they contributed to discussion.

The response to the Bonnard reproductions, etc., was very different from that to the original works, though: 'I think they probably paled in comparison. They certainly did not immediately rush to the display over there when I put the reproduction of the Bonnard up. It was just something else I had put up.' This might have been partially to do with the build-up she had given to the original works:

I was careful to explain to them that they were original works of art that artists had done and that you weren't looking at a photograph or something, you were looking at something that they had actually handled. I think they did see the difference . . . they did think that there was something special about it – magic, you know!

Unlike the reproductions, these works had tactile qualities. Though the pupils were not allowed to touch them, the teacher was aware that some of them did in a surreptitious manner. They looked at the backs of the works, though, noting that some were on canvas and had 'give', unlike others which were painted on hardboard. It was hardly surprising that the reproductions paled in relation to the physical presence and scale of these works, but some of the more unobtrusive works, such as two small etchings by Dorothea Wight, did not arouse much comment at first; however, as the weeks went by they, too, became increasingly significant to the children.

Once the drawings were completed, therefore, the teacher set up a still-life group of a patterned tablecloth, a bowl of fruit, vase of flowers, a jug and an old window frame complete with a lace curtain. With the group leaning against the actual art room window, the landscape and sky formed the natural background and was an essential part compositionally. The relationship to the Bonnards was immediately apparent. One half of the group of pupils formed a semi-circle around this arrangement (there was another still-life utilising stuffed animals and birds from the museum loan service, the imagery related to one of the loan paintings), and each pupil attempted to depict the group as it appeared from his or her viewpoint. 'I intended them to work straight away in paint with that

window set-up because we were looking at paintings in conjunction with them, you see. Our window would have apples and flowers and we looked at Bonnard paintings of tables and windows.' So she talked to them about drawing in paint, emphasising that because they were using brushes instead of pens this did not mean that they could not draw . She explained to them that

> Because you are painting it doesn't mean you've got to stop drawing and stop looking. You look and you work out where things are, and you look at relative sizes and positions. You also look at colour, texture and pattern – all the things that you would look at while you were drawing – you don't forget about it just because you are painting. [See facing p. 131.]

Just as previously she was trying to get them away from a tentative attitude to drawing by a conscious use of pen and ink, here she was trying to break down the notion which many of the children had that a painting is only something you do after you have drawn in first – 'You draw it and then you paint it in. I was trying to get away from that, that a painting starts with paint, even if you draw it in paint in outline.' A close relationship exists here between important qualities which can be derived from both original works and reproductions and the teacher's diagnosis of the pupils' needs based on her knowledge of their previous experience and work. Art room discussion is often almost entirely informal, the teacher getting the class down to work and then talking with individual pupils, but this teacher, in addition, spends quite a lot of time in organised talk and discussion with her pupils: 'We come in at the beginning of every lesson and we sit round the big table. If we are beginning a piece of work we talk about that and I point out things to look for.' Additional points are introduced during the course of the lesson, and if a child has done something from which the class as a whole might benefit, she stops them and talks about that particular thing. In class discussion, she has become extremely skilful at incorporating her pupils' responses and ideas about a subject into her teaching and has become adept at illustrating points from the numerous visual examples which make up the displays in her room, as well as presenting prepared points.

As the work progresses, each lesson still commences with an introductory session in which each child's work is discussed – 'sometimes just a very quick look' but sometimes emphasising that what has been done is not good enough with guidelines as to how it might be developed. This firm teaching framework means that there is inevitably a strong 'house style'. The work is characterised by the pupils' compositional understanding; in the still-life paintings there was an overall unity achieved as individual children skilfully related the foreground still-life objects to distant landscape through colour values and through rhythmic relationships, and though the teacher led her pupils to a conscious understanding of specific relationships between the groupings of objects and the way in which they most effectively related on the paper, her awareness of the children's stage of development was reflected for example in the decorative treatment of the woodblock floor, which the children invariably rendered in a two-dimensional manner emphasising its pattern values. All art departments

have a recognisable 'house style', but there the framework provided the children with a structure within which personal expression and interpretation were afforded adequate scope. Colour schemes varied from bold contrasts to the most subtle harmonies and while some compositions were characterised by Matisse-like decorative patternings, in others the realistic rendering of form was predominant.

In addition to the written work which took place during the first lesson, the original works were used as stimulus for creative writing; the teacher also produced worksheets, and it was arising out of this follow-up work that an increased interest in the smaller paintings and the etchings became apparent. The younger (primary-age) children in the school are not timetabled to use the art room, though the teacher often participates in their practical work by working alongside the classroom teacher, and this partly influenced her in always displaying some of the loaned works around the school. In addition, she put up one work each week in the assembly hall and introduced that work to the whole school as part of the Monday assembly

> . . . to try and make it a bit more accessible to them and make them think a little bit more deeply about it, and we changed the picture every week. Children do come to me and say, 'I've been to have a look at that one in the hall again and I've seen something that you've pointed out to me.' Occasionally I've had them out in the corridor – I've had the woven hanging out in the corridor and I can see it from here. I can see the children going past and I've noticed them stopping and looking sometimes. It isn't just wallpaper – I'm sure it does have some effect on them!

When it is added that the children further interpreted their theme through a range of craft processes – clay, lino-printing, batik – introduced as natural extensions of the work already done rather than as techniques taught in isolation, the completeness of this project is immediately apparent. The sustained quality of the children's work and its logical development over many weeks indicates how much they have derived from the theme. Drawing standards are high in this school, of course, meaning that each such project will immediately benefit from the values and skills which the children have already acquired. There is a variety and diversity in the work because the teaching is also directed towards individual needs, encouraging personal expression of a particularly sensitive kind appropriate to the age of the children. The depth and intensity of the work, in addition to this sound teaching, has developed partly because art lessons are ninety minutes long plus one single period, and the teacher has the children on a continuous basis throughout the year, making the affirmation and practical substantiation of the teaching from earlier lessons possible.

Finally, she observes that

> At least they've been exposed to the original works. I think that what has rubbed off on them would be a lot more than I could have given them had I just

worked in my normal way, which is usually to talk to them, and I also show them slides and reproductions . . . We always look at other artists' work when we are doing a particular project, but I think to have your actual artist's piece of work in the room with you must have more effect . . . And being able to have them around to continually refer to as well – and they are for *me* to continually refer to. If somebody is having problems with something, immediately we can turn our heads and say, 'Look, that's what he's done about it, that's what she's done about it!'

The town does have a museum which she has visited with her pupils, but 'It's more of a museum than an art gallery.'

The greatest justification for this project finally is not to do with technical points the pupils have derived from the works, it is rather that 'The children I have here will very rarely be exposed to original works of art, I'm afraid. They'll rarely, I think – even in their lifetimes – go anywhere to see original works of art.' In such circumstances it is necessary that the mountain comes to Mohammed!

Postscript The teacher would have liked to have kept the set of original works for a longer period, but during the summer term they had to move on to another school, complete with a package of notes and information for that school outlining the use that had been made of them. Though the work described arose out of a specific project, the teacher used the stimulus of the original works to intensify the approach to teaching which she normally adopts. To compensate for the loss of these works, she went to the Bradford Museum and borrowed a further twelve original prints and reproductions in relation to a portraiture project. In addition, she arranged a display of photographs and photographic montages, and a set of Muyerbridge photographs as preparation for a series of practical visits one of her groups was to make to the recently opened National Museum of Film and Photography in Bradford. The portraiture and photographic displays cross-related in many ways, and were both relevant to the children's project and in anticipation of the visit to the new Bradford Museum. The portraits and figure-studies produced by the children were commensurate in quality and interest to the earlier window project (see facing p. 131).

Section 2 Unusual Classroom Initiatives

(a) A school's ceramic collection

In the previous section the skilful use that can be made of original loan works was illustrated but it was suggested that, given the will, any school could begin to build up its own collection. It is only rarely that one comes across seriously acquired school collections, but an obvious advantage of this resource is that, over an extended period of time, both staff and pupils get to know the objects

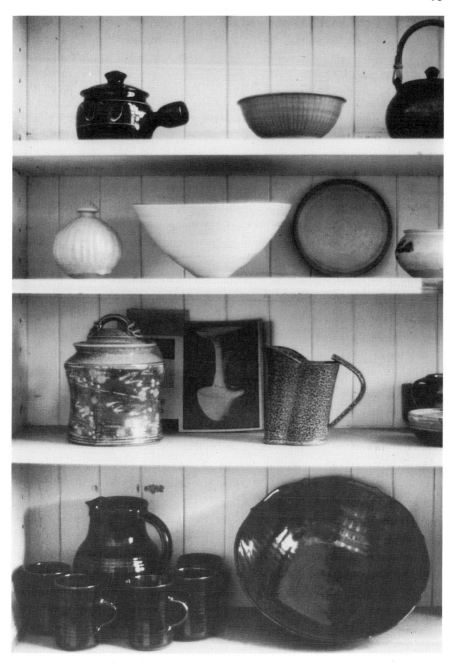

A section of the display case near the art room entrance. The Lucie Rie bowl is in the centre of the second shelf down, a Jane Hamlyn pot and Wally Keeler jug are on the shelf below, the Winchcombe jug and mugs and a David Eeles bowl are on the bottom shelf.

involved both through constant contact and by finding out through research about them in their own right and in relation to the artist's or craftsperson's oeuvre. One interesting example occurred when a new teacher was appointed in the 1960s to a boys' grammar school in the North West. His brief was '. . . to extend the range of work in that school from two to three dimensions specialising in Pottery. I did just that. Took them into 3–D, took them into carving, printing, lino-printing, woodcarving, clay work – the lot. Then the kilns came and there was all that excitement, too.'[6] As part of this process of vigorously extending the art curriculum, he went to the head teacher and made out the case for an annual sum of money to be additional to his capitation for the purchase of original works. He acquired £10 per year to begin this venture. He reflects that he must have been cheeky, because he decided to write to the leading potters of the day, explaining how much money he had at his disposal and what he wanted examples of their work for. They all responded, and so the collection began with works by the likes of Bernard Leach, Hans Coper, Lucie Rie and Michael Cardew. Katherine Pleydell-Bouverie, one of the first generation of Leach's students, sent three pieces of her work for the £10. Each of the ceramicists who responded was also asked for technical information about the particular works: what clay and glazes had been used, what temperatures they had been fired to, etc. All of them responded and Katherine Pleydell-Bouverie provided six pages of information in all, contained in two separate letters. She went so far as to write out not only the glaze recipes used for the specific pieces she sent, but gave equally detailed information about a range of glazes she was currently experimenting with; there was something rather special about the pupils subsequently mixing up some of these for themselves in parallel to what she was doing.

In addition, the teacher was equally concerned to establish in his pupils an understanding that these ceramic pieces also relate to the pottery which is an intrinsic part of their everyday lives. He impressed upon them that there was a living history beneath their feet, and so the boys dug up clay from their own gardens and from the local river and used this in their own firings, experimenting by adding objects like marbles and returning them to a glazed state, taking note of the temperature necessary for this to happen. The boys' researches also led to a second, supplementary collection of pots – this time in the form of fragments which the boys dug up, the fragments revealing a whole world of history. But there was one particular kind of stoneware fragment which kept on recurring:

Weaving at lunchtimes (see p. 199).

(Top left) Boys working on an individual basis at lunchtime.

(Top right) The school caretaker weaves most lunchtimes.

(Bottom) A wide variety of individual and group weavings characterise the work of this school.

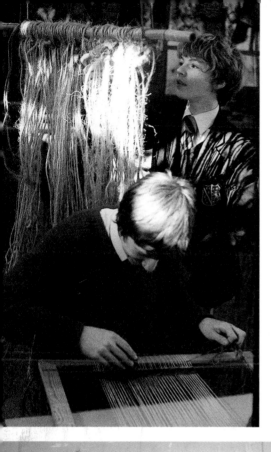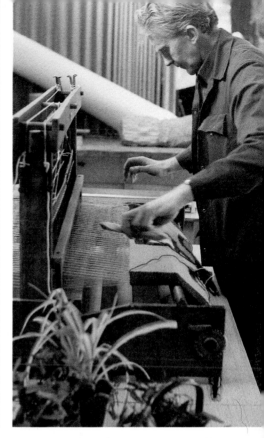

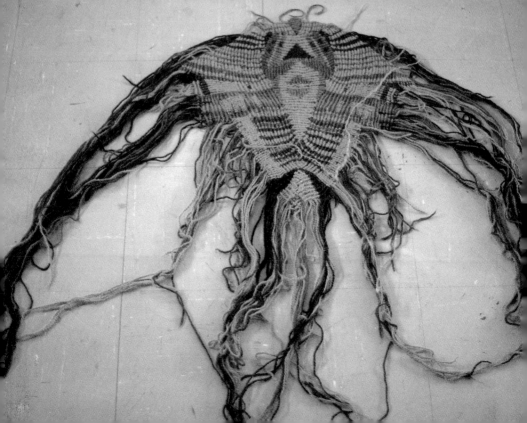

And rather than just accepting it, it needs the skill of the teacher to set up an enquiry and investigation and to say, 'Why are these pieces turning up so frequently here in Lancaster?' and 'Why is it that you are all bringing in these pieces? I wonder where they came from?' And we found that they came from a pottery at Burton-in-Lonsdale which is just up the valley. So we went up there and, in fact, found that at the turn of the century the whole of the village was involved in, or was serving, pottery production. Weaving the big baskets for the pots to go in, the big carboys – the big five-gallon, ten-gallon containers for acid. That's why they moved from earthenware to stoneware, and that's why they were in business. We found the willows still growing there where they used to cut them for making the baskets. Then we found the pottery site which was on the edge of the river and that led us to discover – all in one afternoon – that two hundred yards of the river bank is built entirely of pots that were the wasters from that pottery. It had been there for two hundred years' non-stop production, starting first with earthenware and then going on to produce stoneware – at a very early period, really. Surprising, before the turn of the century this pottery started making stoneware just to serve local demands. So you're straight into social history, then, and your own environment.

They found people living in the village who had worked in the potteries and they showed the boys where the clay was, some of which was dug up for use in school later. Eventually the teacher found the last man to have been potting there when the business went bankrupt in 1944 as a result of the Second World War – 'and so again you are linking it with reality'. This last potter was called Richard Bateson and he is now ninety-four years old:

In 1944 he stopped potting there and went down to Stoke-on-Trent and then to London as a demonstrator at the Royal College of Art. When he retired he came back up to Burton-in-Lonsdale and I found him there and actually got him down to the school for one afternoon after school. From the first year to the sixth form came in and he threw on the wheel all the things that he'd thrown by the ten hundreds of thousands from the small beer bottles right up to the big five-, ten- gallon jars. And he was talking to these kids about the life there and, of course, I was able to relate that to their own research when it came up to O- and A-level Pottery and one or two made studies.

Some teachers might argue that this teacher was lucky – there most certainly is no pottery up-river from their school! It is often said, though, that a good sportsman makes his luck, and so it is with teachers. The narrowly defined, pre-determined art course sits rigidly within the timetable – is, in fact, determined by the timetable and invariably reduces the chances of capitalising

Art department resources (see p. 215 and 229).

Cross-references to the world of art have led to many interesting and varied art room poses being set up by critically conscious art teachers.

on what is current or is going on in the 'real' world outside the classroom. The teacher stresses that art and craft is not just a visual medium, it is a visual and sensory medium. 'You've got the eye but you've also got the hands, and these are great sensitisers', a combination which enables the teacher, in his view, to devise a curriculum based on essential and fundamental priorities to meet all pupils' needs and not just of those going on to study in higher education. The individual's potential has to be fully developed and he is 'surrounded by forty or fifty million other people who have that equal right':

> So there's the individual and the social developing simultaneously and to achieve those ends art and craft can bring something quite special and quite unique. There is a uniqueness in art in itself but there is also the way that it relates with other aspects of life and that's where critical studies can come in so directly by taking not just the pupils' own powers of expression but by letting them see how others have done it and are doing it.

By showing the pupils that they are travelling a road that others have already travelled before or are doing so now, in the process making things like they are doing, 'you can take it outside the classroom and bring in from the outer world'. Through such an approach, teachers make their own luck, as this teacher did. If there had never been a pottery at Burton-in-Lonsdale, some other equivalent opportunity would have presented itself; he thinks that teaching should really be called the learning profession and not the teaching profession and sees the teacher more as a team-leader who brings in other expertise as it is needed. He has since moved to a college of higher education where, for one term each year, he runs a ceramics course for teachers. Interestingly, one of those on the course at the time of my research now teaches ceramics at the same school where his course-leader had taught.

He had been to the head teacher intending to revive the purchasing policy begun in the late 1960s. He discovered that a school governor had set up a trust fund specifically for this purpose:

> I got this large David Eeles bowl. Rather nice slip glazes on it with a little square patch of Chun glaze. I bought six drinking mugs and a lovely Tenmoku jug from Winchcombe and a Jane Hamlyn storage jar. Quite a nice piece – a large piece, salt-glazed – and a lovely mottled blue cream jug from Wally Keeler – that was a super piece.[7]

He hopes to be able to do some salt glazing while on the course, because it is something he relates to personally, 'that's why I put those in the collection', but he sees the next direction as being to extend the range of works to include ceramic sculptural forms. The collection currently consists of about two dozen pieces and they are in 'a showcase that is slapbang in front of the pottery room door so they can't fail to notice them and I think one of the things about it must be that this rubs off on them – they are constantly seeing these things':

> I also use them very much from a technical point of view – lid fittings, handle

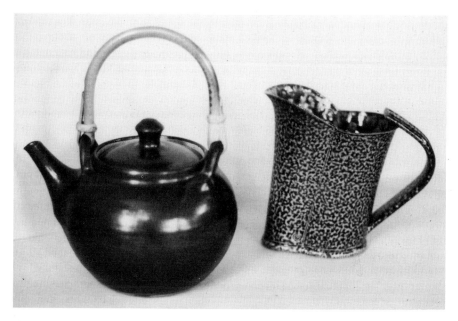

A Ray Finch teapot and the Wally Keeler cream jug. Two distinctive pieces from the collection.

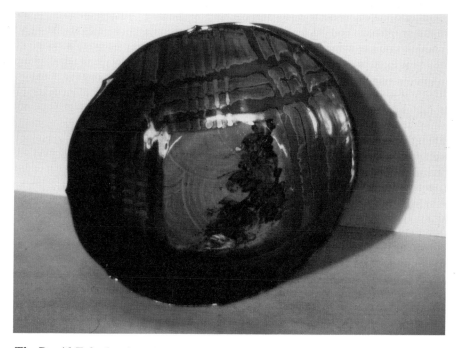

The David Eeles bowl.

extrusions, the proportion of a handle in relation to the jug, and this type of thing. Then, of course, I have tried to choose them so there is a complementary range of qualities and surfaces, textures and decorative techniques, whether it's just throwing rings that break the Tenmoku or whether it's the incised lines of the Lucie Rie bowl.

One of the uses to which he puts the collection, therefore, is that of illustrating technical points in relation to the pupils' own practical work, but 'There's that climate created where you're using them for teaching ends in relation to their practical work but the children are coming to respect them in their own right as being by particular people.' The pupils become quite familiar with the names of the various makers: 'We might get that bowl out because we've seen slides of it or because we've been discussing a particular idea, a way of working or a technique, therefore we look at Lucie Rie and then we get the bowl out – so these things are very useful.'

The O-level Pottery syllabus includes the History of Pottery of which modern studio pots are an important part. To be able to show the pupils original pots in this respect is invaluable and this process naturally extends to work with younger pupils:

Also I find that another useful quality of it is that you can show them pictures out of a book or on slides, and when you actually put the piece in front of them, they say, 'Oh, I didn't realise it was that big' or that small, or that delicate, or whatever it was – and it helps to be able to recognise how a piece was produced. You put a slide on the screen and sometimes it can be difficult, unless you know the technical business behind a work, to decipher it for them – to actually work out whether the oxide was put on top of the glaze or if the glaze strikes through, what type of clay it was, and this sort of thing. It's a tactile business as well, so they can pick it up and feel the weight of it, feel the fineness of the rib, and all these things.

Though there was a lapse between one teacher starting this collection and another continuing it, it is now quite a balanced and substantial one of its type – though in two halves because 'The world of ceramics has changed very dramatically within two decades' – and it is being used as a teaching resource in a variety of ways. Its originator obviously felt that it was 'great' when he discovered that his original purchases were not only still intact but that they were being constructively added to and extended. He established his own pottery in 1961 and still produces his own ceramics, exhibiting regularly and widely. In conjecturing about the ways in which teachers can incorporate some of the residential centre principles into general teaching, Oliver Bevan suggests that they should show their own work to pupils since that puts them on the map as creative people. This teacher was certainly a practising example of the teacher/craftsperson when he was in a school, and to see something of the impact which teaching by example can have in this way it will be of value to look at the work of a teacher who introduced weaving into his school, initially by

taking his loom into school and producing his own work at lunchtimes.

(b) Weaving at lunchtimes

We started weaving at lunchtimes. I didn't have it as part of the programme or the syllabus and one lad after the other simply wanted to have a go . . . With weaving you get involved in it – there's a designing and a thinking time when you get notions about what you're going to do and there's a logical time when you just weave steadily in as craftsmanlike a way as possible, but it gives you thinking time as well so that by the time you've finished that piece of weaving you've got plans for a second one already worked out. So as each boy finished his first piece, he'd got the notion for a second piece or began to want to work along with somebody else – 'Me and him will make a rug!'[8]

The Head of Art in a large 13–18 comprehensive school for boys in Derbyshire sees 'absolutely all the difference in the world' between a boy saying 'Can I make one?' and the teacher saying 'Today you are going to do . . . ' Over the years he has skilfully developed an approach to teaching in which this attitude is central, and the work which pupils undertake voluntarily at lunchtimes and in their own time is vital to this end. At lunchtimes, pupils of all ages work alongside each other and this encourages a cross-fertilisation which results in themes developing right through the school:

Sixth-formers are absolutely vital for giving a lead if they are good, and if one is doing a piece of work, it's when a third- or fifth-former comes and says, 'Can I have a go at that?' that you've got to be free and say 'Of course!' If you say, 'You'll have to wait till next year' or 'You'll do it in the sixth form', you've lost that moment – and there aren't many moments in life like that for any of us. A lot of life – and school is just the same – is mundane . . . A lot of it is unpleasant, not to say tragic, and when it boils down there aren't many moments of pure joy. They are what we all live for and what make it all worthwhile, so you've got to make as many moments of pure joy as you can.

When there is no joy in it, he believes that there is no point in doing it and he is aware that many of the boys devote the amount of time they do to weaving 'because they don't actually see it as timetabled or examinable'. It must not become a chore, therefore, but commitment is demanded. Once a boy has started a piece of work he has to see it through. It is not desirable for a piece to run on endlessly, and it is impressed on the boys from the outset that they can only hope to accomplish or finish a rug if they will come in at lunchtimes and at other times, or even during the holidays. In addition, 'I can ferry the loom home for them.' He thinks that the balance between the designing and the persistence and craftsmanship required to complete the idea is 'absolutely vital because it affects their temperament':

It makes them willing to start at one end of something and work steadily through it until it's finished – and that is vital. If they see you starting something big or if they see you working on the same thing for more than two

weeks they'll come to you and say, 'Don't you get bored with that?' and I like to just get them so involved that they can see that it isn't in fact boring. It's a process from beginning to end, you have to work to accomplish a finished thing.

He thinks that this notion of anything that takes time being boring is common to young children, and they learn otherwise by actually seeing the job through to completion, discovering what each phase of the activity has to offer in the process:

> The exciting thing has been sparked off, and then it's getting down to working out exactly what you're going to do and how it's going to be done and selecting what materials you're going to use and getting it set up. That's where the steam is. Then you can't wait for the first few inches to appear so that you can see how it's going to work, but if you're then going to do another forty inches, the magic doesn't go but that kind of keen edge is not there. What you have got is this steady work and involvement – which is lovely talking time, actually, as well.

Though the pupils still have to pay attention to what they are doing, these conversations often become involved and free-ranging, starting maybe with the job in hand but radiating out to their car and their ferrets, the boys often forgetting themselves and calling him 'Dad'. Plans for future pieces of work are resolved but, equally important, 'you discover and learn all sorts of other things by talking':

> I mean, if a boy comes in at dinnertime to thread up a loom he's at one side pushing threads through and you're at the other side bringing them through and tying. You can have half an hour or three quarters of an hour earnest conversation. It just runs on and it isn't under any particular circumstances – it's not teachers and pupils or schools!

When he was first getting a lot of weaving going, a visitor challenged him about the value of 'weaving yardage'. He emphasises that they don't actually do that. Most of the pieces produced 'are constantly alive'. The boys start on what they call jungle rugs, a simple warp with things threaded through. It is a sampler and they rarely repeat anything, 'so we don't actually do a lot of yardage, but even if we did I think it would be valuable' because a special state of mind is encouraged. It has trance-like qualities but with an awareness of the world around. 'It's a lovely state to get into and I think it's a maturing thing.'

In such a climate, the boys naturally acquire the vocabulary specific to the process, and the teacher deliberately and systematically introduces them to the appropriate words 'right from the outset' with first-year pupils. He sees nothing special about this at all and describes himself as a great one for debunking a lot of the mystique about it. There are odd people who demonstrate spinning at county shows, and the like, 'who make it sound rare and special, and it's not':

> It's a perfectly straightforward, easily understood principle. The parts of a

spinning wheel – the maidens, the mother of all and the footman – they quite like to be told about that, but with weaving I don't labour it by saying, 'Now these are the warp threads and those are the weft', although we have a bit of a joke saying, 'The weft goes from weft to right', so they remember which it is, but at the time you say, 'Which way up is that going to be woven?' You know, 'Is that the direction of the warp threads?' They accept that as the beginning of a straightforward weaving vocabulary, and warp and weft are no problem after a while because they accept that.

Standing next to them while they are weaving, the teacher refers to, and indicates, the reed and the shafts at an early stage, 'and they pick it up and use it naturally without having to learn it'. Pupils acquire the relevant vocabulary through the teacher's use of the appropriate words, clearly explained, in a practical context which makes them real and natural to the boy involved.

The teacher also believes that spinning and weaving are processes whereby boys make discoveries about colour which become part of their experience in a way which the standard contrived and impersonal colour exercises rarely do. Such words as contrast, blend, intermingle, juxtapose are naturally used when dealing with the realities of dyeing and when selecting from mixtures of yarns. For example, a pupil might say, 'Can I take this bunch of colours and put them through the yellow dye and see what happens?':

There's a kind of freshness about it because you can pick up yarns of particular colours and hold them and place them side by side. You can have two swatches and put one through a dye and see exactly what's happened to the overall thing and they will use words then like 'harmonise'. They'll say, 'I put this through a violet dye and so all these orange, crimson, and navy colours have been harmonised', which you don't get quite so much in normal conversation over pictorial composition . . . If you'd got some red fleece and some blue fleece you could spin some red and some blue yarn. If you put the red and the blue on the carder together it becomes violet in the lump and at the time it's spun the violet becomes consolidated and it causes a stronger-looking violet colour – and that sort of thing they enjoy . . . It's there and it's simple to see and you can actually talk about it without any inhibition. One of the nice things about textiles and about yarn is that they're actually there and you can tumble them about or scrabble about amongst a pile of tangled yarns to pull out just the colour you want, and they get ever so fussy.

The important discrimination which this comparing and juxtapositioning of colours develops is, in his view, sharpened by the immediacy of the situation. It is far more inhibiting to have a white piece of paper, a set of paints, a brush – and a notion in your mind. In a similar way, he feels that weaving is particularly relevant to adolescent boys who often feel uncomfortable with the stylisations and simplifications which they make when handling figures in their paintings:

A design worked into a tapestry form, if it becomes stylised, seems healthy and natural, whereas anything that becomes stylised in the way of painting they tend to think is weak or artificial or affected. It sometimes seems much more honest and integral if it's woven in, whereas those same distortions or stylisations self-consciously done in paint, they tend to feel are more superficial and just decorative.

The art department consists of two inter-related studios. A design feature is that the metal beams have been left exposed beneath the ceiling. There are individual looms around the department, but these beams are ideal in that they are frequently used to establish the weave warps, the tension being maintained by the use of weights at floor or table-top level. On entering the department one is immediately aware that weaving is of great importance. Individual pieces, both open or dense in construction, figurative or decorative in design, and either flat or three-dimensional in form, are on display or are in various stages of completion. In addition, large group works are hung over the opening which links the two rooms, or have been rolled up because of the constraints of space, though a third-year piece lit by a spotlight made a dramatic impact in the school foyer and other pieces were displayed effectively around the school. The art lessons are built around a sound course of observational drawing and composition, with pupils entered for both O-level and CSE examinations and a number studying the subject to A-level. The fact that weaving has never been consciously put into the syllabus is also to do with the way in which the department works, for the teacher also encourages the cross-fertilisation of ideas in other media right through the school 'for as long as it takes to work through'. Some 'themes' might develop almost incidentally, but they generate their own momentum and can become very influential – sometimes embracing a wide variety of processes. A recent example developed as a result of the teacher pinning on the wall a drawing he had done of one of the boys:

> Somebody else wanted to have a go and then – because it's perhaps somehow easier to work in clay – once one boy has done it another wants to do it in clay. Then a fourth-former sees what a third-former has done or a sixth-former does a head that impresses everybody and so all the juniors must have a go – and before we know where we are everybody is doing heads, either portraits or masks or woven self-portraits, or whatever. So that runs right through and it's the same with weaving.

The contrast between such an approach and that whereby whole classes, for example, work on colour or texture exercises with their efforts unrelated to whatever else is going on in the department could not be more striking. Though weaving started, and has subsequently flourished, as an extra-curricular lunchtime activity, it inevitably finds its way into the art lessons themselves on occasions:

> I don't consciously stop it moving into lessons at all but that's not where it started. We have a system where each boy goes through working his own line.

I very rarely do a set piece of work with everybody doing the same thing and every boy has a record card in the filing cabinet which he fills in for himself. So he keeps a journal of his own work and then, as he comes to the end of a piece of work we decide between us what he is going to do next so that there's no need for me to call a halt at any stage or say, 'Now you've all got to finish this week because next week we're going to do . . .' I mean, a piece of work takes as long as it takes.

He attempts to avoid the situation where a pupil completes a piece of work without knowing what he is going to do next. He regards this kind of void as being as bad as the set exercise undertaken because it is, say, week seven of the syllabus irrespective of where the individual pupil has arrived at. In recent years external examinations have also become more accommodating. At one time pupils used to do the O-level Craft, Design and Practice weaving paper, but a lot of the boys were put off by the theory – yarn counts, the history of textiles, etc. – particularly as 'a lot of the boys coming into the department anyway were avoiding doing History and English and writing essays'. Weavings can obviously form part of the CSE exhibitions and can be assessed as part of the course work, carrying half of the marks in the JMB O-level Scheme B examination. This option has also proved popular with sixth-form boys who are not doing A-level Art but, having woven earlier in the school, come to the department to weave towards an extra O-level. Some of the examination papers stipulate that 'You may use any medium you wish', and the teacher says:

They'll come and say, 'Could I do this as a weaving, as a tapestry?' and I'm blowed if I'm going to say at that stage that they've got to paint or draw. If they want to do design sheets and work out a design – especially with weaving in mind because you've got to design with the technique in mind – they get involved and are particular about what colour they're going to use and what thickness, and whether they can dye it or overdye it.

Strangely enough, this weaving tradition only began in the school almost a decade ago now, by chance. The teacher had begun weaving himself and had joined a Weavers' Guild. In order to meet an exhibition deadline, he brought his loom into school to complete a weaving of his own at lunchtimes. This aroused the interest of some of the boys and the unusual school tradition of weaving has been evolving ever since. He has been able to use examples in school through the Derbyshire Museums Loan Service and the boys have seen others on gallery and museum visits. He has also been able to borrow and bring into school many varied examples through his Weavers' Guilds contacts. He believes that a considerable divide has developed between the amateur artist and the professional in the field of fine art, but traditionally such practitioners as Tadek Beutlich have consistently participated in workshops and demonstrated their skills to the guilds. He feels, therefore, that it is easier for the boys to see themselves as having a link with the leading practitioners than in painting:

Everybody has got walls at home that they can hang tapestries on. Now I

know they've all got walls that they can hang paintings on, but their notion of a tapestry or a wall-hanging is more generous and wide and broad. Their notion of a painting hanging on a wall tends to be more confined and we've worked to keep them open-minded and to enjoy the tremendous breadth of painting but they do somehow see that as more separate and special. They think of an artist as somebody they're not likely to meet really, or somebody who might be on a hillside with a box of watercolours. Wall-hangings, by comparison, are part of the business of, you know, like probably their mum sitting knitting when she's watching television and whatnot. It's not a special thing by special people because you might be making a rug that you're going to walk on or spinning some yarn to knit a jumper, which is a perfectly normal straightforward thing to do.

To illustrate this point further, he cites the example of the boy who, having taken his weaving home, could not return it for a school exhibition because it was in the dog's basket, and he recently saw two cushions in the back of a parked car which had woven covers on them made by a boy who had left the school years ago. The boys cannot wait to take their weavings home – a marked contrast to the great quantities of work which children do in art lessons up and down the land which disappear into drawers and cupboards never to see the light of day again! He also believes that it is important for the art teacher to have a third area to his life, between school work and private life. To this end he has acquired a now disused village church six miles from the school, added extensions and converted it into a studio. He teachers an adult class of weavers there, and his older pupils often take advantage of the facilities; an evening tutorial there with his A-level students over their personal studies is worth three weeks in school, he estimates.

In addition, he is a fine example of the teacher-craftsman for he has continued to work on his own weavings in school since that first occasion, as also do two of the school's ancillary staff. The boys are therefore used to seeing and being in the company of adults who command respect for their expertise in this field. On my last visit, a green rug was nearing completion. It was the work of the school caretaker who is to be found weaving in the department most lunchtimes:

Once they've seen the caretaker actually making and doing things and being involved in the school as a learning place and a making and doing place, rather than just doing the menial work of keeping it clean, their regard for him is certainly different. The fact that he'll turn to them and say, 'What do you think of that, then?' or 'Do you think you could find me some blue wool?' or 'Do you think I should use blue or green?' makes them feel that they're helping him on as well. And the fact that he talks to us and they talk to him at lunchtime and we all just say 'Hello' to each other may confirm a more homogeneous community.

All these contacts and interactions mean that the boys develop an unusual awareness which only comes home to the teacher, really, when somebody

comments that 'I sat behind a woman on the bus this morning and she'd got a coat on that was two-thirds that way and two-thirds this way' and they've found themselves analysing a winter coat;

> I'm absolutely sure that they become more aware of fibre and fabric and its uses and its variety and various methods but I think they probably become that much more aware of colour and texture as well than through any way I've used before, because everybody knows the feel of clothing next to their bodies and the sensation of warmth once you put a jumper on and the rattle you get if you're wearing artificial fibres that get static electricity, and you know the feel of dropping a jumper into a pile on the floor. They're all intimately involved in what fibre and fabric are.

The teaching approach adopted also encourages the boys to talk about and discuss each other's work in an open manner. Their teacher says that some of the criticisms are amazing, being witty and entertaining, generally good-natured and often tinged with a bit of envy, one lad often coming and saying 'Come and look what so-and-so has done' or observing what a good job somebody or other had made of his piece. A lot of the criticisms are practical – 'Oh, it's not very thick, though' or 'You can put your fingers through this' or 'It won't wash.' The nature of weaving is such that they frequently discuss each other's work and bring their friends in at dinnertime to see what they have done, whereas a beautiful drawing of a leek pinned up often passes without comment.

A further, important area of understanding which has recently opened up is that resulting from a number of opportunities to produce works for public places. The teacher feels that it is only once a piece of work has been taken out of the context of the general melée of the art room and been properly displayed that it is given any significance. It is only when they have been actually hung and lit that 'you consider that you've finished it'. Actually to have to design and then make something to be hung in a specific place or setting is a natural extension of this notion. A large woven hanging has been produced for the County Hall, and they are currently working on an 8′ × 4′ piece to be sited on a wall in the school. This involves a number of boys working together, and numerous alternative approaches have been discussed and designs made. It is going to consist of sixteen strips, some plain but others dyed 'deliberately badly' so that there are some coloured speckles, and over-dyed and dyed in a tightly woven wound ball of wool so that the dye penetrates but not to the centre. This will give subtle gradations to the stripes which should be effective and which will also ensure that the boys maintain their interest as they see these variations developing.

An 11′ × 7′ weaving was made to hang for a fortnight in Derby Cathedral, and it had to compete with the stained glass windows. 'I mean, you can't get much more significant than that!' It was well lit and quite a lot of the boys went to Derby to see it. It had looked *vast* in the art room, of course, but had a completely different feeling of scale in the grandeur of the cathedral. The pupils are currently working on a commission for the local church's seven hundred and fiftieth anniversary, and this is a frustrating but valuable exercise – frustrating

because the church has still not made up its mind as to exactly what it wants, but valuable because the boys involved have realised that it is no longer enough for them to have a good idea – it also has to meet other people's requirements. They have now realised that their designs on paper and their sample weavings are only, at this stage, for submission for approval. Though their work is submitted to an examiner at O-level and CSE time,

> It's very different when you're submitting work to a committee of people whose opinions matter and who are carefully selecting what they want and getting you to produce what they want when you want to produce what you want anyway. It's rationalising all these things and I think it's quite good for them. You don't always have to respect other people's opinions but they do matter. So it's quite interesting. You get the odd lad thinking 'Oh, if they want it like that I'm not going to bother', and I sympathise with that completely because there are odd times when I come away from the parish church thinking 'We might as well do one for in school without half this humbug', but I think the humbug is quite useful.

The teacher maintains that he has kept weaving out of the official timetable so that his pupils can experience the joy of participation for its own sake, ensuring that the motivation for each piece comes from the boys rather than being prescribed by the teacher or examination needs. The underlying impulses which he harnesses are similar to those which can be associated with much Home Art. As the description of the department's work makes clear, though, the teacher is not standing idly by on the sidelines. On the contrary, his engagement with the pupils has as much bearing on the inception of ideas as with the technical aspects which so much art teaching concentrates on. In consequence, a tradition has developed whereby each piece produced is quite original and distinctive, though often emanating from an awareness of each other's work. In the process, many of the pupils have developed an extraordinary understanding of fibres and fabrics and have had the opportunity to see their work in a broader context to do with their everyday lives, rather than it just remaining an art room activity.

The teacher has achieved this partly by harnessing his specific craft skills as a resource for his pupils' benefit. His unique artistic skills, loan collections and school-based original works are all valuable resources which have been considered, but many art rooms are singularly lacking in resources at the present time. An appropriate range is a necessity for the teacher who is committed to making his or her pupils more critically aware. A consideration of the additional resources relevant to this work is therefore necessary.

Conclusion

In Part VI we are brought up against some unpalatable facts. Despite what has been said about the necessity and applicability of work in galleries, only a small minority can expect to have such opportunities offered to them. Furthermore,

those who have least opportunity (pupils in secondary years 1–3), for the majority of whom this is the last chance in school to form positive attitudes to art, are being increasingly exposed to teaching which is a complete antithesis of the critical studies philosophy.

Loan collections should clearly be available to all as a means of promoting awareness through the process of 'living with art'. They provide an experience different in kind if not effect from works in galleries. For some they will be the only way of encountering originals (and this includes those in the school's wider community). As such, they should be broad-based in media as well as in diversity of content and technique, so as to act as teaching aids and to provoke reaction and thought more generally. A pre-condition for their satisfactory use is adequate supporting material, covering the areas of process, form, content and atmosphere.

When loan material is used effectively as a foundation for projects it can contribute towards a form of teaching to set against that which has been criticised. In contrast to the fragmentary and detached courses of learning which students themselves abjure, curriculum work can build up, refer back, mingle response with pursuit of new skills to convey required expression and relate naturally to other subjects. It requires longer periods than is normally the case, contact with the teacher on a continuing basis, and a teacher who perceives pupil needs and who does not teach skills divorced from other concerns.

The second half of Part VI reinforces much of the above findings. In addition it supports those points in Part IV referring to ways of creating pupil demand rather than teacher insistence, including remarks about the value of extra-curricular activity. The weaving example epitomises all that is best in assisted learning: the desire to experiment, the natural acquisition of technical vocabulary, open discussion, acceptance of art in relation to everyday life. In the scheme of this book it substantiates the earlier proposal that teachers should construct a parallel to Home Art within education.

Part VII
A Question of Resources

Section 1 Art Department Resources
In considering what resources an art department needs, the author begins with a critique of John Berger's *Ways of Seeing* as an influence upon teachers' attitudes towards originals and reproductions. He goes on to argue the case for back-up resources, and for developing these even within existing constraints, suggesting what form they should take and giving instances of their use in certain schools. As well as the more obvious reproductions, books and slides, attention is also paid to children's own work as a teaching resource, props for still-life sessions and the provision of reference and study facilities.

Section 2 A Sixth-Form College Approach
The case study of a sixth-form college which follows amplifies what has been said in the previous section about why and how resources should be used. The author includes this, however, as part of the teacher's whole approach to critical studies. He supports his opinions on the value of this strategy with the students' own revelatory and enthusiastic accounts.

Section 1 Art Department Resources

Original paintings are silent and still in a sense that information never is. Even a reproduction hung on a wall is not comparable in this respect for in the original the silence and stillness permeate the actual material, the paint, in which one follows the traces of the painter's immediate gestures. This has the effect of closing the distance in time between the painting of the picture and one's own act of looking at it. In this special sense all paintings are contemporary. Hence the immediacy of their testimony. Their historical moment is literally there before our eyes.[1]

John Berger

This potent passage from *Ways of Seeing* admirably sums up why so much emphasis has been put upon studying works of art and craft in the original. And yet ironically it is the influence of *Ways of Seeing* which many art teachers cite as justification for not bothering with all the effort and fag of gallery visiting

because the main drift of Berger's argument is that we now live in an age in which the multiplicity of reproduced images has taken away the uniqueness of the original: 'Because of the camera, the painting now travels to the spectator rather than the spectator to the painting. In its travels, its meaning is diversified.' Berger then reproduces, very small and in black and white, the National Gallery *Virgin of the Rocks* and adds that,

> Having seen this reproduction, one can go to the National Gallery to look at the original and there discover what the reproduction lacks. Alternatively one can forget about the quality of the reproduction and simply be reminded, when one sees the original, that it is a famous painting of which somewhere one has already seen a reproduction. But in either case the uniqueness of the original now lies in it being *the original of a reproduction.*

Strangely, Berger makes no reference to a third alternative — that one will close the distance in time between when the picture was painted and one's own act of looking at it because of the way that the silence and stillness permeates the actual material in which one follows the traces of the painter's immediate gestures. It is this unique element which so clearly has shocked and excited so many of the youngsters whom I have interviewed and which they recall as central moments in their subsequent involvement with the visual arts. It is strange that Berger, having written this passage, then goes on to build up an edifice of argument which contradicts it without equally seeking in any way to elaborate on its significance.

A consequence of Berger's book, besides affecting art teachers' attitudes to gallery visiting, has also been to debunk the notion of civilisation — epitomised particularly through the work of Lord Clark — as being reflected in a chain of great works stretching through the centuries. What it most certainly has not led to is the teaching of an alternative form of art appreciation, systematically applied, through large collections of readily acquired reproductions each containing some fragment of the meaning of an original work. In other words, *Ways of Seeing* has had a tremendous influence at teacher-training level and many art teachers quote facets of its arguments, and yet it would appear to have caused disarray through a rejection of previous attitudes without any clear, opposing approach having been substituted — except in the work of a small number of teachers who have successfully combined reproduction with other media images in relation to practical work, de-mystifying the art works used in the process of emphasising their practical value.

The book was first published in 1972 and art departments have since been severely affected by dramatic price rises in the basic commodities which they use. Inflation allied to cutbacks in capitation has meant that practical items have had to be trimmed and not surprisingly, given the uncertainty about the place of art appreciation matters, the purchase of art books other than of a technical and technique nature, slides and reproductions have dramatically declined. The DES publication *Art in Schools*, published the year before *Ways of Seeing*, illustrates how spasmodic the picture already was then:

Few art departments have a special allowance for the purchase of art books and quite frequently the majority of the books used in the art room are from the personal collection of the art teacher . . . The visual resources available to the art teacher today are many and varied. The extent to which they are used in any one school will depend on a great many circumstances, some economical, some geographical, but the most important factor will be the energy and the initiative of the art teacher concerned.[2]

The degree to which the art teacher with commitment has had to supplement the school's resources with his or her own books, reproductions, slides and — now — videos has almost certainly increased substantially since 1971. *Art in Schools* continues: 'Only a few will find lasting pleasure in painting pictures, making sculpture or pots, many will enjoy the work of great artists, but all ought to feel that aesthetic standards are an important part of our knowledge of ourselves, our judgements, and our relationships with the world around us.' It is my argument that at present there is little evidence that 'many' are leaving school educated to enjoy the work of great artists but where teachers make it a part of their business the numbers from *those* schools are often considerable. Where those schools then consciously relate their pupils' enjoyment of art to their own practical needs, the knowledge of themselves, their judgements and relationships with the world around them are invariably significantly heightened; such attitudes do not just form by chance without the teacher adopting the appropriate strategies.

For such work to take place, back-up resources are an art room necessity rather than a desirable bonus or perk as they often seem to be regarded. In many schools these resources have diminished to an inadequate minimum and there is often the feeling that the task of regenerating them seems almost a futile one. One of the consequences of the present educational climate is that there is a greater staff stability than has been the case for many years and this means that the most modest beginnings in building up resources can bear fruits for the initiating teachers themselves; in a previous section it has been seen how a school, starting with £10 a year, now has a significant collection of ceramics which is an extraordinarily potent teaching resource. If critical studies are to become a reality in art education it is essential that, however barren an art

(Top left) Nikki's A-level examination painting is strikingly individual, but her use of colour and handling of painting reveal her love of Bonnard, Vuillard, Seurat and Matisse (detail) (see p. 229).

(Top right) Sheila's knowledge of art history led her to produce asymmetrical compositions in carefully composed, but unusual, colour schemes. In consequence, this A-level painting did not fare as well as those produced by more conventionally minded colleagues (see p. 227).

(Bottom) Mary's pastel paintings of meat are a striking example of Home Art produced during the Foundation stage of her art college training (see p. 245).

department's resources are at present, an annual amount of capitation money should be set aside for the purchase of books, slides, reproductions and video material. It might take a number of years to achieve the necessary nucleus to meet a variety of needs, but the essential thing is to make a beginning and then establish a regular purchasing routine. The stultifying effects of resourceless departments must be rectified as a matter of urgency.

If it is accepted that seeing works in the original is the ideal, our attitude as to how to build up departmental resources can be influenced: for example, in what is collected. Any slide collection would inevitably have a general breadth to it but an emphasis might be placed on works which can be seen locally or, if the school makes regular trips to London, major works in London collections might figure prominently. A department might seek to instil in its pupils a desire to travel by deliberately making them aware of, for example, the treasures to be discovered in the Amsterdam or Parisian museums, or the ways in which Italian frescoes are integral to their architectural settings. As one student expressed this notion to me, through her course she was transported to a different part of the world every week and, in the process, a desire to travel to see things was affirmed. Even a slide collection built around the contents of a local collection can be beneficially broadened by reference to other works which help to put examples from that collection more clearly into focus: for example, other similar versions of that artist's treatment of the same theme, other versions of similar subject matter by contemporaries or examples of quite different aspects of that artist's work, etc. A department would presumably want its book collection to be broadly based but even here one criterion could be to amplify the evidence through the slide collection.

Nicholas Penny, in reviewing the series of Raphael programmes on television shown in 1983 to celebrate the 500th anniversary of the artist's birth, touched on both the advantages and disadvantages of television – and hence video – viewing in relation to seeing the originals:

Television also lets us scan, without aching neck, vertigo or danger to our neighbours, the ceilings Raphael painted . . . At times the camera takes you closer to the paintings than is possible, or at least permitted, in reality, allowing us to admire the distant landscapes of the *Madonna di Foligno* and the *Transfiguration* as we only can with the aid of binoculars in the Vatican. What television does not encourage is visual analysis: this means, above all, looking at the whole work, then studying the details and then standing back

A kiln-building project (see p. 238).

(Top left) The kiln being fired in the school grounds.

(Top right) The Raku works of Jon Biddulph displayed in the school entrance area.

(Bottom) The display of Schools Loan ceramics, books and background information provided a related focus of interest.

to view the whole again. Pictures on television are rarely shown in their entirety for any length of time, and even when they do fit the screen, the box can never be the same as a picture frame.[3]

This process of visual analysis involving how one alternates between looking at the whole and inspecting parts or areas within that whole is implicit within Anita's writing about *Yellow Attenuation* by Peter Sedgley and Andrew's description of his first viewing of Seurat's *The Bathers*, for example (see Part II).)

These two aspects of television/video viewing can combine, however, in the sense that the way in which a camera can focus on a landscape detail in a large painting can eventually lead a pupil to a more exacting examination of both the whole and the part of the work when in the gallery or museum – whether it be a painting, sculpture, pot or fabric. In other words, a combination of whole and details in resource form can increase the pupils' awareness of the range of viewing possibilities. It is not financially viable for galleries to produce details of works in slide or postcard form, other than in rare instances, but a teacher can make a unique and personal collection by taking his or her own slides in the gallery. I have built up an invaluable collection in this manner relying entirely on an open aperture and a steady hand, for one is not normally permitted to use either flash or tripod. It is possible to photograph quite freely in the States or in Paris, for example, but the National and Tate are unusual in this respect in that they do not allow photography (though special arrangements can be made to visit the Tate at certain times when it is not open to the public). In most galleries, though, it is possible to gain the necessary permission. There can be problems: in the Fitzwilliam, Cambridge, paintings are hung naggingly above eye level, in Birmingham City Art Gallery they are behind glass, etc., but an impressive collection can be built up quite cheaply nevertheless. The teacher can then whet the pupils' appetites by showing them not only Manet's *A Bar at the Folies Bergère* but can substantiate that with details of the flowers in the vase, the bowl of oranges, the bottles on the marble top, a close-up of the girl's face, etc. These can act as a marvellous aid to encouraging the pupils to look at the original with greater attention in exactly the same way as can be induced by the skilful use of the video camera. However familiar one might be with the work being photographed, it is also amazing how much one discovers in it through the process of carefully composing details through the camera lens – a great help when later using the resulting slides with pupils. This is not to denigrate the slides available from the galleries, most of which are excellent in quality, having been specially photographed in ideal circumstances – it is just emphasising the value of additional details in which the grain of canvas and brushwork, or the crazing of glaze and detail on a pot, can add an additional dimension and aid insight in a special way. Also, the personal quality which such a collection has gives it an extra authenticity in its use.

As was the case in 1971 when *Art in Schools* was written, committed art teachers are still using books from their own personal collections to support

their work. There are a number of examples in Part II which illustrate the pupils' need of book information once appetites have been aroused, and yet in many schools there is only a handful of art books in the library and those to be found in the art rooms often only contain information about processes and techniques. The art department and the school library between them should have adequate book material to meet these pupil needs. In addition, if the teacher accepts the desirability of his or her pupils being informed about art, then the teacher will also need books as an important part of this process. Obviously the choice is vast and the selection will reflect the teacher's preferences in relation to teaching approaches and what can be afforded. A basic set of wide-ranging, informative books such as the 'black-backed' Thames and Hudson World of Art Library series could usefully form a reasonably inexpensive nucleus, but the Phaidon Gallery series, also relatively inexpensive, have a lusciousness of colour-plate reproduction essential for a school library resource. Periodicals like *Crafts Magazine, Arts Review, Ceramics Review, Design*, etc., are an excellent means of enabling pupils to become aware of what is happening now and, put into binders, can contribute further as reference books.

But where should pupils be able to read books? The DES report *Art in Schools* noted:

> Some teachers consider it a sufficiently valuable use of precious space to set aside a small comfortable reading area within their art departments. A low table, easy chairs, small carpet and attractive decor and display are sometimes provided in these areas. Such arrangements – the exception rather than the rule – do have value in the protection of expensive books from the hazards of the working areas. Most teachers content themselves with a small cupboard or drawer and the display and open access to books of quality is not attempted.[4]

There is surprisingly little attention paid to this basic need in most books on art education, and it is incredible that the onus should rest so squarely with the teacher to improvise if any such facility is to exist. The provision of reference/study areas should have been a standard feature of secondary school art department planning years ago. Once a teacher has made pupils aware of how fascinating the world of the visual arts can be, it is likely that some at least will want to substantiate the experience through well-illustrated books – both through reading and quiet contemplation and browsing. There is considerable evidence in this book that many pupils have this capability and it is one which art education in general has done little to promote and develop. To move from quarry- or vinyl-tiled studios to the quiet of the carpeted study area is a civilising part of this process and as such as important to the future development of critical studies as was the provision of ceramic and printmaking equipment and facilities to the broadening of art education which accompanied the change-over to comprehensive art suites. Quite young children can certainly make good use of this resource, but it is dispiriting to see A-level students attempting to carry out essential researches for a Personal Study or whatever in the midst of the

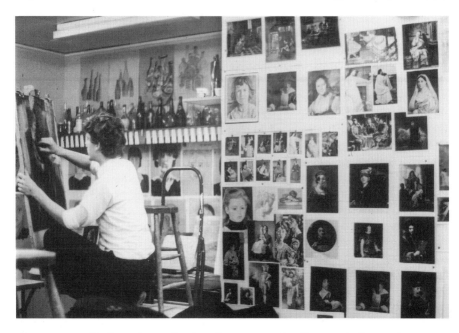

An art room display of reproductions in support of a figure painting project.

hurly-burly of busy, noisy practical studios because of the lack of the necessary provision elsewhere within the department.

Reference has already been made to the gallery established within a community school as a result of space available through falling rolls (see Part VI, Section 1(a)). As art department numbers reduce there is considerable scope for the creation of special display and reference/study areas within the art department – far more beneficial than the establishment of further language or humanities rooms dividing up the art suite! What should have been initial planned provision can often be created by turning the problem of falling rolls to advantage in this respect. The school will certainly formulate ideas of its own about the use of any such space and it is therefore often necessary for the art department to have established its case before the space is vacated.

In addition to reference books, a study area can provide the focus for displays of reproductions, or there could be a projector loaded with slides to reinforce the work of recent practical lessons. This could be set up to project a small enough image to be clear without necessitating black-out. At least one teaching space within the art area should have black-out provision, though. Children of any age-range can benefit from hearing an enthusiast talk about a subject which he or she finds fascinating. There is always scope for a whole lesson being devoted to discussion about the visual arts, therefore, but there are many occasions when the points being made in practical lessons can constructively be substantiated by the use of large reproductions or of perhaps just seven or eight appropriate slide examples in the introduction or lesson summary.

In Part I, Section 2, it was noted that Lara's art teacher had decided that it was her responsibility to do something about the fact that in a school 'Top of the Form' sixth-form students did not even know the nationality of Picasso. This happened about ten years ago and the Head of Art has subsequently applied that energy and initiative, which *Art in Schools* sees as the most important factor, to the problem. In the process, the department has built up a wide range of resources, both usual and uncommon. An extensive quantity of reproductions range from postcards to quite large examples, and a selection will usually be attractively displayed, often thematically, in relation to a still-life or an arrangement incorporating the figure set up in the art department.

These are further substantiated by a good collection of books displayed in glass-fronted cupboards in a small carpeted room situated between two of the practical studios. By such means as reproducing pupils' pen-and-ink drawings for sale at parents' evenings and open days, the department has raised additional sums of money to enable it to make many of these book purchases. But the relatively unusual means of linking all the reproduction and book resource material together to make it accessible to pupils is through a further central resource room of man-made and natural forms. Its two doors give access to both studios and it contains a vast range and quantity of still-life objects – jugs, bowls, plants, lanterns, a range of boots and shoes – and clothing of all sorts to meet virtually any imaginable requirement. There is a ballet dancer's tutu and shoes, a judge's wig and gown, lace stoles and fans, an endless variety of hats, etc. A bed has been made by cutting down an old table's legs, the mattress having been acquired from a caravan. Cupboards and mirrors have been bought cheaply from jumble sales and, because of the initiative shown in the first place by the art staff and through the obvious good use to which these props are then put, parents now regularly send in quite valuable and useful additions to the collection, so that it is constantly expanding and being enriched. In any day's teaching in this department, all these resources – books, reproductions and props – can be seen being used in combination.

A typical example involves two fourth-form groups. In each studio the models in settings relate closely to paintings by Matisse. In one room all the lights have been switched off and the model, dressed in baggy red trousers and a yellow top, sits on a table silhouetted against a window. Next to her, a giant pot plant with large decorative leaves almost touches the ceiling and sets up striking compositional possibilities in relation to the figure. An open book in front of the model is evidence that the teacher has been making relevant teaching points from the two colour plates, and further inspection of this book is invited. In the other room the model, dressed in blue on a bed covered in coloured materials to give a Fauve-like effect, is in a reclining pose. Though viewed from behind, her reflection can be seen in a long upright mirror and a smaller, circular white-edged one which, with a cluster of flowers in a red jug, stands on a cupboard top; an elaborate chain of beads hangs out of a partially open drawer. The whole compositional arrangement is so attractive that the pupils are positively invited to draw or paint. During the course of the morning, the

teacher shows them other examples of similar reclining poses – Ingres' *Grande Odalisque*, Velazquez' *Rokeby Venus*, Goya's *Naked Maja*, Gauguin's *Nevermore* and Manet's *Olympia* – as well as poses by Matisse, of course:

> There are lots of interesting poses of figures lying on a bed and it was a glorious opportunity. There they were, drawing and making a painting of a figure lying on a bed. So we looked at other artists who had done the same subject in lots of different ways, and then it was interesting to hear which ones they preferred, and so on. And it just gave me an opportunity to show them other works of art without them realising they were studying as in an art history lesson.[5]

So simple and done with such lightness of touch, but an essential part of *every* art lesson in that school. Pupils are imperceptibly developing a knowledge and awareness of art, and are forming opinions and judgements as they make observations and express preferences for related works through an examination of similarities and differences. That the approach is effective is affirmed by the fact that every pupil to whom I spoke had made voluntary visits to art galleries. Neither is the approach a hit-or-miss one because every pupil who enters the art department is likewise engaged in seeing parallels between what they are attempting in their own work and what others already have done. Not surprisingly, an important by-product of this approach is that some discover they have particular affinities with certain artists to whose works they personally relate and about whom they want to find out more. Many of the pupils, therefore, also read out of interest while still quite young.

A further resource, that of children's own work, is one which is strangely under-utilised, even neglected, in some schools. Every art room display should ideally be presented to be explanatory to pupils as well as attractive in its overall effect. For example, the presentation of the actual lino blocks and preliminary printmaking stages as well as the completed print, sketches and preliminary studies alongside the final painting, or design sheets in relation to resulting ceramic forms are all valuable contributory material to this explanatory process and younger pupils can benefit enormously from not only seeing the work of older pupils but by understanding the origins of that work and how it came about. To further this process, one Head of Art in a North-West comprehensive school accompanied a school exhibition with cassette recordings in which the pupils talked about their own work. Some of the information was quite basic – how long a particular piece had taken and what materials had been used – but in addition they talked about the formation and development of their ideas and the possible alternatives they might have adopted. One boy described the different softnesses of pencil he had combined in one study to achieve the variety of effects he wanted, reflecting both his knowledge of, and respect for, his art materials. As well as being beneficial to other pupils listening, those speaking about their work doubtless discovered more about themselves and their work in the process. As the head-teacher observes: 'What one doesn't see usually, but does here, is *all* children producing work of quality. There is a staggering

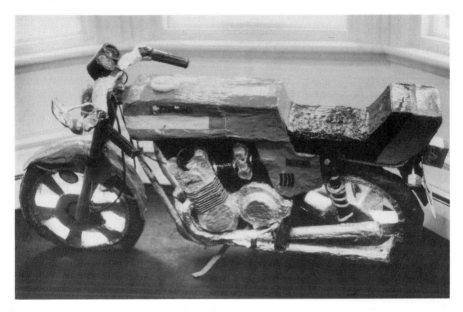

The motorbike is part of a school modelmaking tradition.

amount of talk and response and children have a vocabulary for criticism and discussion. That is why small groups of around twenty are necessary, bigger groups inhibit this.'[6] This head is sensitive to the fact that an informed and informative art room climate is the difference between quality work in depth and what one frequently sees – 'a few talented pupils developing their gifts'.

Another North-West comprehensive school has developed such a reputation for the quality of its modelmaking that when the incoming first-year pupils were interviewed about their expectations in art and craft, the common one was that they all anticipated making models. The tradition began a number of years ago after one of the teachers had been impressed by a two-foot-high papier-mâché model of a lacrosse player which he had seen in the National Children's Art Exhibition:

> That so impressed me that I thought I'd like to try to get some of the kids to do that. And I thought, too, that perhaps some of the kids who perhaps couldn't draw very well or weren't getting much satisfaction out of struggling to try and do 2-D work, might enjoy doing 3-D work; it might be an outlet for them. You know, there must be children who however much you encourage them can't put things down in 2-D but who would find modelmaking interesting and more suitable for their capabilities, really.[7]

Modelmaking was therefore introduced as a means of involving an additional stratum of pupils. Large five-foot models could not be kept out of sight in storerooms, and their prominent display both within the department and around the school was an important factor in establishing a tradition. This has

led to some pupils, whatever else they undertake in the art department, producing at least one major model in each year of their school lives, the inter-change and cross-fertilisation of ideas between pupils of different ages being further encouraged through daily lunchtime activities and the fact that their teacher is to be found working alongside pupils in the department most evenings after school. Within the discipline of modelmaking, there is a flow and transmission of ideas right through the school with no perceptible break at the end of the third year. In consequence, Kevin made a large-scale model of a figure in a go-kart as a first-year pupil followed by a five-foot oil rig, an elaborate and complex piece. In the third year, he produced one of a whole orchestra complete with conductor and a pianist bent over a grand piano. It is a distinctly humorous work, as are many of the school's models. As a fourth-former he made a ceramic sculptural piece, in sections to facilitate firing, of a four-foot-high cowboy.

His awareness of what he is doing and the context within which he operates is reflected in an article he wrote for a local newspaper while still a fourth-former. It was called 'Art put us on the map!', and shows Kevin's understanding of what his unusual art department has to offer:

> Bicycle wheels hang from the ceiling casting inspiring shadows on the walls. Umbrellas are arranged in another corner of the room. Various types of models, all in different states of completion, lie strewn about one part of the room with pupils sculpturing them.
>
> Whilst all this is going on another group may be quietly drawing a still-life scene. Other people may be making batiks or screenprinting. At the moment one first-year group is involved in making rats for a 'Pied Piper' model which will be set up around the art room. If you are short of material for a model, painting or drawing, you don't have to look very far for suggestions. Shelves are full of everything from teapots to motorbike bits. The art rooms are always a hive of activity. As a neighbour said: 'Art certainly put [that school] on the map.'
>
> Art at [our school] seems to play an important part in school life. As soon as you walk through the front door you see all types of models in a glass showcase. Art is not merely another timetabled lesson. It is very much a part of the general way of life in and out of school. This is because as well as the usual classes there is a dinnertime club and an after-school session usually from half-past three to five o'clock . . .[8]

He goes on to talk about the importance of corridor displays, over which great care is taken, adds additional detail about the varieties of models and the school's participation in the Cadbury's exhibitions, mural competitions, etc. The DES *Art in Secondary Education, 11–16* book stresses that it is not necessary for a department to pursue many different activities in order to run a good course because the principal aims can be achieved through one or two main activities: '. . . wise teachers on the whole work from their strengths'.[9] These 'strengths' are not static, however, and this teacher acquired his modelmaking

skills by responding to a need he perceived in his pupils. However, modelmaking has become one of the main activities of the department so that pupils can make quite individual pieces which are nevertheless partly conceived through their awareness of a clearly defined tradition, which has a long-term continuity. This teacher successfully capitalises on the underlying impulses which are apparent in the more potent forms of Home Art already recorded, but the department provides pupils with the space and an expertise and support which enables them to achieve quite unusual results.

To conclude this part there is a section about the critical studies approach of a sixth-form college art teacher, interesting because her evaluation of what she is doing is set against her students' responses. The timetabling accommodates art history and appreciation lessons on a regular weekly basis and the students are helped and encouraged to relate what is learned to their own practical needs. Though the teaching pattern is obviously designed to meet sixth-form requirements, many of the features are also appropriate to the needs of fourth- and fifth-form pupils. Even though practical demands might preclude regular weekly learning about art and craft objects in their own right, the work of many would gain in impetus and direction from periodic in-depth lessons of this type – possibly one a month or every half-term. The increased purpose and motivation of the pupils and their willingness to use their own time would more than compensate for some loss of practical time. What this section certainly pinpoints, though, is the benefit to sixth-form students of systematic exposure to works of art; too many A-level candidates are currently left to research on their own in an unstructured way or examinations are chosen simply because they only involve practical work and the theoretical aspects can be avoided.

Section 2 A Sixth-Form College Approach

The first lesson I got into was on Monet and we were in a dark room and I was late, and I just went in and sat down. There were slides being shown of Monet and I just remember thinking how beautiful they were and how much more they meant when they were explained – and that was just how I got so interested . . . I just couldn't stop thinking about it. That evening I remember going to our library and trying to find some art books. But I couldn't find anything in the library, I mean there were about six books on art . . . So then I went to Wigan library and found some reasonably good books and I just read those that evening . . . I started writing [notes] up in a book and I kept going through pages and pages and pages . . . I just couldn't help it, it was just interest . . . I just walked into that lesson totally unprepared for anything and it just hit – it was just like a revelation, I suppose; it was just incredible![10]

Karen has described an exemplary illuminating experience, and one which took place in the classroom, but she did not intend studying A-level art on moving to

the sixth-form college, and only commenced her art course because she dropped German. On a previous visit to the National Gallery, though, 'I was bored out of my mind! In fact, my sister and I had a scrabble set and we were playing scrabble in the National.' But six months after the Monet lesson, while on a college visit to France, 'I went to the Orangerie in Paris and I spent a whole, well, most of a morning, just looking there and it was just great . . . it was just like swimming in a world of colour.' From playing scrabble in the National to swimming in a world of colour in the Orangerie is a considerable journey and the Monet lesson is the crucial stepping-stone in this process.

Her History of Art teacher is currently the acting Head of Art at the college – there are two other full-time and one part-time teachers in the department. She finds herself increasingly interested in the study of the History of Art herself: 'it's a very absorbing topic'; 'I think what you're hoping to do is to open up something of that excitement to the student, then you don't see it as a two-year course – you see it as the beginning of a kind of journey. What you're hoping to open up for the student is another world, really.'[11] These words are borne out by Karen, who always visits art galleries now 'if they are there, no matter how big they are', and by Julie (see Part II) when she says 'I just want to go on and learn until I don't want to learn anymore!' Having become intrigued by this new subject, many of the students express frustration that this whole area of art study had remained closed to them prior to its being officially timetabled at the sixth-form level.

A small number of students, in addition to their other art studies, follow the AEB History of Art examination syllabus, but the majority study the history and appreciation of art as part of their JMB A-level course, either sitting the three-hour examination or writing the 3,500 word Personal Study on a topic of their own choice, the decision being determined according to ability and inclination. The third course on offer leads to the AEB Art and Craft examination, and the students study a craft – a variety of forms of printmaking or three-dimensional study – in combination with the painting and drawing activities which are also common to the JMB course. The students enter the college at sixteen from a wide variety of school art backgrounds and the teacher feels that as their course is effectively for only five terms it is essential that they see this phase as part of a larger whole. The gallery visits are an important element in the course but book, slide and video resources are an essential day-by-day necessity and she could not cope without using material from her own personal collection:

> One of the problems I found when I went there and I started to teach the art history, having looked at the slides that we had, I had to reject them, really, because it seems to me that it's pointless to show students marvellous works of art – for example, we obviously talk about colour in our subject – and most of the slides were inadequate from that point of view. Also the selection of slides was minimal, really. For example, you could only look at one or two works by any given artist so I had to build up my own slide collection. It has

to be a growing thing, it has to be ever-increasing, because the other thing that I found was that art stopped after the sixties in our course if you looked at the slides that we had, and of course art is an ongoing thing and it's happening now.

Likewise, books pose a problem and she estimates that it would need hundreds of pounds for books alone to be able to do the job properly, given the price of good art books these days:

> I still have to use my own books, though of course we have got Drumcroon now and we can direct students to their library. But it's not good enough because I want to use books and illustrations on a day-to-day basis. Obviously when you're pointing out to a student you want materials on the spot of that nature, so it is inadequate and it is a frustration.

What she would like to do, ideally, would be to be able 'every time I go on holiday to just buy a representative set of slides wherever you're going' and similarly books – but she is very pleased at the recent purchases which the department has been able to make. She always starts the Art History courses either with Impressionism or with the Romantics because the students come without any enlightenment about the history of art:

> My thinking is that students readily identify first of all with the emotional, the representational qualities, in those products. Also, they are nearer to their own times. If I started straight in with contemporary art some students would find it difficult to immediately relate to those products; I mean, there are apparently no human elements in them – apparently, I say.

The first such lesson she treats with the utmost importance:

> I like to take a work because I think it's very engaging for students like, say, *The Haywain*, that they will have seen somewhere in their lives and have accepted at face value just because it's there on a wall, and I like to reveal all I can tell them about that particular work. What's gone into it, what the artist was considering at the time, what impact that work had on other artists like Delacroix – so the whole world of that particular art product becomes absolutely magic for them because they never thought that that picture in Boots stood for that, you know, and at that point you've usually got the students because they say, 'If all that information, excitement is to do with that one work – well, there's hundreds of works to come' therefore 'What are we going to do next week?' and 'What'll be the punchline for the next piece of work that's coming up?' and there's always something.

The essential element in the course is that the students discover that works of art can be 'read' and care is taken to match what is said with the verification of those facts through what can be seen by the students in the works themselves. She tries to avoid the kind of general statements which are frequently made and are invariably interpreted as 'rules' by students as, for example, when it is stated

that Seurat only applied dots of 'pure' unmixed colour – a statement immediately contradicted by the evidence of the subtle colouring of many of the dots themselves as revealed in the actual paintings. To begin this journey which she hopes the students will embark upon, therefore, obviously means that the main focus of the course is on 'looking at works, deciding and discussing how works are made', imparting what you know about the artist which he or she has given expression to in the works, so that 'the student should understand that the works are done by a person, who was a "real" person, with human emotions and intellect and, I think, to get the student to identify with the person through the works is what it is about', and for this to be possible 'it's also to do with the students being able to have the tools to read a work of art'.

The appropriate language is one of these tools, and in the history and appreciation sessions students come to terms with the complex subtleties of works of art through their observations of underpainting, scumbling, impasto, transparency and opacity and discussions about nuances of tone and colour – none of the words necessarily new ones to the student, but used in context to develop observational powers which are further heightened in front of the actual works, because gallery visiting is seen as an integral part of the course. Many of the students become extremely perceptive in their observations of works, as when Anita concludes her JMB Personal Study on 'Optical Inclusion' with a relatively short paragraph on Seurat's *The Bridge at Courbevoie* (1886) which, she says, 'generates stability and calm'. Her final reference is to Leonardo's *Virgin of the Rocks*, the work with which she had begun the Study:

> The repeated verticals and horizontals maintain a steady balance of natural equilibrium. Colour and composition are both contributing factors to an essence of peace. There are no brash colour contrasts, nothing that disturbs the eye within the composition. Stepping down the bank towards the water the strips of green contain sprinklings of peach-pink and swamp-green, they make a base for intervals of blue-green, violet and purple for the dark banks and yellow and mustard for the light. Dark verticals of blue, black and purple dots interrupt the picture at intervals acting as sturdy posts for the calm pastel coloured horizontals, and both tones fade gracefully into the distance. As my eye travels into the centre and furthermost point of the picture, the final central conclusion is a hazy mass of pale blue-grey and lilac spots which evoke the feeling of misty air rising from the water. This idea reminds me of that misty seascape in *Virgin of the Rocks*. A more scientific approach Seurat's may be, but finally, no less poetic.[12]

Anita carefully finds the precise words to describe specific colour nuances, is able to discern the main compositional devices used and is obviously sensitive to the subtleties of mood and atmosphere. This ability has not come about by accident but through the teacher's conscious aim to give her students the necessary 'tools to read a work of art', particularly pertinent for those who produce Personal Studies. She observes that

First of all the student becomes absorbed in that topic, and by that I mean so absorbed that he or she will be active, will actually have to do something to satisfy that need, that absorption in the topic, so that he or she will research avidly. What that means is that they will go out of their way to fill in the pieces, to follow an idea tenaciously. The student will know something extra about the artist other than he or she could ever read, and of course this brings you back to the galleries because part of any good study should be the student working in front of an original piece of work. I don't mean simply describing the work, but taking note of how they think that thing was done, even down to very, very fine analysis of colour. It can be quite tenacious and painstaking that kind of analysis and then having done that trying to unravel why the work looks like that, and this is where the research then comes in and the discussion. And the research, of course, is exciting because you are looking in all sorts of directions. It's like the sketchbook – even though you know the topic is about Manet or your sketch is about near and far, you don't know exactly where you are going to end up because sidetracks can become very interesting.

Though some of the students' English might present a problem, she is aware that this avid research makes many of them lucidly articulate through having something to say. 'They have this terrific desire to communicate ideas that they have understood.' The precise nature of Anita's description owes a great deal to the equally careful matching of words to images in the lessons she has attended:

For example, it would be no good putting up a picture – and I think a lot of art history is done in this way – and reading out from a book the sort of data to do with the artist or even talking about certain qualities in the work. I think you've got to complete the picture by actually showing them in the works where that happens. There's got to be a kind of logic to it as well so the student can actually say, 'Yes, what is being said is right. It's there.' The works are not just flashed up as a background, a sort of atmosphere, to what you're talking about.

This book outlines many ways in which children can be helped to an increased awareness and understanding of art, and many art teachers have rejected – or avoid – the art history lecture, even to sixth-formers, as a means in this process. But this teacher's students testify to the lasting effects which these lessons, using slides in a darkened room, have had upon them – 'It just caught the imagination completely'; 'I got to the point where it was like "The next thrilling instalment next Monday morning at third lesson!"' Of course, for this to happen the teacher is not only drawing on previously acquired knowledge, she also takes the preparation for each lesson seriously. Many of her students willingly research on their own, often purchasing their own art books, but she feels that it is unforgivable to direct them to books if the teacher has only given them a generalised potted background first. She seeks to develop in her students an ability to confirm and build on the evidence of their eyes through study and

research, but feels that if the teacher has not provided the necessary initial framework, then the majority of students will inevitably resort to plagiarism. Indeed, she often finds herself helping the students while they are researching:

> When a student is researching in the art library, if he or she asks me where a book is I find it's not enough to just direct them to it – I have to help them or impart something to them from my knowledge. Not because I want to show off but because there's usually something interesting that you can point out to the student that will ring a bell or get them interested in that particular topic, and I think those are memorable to students because they've been memorable to me.

The art library/reference area is a carpeted space located centrally in the department. It has comfortable chairs and accompanying tables, making it ideal for students' research and study. It is readily accessible to those working in the 3-D and printmaking areas and is separated from the spacious – but busy – painting and drawing studio by an open divider on which stuffed birds and animals, skeletons, butterflies, etc., from the Museum Loan, the department's own range of natural forms, or ceramic objects from the Schools Loan Collection are variously displayed. The studio has extensive wall-display surfaces, made possible by the open beams and overhead lighting, and the students work at art desks, trestles and easels. The proximity of the library/reference area to all the practical spaces is a design feature, but the teacher is aware that a student can learn all manner of things through history and appreciation lessons without ever necessarily deriving practical benefits from them. It is the teacher's function to help students to relate theory and their enjoyment of the works of others to their own needs.

To do this, the teacher has to be sensitive to the individual needs of different students. Some 'readily identify with key artists and they feel that they simply want to try out some of these ideas':

> Now I can't legislate for who that artist may be or when it will be, but usually throughout the lower sixth you find through feedback the way a student actually wants to work, that there's some artist or a group of artists who have triggered off an interest and it's something to do with the way they actually evaluate their own work. They start looking at their own work in a different way, almost seeing what they do through the eyes of another person.

She cites Kathryn as an example, taking a clue from the fact that she was 'absolutely mad on Van Gogh':

> She's always been drawing with an HB pencil and always rendering forms in a particular way that you can with a pencil, so I started to talk to her about the drawings on the Crau and how he would use a stick sometimes and she's now drawing with a stick. Now alright, you may say that's only a technical thing but I think that she has started to look at his drawings and the different ways things can be rendered, the way he can translate texture very easily with a

stick. She's interested in texture and recognises it in the world around so she wants to use it, and at that point she is sort of identifying with his thought-processes.

Sometimes the link comes about through the clues in the student's own work – one, for example, never draws in line:

She draws tonally – in areas of tone – the most beautiful drawings! And I say, 'Have you looked at Seurat?' So we look at Seurat together and we look at the way he models form through soft gradations of tone and how he translates that into colour, and now she comes back to me today and says, 'I've been looking at Seurat. I've bought myself some conté crayons because I want to try out some of these very soft modulations of tone that he goes for.' So she has been active in the sense that she's got out books on Seurat, she's investigating pastels because she thinks that would be a good way of expressing her ideas to do with volume and structure which are particular to her. They came from her but now the artist, if you like, supports something innate within the student.

This student's work is still at an important formative stage but Adrian's admiration for Henry Moore's sculpture and the underground shelter drawings resulted in numerous studies of his sister in bed executed in a wide variety of media, but linked together by a striking monumentality.

The teacher also thinks that sometimes it is necessary to launch something globally, asking her group early in the course, for example, to set up a grouping at home relating to, say, Degas' *Woman with Chrysanthemums* where they are looking at the relationship between a big bouquet of flowers and a figure for essentially compositional reasons. Likewise, their understanding of Degas' compositional means is affirmed through drawings done around their homes of objects near and far. A large foreground door handle leads the eye into a domestic interior with prams and stairs in John's version, and led to an interest in dramatic contrasts of scale which resulted in a whole series of studies made around Liverpool's dockland. Also from such beginnings, Anne became increasingly fascinated by Degas' compositions. 'She liked the asymmetrical compositional ideas and she liked to work in the privacy of her own home; there was something intimate in the same way that his works were intimate. She felt this affinity through that kind of private world of Degas and she would set it up in her own room. She has to be encouraged to do that – how to do it.' It is revealing to hear this same process described from the student's standpoint. Anne had not done art for the two previous years, but when she first saw slide examples at the beginning of her course she thought, 'Oh my goodness! Brilliant!' She continues:

The figure drawings of Degas I really did like – because I hadn't seen them before. It was a different style of painting altogether from what you had seen before on television. You'd see the Great Masters – but these were different! Something that you thought before, 'Oh, I don't like that', you began to like

it more . . . Then when you start drawing, you start thinking, 'Well, I might try a set-up like they did, well, I'll try!' Say, like Degas' figure drawings, because I like figures, but I can't get anyone to pose, so I use myself. So I tried to do that kind of set-up and I think it helps you in your work to study the painters – it's helped me. It's given me more ideas about what to do. Before, you'd just see something outside like the buildings, and you'd just draw that. You look at things differently now. Things that you wouldn't have found interesting before, now you do. It's changed the way that I look at things![13]

For this interaction between the theoretical and practical aspects to be most likely to take place it is obviously desirable that the same teacher is responsible for both areas with the students, conflicting with the notion that at this age students benefit from contact with the viewpoints of various teachers. A colleague of a number of years' standing was Anne's art history teacher and the practical carry-over was achieved through co-ordination between student and teachers, but Julie (see Part II) reveals how her awareness of her surroundings was vividly heightened through her art history studies. In her case the clues were never picked up and utilised elsewhere, and in consequence she began to find her practical work a chore compared with her desire to find out more about art and artists.

The teacher sees an exact parallel between the kind of avid research her students develop on the one hand and their use of the sketchbook on the other:

It's the most personal thing they have and I think one of the most important things about art is that the student is embarking on a journey of self-discovery . . . Some of them have never had a sketchbook, some have. I treat it with great respect because the sketchbook is their visual record of all the things which affect them visually and the exciting thing is to see a way through, if you like, to that individual through the sketchbook to see what makes them tick. Now this is complex because obviously at first I have to, perhaps, launch a global subject on them or an idea where they've actually got to use a certain set-up or a certain relationship of objects so that they're thinking compositionally. But the exciting thing for me – because it happens at all different stages – is where the student actually takes off and finds his or her own personal way through . . . So the sketchbooks are very important things to them.

So important, in fact, that the students devote many hours to drawing at home and outside and – though they always paint with their sketchbooks at their sides – they look after them with loving care. Though this very personal quality underlies each student's work, she puts great emphasis on group discussion and criticism as well as on the individual tuition so characteristic of art teaching.

I will use students' work as examples just as easily and as readily as I will use works of art which are established. Over the last few months since the AEB work was returned, I've used it and I see other members of staff using it

constantly to point out a method of approach, or a compositional idea, a colour relationship and so on, that students might not necessarily consider as a possibility. The students will always make it their own.

Once a particularly strong character, or group of characters, 'takes off' this helps in the formation of a group identity from the interactions which can result. She is aware that the students look at each other's work and for the very best of reasons say 'I will try that.' There was, for example, a special rapport between Sheila and Anne. They were comparing notes with each other over 'these strange asymmetrical things, these complex things with mirrors' and each was saying 'Oh yes, I'll try that' or 'Have you seen this? I've done this.' The initial trigger was Anne's love of Degas, 'and then of course it takes off within the studio'. A third member of the group, Nikki, became friendly with Sheila and Anne through their work. She says that she got a great deal from their work, 'I like looking at people's compositions to see how they've arranged things and to see what I can do myself.'[14] What exactly has she discovered through these observations? (See Sheila's A-level painting facing p. 210.)

> Inter-relationships of shapes – that's very important for me. Shapes flowing into one another so that you are confined to the picture area, and the way that you draw your shapes leads you into more important aspects of the picture that you want to concentrate on, so that your eye is not carried straight off the page, so that it revolves round the actual piece of paper.

Nikki felt 'really humiliated' when at third-year option-time her art teacher advised her not to do art because she was not good enough. After a four-year break from the subject, she had stayed on for a third-year sixth just to do art. She reached an extraordinary high standard in what was basically a two-term course:

> The teaching you have here is excellent. They tell you exactly what to look for and they help you through the whole process of your drawing – absolutely everything, I can't really describe it. They just discipline you to pin down exactly what is in front of you and you really look and analyse it . . . If I hadn't had that discipline that I've had here I wouldn't have got anywhere at all. The change is so drastic, I can see that now – just purely through the teaching.

The personalised and private element in much of the work has already been stressed, but Nikki also emphasises an unusual social aspect in the relationship which can be formed through the students' interest in each other's work. This is in sharp contrast, in her eyes, to the subjects she has been studying during the four years she has been away from art:

> It enables me to express myself more to other people. Because doing Sciences, you do the work, you do your exams, and you get it marked and all it is is results on a piece of paper. It doesn't mean anything. Everybody does it; different people get different grades, but that's all it is to me. I know you learn a lot,

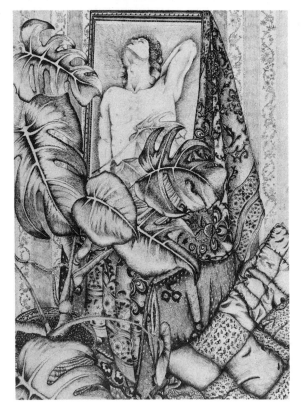

*These sketchbook studies
by Anne, Sheila and
Nikki illustrate the
interactions between
students which can take
place.*

but there is no giving of yourself to anybody at all. There's no relationship formed with other people by doing Sciences and things. When you draw, you're expressing what you think of the subject that you are drawing, and your whole personality comes into it. You can't help it, it just all comes out and people come and look at your drawing and they'll talk about your drawings to you and – I don't know – it's just a whole giving and sharing. It's really good [laughs]. It's something that I've never come across before. It's fantastic, it really is!

These complex inter-relationships contribute to the momentum of the individual student's work in a most positive manner.

A cornerstone of the course is drawing from the clothed model, many of the carefully composed poses incorporating still-life objects and echoing the central figure from Manet's *A Bar at the Folies Bergère*, or the *Olympia* or the Velazquez *Rokeby Venus*. In preparation for the JMB examination students are timetabled for three hours' painting each week with one hour provided for the art history and drawing courses respectively, so there are time constraints. However, students voluntarily use the studio facilities at lunchtimes and in spare moments, and the majority stay behind for ninety minutes an evening each week to work from a posed model. In addition, the many hours spent at home producing complex and fascinating sketchbook studies for subsequent use in the studio is a reconciliation of the Home Art values already referred to, and those underpinning the college course. The students are extremely successful in examination terms, but what they produce is a natural continuation of their course, rather than being a contrived response to an examination question. In consequence, Nikki can observe that she spent every available minute of her time over three weeks on a preparatory drawing of plant forms, fabrics, mirror and reflected figure, the group set up in her bedroom as a study for her examination painting: 'I was really into that picture. I don't know in hours how long it took me to do it, and I don't want to know – I don't care. I loved every moment I spent on that drawing!' Significant when one considers that examination pressures are cited as the commonest reason as to why teachers cannot adopt a critical studies approach and a genuinely enquiring attitude to their practical work. (See drawing opposite and detail facing p. 210.)

Though the art history and appreciation course is taught as a specific subject, it is also carefully and skilfully integrated into all areas of the practical work, rather than remaining a separate knowledge-based, theoretical aspect of the subject. There are important facets central to all the arts which go beyond words; by teaching what can be taught in a thorough and practical way, the students gain insight into these elusive areas. As Anita says, 'You are just more conscious.'

Following his first contact with Degas, Monet and Renoir at the age of fifteen, Bruner describes creating those pictures 'and a real world in which they existed' – a vivid example of heightened environmental awareness in which memory retention and the imagination equally have a part to play.[15] These students

Foreshortening is a characteristic of Laura's figure studies.

re-create a real but private world in their own bedrooms, homes and home surroundings which are derived from the interests and a new view of the world which they have formed from their studies of artists. This personal source of subject matter which they constantly utilise is a rich example of a total fusion of school and Home Art, for content is combined with acute awareness of formal needs and means. Many of their collections of art books, magazines and reproductions are already impressive, and their studies of art and their own work affirm each other – just as the boundaries between exacting work undertaken at home and what is done in the art department become indivisible. The cross-fertilisation of ideas between similarly motivated students leads to constant but almost imperceptible shifts of emphasis as the focus moves from, say, figures in elaborate interiors to sequences of dramatically lit self-portraits to foreshortened studies in which large-scale legs feature prominently. These

studies are the sole means by which the students allow others a glimpse into an area of their own intensely private worlds.

In this partnership between teacher and students, the latter – in the way that Hargreaves suggests – are allowed to move freely from the 'outside' to the 'inside' of what, to them, is a whole new world – that of the visual arts.[16] Their response is to give freely of their own time in a remarkable way. They are all students who have opted to study art, but some of these same principles of making the art form open and available to any pupils or students who choose to participate characterise a type of school-based project which is designed, at least in part, so as to bring the visual arts to the wider school community.

Conclusion

At a time of financial restraint, the argument for improved resources is that, of necessity, a rounded approach to art education must include reference to, and integration of, physical objects, materials and visual images. It has been shown that much can be achieved with limited investment and with advantage taken of changing circumstances.

However, in keeping with the ethos of critical studies as expounded so far, integration and reinforcement are all-important. The selected case study is multi-faceted. It exemplifies this theme and adds deeper insights into the use of resources. For example, teachers should impart something of their own knowledge to magnify the potential of the resource; also, images and other materials should be investigated in comparable ways to those used with originals to discover essential qualities.

The case study harks back to Parts II and III in, first, exhibiting means by which the conventional art history lecture can be enriched and, secondly, in taking up the theme of Home Art once more. In the latter case, the author deduces that relationships formed with other students, partly as a result of group discussions, can contribute to the momentum of pupils' work. With this motivation the impulse found in school extends beyond it with students spending considerable time working at home. There is thus a fusion of Home Art and school art, with an attendant emphasis on personally expressive practical work given enhanced structure and meaning because of the students' studies of the works of others.

Part VIII
Art and the School Community

Section 1 Beyond the Timetable
The tension between school systems and the needs of the visual arts is the subject of this section. The author considers different types of activity that might bring about experiences central to art otherwise not possible. He evaluates extra-curricular activity, exhibitions and displays and visits by artists and craftspeople.

Section 2 A Kiln-Building Project
Both the case study in Section 2 and that which follows in Section 3 demonstrate, in completely different ways, the effect of a combination of the three elements already located. From a project to build a kiln with the help of artists grew a cross-curricular initiative providing opportunities for involvement for all pupils, an idea which was larger than the timetable itself.

Section 3 'Rigby Revisited'
This sixth-form college case study has, as its starting point, an exhibition of past students' work. Its startling success in reaching out to many different communities of interest within and outside the college is described alongside the original conception and realisation.

Section 1 Beyond the Timetable

If we look back on our schooldays, what were the moments when something really important and memorable happened? And where were you when it happened? In the classroom? Doubtful. More likely in a play, a concert or on a school visit. On an excursion at camp along with friends and a teacher you were getting to know. But these events are regarded as frills, as peripheral little stopping places on our long educational trip. But the experience of many people points to the fact that such moments are central to learning and, therefore, what we should begin to do is to turn the school inside out – put the peripheral experience into the middle and put the classroom experience on the fringe.[1]

<div align="right">Harry Rée</div>

I began my teaching career in one of the early comprehensives, streamed from A to H in the days before setting, banding and mixed-ability groupings. Each year it held a Festival of the Arts, consisting of exhibitions, plays, concerts and gymnastic displays, but what remains most vividly in my mind was the music drama which the Head of the PE department produced for these occasions. The play tended to use the more able pupils but the music drama involved mainly the E and F stream pupils. A mimed dramatisation, it relied entirely on movement and gesture and the first year I was at the school it was enacted to Sibelius' *Finlandia*. Staff, pupils and general public alike found the performance extremely moving and the standard achieved extraordinarily high. The children involved had few school achievements to their credit but they were aware that on this occasion they were part of something special – and in the process the *Finlandia* Suite assumed a particular significance. They came to love its expressive beauty because of the meaning it acquired through their personal involvement with it.

In the course of my writing this book, a programme called *Carmen Comes to St Aidan's* was shown on television. Opera North visited a Sunderland school. The team of four consisted of a pianist, tenor, mezzo and producer. At first the children watched and listened politely, but first a few and then eventually, for the last-act chorus, considerable numbers were skilfully involved. By the time Don José murdered Carmen at the opera's climax the atmosphere was electric, the pupils obviously captivated. Only rarely can these kinds of experience be stimulated within the confines of the normal school timetable.

The testimonies and approaches adopted by many of the teachers whose practices have already been outlined here also reveal that the visual arts often fit uncomfortably into the conventional school timetable. Rée refers to the impediment imposed by 'the damned timetable, where the arts teacher, and each pupil, are forced to break into the production or the rehearsal, into the act of creation in painting or printing or potting, at the sound of a bell or a tannoy . . . '. He would like to see a radical change in the overall running and organisation of schools, but in the meantime he believes that arts teachers should strive to 'modify the disadvantages of school' by at least spending 'a bit of time taking down the obstacles and barricades against the arts which schools traditionally put up'. The timetable is intended to facilitate learning but many arts teachers would agree with Rée that, in practice, it often seems more like an inhibiting straitjacket. What it does do is to provide a necessary regular allocation of time in which to practise basic skills relating to the arts subjects, but frequently to the exclusion of the kind of aesthetic experiences which are central to those subjects. It is for this reason that so many teachers of the visual arts devote so much of their time and energy to extra-curricular activities at lunchtimes and after school – making them infrequent visitors to the staffroom, and sometimes causing resentment with colleagues who do not feel the same need to give up their time for additional voluntary teaching.

At a recent art teachers' course I heard a young teacher announce that she did not hold with art clubs because they are elitist; it was either the middle class or

'talented' pupils who attended and 'rarely those you really want to influence'. By the same token, sporting activities would have to be greatly reduced because teams tend to consist of pupils who are good at or who enjoy the sport rather than being composed of those who prefer to do a paper round instead. Equally, the *absence* of these activities ensures not only that the talented or interested are penalised but also no provision exists for those the teacher 'really wants to influence'. Teachers who do run these clubs do so as an extra means of enabling additional numbers of pupils to realise their potential more fully. Lauretta Rose has talked about a distinctive genre of art, 'School Art', and though this might, in part, be determined by examination requirements it is equally the product of set lessons in which pupils have to be told what to do.[2] Examples have already been cited where the standard curriculum has been fed and replenished by the attitudes formed in an additional context where pupils' work arises out of personal need as opposed to them only doing that which is prescribed. Rée wants 'to turn the school inside out' so that its structure encourages these central learning experiences rather than it be left to individual teachers to decide whether or not they choose to settle for only that which can be achieved within the present constraints.[3] It speaks volumes for visual arts teachers that so many choose to do so much more.

Predictability is the great enemy of the arts in schools, but even within the standard course it is possible to make pupils sit up and take note. Hargreaves argues that surprise is a feature of the conversive trauma and suggests that

> There is no reason why teachers should not self-consciously plan surprises for pupils. Art rooms everywhere look remarkably alike: their walls are usually covered with pupils' work, and occasionally a reproduction or two can be found there. The trouble is, my observations suggest, the children so rarely look at the walls: the art work there is mostly treated as unimportant wallpaper. Encouragement to look at the walls could be fostered by planned surprise. For instance, one week the walls might be left completely blank; another week just one picture exhibited; the next week pupils' work; then the week after some highly contrasting reproductions, and so on.[4]

Fairbairn's observation that schools are so often bare places with an atmosphere like that of a barracks has already been noted,[5] and it must be stressed that many visual arts teachers wage a lone battle spending considerable time and energy putting up displays around the school in buildings which often look as if they were designed positively to frustrate their efforts. Also, compared with the arid drabness which still characterises so many classrooms, art departments are often a visual oasis within the school. Having said that, I would go further than Hargreaves and suggest that every art department might beneficially devise its own exhibition programme throughout the school year in which strongly contrasting displays successively supplant each other. This might commence with an exhibition which summarises the pupils' achievements of the previous year, with all age-ranges represented. If the school can draw on a loan collection, the 'density' of that first display could then give way to a handful of works by

mature artists, possibly all larger in scale than the standard school product. If these were captioned, some questions posed to engage the pupils and parallels drawn with reproductions, encouraging them to compare and contrast, a quite simple exhibition could become quite significant. Individual pupils might next be allocated appropriate areas in which to present displays of their own work in as attractive and explanatory a manner as possible, and so on. CSE and 16+ displays are an automatic feature of any school year, arrangements might be made to borrow the work of one or two former students now studying the subject in higher education, an exchange of work with a feeder school would also have diplomatic benefits. Add to this possible contacts with a local artist or maker and the interest which would be shown in the art staff's own work and a varied half-termly exhibition programme could soon be devised. The effort involved would more than repay itself through the surprises and interest which would be generated. Of course, the local artist or craftsperson might also be willing to come into school to talk and demonstrate to the pupils, for the impact that, for example, Pierre Degen and Oliver Bevan have had on groups has already been recorded.

This last approach has considerable value:

> The great value has been to make art more accessible . . . Something that most impressed me was the lack of inhibition and absence of preconceptions about Art and Sculpture displayed by most people confronted with Lee's work. Something to do with the work being in progress, wood chips underfoot, the artist stopping, looking, thinking – these elements combined to create an atmosphere which seemed to narrow the distance between viewer and object – artist and public.[6]

The speaker is Head of Art at a village college in Cambridge and he is reflecting on the residency of Lee Grandjean. He had been involved in the setting up of the residency from the outset, looking at hundreds of slides and photographs of sculpture with the Eastern Arts Visual Arts Officer. This resulted in four sculptors spending a day each at the college, these visits 'extremely useful and stimulating in themselves as most of the artists spoke to groups of children about their work and often received a very lively response'. This process led to Lee Grandjean being in residence for two weeks. This Head of Art emphasises that the object of the Artists-in-Schools scheme is not to duplicate the teacher's role but rather to create a studio space or working environment and for them to produce their own work, the nature of the contacts made depending very much on teaching styles and the ethos of the school: 'In our situation that often meant simply quietly watching Lee at work, the bolder pupils posing questions or answering them as Lee often initiated conversation. Sometimes Lee would speak more formally but briefly to whole teaching groups and this was linked directly or indirectly to their classwork . . .'.

Placements through both the Artists and Craftspersons-in-Schools schemes result in a multiplicity of approaches reflecting the uniqueness and variety of approaches special to every individual artist and maker, and the demands and

expectations – sometimes constraints – of the schools involved. In each case, unless the placement is a disaster and a mis-match, the pupils should experience something additional to that which arises out of the normal everyday workings of the school and this, in turn, will obviously modify and influence their attitudes to their own work. It is this aspect which the Deputy Head of a school in Yorkshire comments upon during the residency of Carmel Buckley:

'A woodcarver to spend five weeks at [the school] working with small groups of children! Well, maybe the newness of the medium will hold them for a couple of weeks, but . . . '

Knowing the kids as well as we do we are aware that despite their many qualities, lengthy application does not usually fall into their repertoire – particularly in the Arts. A rapid improvisation is easier than an in-depth analysis of relationships; a painting completed in an hour more rewarding than deeper involvement over a longer period. It is the syndrome of the quickly and superficially achieved end-product. But by the nature of the medium and its material, wood carving is a painstakingly slow process. It says much for Carmel Buckley's dedication, personality and approach that the majority of the kids are still 'in there' and that the harvest which has emerged from large blocks of trunks is so exciting . . .

Rough hewn masks, a giant foot, animal shapes – all have a primeval, almost ritualistic quality, and all have emerged not only from a gradual familiarity with technique but as a genuine personal expression of the experience through which the kids have passed.[7]

However well we think we might know our pupils, the additional stimulus of contact with a visiting artist or maker can reveal new depths of insight and involvement.

Some artists just want studio space to get on with their own work, others go to considerable lengths to involve pupils in what they are doing and to encourage them to participate in related activities. A piece of the artist's work is often purchased by the school, usually with help from the Regional Arts Association, as a permanent outcome of the residency. Richard Harris spent his residency at a comprehensive in the North East working on a sculpture to be sited in the school grounds: 'If I had simply provided the school with a sculpture, it would have served to alienate people even further from art. Due to the fact that I am working as a member of a group, pupils tend to look at art in a more open frame of mind.'[8] The pupils felt very much involved in this project because Richard Harris sought their active participation, assuming a role himself not unlike that of a team-leader. One pupil observed: 'Richard's weekly visits made us think more about our own designs, everyone feels that they have had a hand in the final design, though it is difficult to pinpoint any individual's contribution . . . I personally have enjoyed working in the team and feel much more confident about attempting further work of a similar nature.'

Schools tend to be insular institutions – worlds of their own – so visiting artists and makers can sometimes appear to be a threat or challenge to the art teacher,

presenting different values and undermining him or her in the process, but the Head of Art at the school Richard Harris visited sees the partnership between 'a teacher, working with a specialist from outside the school, each contributing his own particular skills' as being something that 'enhances the pupils' education'. In these examples, the effect of the visitor as a catalyst can be seen. This sometimes happens with only a limited number of pupils, but on occasions a whole school population can be dramatically affected by resident artists or craftspeople.

An example of this process in operation was when a spinner and dyer went into a Lancashire primary school. She worked with a third-year junior class, a related display bringing her presence and specialism to the attention of the whole school. Wherever possible, the authority art adviser should be involved in placements, and one of the benefits which resulted in this case was that the art adviser was able to extend the project by then going into the school himself to launch a weaving project with the class, utilising the materials which had been spun and dyed. This led to designs, derived from the observation of classroom objects, which formed the basis of the weavings. The work produced resulted in an extensive exhibition in the school. From the discussions this generated, it came to the head teacher's notice that some of the younger children were quite upset, believing that the sheep had to be killed to obtain its wool. She contacted a farmer, and on a hot summer's day the whole school came out into the playground to observe a sheep-shearing demonstration. From the spinner–dyer coming in to work with one class, a natural momentum had been generated and utilised to involve the whole school as a community in something which, even in a primary school with its more flexible day, would not normally have happened as each class and teacher went about their business.[9]

Three separate elements have been touched upon so far in this section. These are:

1 Extra-curricular activities such as lunchtime art clubs, sometimes taking the form of special events over a period of a school week.
2 Exhibitions and displays deliberately planned to surprise because of their contrast and presentation with what is normally seen or was previously displayed.
3 Visitors working in the school extending pupils' awareness of the visual arts in the process.

Each of these elements can have an appreciable effect in their own right: combined they add up to something quite unusual, as is illustrated in the two following examples. The level of planning and the demands on the staff involved could not be sustained on a regular basis, but the rewards are considerable. Every school could organise and stage an event, certainly combining two if not the three elements, on an annual or biennial basis, but certainly within the school life of each generation of its pupils. Change takes place slowly in schools and one day a secondary school structure more conducive to enjoying and learning about the arts might be achieved. In the meantime specially organised

events of this kind can do a great deal to 'modify the disadvantages of school' and in the process go well beyond what the timetable allows. The building of a kiln in the grounds of a secondary school by two resident ceramicists acted as the focus and catalyst for one such combined venture.

Section 2 A Kiln-Building Project

A North-West 11–16 high school became involved in a kiln-building project in the autumn term of 1983. The initial invitation came from the authority who were already engaged in another project with the Horse and Bamboo, a regionally based community group who, as part of their role, had previously worked in a number of schools. They had two ceramicists on their staff, and so the idea of a kiln-building project arose. The head of the art department was keen to be involved from the outset because of the possibility of involving the whole school as well as the additional stimulus which the project would bring to the art lessons. His initial response was:

> It's a great opportunity for the kids to get involved and see what happens inside a kiln because I've done some kiln-building when I was at college and it's always been one of my great loves in terms of education with clay, because I think that so much that happens in the classroom the kids miss the relationship – what they get back is something that's transformed magically, they suddenly see a glaze on it.[10]

The teacher might explain what happens, but 'they've never had an understanding through experience, it seems to me. They've only had an understanding, if you like, through trust.' The opportunity to have a kiln-building session in school was therefore a chance to get over what he saw as 'quite a large barrier in their understanding'. Planning began during the summer term, and the last week of September was scheduled as being when the project would actually take place (see facing p. 211).

He admits that he may possibly have 'gone a little bit too grandiose in my ideas which I had to start trimming down eventually because it was getting out of hand'. Instead of all 800 art pupils making pots, two or three selected classes would produce the work but everybody would have the opportunity to see what was happening. The size of kiln which was feasible would necessitate each child making minute thumb-pots and defeat the whole purpose of the project which would become a limiting rather than a broadening one. Equally, it would have been unacceptable for all pupils to produce ware, and then the excessive numbers made it impossible for them all to be fired.

He wanted the groups involved to have an understanding from conception through to the finished product. Clay forms would be developed from sketchbook studies (sketchbooks are used in the lower as well as the upper school) of natural forms like fungi and shells. In the event, children also brought

in charred pieces of metal, photographs, rusty surfaces and lots of textural things cut out of magazines not related to specific objects but which gave them an idea of the sort of things they were looking at in natural forms, and they collected this information on a worksheet basis.

As with most projects of this kind, they take on a life of their own and grow in unexpected ways because, by their very nature, they stimulate and generate ideas. From an early stage, the art staff agreed to turn the whole of the timetable over to ceramics, with the Raku kiln as the focus for the week. One of the participating groups had visited Drumcroon a fortnight before to meet Jenny Beavan, working as a visiting craftsperson in relation to her ceramics exhibition. Many of the pupils were surprised at the variety and range of colours she used. 'That got rid of a preconception, because in school you can spend so much time on glazing that you don't get anything built', so this was another exciting possibility. By turning the whole week over to ceramics 'it allowed us to show the kids many facets of colour and glazing and even the technique of Raku and its tradition'.

In their initial thinking, the art staff were aware that all their pupils would have to spend some time working in the art department, but would also go outside to the Raku kiln, conveniently sited adjacent to the art block, and to the school entrance hall. In this attractive space – made into an exhibition area by the previous Head of Art through the installation of a trackline and spotlights, the surfacing of a large wall area with cork tiles and by making a set of display boxes – it was envisaged that a display on the tradition of Raku would be supported by the pupils' course work, and as their pieces came out of the kiln they would be linked to the visual wall display and ceramics pieces produced in art lessons.

This idea developed considerably, though, when the suggestion was made that a set of ceramics from the Schools Loan Collection might beneficially be used. This led to a really substantial exhibition, supported by information sheets about kilns, Raku and glazing displayed on the wall and a wide variety of books on ceramics. The works on display included an impressive collection of John Leach pots, from small pieces to a 27″ tall storage pot, an elaborate decorative bowl and small teapot by Jenny Beavan, a large black glazed plate and teapot by David Lloyd-Jones and a set of Raku pieces depicting Salford demolition sites by Jon Biddulph. What was to have been a display of back-up information therefore became an attractive, substantial exhibition of great teaching potential. For all the children to extract the maximum from the kiln site and the exhibition, it was necessary to co-ordinate the movements of as many as four groups of pupils simultaneously timetabled to the art department. This meant a rota: 'We did twenty minutes of a worksheet in the classroom and then we'd take them out to the site while there was another group doing worksheets in the classroom and one group was looking at the exhibition, and then we'd move round – otherwise we'd have had sixty children round the site.' In the event, the week ran very smoothly and the teacher's desire that the children fully understand the firing process was realised:

The astonishment and the understanding on children's faces that came about! And the fact that you can actually say to them, 'Well, look. This is what actually happens in a kiln', particularly with a wood-fired kiln because it's so visual and you take off that door and they can see the flames shooting up. They can see the airflow, they can see the glaze glistening on the pots, and for many staff – never mind the children – that's an experience they've never had the chance to see . . . These kids and the staff who were watching could actually see what was happening to the glaze – it was there in a molten state. The understanding that took place! You can't describe it, it's a perfect way of getting complete understanding from the kids.

Sue and Laura from the Horse and Bamboo built the kiln and were responsible for the firings. The children called them by their first names, 'which helped break down traditional school barriers'. The children were well informed, aware of terms like 'firebox' both through their worksheets and the information accompanying the exhibition, so most of their questions to Sue and Laura were to confirm information. One of them would then give a description of the firebox and demonstrate its purpose: 'They were people, if you like, getting on with their job and that's how they were treated. The children didn't react as "them" and "us" and the more the children got confident and involved in the project, the more they were actually prepared to help stoke the fire up and re-mortar the cracks with clay.'

For practical reasons, the organisation of the art groups had to be carefully co-ordinated but an important aspect of the week was that the *whole* of the humanities department's teaching was also turned over to ceramics. The head of humanities had responded to the idea of a clay week from early on:

He was all for breaking down categorised forms of knowledge between departments and areas, and the next thing I knew he handed me a worksheet and said, 'Can you give me a timetable you're going to do for the week and this is what we have in mind.' What he'd actually given me was a full layout worksheet which he was proposing to cover with absolutely every kid in the first two years.

The involvement of the humanities department was important because they taught about the development of civilisation as illustrated through ceramics, and the nature and properties of clay – 'the changing face of clay from its volcanic state right the way through to how the same parallel takes place in a pot from its plastic state through to a glazed form'. It was exciting for the art staff to see the children arriving in the art department to take up these themes again from a different standpoint, but with 'half the knowledge in their heads already': 'We were able to expand upon that and fill the gaps, and to actually give them visual experiences rather than purely theoretical classroom-based stuff – and I think that's when it really started taking off.' This humanities involvement was also important because it aroused interest in the project amongst fourth- and fifth-year pupils who no longer studied art. Some of these came out to see the

kiln officially in humanities lessons, but the packing and firing of the kiln generated a lot of interest in its own right:

> We were doing firings through break and building through the lunchtime and stoking up and so forth straight after school. We were often unpacking a firing at three-thirty, which we'd timed so we'd be able to get any kids that were coming out of school to be able to come and watch. Half the fourth- and fifth-year kids who were watching at lunchtimes and breaks didn't even do art, so they were getting just as much of the experience. The fact that it was happening – actually taking place – and the involvement, that was the important thing.

Children became so involved that they were asking if they could go and clean pots up as they cooled down. 'They weren't their pots but they were just so interested and so keen on seeing what was underneath the carbon that they just wanted to do it.' Once cleaned up, these pots were then displayed in the entrance hall, so the exhibition there was constantly changing and expanding. The children's work that is normally displayed 'can just become window-dressing and that's all. Children see things there, they look very nice – but they walk past them.' With this exhibition, though, the staff were able to engage the children in discussion, with likes and dislikes and the whys and wherefores considered:

> You couldn't get much more of a contrast in styles than between, say, the John Leach stuff and the Jon Biddulphs, because they represented completely different facets. First of all, the sheer craftsmanship that comes across in the material – this is what bowled the children over. But equally you get over this idea that clay is good for one purpose only, to make vessels.

For all the emphasis on clay as a sculptural and drawing material in the classroom, it was actually seeing these contrasts 'that changes an experience into understanding'.

The Biddulphs, of course, were Raku-fired and parallels were drawn between the effects he had obtained and those in the children's work; some were aware of these links without need of anyone to point them out. They could also see that these effects, though accidental in their work, were part of a tradition. Biddulph had more choices, deciding on particular effects through practice and experience. The book display was used to amplify such points, through additional illustrated examples – but it was valuable for teachers to see the sheer breadth of ceramics books which are now being published.

In addition to non-art pupils, many members of staff also came to see the firings – one of the deputies couldn't keep away and was there most evenings. The head teacher visited the site and there were five offers from non-art teachers to help build another kiln. They should eventually get their opportunity because it is the intention to have a Kiln Week every year and do 'a co-ordinated study between art and humanities, and next time we want to bring in the chemistry side of it'. The chemistry department deal with reduction of

materials as part of their third-year syllabus, but it is normally taught as a theoretical scientific principle and the gains here are obvious:

> For example, we used a glaze based heavily with copper-oxide, so when we put it under a reduction firing via the Raku technique the oxide returns to its natural state. We were getting tremendous variations of colour from natural copper right the way through to what you would expect with copper oxide where oxygen is present, of the greeny-turquoise colours. I couldn't think of a better visual aid to show children chemically – never mind aesthetically!

He will make modifications the next time, however. Using simple basic forms, he would like to do some Raku firing to enable the children to understand more fully what effects they can realise in glaze so as to enable them to see:

> . . . that the glazing is totally inseparable from the conception of the pot and unless they see it that way, glazing will always be just an addition, which of course it isn't. Particularly in Raku, it's part and parcel of the whole process and at the moment the children don't see that, they just see the glaze as being something you add on afterwards to make it look a little bit stronger.

This work would be allied to a course project relating to natural forms derived from observational work, so that two distinct courses with different aims would come together in practice. One regret is that the kiln was built to be temporary and had it been made to last the catalyst effects of the week could have been immediately capitalised upon. Nevertheless, it is important to build more now that the children 'know the why and wherefores. They understand why you need an updraught and so forth. These are terms the kids are familiar with now, so it would only be natural to build upon that experience.' The term 'Raku' is now no longer a novelty to the children either:

> As far as is possible, they understand what the word Raku encapsulated but, I mean, it's such a complex form of art – the traditional Raku, anyway – you can't expect to get a child to understand totally that tradition within a week. You know, the things at the tea ceremony and so forth. That sacredness, it's almost religious the reverence the Japanese have for the forms. But the facet that they do understand totally when they use the word is what happens to glazes, why they change colours, why it's only possible to get these sorts of results through a reduction firing of the Raku ilk.

Rigby Revisited (see p. 243).

(Top left and right) The art department took on the appearance of a gallery.

(Bottom left) Sylvia Wright, one of the resident artists, painting with a house brush on one of her large canvases.

(Bottom right) By the end of the exhibition, students' easels and trestles had reappeared and many visiting groups of pupils had attended.

Because reduction firing is impractical in the classroom, the children had hitherto remained unaware of the possibility.

This project is yet one more illustration of how a constructive idea, once acted on, proves to be the starting point for something which grows into a larger, more significant whole. The involvement of the whole art staff and then of the humanities department – with the promise of future co-operation with the science staff – led to a heightened teaching commitment relatively uncommon in secondary schools. Even though the conventional timetable remained in operation throughout the week, the kind of valuable cross-references and illumination through real experience which the timetable so often seems to inhibit not only took place but did so across disciplines. Not only did non-art pupils become involved, but the focus of an unusual and powerful stimulus generated some corporate community feeling. Though art groups had to be tightly organised, for practical reasons, both pupils and teachers willingly participated at breaktimes, in the lunch hour, and after school. The stimulus of the kiln led to the pupils seeing the relationships between their own work and that of mature artists, and between books and printed material and the study of those works. Most important of all, though, a vivid understanding through experience came about in a way that theoretical explanations alone can rarely achieve. When a sixth-form college approached its former students who had gone on to study art in higher education and invited them to exhibit their work collectively in the college, an equally fascinating combined venture resulted.

Section 3 'Rigby Revisited'

I thought it was really exciting coming into the department when it was like that and it was very interesting to see how diverse the work was that came out. All the people there had gone through the same department, had been taught

The Last of England *by Ford Madox Brown: key stages in the production of a painting (see page 262).*

(See facing page 258 for completed painting.)

(Top left) After six weeks in early 1853.

(Top right) 1 September 1854.

(Centre left) Brown painted out the self-portrait in September 1854 and this was how the painting looked in March 1855.

(Centre right) 29 March 1855.

(Bottom left) The cabbages were painted in the April, and the man's head begun again between 19 and 22 August 1855.

(Bottom right) 2 September—completion on 11 September 1855. (The man's hand was painted out and repainted during this stage.)

by the same people – and yet the way they'd progressed was so totally different. I suppose it opened up what comes after the sixth form . . . It just makes it seem more alive to see finished products from outside the college – that it's not just what the college is producing but you're seeing what other people are producing.[11] [See facing p. 242.]

Angela, a lower-sixth student, is recalling six months later the impact of coming to a sixth-form college and immediately being confronted by the 'Rigby Revisited' exhibition. The title was chosen because the work was all produced in higher education and beyond by former students of the college, which is called St John Rigby. Over 150 pieces of work embraced graphics, ceramics, architecture, painting, printmaking, embroidery and textiles, 3-D, etc., and were produced at colleges of higher education and on foundation courses, at universities and polytechnics, and privately or commercially by those who had already obtained degrees. Besides opening up a picture of the possibilities on leaving the sixth-form college, it also had an effect on Angela's attitude towards studying the subject while at the college. Without the exhibition having taken place, 'I don't think I would feel as much interest in the department. I see the department as willing to try something different, something slightly unorthodox. I think having that so soon in the year was like a real motivation – it was kind of an event which follows on.' These reactions were not only restricted to the students, but the preconception as to what schools and sixth-form colleges were like and how they operated were altered for the department's two probationary teachers. One, for example, was pleased that it happened because

> I was very impressed by it. I was surprised, really, that a sixth-form college could do that because I'd only done PGCE. I was expecting a school-type atmosphere and then, you know, I was in here in the exhibition and I was really impressed by it . . . I could see it was of benefit because of the way the students worked after that, and quite often in some of the ideas afterwards.

The art department took on the distinctive appearance of an art gallery. All the art room furniture was stored in an adjacent building where the college canoes are housed – with the exception of the low coffee tables and comfortable chairs from the reference/study area. These were grouped in the centre of the main art studio to encourage informal and leisurely viewing. Where possible, one student's works would be grouped together and this led to strong contrasts between one area and another. Ian's first-year BA paintings done at Sheffield dominated the main wall of the painting and drawing studio. Large irregular-shaped canvases, they were rich and dark in tonality alleviated by pale lines with diffuse edges. Seemingly abstract at first glance, the forms and shapes derived from the multiple photographic images of planets taken by space rockets. A large, dramatic triptych on the opposite wall had been a central feature of Peter Clayton's BA show at Lancaster, and contained strong echoes of Max Beckmann. Extra display was created by hanging screens over the open dividers between this studio and the reference/study area. Angela's bright,

richly-coloured embroidery textile panels, produced at Crewe and Alsager, enlivened this space, while on the reverse side many of the students were affected by Adrian Johnson's introspective self-portraits and figure studies, either painted in thick impasto or drawn in a dramatic combination of charcoal and latex. His degree was from Ruskin, Oxford, and his latest studies had been produced at home. By school standards, many of the works were large and the acting Head of Art was aware of the significance of visual impact: 'Some of them were completely bowled over by it and baffled. The lower sixth coming in didn't expect an art department to look like that, of course, because they are conditioned to what they think art departments should look like.'[12]

If it had just been an art department exhibition it would have been unusual and impressive but it had been envisaged as a college event from an early stage, the intention being to involve as much of the college community as possible. The exhibition therefore began in the entrance and foyer area where the impact of Sylvia Wright's 8' × 5' oil, *Illuminated Night*, established the mood. She still works in Leicester, where she obtained her degree, in the Knighton Lane Group Studio, of which she was a founder member. A set of paintings and prints by Tony Lysycia also helped to set the tone of the exhibition, but unfortunately it was impossible to transport his sculpture, which he regarded as his main achievement in his second year at the Royal College of Art.

Other works ensured that the flow continued into the library where a variety of graphics, photographic and illustrative work was displayed on screens and Myles' architectural drawings were complemented by three-dimensional models. Large paintings and textiles were hung on panels at the ends of bookcases but the central feature dominating the library was the mural-like effect achieved by presenting a sequence of Mary's five-foot-high pastel paintings of meat carcasses side by side. A pupil of limited academic attainment, she had become fascinated by Wigan market's meat stalls as an A-level student but this interest was considered inappropriate to her foundation-course studies. The pastel paintings had therefore been produced at home and are another fascinating example of Home Art. They aroused great interest at her BA interviews, though, and she has since presented them to her sixth-form college, so they are still hung in the library. They were followed up by large sculptural pieces produced on her Fine Art course at Portsmouth – but these too could not be transported for the exhibition, unfortunately (see facing p. 210).

To link the library exhibits to those in the art department, the college's own course work by A-level students who had left at the summer was displayed along the linking corridor, ensuring that the exhibition was continuous and unbroken from first entering the college until arriving at its culmination in the art department. Equally important, it enabled comparisons to be drawn between the standards and values of the college course with what had been achieved since from that base. No visitor or member of the college could remain unaware of the exhibition. A member of the art department staff observes that

If the exhibition had merely been contained within an art department then it

would not have been noticed and it would have been just another art department function and it would still have had the mystique and mystery that surrounds art departments. People probably wouldn't have ventured down into the department – or very few would have.

Starting a couple of weeks in advance, notices appeared in the college bulletins announcing the exhibition. Beginning simply with the intriguing wording 'Rigby is being revisited', an additional amount of information was added each day culminating on the last day of the exhibition with a notice which utilised three of the exhibits' titles indicating that this was a last opportunity to see *Orion's Sword, Illuminated Night* and *Richardson's Curve*. The scale of the exhibition also meant that preliminary activity was apparent. One upper-sixth art student commented that her non-art friends could not wait for this exhibition to open! It had had to be organised at a time in a new academic year when student needs were of paramount importance, meaning that the two senior art teachers were working until seven or eight o'clock each evening, ably assisted by John, the technician, and Ian, the Sheffield student already mentioned. He gave up a great deal of his time to assist, observing afterwards how exhausting it had been but he had learned a great deal, never having realised just how much went into the planning and hanging of an exhibition. The staff, too, found the preparation and presentation very demanding, but the observation of one summed up the feeling:

> I did enjoy it very much. I like that type of activity and that sort of involvement, and I do think it's part of the teacher's role to see that an exhibition is mounted and arranged properly and that people can see it in the correct way. If it means hanging up paintings, nails in walls and all the rest of it, that's all part and parcel of the job . . .

The Head of Art had been able to use the college minibus to borrow some screens and had driven to Sheffield to collect Ian's paintings in the week before the course to which he was seconded began, but his two colleagues had the problem of arranging a large-scale exhibition while having to allow spaces for works which some students could not deliver until the day or two before the exhibition officially opened.

The idea was a natural outcome of the interest any art department has in its former students. They frequently came back to visit, so the staff were aware of what many of them were doing. Sometimes students would bring their portfolios along and this led to some displays of individuals' work within the department and each year one or two art students agreed to talk at college careers forums, so many contacts were maintained, but

> Over eight years quite a number of students had gone on to study art in higher education. Obviously you get some feedback on what they're doing and where they're at and so forth – and it was tantalising. You knew that so and so was off to do a Foundation Year and somebody else was doing Painting somewhere and of course it begs the question, 'Well, what are they doing?

What does their work actually look like? What's happening to them? Are they all pursuing Art? Have they given up?' and so on. It had been discussed, it had been in the air and we thought, 'One day we're going to get round to doing this. We're going to invite our students back.'

The scale of the exhibition had grown quickly, though, once they sat down and went through the lists of former students, picking out those who had gone on to study Art and Design, and when thirty responded offering on average five pieces each it was obvious that the exhibition was going to be varied and impressive. It was never seen as just a nostalgic celebration of the past, though. Its impact on the incoming lower sixth has already been recorded, and the acting Head of Art is equally clear about its importance for the upper sixth:

> Now obviously it was going to be exciting for our present students. We obviously had a vested interest in it in that students are always saying, 'What will I do next? Where will I go to and how will I be working there?' These are questions they ask you at upper sixth and we had a vested interest in them seeing what the next stage on was, and also new students coming into what would be an exciting department visually.

The exhibition was seen, then, as offering unique teaching opportunities and to extend this further, the possibility of some of the artists represented being involved was explored. The authority was prepared to make some funding available for this purpose – plus financing a properly produced colour catalogue and a preview – and they approached North West Arts, the Regional Arts Association, on behalf of the college. This resulted in four artists being invited to work in residence for a week in their former art department. It was agreed with North West Arts that these artists would already have obtained a first degree to satisfy their requirement of their being professional artists.

Sixth-form students assisted at the well-attended preview, some taking the opportunity to chat informally to the various artists. No practical work was scheduled for the beginning of the next week because, having created an art gallery context with resident artists working, the intention was to devote the week to the study of art – both that on display and that being made – and so the art staff took on the role of guides and discussion leaders. Other members of staff were invited to bring their students, and visitors included Office Arts and Drama groups, and the English department brought over 140 students during the week, the English staff generating a great deal of discussion followed up later with written work. Thanked for their support, their immediate response was, 'Oh, no. Thank you for the stimulus!' The week had been well advertised and many head teachers and art teachers from neighbouring and feeder schools attended the preview. In the following week, in addition to parents and members of the general public, fifteen school parties visited. This culminated in a hectic Friday afternoon where the four resident artists, joined by Ian, were all working, the A-level art students were also painting and drawing, their easels and art desks having gradually reappeared as the week went on, three English

teachers were involved in looking and discussing with their groups and there were two visiting groups of feeder school pupils, one led by a Head of Art and the other by a deputy head teacher. It was estimated that over 1,000 visitors had gone through the exhibition during that week in addition to the department's own students and other college students dropping in informally.

Each group officially spent some time with each artist and in addition many of the art students spend their free periods and lunchtimes in the department, so considerable demands were made on the resident artists. They had come with clear work targets but even though they stayed on well into the evenings they could not achieve these. Not that they minded – as one observed, 'You're learning all the time with the pupils while you're talking and seeing their responses.' The situation was also an overkill one for the A-level students:

> You were being bombarded with things from all sides – especially if someone had never looked at art before. I think a lot of people hadn't looked at art until they started doing these art lessons but I think you can look back on that as an experience and draw things out from it and understand a bit more about art.

And the resident artists were an essential part of this process for the students: 'I think it brings their work alive. I mean, sometimes you might look at a picture and get nothing from it and then after talking to the artist it demystifies it and you can see what it's about and that they are just ordinary people.'

Obviously a plan had to be devised to avoid congestion and chaos, and so some groups would start in the art department, or even in an agreed area within it, while others would commence in the college foyer area. Wherever possible, members of the college art staff would lead both college and visiting groups around. On entering the art department, Lorraine Taylor was the first artist they encountered. About to stage her MA exhibition at Cardiff, she produced unusual ceramic box-like structures, the deceptively illusionistic planes made even more ambiguous by delicate decoration and the deliberate use of spotlights to create strong shadow shapes. Using a special industrial clay in slip form, she cut out her basic shapes with a knife and had evolved a very personal way of working. She found the week a great experience and valuable for her own development, and her former teacher felt that in talking to the students: 'Lorraine was incredibly concise. Because, obviously, a process has a stage-by-stage explanation. She was excellent in the way she described processes and what she was trying to do.' Lorraine felt that whereas many people accept the actual process of painting and drawing, with her particular use of ceramics

> They question what it is I'm doing in the first place and throughout the whole week that's the main thing that people have asked and I've had to justify using ceramics as a means of expression rather than its traditional use for functional objects. You're at college with people that are at the same stage of development as you are and it is the first time that I've really had to explain myself in different terms.[13]

The thing that struck her most was 'the idea of me being questioned directly

while I was doing the work', but she did this with poise and clarity.

Sue Kane was the most introspective of the four artists, and she tucked herself in a corner surrounded by her small studies which are exquisite and delicate. She obtained her Textiles Degree at Manchester and her first commercial success was in selling some of her designs in New York. She was at her best when talking to small groups and individuals and her work aroused great admiration and interest:

> Sue didn't want to give lectures and we respected that. It wouldn't have been any good us making her do it but she was no less popular in the sense that she did communicate with small groups and her work was so incredibly beautiful that all the students went up to her and caught their breath when they saw what she was actually doing. She had communicated, if not verbally – she had communicated to those people.

Sylvia Wright and Anne-Marie Quinn, the two painters, increasingly developed a double act as the week progressed. Their work was in complete contrast. Sylvia's large, gestural abstract paintings were produced with house-painting brushes, the canvas flat on the floor, while Anne-Marie set up a mirror and produced a pastel painting, herself as the model, with the materials and objects she had brought, transforming a corner of the studio into an intimate interior enlivened by her own displayed works:

> We're both interested in spatial ideas and the children come in and when I've finished talking they've said, 'Do you like her work?' I said, 'Well, have you spoken to Sylvia?' I've started to talk about the similarities and they've had a new understanding. That's been one of the most satisfying things – to get them looking and to get them understanding something that's not immediately apparent.

To which Sylvia adds:

> They've been crossing over between the two of us. I've been using Anne-Marie's work all the time. I've been trying to explain the points I'm making about painting, drawing parallels between my work and Anne-Marie's work and they say 'Oh yes!' you know, as if it's really amazing that there could be some similarities between the two.

The staff became sensitive to this relationship and helped to cultivate it because of the benefits to students:

> They worked in a totally different way. One was very representational and one was non-representational, and yet it comes down to the language of painting, really, and this is something students can understand very easily – a sort of basic language of form and shape, colour and texture. The relationships and the juxtapositions of those things are as valid in the work of both Sylvia and Anne-Marie, and both find affinities in Matisse because they are excited by colour relationships. The way they gave expression to it was

totally different but obviously those relationships had struck home with both, so at that point they are on a wavelength.

By the end of the week Anne-Marie was threatening to 'pinch' Sylvia's Matisse book and students were saying, 'Well, what is it about Matisse?': 'Our students were trying to equate what they saw in Matisse with what they actually saw in terms of a product from the two artists.' Sylvia was working in close proximity to Ian's large abstracts and this brought about another set of important relationships. Some pupils thought they were Sylvia's and so she naturally began to talk about them. Ian came in voluntarily and by the end of the week he and Keith were constantly taking his largest canvas down and turning it to the wall, for Ian to show how he constructed his irregular stretchers and attached the canvas to them.

Yet another development was that, the students' easels having reappeared, the resident artists began talking with the students about their work:

> I found I could walk around and see other people's work and see something in it and talk to them about their work and they made me see it in a different way – accept their work more – just as I've found I've been learning a lot about my own work by talking about it. It's been a fantastic experience and it just furthers your development.

The scale and quality of the exhibition alone would have ensured that many students would have been affected, but the artists added an essential extra dimension. Their work was diverse, some of it unusual and controversial to younger students, but an important factor was that they had all been students in that department themselves. In the process of opening up a picture of the breadth and possibilities of the visual arts they were also affirming the values of the college course. Questioned about her seemingly incomprehensible colour-field abstracts, Sylvia frequently picked up her sketchbooks to explain the origins of her ideas and in the process she stated that the most valuable element in all her training had been her sixth-form-college drawing course and her training in the use of the sketchbook. 'Take full advantage of it while you are here – it will never let you down!' she emphasised.

> One of the exciting things – and it wasn't prompted by us – was that every one of those students said how glad they were that they'd come through a system which relied so much on the sketchbook and drawing and how they valued it. Whatever they'd done – whether in textiles, ceramics or fine art – they said this to our students. Immediately the students think, 'Here's another student like myself who has gone through the system and come out with a degree – and very good degrees in most cases [three had got BA Honours Firsts] – and yet they can say that what they had was of value' and that wasn't prompted by us. They openly said that without any soliciting from us.

One final observation about the artists was that their dedication and commitment to what they were doing was vividly communicated to adults and

A self-portrait by Adrian Johnson. One of the works in the Rigby Revisited Exhibition.

The influence of Adrian's work could be discerned in that of the students' many months later, as can be seen in these two self-portrait studies.

pupils alike. Their values and attitudes were important whatever a student's career intentions might be on leaving the college:

> It's interesting because they couldn't say, any of them, 'I am a success in monetary terms', but it wasn't a turn-off but a switch-on for most students. They could sense that those people were happy, they were doing something they absolutely loved and the kids caught it. Ian, for instance, talked about his asymmetrical canvases – and all the love and caring that had gone into designing just the right shape for those ideas! The students knew that was a meaningful thing, they realised if somebody is prepared to go to those lengths there is more in this than just a job – it's beyond just an activity. Anne-Marie was darting all over the place, picking up pastels, pointing out things, and this kind of excitement communicates to students that what they're doing is fun and it's good.

Angela was drawing on the experience six months later and within a fortnight five students had made course changes so as to study the History of Art as an additional A-level art subject. At feeder-school liaison meetings a number of fifth-form pupils have cited 'Rigby Revisited' as being instrumental in their intending to do A-level Art. Ian's paintings have since been displayed in his 11–16 high school, and in exchange all their paintings, drawings, printmaking and ceramics have been featured in the sixth-form college. A number of works were sold and one of the college deputies – a daily visitor to the exhibition – commissioned three works from Sue. The week was the most financially rewarding to the artists in their careers to date. One of the probationary art teachers purchased a self-portrait from Adrian out of her first month's salary and this led to her students producing an impressive series of large charcoal portrait heads. Many of the students saw the importance of the exhibition as Angela had done – as an event and 'a real motivation' and it established the art department as being a major one in their eyes. The English department were grateful for the stimulus and it succeeded in involving the college community as well as opening it up to a wider public in a spectacular manner. Though the conception came from the art staff, their efforts elicited the support and help of the college principal and the local authority. It was demanding on the art staff but the benefits more than repaid all the effort involved, for it contributed a great deal to broadening the students' horizons and understanding of the visual arts in the most vivid and enjoyable manner.

Conclusion

Our attention has been drawn to the incompatibility of the regulated timetable with those aesthetic experiences and experiments which the author has already shown should be central to art education. The pragmatic approach counselled is put forward in the context of other views emphasising radical structural changes so as to bring experiences at the periphery to the heart of the curriculum.

The measures explored – extra-curricular activity, exhibitions, visitors in the school – are compensatory certainly but valid in their own right. Variously they introduce concentrated time-spans for extended involvement, elements of surprise and accompanying perceptual changes, and the stimulus of different insights and techniques. They help to break down the insularity of the school and create a balance with existing provision in art education.

However, it is when these elements are combined that they have the most telling effect, enlarging each other and the curriculum, with the possibility of also developing the school's role in the community.

In reaching this final conclusion we should not overlook points made about understanding through experience, the effect on pupils of their peers' (or near peers') achievements and cross-curricular planning. Nor should we be unaware of the effects on artists of involvement in such projects and of the partnership needed to ensure that they contribute successfully.

Part IX
A Way Ahead

Section 1 Training
One of the major requirements to ensure the establishment of critical studies is identified in this section. The topic of training is considered, both in terms of initial and in-service courses, and for both teachers and curatorial staff. The author accumulates a range of testimony, course and project examples to convey the practicalities, and necessity, of the types of training recommended.

Section 2 A Critical Language
In this section, the recurrent theme of pupils' use of language is extended into an examination of the validity of verbal response and the manner in which it may be induced. The role of the teacher is considered in encouraging the development of a critical language. Suggestions are made for in-service courses to support teachers in this area.

Section 3 Examinations
The argument is made here that examinations have a constraining effect upon the potential of critical studies and should therefore be reformed. Related matters which prevent adoption of critical studies are also included. The author scrutinises existing examination requirements, states why they are lacking and makes a fervent plea for a broadening of their scope.

Section 1 Training

Any school deciding to make critical studies an integral part of its art education programme can make an immediate start. There is scope for the introduction of a whole range of talking in addition to the type of one-to-one discussion between teacher and individual pupil which the visitor to an art department is most likely to see. The pupils' own work is an often under-utilised resource, and there are benefits to be gained from children understanding more clearly what other pupils in the group and the school are doing by regularly having the opportunity to talk about their qualities and values. There are equal benefits to be derived from planning the kind of exhibition programme utilising the work of both pupils and others, with the work accompanied by explanatory captions, working

stages, etc. In areas where there are schools' loan schemes, those who administer them would almost certainly welcome initiatives as to what the school requires and enquiries about its collection for possible future use. Sets of reproductions can be obtained quite cheaply and there should be school library provision for purchase of at least some essential books, if there is none already available. A clearly presented case for introducing a positive critical studies element into art courses might enable teachers to obtain setting-up allowances for slide and book purchases, for gallery visits to be planned well enough ahead to overcome organisational problems and allow for the necessary preparation work. Many sound examples of good practice outlined in this book clarify underlying principles relevant to most school situations, with inevitable adaptations. Teacher inhibitions need not be a deterrent, because the teacher will find him- or herself in a stimulating learning situation as well as the pupils. Even though any individual school can make a start, however, major initiatives are required at both initial and in-service levels if critical studies is going to assume its rightful place in art education on a national basis.

(a) Initial training

When teacher-training is most successful, the particular values and the body of knowledge which go to make up the prospective teacher are harnessed to appropriate strategies so that they can be utilised for the benefit of future pupils. If critical studies is going to take its rightful place as an integral part of art education, it is clear that the role of teacher-training is an imperative one. The issues are obviously different for art students in colleges of higher education and those undertaking PGCE courses placed end-on to their specialist art training. The PGCE lecturer might feel that it is his or her responsibility simply to accept whatever body of knowledge the various students have acquired, and then to help them find ways of making it accessible to others. In contrast, the combination of art studies and teaching methods and approaches are simultaneously being acquired in college of higher education training.

Though the main focus for the CSAE Project was initially with the 11–16 age-range, the way in which critical studies awareness has to be cultivated on a long-term basis has meant that the work has inevitably extended to the sixth-former and attention has similarly been paid to primary needs. It would be inappropriate not to make passing reference to primary-teacher-training issues. The matter is complex because of the time pressures involved and a frequently held view that a child-centred education with respect for the stages of development is at variance with the imposition of the external knowledge and influences which critical studies is assumed to entail. The approaches of some skilful teachers demonstrate that there is an essential balance between the introduction of the visual arts to young pupils and the process of drawing out responses from them. These two seeming opposites are in no way irreconcilable; each can and should support the other. The notion of the young child's 'imagination' being sacrosanct has led to too many inhibitions about influencing children through the use of man-made images and full discussion with groups

and individual children, according to needs. In consequence, many art lessons become divorced from the rest of the primary curriculum and in some instances children will, for example, produce the same image of a house many times over quite long periods as an almost Pavlovian response to the words 'art lesson'. In an article called 'Uncritical, Unconfident, Uncommunicative' Caroline Sharp, an assistant research officer for the National Foundation for Educational Research, writes that

> Artistic activity was also sometimes divorced from critical appreciation. Children were not taught to look critically at their own work or that of others. Teachers who praised artwork would do so without saying what features they particularly liked, and why. Many teachers, while able to assess critically children's written work, seemed unable to appraise their artistic efforts.[1]

Her description of situations in which 'Teachers provided materials, gave the class a title, and left them to get on with it', indicates the need for a concerted in-service programme but particularly points to the scale of the teacher-training problem.

Many college of higher education art students are undertaking projects aimed at monitoring the effects on both vocabulary and practical work by introducing children to art and craft objects. This involves an accompanying increase in conversation, storytelling, descriptive and analytical responses. In their own practical work, many students are similarly being encouraged to see that there are important lessons to be learned from the study of the world of the visual arts in general. The majority of primary teachers do not undertake any specialist art studies as part of their training, however, and a high percentage of those will not have attended any art lessons since their third year at secondary school. They are likely to spend, maybe, ten two-hour sessions on general art studies while at college. Given these circumstances, it is important that a percentage of this time is given over to critical studies and related matters, but what can be accomplished in the time is neither here nor there in terms of the scale of the problem. Because society sees and values the importance of numeracy and literacy skills, it expects its intending primary teachers to have obtained minimum qualifications in these areas and they form an essential part of course content. Unfortunately, little consideration is given to the important part in our lives which is played by what might be termed visual literacy. To be illiterate or innumerate is seen as indicating that one leads a proportionately more impoverished life, but little account is taken of the disadvantages which visual illiteracy entails. Over a period of time, critical studies could make an important contribution to this raising of awareness, and then perhaps this inadequacy in the training of primary teachers will be treated with the seriousness it requires. It is ironical that, having begun teaching, many primary teachers come to see the importance of art and craft activities – not only in their own right, but as a basis for general learning across the whole range of the primary curriculum. In the process, some become painfully aware that they are ill-equipped to meet their children's needs in this respect.

By comparison, the majority of secondary school art teachers now undertake specialist art college courses prior to the commencement of their teacher-training studies. Art college students develop their understanding about art in many ways but on becoming teachers usually only consciously recall their art history lectures as being how they learned about art. It is unfortunately the case that it is at art college that the notion of the art history lecture as a totally divorced area of study is often developed. Fraser Smith describes an incident in which, when interviewing applicants for a PGCE course, he enquired whether they were required to take art history in parallel to their other undergraduate work. The replies varied:

> One young man said, no, he didn't and he didn't think he knew much art history. Honest, I thought, but not very promising. Later that morning, talking while showing slides of his work . . . he told me in some detail of his 'philosophy of sculpture', of this interest in Mayokovsky, in Tatlin, Malevich and the European constructivist movement. When I reminded him of what he had said earlier he was at a loss for a moment. 'Ah, yes,' he said, 'I see what you mean. But I just think of it as part of my work.'[2]

An illustration totally in keeping with the testimonies of the younger pupils but one which was only brought into focus for this student as a result of a chance conversation. The Senior Lecturer on the PGCE (Art and Design) course at a southern polytechnic believes that this kind of self-knowledge about the student's own personal development, with the time scales involved, etc., is necessary for him or her adequately to understand the pupil's learning potentiality.

> They sometimes fail to realise that they have a great fund of resources and if they begin to reflect on the nature of their own formative development they will see a very interesting pattern for children in schools. I think the students become what they are not only as a result of what they do within an institution like an art college following a syllabus, if you like, but they gain their understanding through social interaction with their fellow students and by looking at artists' work and by hearing people talk about it – by the total social context in which they operate.[3]

The course's PGCE students are divided by choice into four groups each of which, throughout the year, adopts a particular as well as a general focus. These are Museums and Art Galleries as a Resource in Art Education; the History and Appreciation of Art; Art and Design; and Design Education. This particular lecturer runs the Museums and Art Galleries course, and at an early stage in the year each student produces a large flow diagram in which they pinpoint important formative experiences – at whatever age – and then trace the subsequent developments which have led them to the PGCE course. In the process they begin to unravel the important influence of a particular teacher in their school days, an artist on the development of their work, the significance of particular gallery visits or exhibitions, etc. Sometimes fairly insignificant events

in themselves are brought into focus and their overall importance fully realised for the first time. Out of all this, the students sequence their own experiences into an organised form which serves – at a fundamental level – as a wide-ranging inventory of possibilities. When these possibilities are seen in the context of an experienced and purposeful sequence of events, the potentiality of using this pattern of ideas as a basis for curriculum planning becomes apparent. The tutor calls this pattern of events 'The Big Idea'.

> The Big Idea, I suppose, relates to the starting point for a curriculum programme in that if you are going to teach art you have got to have an idea of the broad potentialities of it. If you don't look at the broad possibilities you might get stuck with an actual teaching tip that you've picked up from your own schooldays. You could be in danger of seeing art as simply a progression of isolated one-off lessons, whereas the idea of identifying the Big Idea is that you actually begin to see the broadest possible relationship of various features that go to make up some sort of understanding of art both in its practical and theoretical context.

In looking back, particularly to art college days, the lecturer has already emphasised that the relationship between the syllabus followed and the art college social context is important. Likewise, the curriculum programme for the school has to take account of the pupils:

> When the student is actually aware of the various features of his own contextual development, he then has a greater sense of the need to realise that the children he teaches come from a great variety of different social contexts where there are so many issues affecting the child's understanding, motivation and interest in whatever projects are initiated – therefore the student must make provision in curriculum planning for reaching out to that very broad spectrum of experience. Clearly, such experience is not exhausted by practical work alone.

The Museums and Art Galleries option course was initiated in 1981 and was jointly organised by the Tate Gallery, the local museum and art gallery and the polytechnic, the initial suggestion coming from the Tate's Education Officer. Central to the philosophy of the course is the tutor's belief that there is a link between the student's self-analysis and pupil needs, and art teaching must therefore extend beyond the classroom but with the art room and gallery experiences integrated. Some of the schools involved were initially 'a little sceptical simply from the organisational point of view about taking children to a museum and art gallery and worried about how they would behave themselves', but the students have successfully convinced most schools – and have even had some longer-term influences:

> The teachers have been able to see in the approach to the lessons planned before the museum visit that the museum could be very useful and interesting

The Last of England (see p. 262). The completed painting unframed (detail).

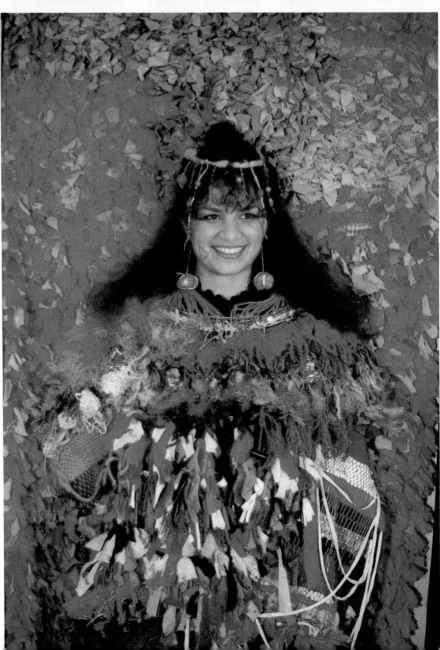

in relation to how they [the students] were preparing pupils in the classroom . . . Some of the students also showed the members of the staff they were to be working with an ideas map in the form of a flow diagram of the various kinds of features that might operate over a period of time in a series of art lessons. From looking at this pattern of events I think it becomes much clearer to see the value of museums and art galleries and the objects within them, and how they will integrate with the practical work that goes on in the classroom.

In addition to the Tate Education Officer's enthusiasm, the lecturer feels that they are very fortunate to have two staff at their museum and art gallery who are 'very much involved in the implications for education and they're more than anxious to involve schools and to encourage them to visit their museum' – sympathies not lost on the students: '. . . it is good to know that the education department is only too happy to have school parties . . . they want to promote the museum as an important learning resource'.

There is almost a social expectation passed on to children that art galleries and museums are boring. Many examples occur in these pages, sometimes with quite young children, and gallery attitudes and the isolated one-off visits can unfortunately confirm the idea. On the course, therefore, this issue is being tackled in a direct way:

> . . . and the students are doing this remarkably well. They are taking on board this idea that a lot of children think of museums as boring places but they are so organising the structure of their lessons prior to the visit that when the children go to the museum they don't have this preconception. They look forward to it with interest and excitement because they've had a foretaste of what it might be in relation to their own work . . . they understand how it's going to benefit them when they go, how it's going to benefit the work they're doing. So it's not something detached from work in the classroom. It's a clarification and a development of it and that, in a sense, begins to open up the very broad nature of what art and related objects can be all about.

The students' work is extremely well documented, revealing programmes of teaching in which pupils' attention is focused on comparisons between Western and other cultures, the formal relationships and differences in a range of works, etc., with pupil responses recorded – these issues arising out of courses which are also practical in their structure. In the process, the students themselves

Eram (see pp. 294–295).

(Top row) Eram's clothes, both European and Asian in design, are a vivid example of the Home Art of a pupil unable to obtain an O-level pass in needlework.

(Bottom) Eram wearing her woven dress in front of a weaving by Angela Cusani, the school's Artist-in-Residence.

cannot fail to grasp the significance of museums and art galleries as an indispensable teaching resource. One or two responses will suffice:

> I felt that an insight into the workings of museums is an insight into the broadening of art education, i.e. the realisation that art teaching is not primarily classroom-bound, that museums can provide a useful resource for art education allowing both children and teacher to learn and see things that might be out of range if the lessons were confined to school.[4]

> Gave me the opportunity of including a critical/appreciative aspect of art and culture to the art lesson. Also valuable to take the students out of school, so the subject becomes broader for them.

> I found that constant use of real artists' work a good point of stimulation, making points for discussion as well as practical work.

> Pupils need to see any subject in the overall context of how the subject exists in the world. Practical works should be undertaken in the context of art done outside school [by artists], critical appreciation seems to develop in looking and talking about artists' work, rather than their own – easier to talk about an anonymous piece of art, rather than their own.

One felt that more was achieved on the single school visit to the museum than in the sum total of the other six lessons with that class, another stressed the benefits of children coming to understand their own work in comparison to that of others. The value of slides and reproductions as a classroom resource was also emphasised and the importance of 'understanding about art which they can use and find interesting long after school and for the rest of their lives'.

Jane is one student who claims that the course has changed her whole attitude to art education because even though she had been through the 'art system' her knowledge of any history of art was minimal:

> I was always extremely self-conscious of this and my lack of confidence in this area permeated through to art appreciation and criticism. Art critics' terms such as 'movement', 'structure' and 'rhythm' always baffled me and I was left feeling very sceptical about my standards and criteria for producing a painting as compared with theirs. I had certainly never even considered 'rhythm' when holding a paint brush . . . never having been educated in art history or appreciation I resigned myself to the fact that each painting or art object must have one particular correct interpretation and meaning, and I was far too ignorant and lowly to contradict this: my place was to agree with the 'answers' to the work, not to contribute and certainly not to criticise it. The one unchallengeable interpretation would be found in books or on television by art critics and must be learnt, if my art appreciation were to improve. Horrified and scared by this dreary prospect, I shut my mind off and decided to suffer in silence.

It has to be worrying that a student – whether intending to teach or not – can go

right through the 'art system', studying the subject at school as well as at college, and that that system provides her with so little in this area. Jane is certainly not alone in this respect. Teacher-training courses like this one are therefore essential at a remedial level as well as at the positive one of helping students to offer children a broader experience of what art education can be. The Tate's Education Officer is aware of how much Jane gained from her course and observed her teaching in the ethnic galleries at the local museum 'and she taught extremely well . . . The teenage students without exception were fascinated.'

The tutor in charge of the PGCE (Art and Design) course at a Midlands polytechnic School of Art Education is also concerned about the prevalent notion which Jane had that each art object 'must have one particular and correct interpretation and meaning':

> In art education, we've tended to start with the art 'out there' in the galleries as it conforms to abstract concepts put on it by historians. In consequence, it seems to me that a considerable failing within art education has been an inability or reluctance consistently to engage children in discourse about works of art. I also think that one of the biggest drawbacks which art teaching has suffered, and one of the biggest burdens it has carried in terms of theoretical content, is the single notion of the history of art as sequential, linear and deterministic. If a historical perspective is to form an important component of an art curriculum it may be helpful – following the work of Joshua Taylor in the States – to think in terms of histor*ies* of art. This embraces the idea that different aspects and approaches to the subject may have special relevance for work with a particular age group or within a particular educational context. For art history to have meaning and relevance for most children, it must cease to be taught from a neutral and depersonalised standpoint.[5]

He believes that one of the art educators' central problems is that of finding strategies for holding the child 'with' the work of art – a concern with the act of looking – and allowing him or her to approach the work from a number of directions:

> Much of the research in art education has ignored or denigrated the importance of initial storytelling and speculation in the child's development of a genuine understanding of works of art. I think that when a child tells a story about a work – be it a Leonardo or a Lowry – this is the stage when he or she can hypothesise, can tentatively reach out to a work of art and invest it with personal meaning. Without going through this stage, what Douglas Barnes calls 'school knowledge' is less likely to become 'action knowledge' – the pupils' 'assimilation of knowledge to their own purposes'. The skilful teacher helps pupils to articulate their own understandings and communicate their viewpoints, and to this end the art teacher needs to draw upon a wide range of approaches, including history, criticism and formal analysis.

When his students on teaching practice encourage children to work in this way they greatly enjoy it, although there can be a problem in a school art department 'where children may be required, in a sense, to over-produce; where the art teacher does not talk enough with the children or work with them in a collaborative manner'. One of his concerns is that

> The balance of art education has been *excessively* in favour of producing art to the exclusion of any sustained and systematic consideration of how children may be helped to understand both their own work and that of adult artists. By the end of the third year in a secondary school, after which only about a third of our pupils continue to study art, it is alarming that few will have even begun to acquire the necessary basic critical vocabulary or communication skills for them adequately to understand, evaluate and appreciate works of art. Art is a central part of the good art teacher's own way of life, it is woven into the texture of his or her life – yet most children opting against art will have had little or no experience in, or from, the school of art.

In consequence, the PGCE art education students go on teaching practice with a clear brief that teaching programmes should include a positive critical studies component. This tutor has established close links with the city museum and art gallery which has helped students to introduce pupils to original works of art. This has led to the staging in the gallery of two exhibitions which have shown the work produced on teaching practice projects in relation to works from the gallery's permanent collection. He would welcome more museum exhibitions along the lines of one mounted several years ago, focusing upon Ford Madox Brown's *The Last of England* (see facing pp. 243 and 258):

> It's a very popular and well-loved painting in the city and for this particularly revealing exhibition it was taken out of its frame. Frame and painting were hung separately. The frame, a lovely, perfect, empty gold circle, contrasted with the canvas hung next to it. Suddenly one became acutely aware of the sheer physicality of the oil paint on the canvas. This beautifully glazed and rather remote Pre-Raphaelite work ceased to be a 'perfect' object in which the paint and canvas seemed as one; it became a manifestly painted object with individual brushstrokes and irregularities of surface. The circumference of the picture, normally hidden by the frame, was painted in a rough, scumbly manner – I tell my students I always felt that when I looked at that I could paint that last inch myself!

A series of reproductions set out the stages by which the painting developed, as revealed by Madox Brown's detailed diary record, and there were photographs of the canvas taken under ultra-violet light to show the underpainting. The exhibition emphasised the process of painting rather than the perfection of the end-product. A particular revelation was where the artist had begun:

> One set of diagrams, illustrating the sequence in which the painting was carried out, makes reference to the woman's scarf – the most luscious,

enjoyable and formally important passage of paint in the whole work. It showed that this magenta strip, blowing in the breeze and compositionally linking the two main participants in the drama was, in fact, the very first part of the work that Madox Brown painted. It holds the whole together and, partly because of its colour, must have been an irresistible starting point.

The demystifying nature of this exhibition made it ideal for teaching purposes and this tutor's personal enthusiasm ensured that his students made good use of it with pupils, and his extensive photographic record of the exhibition means that he can still focus students' attentions onto that work – now restored to its framed perfection. There is scope for many more exhibitions of this nature and the kind of clear understanding which he has tried to establish with his city gallery can help to generate them. He believes that the exhibition also points to methods which any teacher could fruitfully employ:

> It seems to me that there's a very nice model here for teaching if one could get hold of paintings – jumble sale paintings, or whatever, or from junk shops – and do just the same. Take the frame off, scrape bits of it away. The children could handle the painting, actually take some of the paint off it, have a look at the back of the canvas, for instance. What does the canvas look like? How heavy is the painting? Why was it painted on canvas? How long might it have taken to complete? All very interesting information about paintings which help children to grasp the totality of the work and assist them in the essential early stages of their search for meaning. There are many basic questions, some of them quite practical, which children ask about works of art which we ignore to the detriment of their learning.

A major initiative arising out of his involvement in the CSAE Project is that, in addition to their two teaching practices, some students are going into schools with a brief to combine their BA skills with their concern as communicators as trainee teachers; they are working as artists in schools.

In 1983, four worked in this manner, three in art rooms, but

> In one case the student worked out in the foyer as well, in what was actually a dining-room-cum-entrance-hall, and in fact she had a corner there and she drew and printed and that was absolutely marvellous. At lunchtimes you could actually see children eating and then looking at the things she was doing and that she had done – and that was good. What I want to do now is to put the students in slightly more public places in schools, if that's possible.

From that first tentative move, it is the intention to put fifteen students into ten schools and a county art adviser has offered his support. They will be based in the county's schools and he will monitor the placements from his standpoint. What he wants from them is that they 'import magic into the schools', as happens when the animal man goes into a school. Their tutor regards this as an excellent brief; instead of animals it will be art that is being shown to the children by trained artists and craftspeople with a genuine concern for the

schools' and children's needs. He feels that sometimes resident artists are chosen solely on the quality of their work and this can lead to a sad, rather impoverished state of affairs when it is apparent that the individual does not really enjoy being in that kind of environment. Heads, deputies and other subject teachers, in addition to art teachers, became quite excited about what was happening during the 1983 pilot scheme. There could be great potential in this kind of collaboration between PGCE course students, art advisers and schools in developing further schemes of this type.

The school emphasis on practical work alone has virtually precluded any systematic development of critical awareness and enjoyment in all but a small number of children. Many young teachers, having come through the 'art system' as impoverished as Jane was, have in turn accepted that practical work is all that need go on in schools. It is at the stages prior to the PGCE year that students should develop significant insights into, and knowledge about, the visual arts to be further built upon in later years. Ideally, a range of strategies for utilising this knowledge for the benefit of the children they are going to teach should be the concern of the PGCE course; those strategies without any prior understanding can obviously only be of limited value. Nevertheless the teacher-training approaches outlined here are representative of a general concern at both PGCE and college of higher education levels that visual arts teachers should be prepared to meet a wider range of needs in children than has often been the case in the recent past – examples such as that of Jane prove that valid compensatory training is possible. There is a strong nucleus of young teachers now coming into schools with a more rounded view of what art education might entail and in the immediate future they will, one hopes, make a correspondingly significant impact on their schools through evidence of a broader interpretation of art and craft teaching.

It is over twenty years since the principle of a trained graduate teaching profession was agreed; teachers should have expertise and knowlege about their chosen specialist discipline and should also have knowledge of children and an awareness of their educational needs. This combination would better ensure that the teacher had something of value to communicate and the necessary means at his or her disposal to do so. In spite of all the developments which have taken place in art education in recent years, though, it is only now that discussion has begun as to how the visual arts, in all their variety, can be brought to children rather than remaining 'out there', and the important role of the gallery and museum in this process is being realised.

Traditionally the majority of art gallery and museum staff are appointed from university backgrounds because of their art history qualifications, often with the additional bonus of an extra year's post-graduate studies in gallery and museum curatorship. With the growth of gallery educational services, though, there is an increasing case for there being an educational component as an essential aspect of these post-graduate course. Just as many teacher-training courses, such as those described, are now helping prospective teachers to consider ways in which galleries might be used to assist their work, so in their training gallery staff

might study ways in which their services might combine with the work of schools. Similarly, consideration could beneficially be given to the ways in which children at various ages might engage with visual arts objects, and what practical expectations it would be reasonable to have of children at their different stages of development. If galleries are to become an integral feature of schools' critical studies work, the place for their education officers is with pupils and students and not in the back room. The knowledge of children being referred to has a bearing on worksheet content and workshops if it is accepted that the 'old crocodile' format of gallery lecturing is no longer viable as the sole means of imparting information. As we have already seen, though, an understanding of pupil needs can also have a bearing on exhibition layout, catalogue information and even the initial conception of exhibitions – with the gallery's adult public also benefiting from the results of these considerations.

It has already been pointed out that, compared with the classrom teacher, gallery staff usually only have one opportunity with a particular group of children. If they are unsuccessful it is improbable that those pupils, or even that school, will return. Allied to the fact that many young gallery staff with educational responsibilities have expressed to me their feeling of isolation – galleries are geographically further apart than schools – this pinpoints another area of concern which could be met through appropriate initial training. Reference has already been made to an Exhibitions Officer in a gallery who now expresses embarrassment at her initial approaches to schools. She came to realise that 'teachers were at one side of the fence, the gallery was on the other side, and neither of us knew what the other one had to offer or wanted, so obviously there was a problem'.[6] One could not have a clearer statement as to why both teachers and gallery staff should come to their respective posts, through appropriate training, with an awareness of how they might mutually benefit the children within their charge. Otherwise, by default, each is in danger of remaining unaware of the skills and the benefits to children which each can offer, and how both parties can complement each other.

Another important aspect of this gallery's staffing is that the art history knowledge of one officer is complemented by the practical skills of the other; one received a university art history training, the other studied sculpture at a polytechnic. Between them, they combine a range of skills which ensure that preparation, discussion of a range of workshop needs and the practical engagement with works of art and craft can be undertaken with the knowledge that the theoretical aims of the gallery stand a good chance of being realised in practice. There are now a number of university Fine Art courses which seek a balance between art history study and practical activity, and there is a need for gallery staffing to reflect training in the range of skills which educational work now entails; if there is a need for teachers, in their initial training, to consider ways whereby art and craft objects can become meaningful for children, it is also important that gallery and museum staff have the necessary practical understanding to help children relate to those objects through appropriate workshop and practical activity.

(b) In-service training

Though the initial training of both prospective teacher and gallery officer is of the utmost importance, the real benefits are for the future. Many staff already in posts recognise the importance of the issues related to critical studies, but are sometimes bemused as to how they might proceed to broaden their teaching in this respect. If gallery and school staff are to combine successfully to stimulate interests in children which will continue to develop, often finding full fulfilment long after schooldays are over, it is important that they are able to draw on appropriate experiences which have similarly and beneficially affected them. Teachers, in particular, can be highly critical of their own training in this respect, meaning that in-service training of a compensatory nature is sometimes as important as that concerned with devising strategies to utilise existing knowledge and understanding – examples like that involving Jane, the PGCE student, vividly illustrate this need. If exposure to original works is important for pupils it is equally an ongoing need (along with criteria for 'reading' them) for all who are involved in visual arts education.

The numerous in-service approaches which can be adopted will obviously vary in relation to local needs and resources. Some of the CSAE working party involvements have already been outlined through specific case studies, but an important general feature which has emerged has been the co-operation developed between groups of teachers and local gallery and museum personnel, with both frequently represented in the groups. In one authority, for example, working party members met at the local museum and art gallery and their discussions with the Keeper of Art have led to the development of worksheets focusing on the numerous portraits in the permanent collection which cannot be regularly displayed because of lack of space. The group has also made contact with the nearby university in relation to its small gallery within the Department of Art History, and one school – closely involved in the Project from the outset – organised an exhibition of John Piper's work at another gallery which was extensively used by a number of schools in the area.

The Curator and Education Officer at a City Art Gallery has been an active participant in another working party which has met regularly in the gallery. The group's discussions led to work relating to three main themes: Light, The City and Movement. Sets of slides were made of paintings and sculptures which the group selected from the permanent collection as being most appropriate and useful in relation to these themes. The eighteen works chosen were diverse and varied; for example, Lord Leighton's *The Return of Persephone* and Lady Elizabeth Butler's *Scotland for Ever*, Sickert's *The New Bedford* and a Ginner city canal canvas, paintings of the Thames by both Derain and Atkinson Grimshaw, *Searchlights* by Nevinson and Spencer's *Christ's Entry into Jerusalem*, and a striking contrast between Caro's *National Grid* sculpture and Barry Flanagan's *Cricketer*.

Some teachers chose to use their own material but ten sets of these slides were ordered by teachers for use in their schools, but specifically in relation to projects related to the three themes to assist the pupils in seeing a greater range

of practical possibilities. In addition to considering ways in which this material might best be utilised in the classroom, the teachers also compared the slides with the originals, their scale, colour, tonality, etc., analysing the works and their personal responses to them. Besides being of value in the classroom it also benefited the children, too, when they subsequently visited the gallery to see in the original works qualities with which they had already become familiar.

A further group similarly focused its work on the themes of Space and the Human Form leading to projects related to Giacometti's sculptures and Hockney's paper pools. Another group was in a position to use rich resources like the British Museum, the base for a critical studies course of a week's duration followed by subsequent meetings, and generated work in which analogies were drawn between the children's studies of posed figures and the sculptures in the Assyrian rooms, for example. Well-documented slide sets and notes of a thematic nature have been produced in liaison with galleries like the Tate, and a London Institute-based group of teachers has explored many facets of what constitute critical studies over an extended period of time.

Though originally conceived as an 11–16 project, the CSAE emphasis on the individual's subsequent development as a result of key formative experiences has inevitably led to work with both younger pupils and older students. Some of the groups have included teachers of all age-ranges from the outset. Discussions and follow-up work in which the same or similar Museum Loan works might be used with different age groups have increased teachers' awareness of the concerns of others, making a valuable contribution to the problem of co-ordination in the visual arts education of different age groups and different schools.

Many of the teachers involved in the working parties had previously made use of gallery and school loan schemes but the conscious and systematic use of these resources integrated with practical courses has inevitably led to re-evaluation of teaching approaches and methods. Some of the groups will continue to meet beyond the actual life of the CSAE Project which generated them. One can only hope that many of the links formed between schools and galleries will develop and strengthen, and this aspect of the working parties is a valuable in-service model for others to follow for it has certainly made teachers aware of a greater range of teaching possibilities.

Reference has already been made to higher education institutions, but in addition to their teacher-training role, their work with practising teachers studying on MA and MEd courses, in hosting teachers' meetings and conferences or in running teachers' groups has contributed significantly to the critical studies debate. Out of a variety of additional courses which these institutions offer, an interesting example which increases understanding through combined study and practice is the DES-approved one-term ceramic course which one college of higher education offers each year. Eight teachers can be accommodated because they utilise studio space which also has to be shared with the college students; the latter benefit greatly from contact with these teachers who are highly productive because, in the main, they have a clear

knowledge of what they want from the course. The teachers come from both the primary and secondary sectors. Some enrol to acquire new skills, others to further their knowledge within the field of ceramics. What is important about this course is that it makes the teachers conscious of the potential of clay as an expressive medium in the classroom, rather than teaching isolated ceramic skills. This is done by emphasising 'the relationship of ceramics with other creative media and especially with drawing as a fundamental discipline'. Also through the teachers combining the great deal of practical work packed into each day with the study of ceramics which involves them in field excursions and visits to Stoke-on-Trent, etc. At the Victoria and Albert Museum the Education Officer arranged period displays to. enable them to see ceramic pieces in the same context as furniture, wallpaper, fabrics, etc., which had been produced during the same period. The teachers drew while in the museum so as, like children, to see more sharply through the discoveries they make by drawing. One teacher confessed to coming on the course to meet other teachers ('I'm in a complete vacuum where I am'). But in addition to being a valuable regenerative term, the teachers are led to a broader view of how clay and ceramic studies can enrich the school and art curricula. There is a great need for this type of broadening in-service training on a regular enough basis for teachers never to feel isolated or in a vacuum.

In addition to their many other duties one group which has done a great deal to raise the level of consciousness with regard to critical studies-related issues through in-service courses and provision of services are those art advisers who are active in this field. Many of the meetings and conferences which I have attended in the capacity of CSAE Project Director have been organised by art advisers and my attention has, in turn, been drawn to the variety of activities which they have initiated or facilitated: school provision, background contributions to gallery education officer appointments, artists and craftspersons-in-school placements, in-service courses involving artists, craftspeople and arts officers or focusing on the use of schools loan art and craft objects, many of which schemes they have initiated in the first place.

An energetic art adviser underpins the work of the Residential Arts Centre referred to earlier, and a number of art advisers organise similar weeks in which pupils, teachers and visiting artists work together. A Summer School week was organised by one adviser and took place at a centre by the sea. It was residential, and a duplicated document, 'Responses', records the students' reactions to the week. These are remarkably similar to those of the Residential Arts Centre pupils, illustrating what a powerful revelatory model these residential weeks can be and how important they are in leading young people to new insights and understandings. Harry Rée writes emphatically about the way in which the school bell frustrates the creative processes,[7] and pupils and students clearly derive great benefits from these in-depth working sessions made possible through the efforts of active art advisers.

This book has also laid stress on the value of authority-based school loan collections. In addition to their purchasing responsibilities, many art advisers

run in-service meetings and courses to explore ways in which loan works can be used as an integral part of classroom practice. An important project of this type is that recently run by a group of advisers. The resulting work is documented in *Using Pictures with Children*. Already recorded in these pages is the use of original works in a middle school, undertaken through involvement in this scheme, which was in two parts: 'A survey was instituted which examined teachers' attitudes to and uses of the original works of art when in schools. Arising from the survey a curriculum development project was undertaken which explored a range of ways of focusing pupil attention on the works of art.'[8] The publication concludes that the project 'created a much greater awareness of the potential of the original works of art collection as an educational resource of great value'.

Many art advisers' interests and concerns about issues related to critical studies precede the CSAE Project, and many have readily 'tapped in' to its enquiries and work to give added focus to what is already going on in their areas. The CSAE Project has, in turn, greatly benefited from their interest in bringing to the Project Director's attention developments in their areas which, in many instances, they have been quietly pursuing over quite long periods of time. Co-ordinating agencies such as art advisers, higher education institutions and art galleries, which consciously bring groups of teachers together as part of the educational service which they offer, all have an important part to play at an in-service level which is essential if there are to be fruitful developments in the place of critical studies in art education. Just as art and craft teachers are always developing their own skills and increasing their technical knowledge appropriate to the practical work they undertake with their pupils, so a group of teachers and gallery staff will proceed further in their considerations of the use of art and craftwork by responding to each other's points of view, experience, hopes and fears than when working in isolation or with only scant contact.

A growing concern about the need for greater continuity and smoother transition in the change from primary to secondary schooling is likely to be reflected in in-service courses generally in the near future. Aspects of the CSAE Project's work can contribute to improved assessment and evaluation procedures essential to this process. Some of the working party groups have included teachers of all age-ranges from the outset. Discussions and follow-up work in which the same or similar schools' loan works might be used with different age groups has increased teachers' awareness of the concerns and values of others. One of the significant characteristics of Timothy's Home Art was its natural development over a long time, and an evaluation of teaching methods to enable equally valid personal interests to be cultivated within the school system would be beneficial.

Section 2 A Critical Language

An important aspect, with implications across all age-ranges, which needs to be

attended to at in-service level is that to do with the whole range of language discussion which the visual arts can stimulate. Many of the pupil and student responses recorded in these pages suggest that courses which encourages greater discussion, and the formation and articulation of attitudes about the visual arts, could reveal unusual capabilities of which art education in general takes little account at present. Further, some reveal extremely illuminating attitudes which suggest that, through a broader study of art, pupils can become more aware of their own personal expressive needs: Witkin observes

> . . . that although the art lesson traditionally has facilitated the act of expressive feeling it rarely does much to stimulate it or to develop it. Idea and feeling are very personal and very private to the art teacher. He is prepared to help in the facilitation of their expression but tends not to encroach upon the world of idea itself.[9]

The pupil and student testimonies reveal, however, that it is in this very issue that the divide between School and Home Art comes about. On the other hand, a number of the teaching examples described reveal that through a sensitive use of critical studies approaches, at least some teachers do become involved in a partnership in which their engagement with pupils involves them at the inception of ideas, rather than them just being involved at technical levels. All have one teaching dimension in common – talk and discussion. The use of language is accepted as essential to this process and the pupils are able to make judgements about their own work by using and applying criteria which they have arrived at by the study of other artists.

Some pupils reveal illuminating attitudes of which their schools have little or no knowledge, hinting at a reservoir of untapped potential in children of all ages – untapped because they lie outside 'the framework of educational opportunities that have actually been provided'.[10] Lara was judged to be not very good in relation to that framework, but nevertheless her understandings and insights, once revealed, alter our assessment of her without our even necessarily referring back to her practical work. Fraser Smith suggests that 'We need more *conversations* in art appreciation. One of their functions might be to draw out and examine the substantially *objective* nature of aesthetic knowing or "understanding"'.[11]

The balance between the personal nature of Lara's response to George Grosz and – unlike her father – her trying to get other books to read up on it, and Jane's reaction to Carel Weight of not only trying to repeat the experience by other gallery visits, but of reading 'books that criticise art as well, to see what other people think about certain paintings' is an important one. Increased self-knowledge and objective understanding can both be cultivated from this natural balance, with the pupil's own responses being utilised as an essential element. The significance, for pupils of all ages, of forms of learning which result in the subject extending out of and beyond the school are certainly worthy of in-service attention.

For this to happen, attention must be given to the balance between a good,

systematically taught art course and the commensurate development by the pupils of a critical language which is relevant to their needs. Brian Allison admirably sums up this relationship:

> The acquisition of an art vocabulary is fundamental to learning in art. Even a most limited art vocabulary is necessary before one can begin to adequately, or even minimally, describe, discuss or communicate feelings about art objects. From the infant school onwards, a child's art vocabulary should grow at levels of range and complexity commensurate with his developing intellect. It is important in the acquisition of any art vocabulary that the child is given as much opportunity as possible to actively use it.[12]

Talk initiated by the teacher is essential both to the formation of this vocabulary and to its use. This talk should not be over the pupils' heads through pretentious use of jargon, but it should make sufficient demands to stretch them. In her description of Seurat's *Bridge at Courbevoie*, Anita impressively conveys the mood and feeling evoked by that work. She does this through a carefully chosen and often analagous use of words. To convey particular nuances of colour she describes them as being peach-pink and swamp-green, mustard, pale blue-grey and lilac. Her teacher recounts an influential anecdote which a former tutor who had been an assistant of Sickert had related to her. The painter had recommended that one should never note down colours as being blue, green or red when out sketching because this was meaningless back in the studio. He related colours to foods, so would note down tomato, cherry, beetroot, lobster, carrot – not just 'red'. Anita illustrates that she, in turn, has benefited from art room language which is precise enough to draw attention to subtle nuances, as her evocative analysis of the Seurat conveys. She describes the work and simultaneously communicates her responses to it through a careful, almost restrained, use of perfectly ordinary words rather than a contrived 'arty' vocabulary. Similarly, the middle school teacher whose work is described in 'The practical use of loan material' sub-section (Part VI, Section I(c)), says that she thinks the names of paint colours are so beautiful that they naturally intrigue children. She consciously makes them aware of reds by encouraging them to distinguish between carmine lake, rose madder, crimson, vermilion and magenta, deliberately matching the name to the colour whenever discussing with her pupils. It is interesting that her eleven- and twelve-year-olds are sensitive to these distinctions and that they are clearly reflected in their practical work – once understood they are naturally applied – and yet one frequently hears teachers instructing fourteen- and fifteen-year-olds to make something more red, or more green, etc. It is not mere coincidence that these middle school children are encouraged to look at, and talk about, art other than their own as an intrinsic part of their weekly lessons.

Matching colours found in nature or in art objects to foods or names on tubes of paint are both simple devices to lead the pupil from the general to the specific. A range of similar strategies could constructively be incorporated into both initial and in-service courses. That PGCE student who was baffled by terms like

'movement', 'structure' and 'rhythm' had not benefited from any systematic application of vocabulary to practical work throughout her training in art at higher education level – let alone at school. What, then, are the chances of her school colleagues who did not undertake further art studies of formulating ideas and attitudes about art objects in adult life as a consequence of their schooling? I recall a particular lesson in which a teacher sought to encourage discussion when introducing a group of pupils to a newly delivered set of schools' loan sculptures. He emphasised his reactions to each – but only through phrases like 'I think this one is brilliant'. The lesson had afforded an excellent opportunity for discussion utilising an appropriate range of vocabulary to convey adequately to the pupils why the teacher regarded one as 'brilliant', the next 'superb', and another 'fantastic'. By agreeing or disagreeing, pupils would have had to search for an equally relevant range of words to clarify their opinions and responses. In the event, they replied in kind – the works were either 'great' or 'rubbish' and a golden opportunity had been lost.

Numerous art teachers have told me of the difficulties they have in finding words to communicate what they feel about art objects, pointing to the need for in-service courses to equip them better to exchange ideas with their pupils. Courses in which, for example, they might devise teaching material derived from art gallery exhibits or from sets of schools' loan original works (reproductions could suffice in authorities devoid of this basic resource). From the discussion among teachers which could be generated, a teacher could analyse the content, form and structure, mood and technical means adopted in the works. Consideration could be given to how they might lend themselves to storytelling, creative writing and environmental investigations and how they might relate to or stimulate practical work in the pupils. Relevant book material could extend the study of the specific works outwards to other art objects which relate to them technically, thematically or in formal terms. They could lead to broader projects on, say, oil painting, watercolour or printmaking; the seasons, the man-built environment or figures at work; near and far, surface pattern and texture or colour harmonies and contrasts.

Project material of this nature devised on in-service courses could lead to the clarification and classification of a range of vocabulary relevant to the set of works. Consideration could be given to which words are already likely to be known to the teachers' pupils, which are outside their grasp and which they might appropriately be introduced to and by what means. To give an example, an analysis of the four categories of content, technique, formal means and mood of a set of schools' loan prints of architectural façades by Brendan Neiland stimulated the use of the following words:

Reflective	Horizontal	Superimpose
Surfaces	Suppress	Discern
Distorted	Accentuate	Passages
'Cityscape'	Speckled	Contained
Intermingling	Lithography	Bold

Framework	Screenprint	Composition
Converge	Restrained	Strong
Grid	Muted	Straight
Complexity	Neutral	Mass
Balance	Sparkle	Photorealists
Tonality	Positive	Airbrush
Structure	Negative	Spraygun
Rhythmic	Mystery (sense of)	
Organic	Layers	
Vertical	Subtle	

By initially writing about examples in their own terms and then making similar compilations of the words used, teachers representing different age groups could gain insight into each other's needs by determining which words are or are not relevant and which could or could not be introduced to their pupils – some might feel that virtually all were inappropriate, but it would be interesting to see how their children might react if encouraged to talk about them and undertake related activities to them while living in their company in the classroom for a term.

On a recent visit to an artist-in-residence in an 11–16 high school, I was sufficiently startled by an obvious, simple device to realise that it was quite uncommon in most schools. She had displayed a set of third-year figure studies, with the model wearing a dress which was normally a 'prop' for her own work. What was unusual was that she had attached brief analytical statements to the drawings. These appraisals affirmed the discussions which had taken place during the lessons. By applying the same kind of critical vocabulary to their works that they might normally equate with acknowledged works of art, the pupils were being encouraged similarly to consider and evaluate their own drawings – a critical vocabulary is as applicable to the pupils' own practical needs as it is to the broader study of the visual arts.

This book is rich in examples of pupils who have been helped to make considered art responses and have applied a correspondingly rich and expressive vocabulary to communicate their observations and responses to others. In turn this vocabulary is indispensable for the pupil to negotiate adequately with the teacher about his or her own practical work – particularly in relation to still unresolved problems and ideas. The balance between the methodical and continuous introduction to an appropriate critical vocabulary and the stimulated use of language arising out of those illuminating experiences which Hargreaves pinpoints is a crucial one, and a basic aim of art education should be to ensure that as many children as possible benefit from both.[13]

Section 3 Examinations

No consideration of a way ahead in relation to critical studies in art education

would be complete without reference to examinations. The majority of art teachers are not particularly enamoured of examinations, but accept them as a necessary evil with which they have to live; they are well aware that their subject would lose all credibility in the eyes of most parents and their staffroom colleagues if it did not have the 'respectability' of being examined. For some, examinations loom so large that they are the main justification for what they do – examination success sometimes becomes the recompense for spending time teaching art in ways which, in many respects, go against their natural instincts. Assumed examination requirements as well as their constraints are frequently cited by art teachers as being why they cannot adopt more varied or contrary approaches to those which they are already practising. Critical studies approaches and the art examination system therefore have a crucial bearing on each other. This relationship has ramifications across the whole spectrum of art examinations from the set three-hour art history and appreciation-type written paper to the displays of predominantly course work with a central set piece or project which are now so typical of what is examined at 16+.

Louis Arnaud Reid suggests that courses in 'art appreciation' are often held in contempt because of the way in which they have been taught more than anything else,[14] and in the case studies used in these pages there are examples of students who, in being prepared to sit set A-level Art History examinations, have become fascinated and quite absorbed by the subject. Once involved, these students often express regret that they had not encountered this interesting world at an earlier stage in their education. Even though they cannot completely avoid the pressures of the system – for the two years of A-level study, with their examinations and course and job applications and interviews, can be highly concentrated ones for some students – they are still able to enjoy the subject in its own right. Having begun to visit galleries of their own volition and reading – often even buying – art books out of interest, the actual examination can be an enjoyable experience for some students who find the challenge of setting down aspects of their often quite profound knowledge stimulating. On the other hand, though, art history lessons can degenerate into a monotonous plod through the centuries, being perceived by the students as essentially to do with facts and dates which have to be learned, memorised and regurgitated as necessary. Indeed, the subject is sometimes similarly perceived by teachers themselves. This was the model to which they were subjected in their training or they missed out altogether on this area of art education and assume that this is the only teaching approach possible. These assumptions are quite prevalent, and lead a surprising number of schools to seek out those A-level examinations on offer which are purely practical, or in which the art history component is optional – section three of a paper from which only two submissions are required.

Many students are entered for a written project, such as the JMB A-level Personal Study, when one is on offer as an alternative to the more formal examination. This is sometimes offered to the students, unfortunately, so that the teacher can avoid having to run an appreciation course – even though the study is supposed to emanate from a background course. Invariably, the

resulting studies become concoctions of book information which one has already read – it is surprising how long some can appear, even though they do not exceed the allotted number of words! Students often remark that they prefer these assignments to risking an 'off day' or not getting the appropriate questions for them to utilise their knowledge on a set day at a prescribed time – but too much onus is placed on some students. By comparison, those quotations from A-level Personal Studies used in this book reveal qualities of investigation, research and response of an unusual nature conveyed in vividly personal language; background reading has affirmed and substantiated their perceptive studies of actual works, initially stimulated by their course. One of the criteria which I apply when reading them is that I expect to be sufficiently alerted to qualities in a work with which I might already be familiar, to want to go and look at it afresh. Anthony and Anita led me back to Turner's *Dido Building Carthage* and Sedgley's *Yellow Attenuation* in this manner, and I was not disappointed. This is a high expectation of a student but one which many can fulfil when the background course both has purpose and is stimulating enough to make the students active in their own right.

Once affected by their studies of art, the students will invariably seek to emulate aspects of those artists' works which they most admire. This process of even imitating as well as emulating is as natural in the adolescent student as it was for Neiland to 'put on' another artist, Léger, or for Cézanne to seek to re-do Poussin from nature. The identification with an artist arising from the sense of revelation can lead a student to seek out compositional and technical parallels of his or her own, and allied to a heightened awareness of the environment can affect choice of subject matter, and how its moods and atmospheres are rendered. This is a natural process and these influences will inevitably manifest themselves in the student's practical work. From my observations in recent years, though, the sad truth is that these students would appear to be at a disadvantage in external examinations. Unusual asymmetrical compositions conceived in striking colour schemes of harmonies and contrasts, and rendered in paint applied in a lively manner, would seem to fare less well than versions *from the same institution* in which the main motif is set down centrally in a safe range of neutral and tertiary colours which have been laboriously brushed in.

Similarly, it is now over twenty years since the practice of submitting preliminary studies with the examination piece was introduced, and yet the sole preoccupation with the end-product is still such that one examiner could recently inform an art teachers' meeting that these studies were only looked at in borderline cases; the student who sees the necessity of braving the elements to work directly from nature is likely to be at a disadvantage compared with a neighbour who 'lifts' an idea directly from a magazine illustration or photograph. In the often symbiotic relationship between teacher and examiner, one continues the dubious practice of copying and the other supports it through high marks on the grounds that it is typical of school art and the greater percentage of work received! This discrepancy between ways of thinking and working processes on the one hand, and emphasis on end-products on the other,

can negate the adoption of critical studies approaches as effectively as some teachers' desire to side-step the responsibility of teaching art history and appreciation in its own right by whatever methods.

This A-level examination pattern is an interesting one in that there is a consensus of agreement that this age group should have a balance in their diet between studying and knowing about art and making art. Some of the implications, particularly in relation to the ways in which the study of art can modify practice, are equally relevant to pupils examined at the 16+ stage. O-level art history and appreciation examinations have traditionally existed, but in the absence of any similar consensus at the 16+ level, few candidates sit them – and those that do are often lower-sixth pupils doing a dummy run prior to A-levels proper the next year. In their absence 16+ examinations, whether external submissions or of the display type, reflect, almost without exception, the total emphasis on an unalleviated diet of practical work. The teacher whose commitment to critical studies is such that he or she actually devotes time to it has taken an unpardonable risk in the eyes of many colleagues – pressure of time is cited as the most common objection to the teaching of critical studies!

So what of the many pupil responses about art recorded in this book? These certainly conform with the Assessment of Performance Unit (APU) document's definition of 'Artistic Appraisals', which is seen as the principal aspect of our engagement with the arts:

> This involves the application of one's skills, knowledge, experience, sensitivity and insight to a judgement of a meaning and value of works of art created both by others and by oneself . . . artistic appraisal should be personal, in the sense that children should experience and think about the work for themselves. Yet it should be objective in the sense that children should develop the ability to give sound reasons for their judgements.[15]

The APU commissioned a 'desk-study' to review and evaluate the suitability of tests in the field of aesthetic education which were available in this country and overseas. They concluded that 'there are no available procedures suitable for assessing ARTISTIC APPRAISALS and these would need to be developed.' The extracts from the Personal Studies of Anita, Joe and Anthony were all written to be examined, though, and all undoubtedly fall squarely within the definition given of artistic appraisal. All are personal in that each student has clearly experienced and thought about the works, and objective in that their responses are appropriate to discernible properties in the works and are supported by sound reasons. Whatever abuses of the Personal Study might exist at the other end of the spectrum, therefore, its format definitely can accommodate artistic appraisals – and on reading these extracts any examiner worth his or her salt should immediately recognise them as such. What chance, then, of finding similar scope to accommodate artistic appraisals in the new Joint GCE O-level and CSE examination syllabuses? Because, if absent, the 16+ door is likely to remain firmly closed in their face for at least the next decade.

A first glance at the Northern Examination Association syllabuses (just

published at the time of writing) is encouraging. Each of the seven syllabuses, A–G, contains a section in keeping with that in Syllabus A(vi): 'Making informed responses to contemporary and historical Art and Design: through an awareness and appreciation of artistic qualities, and an analysis and evaluation of design, and the forming and expression of judgements.'[16] In the aims which embrace all the syllabuses, there is also encouragement to some centres in 1.4 to develop the value of this area, 'both for the student personally and for the consequent stimulus which it can provide for other work'. For these centres, 'this might become a taught element of the course which will provide a substantial part of the presented course work . . .'. Then the aims for all potential candidates are listed in 1.5–1.7 and include, for example, the stimulation, encouragement and development of:

(f). intuitive and imaginative abilities, and critical and analytical faculties, and;
(h). awareness and appreciation of relationships between Art and Design and the individual within the historical, social and environmental context.

But a distinction is then made between these aims which 'include references to a number of attributes and qualities which cannot or should not be assessed for examination purposes but which, nevertheless, form an essential part of any Art and Design course' *and* the assessment objectives 'which all refer to qualities and competencies to be assessed'. *The assessment objectives make no specific reference to any critical or appreciative aspects whatsoever,* and the disclaimer in 2.1 that the absence of qualities and skills included in the aims 'does not diminish their importance' does nothing to rectify this omission. They have been banished to the same optional corner which was occupied by the previous O-level art history and appreciation examinations – and they will be treated with the same neglect and disregard.[17]

Had an attempt been made to accommodate 'artistic appraisals' in these assessment objectives, the whole content of art education might have been beneficially broadened to enable children to see their own efforts as part of a larger whole. In their certain absence from all but a minority of committed schools, that genre which Rose categorises as 'School Art' will be perpetuated:

What does it mean to have drawn a coffee-pot beautifully shaded, floating uncertain of its size or meaning in the middle of a sheet of white paper? Well the meaning in any real terms won't (unless you are very lucky) be discussed. What it will mean to someone is a B plus and a suitable candidate for 'O' level. What does it relate to? Only itself.[18]

Throughout this book, the integration of critical studies approaches into the general structure and fabric of day-by-day art lessons has been advocated. It has been demonstrated that some teachers are already doing this with remarkable success; the models already exist and show that pupils across the whole ability range can benefit from their application – those maladjusted children who so enjoyed their day in the Tate will not even sit 16+ examinations. The

assessment objectives should therefore be extended, and pupils expected to show evidence of broader understandings than just those involved in making their own art.

By all means let the category who enjoy the stimulus of writing produce illustrated pieces of work along the lines of a modified Personal Study, or show evidence of knowledge of a subject or period through 'structured studies involving essays or projects'. For others, though, a commentary added to a set of slides – possibly some taken by the pupils themselves – showing relationships between their practical work, the environment and the work of others could be informative. For some again, the background to their displayed practical work might be communicated through cassette commentaries illustrating the basis and inspirations from which their work has emanated. Other commentaries might equally give added meaning to montages of reproductions which are of special significance to pupils, making clear as to why. The close links which can form between gallery responses and pupils' own work have already been noted, and for the pupil to be encouraged to demonstrate these links by the use of video, slide or cassette in addition to the written word could be fascinating and revealing – even though some approaches might only become feasible in time.

There are surely a whole variety of means which could be adopted to enable pupils to demonstrate the relationship between their practical work and their wider interests, and pupils who can show that they have abilities in 'artistic appraisal' should be given credit for having these vital understandings and interests. They should no longer be assessed – passed and failed – purely on the strength of end-products. It is not only the hidden interests of pupils like Lara that are of concern, it is all those which remain unformed in children of similar potential because too narrow examinations requirements result in their remaining unaware, and on the outside, of the whole world of the visual arts through resulting course content or lack of content. Obviously one can only conjecture about the possibilities because the idea of a sit-down written examination to test knowledge about these non-practical areas is so ingrained; the APU *Aesthetic Development* document only envisages pencil and paper questions which might include multiple-choice papers, open-ended papers and self-report inventories. If the examination assessment objectives were to give the necessary scope, though, the Boards would be leaving the door open for a whole range of possible developments in art education without which the new examinations – for all the undoubted good intentions – will simply maintain the status quo.

Conclusion

At this juncture, sufficient motivation and evidence should have accrued to propel the concerned teacher into critical studies developments of his/her own. There is a clear basis for practice in this book sufficient to assist the individual in making his or her own explorations.

However, it becomes apparent that critical studies will not become a widespread reality with potential benefit for all until there are changes in training (with an accompanying encouragement of critical language work) and in examinations.

The changes envisaged are detailed ones in the case of training intended to prevent and ameliorate the divorce of appreciation from practice. The student-teacher Jane exemplifies the main problem, of the intending teacher whose involvement in art has been solely practical. Compensatory initial training must therefore generate a concern with the act of looking and include appropriate strategies to equip students for the future (in such form as course elements on the use of museums and art galleries). Primary and secondary teachers have differing undergraduate backgrounds and provision should reflect this.

Gallery staff should accordingly have an educational element included in post-graduate courses. They should gain an understanding of child development as a basis for devising materials and conceiving exhibitions; they should further develop practical skills as a basis for setting up workshops; they should study the ways in which their services could combine with work in schools.

When it comes to in-service training, apparently the most beneficial and logical structure is one in which teaching and curatorial staff learn together or with one group gaining from the co-operation of the other. There are advantages in teachers of all age-ranges being in groups so as to improve the awareness of continuity. Cognisance is taken of the leading and co-ordinating role of higher education establishments, institutions and art advisers in particular.

An essential element in teachers' courses should be an awareness of the part discussion can play in revealing pupils' hidden capacities, assisting in assessment of them and in creating a partnership to involve teachers at a deep level in the inception of art. For this to happen children must be helped to develop a critical language and teachers equipped to bring this about. As a result pupils will enter into possession of art through description and response and their language will itself develop as a natural concomitant of the illuminating experience.

Changes in examinations are seen as enabling rather than prescriptive. A broadening of examination requirements would have an effect on teachers' attitudes to critical studies. However, examination boards' preoccupation with the assessment of end-product must end and they must be more open to experiment and the underlying developments which have gone to produce the work. This is a crucial time where examinations are concerned for warnings to be heeded.

Conclusion

Art history and appreciation lessons are usually taught in a distinctly different

manner – often, even, in an available classroom rather than in the art room – from the practical lessons which constitute so much of the art timetable. In addition, these history and appreciation lessons are likely to be taught to relatively small numbers of more academically able, older school pupils. Frequently, little attempt is made to relate their content to the pupils' own work, and the remainder of the school population is likely to be receiving an unalleviated diet of practical work. 'Critical studies' is a term coined to subsume art history and appreciation, but it also incorporates all the additional means whereby children can be brought to an increased awareness, understanding and enjoyment of the visual arts. Few of these means are new and there are few, if any, teachers who do not utilise, however occasionally, at least some of these methods in their teaching. If the constituent elements are generally familiar, though, it is only rarely that one comes across courses in which they successfully combine other than on a purely haphazard basis. Critical studies in art education, then, does not represent a newly invented and separate curriculum area divorced from children's practice of making art and craft objects. It is sometimes an independent activity in which the focus is on the study and contemplation of visual arts objects in their own right, and at other times it involves complex and subtle inter-relationships with the children's own work. Once this is accepted, its significance and breadth can be fully appreciated because it can form the basis of an approach to art education in which pupils can experience all the benefits and virtues implicit in making art: development of analytical and observational skills, sustained application, personal expression, etc. But simultaneously, they can have opportunity to look outwards to the whole diverse world of the visual arts, and also see their endeavours as part of this larger whole with each aspect nurturing, affirming and enriching the other.

1 Critical Studies and Expressive Work

The majority of teachers, art educators and gallery staff who have made themselves aware of the work of the CSAE Project have been responsive, and concerned as to how they might constructively apply its principles to their particular working situations. Dissenting cynics, considering the relative absence of critical studies approaches in so many institutions at the present time, are surprisingly rare but invariably have the same predictable stance: the Project represents another attempt to make art education respectable at a difficult time through contrived means aimed at giving the subject an 'academic' veneer. In the process its advocates 'have tended to abandon the central ground, the essential character of the subject. They are MISREPRESENTING OUR CASE.' What exactly is their case? It is that they 'believe expressive work, the engagement of children's feelings through Art to be important, more important than any glib rhetoric about "visual education", "critical skills" etc.'.[1]

The writer cited further states that 'what goes on in our Art rooms does not match the rhetoric'. This, unfortunately, is all too frequently the case. Critical

studies approaches are only occasionally adopted systematically, but in their absence it is only rarely that one comes across genuinely 'expressive' work or evidence that there has been 'engagement of children's feelings' at any but the most superficial level. The notion that being informed and knowledgeable about art *and* producing 'expressive work' are somehow incompatible and at variance with each other is a strange one, often supported by expressions of fear about pupils' 'originality' being impaired in the process. It is further supported by a related argument that the school curriculum is predominately 'academic' and talk-centred. Because the art room offers an alternative, compensatory mode of learning, talk must therefore be consciously kept to the minimum so as not to affect 'original' expression. Most art educators are united in the belief that the art room is one of the few places in school where pupils are able to make personal statements. The value of compensatory learning afforded by many art departments has also been acknowledged in these pages. But it is difficult fully to support arguments which also require that pupils be kept in a state of ignorance about whole aspects of the subject so as to make them realisable.

In reality, of course, there is far more evidence of children doing colour, line, tone and texture exercises, etc., of technique and skills being taught – though often in isolation – and of subject matter being chosen on the assumption that it will approximate to their assumed interests – though often leading to second-hand copying – than of expressive work being undertaken. When one does come across the exceptions, they stand out in a startling manner and are invariably the products of courses in which teachers have taken positive steps to ensure that their pupils are able to relate what they do in their own work to the broader context of the visual arts world. In other words, genuinely expressive work on any appreciable scale would appear to arise most frequently out of circumstances in which insight, awareness and understanding are also fostered. It is here, then, that the TRULY CENTRAL GROUND of art education should be located. The fortunate pupils of the most successful exponents working in this area, achieve an interwining and enmeshing of knowledge about the visual arts with informed practice – a combination which has lifelong implications and frequently leads to both genuinely expressive and simultaneously demanding practical work.

2 Some Basic Stepping Stones

In spite of some inevitable objectors, though, the commonest reaction by far has been the enthusiasm of art educators for the principles of the CSAE Project and the nature of the learning experiences which it has revealed. The ready acceptance that it corresponds closely to an ideal of art education which many state they would like to practise was summed up by one teacher who, at the discussion stage completing a critical studies meeting, said: 'You have described my ideal of art education, but how can I make a start along these lines in my own situation?' Any art educator with the will can begin to put critical studies

principles into practice – at least in part – and it might be constructive to set out the main stepping stones which will aid the process.

One of the unifying characteristics of the teaching examples set out in these pages is that the teachers concerned are still learning, making new discoveries for themselves and extending their own knowledge in the process of assisting their pupils. The problem of some teacher-training students having gone right through their art training without having been helped to associate what they are doing with even the most fundamental art vocabulary has been noted, and many art teachers complain about their feelings of vulnerability because of the inadequacies of a training in which the once-weekly art history lecture was presented so that it was totally unrelated to all other aspects of their studies. Though critical studies are also pertinent to primary children's needs, their teachers are likely to have had no art training whatsoever; many teachers feel inhibited by absence of training and their consequent lack of knowledge. The infinite variety and diversity of the whole world of the visual arts, relating, as they do, to every aspect of human experience and aspiration is why they are so significant, though. The most knowledgeable art educator is still learning and could continue to do so throughout his or her life. Children have the same potential, and the fact that teacher and pupil are simply at different stages of the same continuum can be a desirable asset. It is probable that more aversive experiences are brought about in pupils by teachers who have stopped learning themselves and are giving out previously acquired knowledge than by those who, whatever stage they are at, can still experience excitement at new-found discoveries. An essential prerequisite, therefore, is that the pupil is more likely to become aroused by art objects when the teacher communicates fascination as a result of also being in an ongoing learning state – and this cannot happen in the absence of resources.

(a) The children's work

The children's own work is the one resources of which immediate use can be made in all schools. Reference has been made to the value of arranging an 'exhibition programme' in the art department aimed at focusing attention on specific exhibits because of the contrast to what was previously – or is elsewhere – on display. Though the art department is often a visual oasis in an otherwise bare or sparsely decorated school environment, the regular visitor can come to regard imperceptibly changing displays as general background. Supporting captions, labels and written information, provided by both teacher and pupil, can help to focus attention and make the work of pupils of different ages, or who are using different processes, comprehensible to others. The preparatory stages of supporting sketches, designs, maquettes, etc., displayed in combination with the finished work, can reveal thought-processes and working stages to other pupils so that, for example, a third-year pupil at option time can make a decision based upon some knowledge of what is to come as well as on what has already been experienced. These and similar devices can help pupils envisage the totality of the school's work, rather than only gain insight to their specific course

within the overall structure of the scheme of work. It is equally important to take work outside the art room even though some schools are architecturally notoriously difficult to enhance. Nevertheless, there are spaces within most which, with a little imagination, can be made into attractive focal areas to extend the above principles for the benefit of all pupils whether or not they are studying the subject.

Similarly, importance has been attached in this book to art room talk and discussion. The emphasis on practical work frequently leads to perfunctory lesson introductions in which the emphasis is on giving and clarifying instructions, followed by practical work extending almost to the bell with just enough time left to clear up for the next lesson. In these circumstances, the one-to-one talk characteristic of art lessons is often of an essentially technical nature. In the examples outlined in these pages, though, the relevance or broader discussion has been seen, leading on occasions to subtle interactions between the work of different pupils as they develop their own ideas in relation to those of colleagues. The process of comparing and contrasting is a fundamental aspect of art education and one which could have helped that student who got to the PGCE stage of her education still bemused by words like rhythm, movement and structure. What chance for the pupil who drops Art at option time of seeing the relationship between words and actual practice, when a person who specialises in the subject beyond school can remain unaware of the relevance of this relationship? Such words would soon assume relevance if discussions about the pupils' own work involved comparison between essentially linear and rhythmic examples and structurally modelled and monumental pieces, for example. In the process of acquiring that essential basic vocabulary, the pupil can simultaneously be led to see a wider range of practical possibilities, what is special to his or her own work and what characterises that of other pupils not only in the group but in the school as a whole. The pupils' own work, then, is a resource which is often under-utilised but which is readily available for immediate use at no cost. Desirable though it is that full and systematic use is made of the pupils' own work, there is a pressing need for pupils to become aware of art and craft produced outside the school.

(b) Introducing original work

More careful planning and preparation is needed if pupils are to benefit regularly from being introduced to original art and craft objects. Close liaison between related educational institutions can provide one immediately available source of work which is of particular interest to pupils. Primary pupils in particular can easily remain unaware of art other than their own, reducing their aspirations in consequence. It is therefore of the utmost benefit for secondary school work to be displayed in feeder primary schools and for sixth-form college or local art school work to be similarly exhibited in the secondary school so as to make pupils continually aware of the range of possibilities available at each forthcoming educational stage. Occasionally the former pupils themselves are only too pleased to lend their higher education portfolios for display in the

secondary school; the concept of 'Rigby Revisited' was a natural extension of this principle and offered a unique insight into the spectrum of possibilities available. With similar captioning, labelling, etc., to that already proposed, the value of this type of display can be further maximised.

These examples all relate directly to the pupils' own potential needs, but there are also examples in this book which could easily combine to introduce a fascinating strand into any course. There are invariably artists and craftspeople living within the neighbourhood who are willing to bring their work into the school and talk about it, make small groups welcome at their studios or demonstrate in the school (as happened with the retired potter in the 'A school's ceramic collection' sub-section). The examination of old paintings purchased at a nominal price from the local junk shop is another model which utilises reasonably available material, and that could equally be extended to include models, pots, fabric works and the like. In removing the paint surface, seeing what underpainting or primer was used, examining the back, studying the frame, etc., pupils can come to understand what is normally taken for granted. In addition, there are some teachers who are able beneficially to introduce their own work into the school and, as in the example of the teacher-weaver, reveal their working processes to advantage through actual classroom practice and discussion.

That original works can be purchased by a school has also been demonstrated. The local artist and the college degree show can offer excellent bargains – but it is interesting that a school could also acquire works by the leading potters of the day at nominal prices. In purchasing original works, long-term planning is involved as the collection takes on added significance with each new acquisition. These collections are special in that the school can usually obtain detailed information about the specific works. Finally, there was the intriguing example of the art gallery created within the school, introducing a regular series of varied exhibitions which can obviously be fully exploited from an educational standpoint. Even though a gallery as such will not normally be feasible, a special display area can often be established with a little imagination. In these and related ways, it is possible for a school to introduce to its pupils a wide variety of worthwhile original works. With the proviso that the art gallery cited opened with an exhibition of Henry Moore prints, these works will not normally be 'great' art, and it will be necessary for the school to introduce such through second-hand material.

(c) Second-hand resources

Seeing these great works of art and craft in the original is undoubtedly an essential need for pupils and students of all ages, and in their testimonies they vividly communicate their sensitivity and responses to the added layers of significance which they perceive in the original but which were not conveyed by the same work in reproduction form. Nevertheless, they consistently place emphasis on the need for prior knowledge and explanation as a prerequisite for getting the most out of gallery visiting; one student's analogy of galleries with

museums – that the former just contain pictures, whereas exhibits in the latter are informatively captioned and with many of them operational – is a telling one. To aid teachers in their task of appropriately introducing pupils to gallery works, back-up resources are a fundamental necessity, both for short-term preparation prior to specific visits but also for the long-term forming of views and attitudes.

There is an exceptional range and quality of resources now available to the art teacher. Gallery slides, well-illustrated books, reproductions and video films, for example, offer a range of visual material and information which, in combination over a period of time, can be used to telling effect. In addition, it is now easier than ever before for teachers to produce valuable material of their own by using modern reprographic means, and making slides or video material for classroom use, etc. The main problem can be that of forming the most pertinent and sensible selection from the sheer diversity of material which is on offer. Nevertheless, rather than this material being available only in the art room, the pupils and students make it clear that it becomes most usable within the framework of a carefully teacher-devised course; even when the pupils have begun reading around the subject in anticipation of particular lesson topics, they emphasise that the lessons were still necessary to provide the necessary content to give added meaning to their researches. These resources are best utilised, therefore, in conjunction with teacher interest and knowledge.

In addition to their specific value in relating to gallery visits, books, slides, etc., can contribute significantly to practical lessons. Reproductions can provide stimulus, as when the middle school teacher extended her window project by using a Bonnard painting, or they can be used to draw parallels with what the pupils have already done. It was in this context that the junior school pupils were initially introduced to Munch's *The Scream* which then became, in turn, the stimulus for the next practical phase. It is a perfectly natural procedure to introduce children to appropriate examples produced by other artists as a means of affirming what the pupils are doing or to trigger further developments in their work through the use of challenging stimulus. When the course is systematically taught, the pupils' critical understanding can likewise develop in unison. A drawing course, for example, might develop in pupils an awareness of the significance of arrangement utilising the full area of the sheet of paper; of how line can communicate rhythm and movement, be graceful or expressive; of how tone can be used to render form or be a means of realising dramatic effects; of how a figure or object can be adequately set down on its own or be the main feature in a fully realised environment; of how different media are appropriate to different contexts and needs; of drawing as a preliminary design for work in other processes. In grappling with all these issues, pupils can be helped through regular discussion illuminated by appropriate examples from the world of art; the chiaroscuro studies of Rembrandt, Goya and Daumier, the dramatic conté effects and the form of Seurat, the textural and expressive qualities of Van Gogh's reed studies, the rapidly executed studies of Rodin and Delacroix, the rhythmic flow of hair and water in Leonardo, the delicacy of Chinese

watercolours, the translucent qualities of Japanese prints and the decorative impact of Melanesian motifs – the list is endless, the variety and choice of examples infinite and, incidentally, the potential to bring a greater continuity to the different phases of education considerable.

It is the sad truth, though, that many art teachers are currently working in rooms devoid of even the most basic slide, reproduction and book resources and it is here that real, long-term investment is a priority. In times of expenditure controls it is inevitably difficult to meet all the demands made on often hardly generous art capitation allowances – HMI had noted as early as 1971 that art teachers were frequently having to use their own personal collections of art books as teaching aids. (Imagine their science colleagues doing this on a regular basis.) Some art teachers have already successfully used their commitment to critical studies principles as a lever for obtaining additional sums of money to commence at least the process of acquiring the first basic resources from which to begin teaching on this basis. It is then necessary for a percentage of each year's capitation to be allocated to build on this base so as to ensure that the school develops and maintains an adequate, up-to-date collection of slides, books, reproductions, etc. – ideally housed safely in an accessible resource area within the department – so that pupils can study and enjoy them as an essential part of a balanced, fully rounded education.

(d) Collections of original works

All the above moves can be taken by the teachers themselves, but they should also be able to extend and amplify this type of work by drawing upon local region or authority resources provided specifically to meet these needs. It has already been emphasised that every local authority should administer its own schools' loan collection of original works of art and craft, because this is the most effective means of bringing original works to the maximum number of pupils. Many of these collections also contain reproductions – some predominantly so. These are of value, but as it is quite feasible for a school to build up its own sets of reproductions, the acquisition of original works by the local authority should be the priority. As one teacher observed, minor art seen close to can be a great deal better than great art seen through reproductions or from a distance. In the middle school project described, the children's immediate responses to the schools' loan original works affirms this observation; it took the skill of the teacher then to focus the pupils' attention on the Bonnard and other reproductions.

There is a world of difference between this type of project utilising schools' loan original works with which the teacher has been involved at the selection stage and a van periodically depositing 'anonymous' sets of prints, drawings, etc., at the school. Where loan schemes are available, critical studies-conscious teachers should familiarise themselves with the contents. The demands which they can then make on its administrators to meet specific needs will frequently lead to a productive partnership between school and authority, with the requests of one met by constructive suggestions about appropriate works available by the other.

The value of pupils 'living' with well-presented original works for a term or longer has already been illustrated. Apart from pupils having the opportunity to contemplate them and reflect on them at their leisure, a whole range of teaching strategies can be adopted to help them engage with art and craft objects. Storytelling, worksheets, the use of art objects as aids to the pupils' own discussion of their form, moods, content and techniques, etc., are all strategies which have been illustrated in these pages. Even teachers creating art room approximations of art galleries and introducing different works each week to the school in assemblies further demonstrate the potential and range of possibilities which loan works can offer the school. Where collections offer diversity, schools can constantly be planning contrasts between one display and the next so as to introduce that element of surprise which is such a constant feature in the illuminating experiences described. Schools' loan works are often used simply to brighten up gloomy corridors – an important function – but they can also provide a constant source of frequently changing original art and craft objects which children of all ages can be helped to interpret, 'read' and enjoy. And though 'minor' works obviously constitute the greater part of these collections, some of the long-established ones do include quite noteworthy examples and it is still possible to purchase prints by leading practitioners of the day at quite reasonable prices.

(e) Artists and craftspeople in schools

In addition to individual initiatives like that of the teacher who made arrangements for the retired local potter to demonstrate in his school, a similar impact can be achieved through the placements administered by the Regional Arts Associations. The most successful are often those which result from the combined efforts of association visual arts officer, adviser and teachers, with care taken over matching artist or craftsperson to school. This matching might lead to an affirmation of the school's strengths or the main criterion might equally be that the artist's discipline and working methods are a natural extension of what is already practised in that school. Yet again, a main virtue of a placement might be that the children will experience an aspect of the visual arts which would not otherwise be possible in that school. Whatever the criteria, the successful residency brings an unusual vitality and stimulus into the school and gives pupils unusual insights into at least one artist or craftsperson's working processes, ideally from the inception of an idea to full realisation as manifested through at least one work. A residency can lead to unusual developments in the children's own work because it is probably the most natural school-based means of establishing that special empathy between pupil and adult practitioner which, it has already been illustrated, is such an essential part of the 'aesthetic judgement proper'.

The artist or craftsperson should, therefore, be an effective – and willing – communicator in addition to being an obviously accomplished practitioner, and must certainly not be a reluctant resident in the school because this is the only available means of securing payment whilst working. I have observed artists and

craftspeople working in schools with no evidence of what they stand for other than the immediate piece of work which is in hand. To maximise the impact of their presence on pupils, other examples of their work should also be attractively displayed in the school and in the studio area in which they are based. Their different working methods, processes and approaches – as well as personalities – and the varying school circumstances ensure that each residency is unique, and one would not wish it otherwise. Nevertheless, an agreed timetable in which the artist or craftsperson has clearly determined amounts of working time balanced by sessions in which he or she has a clear brief as a communicator can assist each party in getting the maximum out of the residency. Pupils often express surprise at the sustained working periods of many artists and craftspeople, and breaks and lunchtimes often figure prominently in residences. It is at these times that pupils visit voluntarily out of interest, frequently leading to parallel practical endeavours on their part which are close in their motivation to the many voluntary and Home Art examples already cited.

One major problem concerning official residencies of this nature is that funding levels permit too few – possibly two or three, each of a week's duration in a school year – within any one authority. This means that the care over placements as recommended often means, in practice, placement in already successful art departments or primary schools. To complement these residencies, though, there are other models worthy of attention. The example in which PGCE students worked as artists in schools with a brief 'to import magic into the schools' while combining their BA artistic skills with their PGCE concerns as communicators is an interesting model, both for what they can bring to schools and their own perceptions of a range of possibilities in schools as potential teachers. The intensive nature of the PGCE year is obviously the main constraint, but its idea chould be extended to BA students gaining invaluable experience in schools as part of their training, with the schools likewise benefiting.

A further experiment being conducted in my own authority, extended in scope through the support of the Calouste Gulbenkian Foundation, involves long-term placements in schools, each of half an academic year's duration. The artists are former Wigan pupils who, having obtained their BAs or an equivalent art qualification, have returned to Wigan but with little prospect of full-time employment. They are either based in a high school, spending some time working in each of the feeder primaries, or in each of the feeder primaries in turn with, say, one day each week in the high school. Though the Manpower Services Commission was unsuccessfully approached for additional support, what is actually taking place would seem fully to meet their criteria in relation to community benefits and to the individual artists concerned. There ought to be every chance of similar initiatives elsewhere gaining the necessary support, however.

Looked at in the round, then, there is considerable scope for developments of this nature. The effort is undoubtedly worthwhile because, though there are

disastrous school residencies on record, when all the parties involved are operating on an agreed basis, the ways in which an aspect of the visual arts can be brought vividly into focus become relevant and the effect on pupils can be dramatic. A fresh vitality affecting attitudes and apparent in the pupils' own work is frequently an obvious legacy of a successful residency.

The above section is concerned with the wide range of resources which can be introduced into the school context and ways in which they can facilitate critical studies teaching approaches. They will normally be used in timetabled lessons, though it has been observed that artists and craftspeople frequently generate important informal contacts at other times in the school day. The standard school timetable does not comfortably accommodate the arts subjects. Combinations of these resources – resident artists or craftspeople in conjunction with exhibitions, as illustrated in 'Beyond the Timetable' (Part VIII, Section 1), for example – can help to militate against timetable constraints by occasionally or periodically providing opportunities for the whole school community to become involved in enjoyable celebrations of the visual arts.

(f) Visits outside the classroom

These principles can be further practised and developed outside the classroom in authorities with residential arts centres where it is possible for pupils to undertake week-long projects freed from the normal timetable constraints, their working routines approximating more closely to those of resident artists themselves. In these circumstances, working alongside artists and teachers, different types of relationships are formed between colleagues and adults, and new attitudes and realisations about the visual arts can arise out of these intensive weeks. In the normal routine of the school, by comparison, if they form at all it is likely to be over much longer time-spans. Similarly, the provision by an authority of an art centre along the lines of Drumcroon offering a service to teachers and pupils alike can also dramatically affect pupil perceptions and attitudes. Its combination of an abundance of all the resources necessary to critical studies teaching and exhibitions which it seeks to inter-relate as closely as possible with school practice places it at the focal point of the authority's art education services with its implications discernible in all categories of educational institutions. What it offers and the way in which it operates ensures that at least a percentage of its visiting pupils are likely to be marked for life.

Both of these centre models are worthy of emulations and they also have many important implications for the art gallery world. When heeded, these can significantly modify the whole nature of a gallery's practice, as has been illustrated in the section where one gallery's education policy in action has been described. Their full commitment to an educational role has altered the gallery staff's approach to the selection and forming of exhibitions, their presentation and support through additional back-up material and work. In accepting that tomorrow's adult gallery consumers are the children of today and that in the absence of appropriate 'training' in how galleries can be used and what they

offer, pupils are unlikely to use them in the future, the staff have discovered that there are bonuses for their present adult visitors. The majority of pupils cannot develop these understandings through art centre usage because of lack of availability, and it is in the gallery that their most important direct engagements with visual arts objects are going to take place. In the case studies recorded, pupils reveal time and again the full import of these formative gallery experiences which affect them at deep emotional levels as well as engaging them in often exceptionally demanding analysis and study.

3 Aversions

In contrast to these positive responses, though, there is the ever-present threat of its negative counterpart, the aversive experience, which can nullify all the best of intentions. It can have the result of those affected turning their backs on art galleries for the whole of their adult lives. Examples of its causes have already been illustrated. Aversive attitudes to the visual arts in their entirety can stem from routine, undemanding practical art lessons. Permanent – certainly long-term – damage can be caused in the transfer from a positive teacher to one who is unmotivated and uninterested within the same institution as well as that caused by the move from one establishment to another which is less sensitively aware in general approach. Inadequate preparation for gallery visiting at one extreme and boring preparation overlaid with more information of a factual nature than the pupils can readily absorb can be equally as damaging. A general absence from the art course of critical studies strategies means that many pupils will be ill-equipped to approach gallery works with any adequate criteria to enable them to proceed beyond the cursory glance – a constant complaint of teachers is that when they did take their pupils to a gallery they went through the whole place in a matter of seconds. Within the gallery itself staff who belabour groups of pupils with inappropriately pitched information at a conceptual level can be guaranteed to turn many off. At the opposite extreme there are guides who, in their attempts to make the pupils active particpants, fail adequately to impart information and put all the onus onto often self-conscious youngsters by asking increasingly obvious questions in their attempts to get some response. The guide's knowledge can help the pupils to recognise what is unique in a particular work; in its absence, one pupil's observation that all the works can seem the same as each other, without any standing out as being significant, is a fundamental one; the pupils' reactions can closely resemble those of the ill-prepared groups wandering aimlessly through gallery rooms, as already discussed.

One further important issue relating to aversive experiences is that of the art history and appreciation lecture. This teaching model has already been widely rejected by teachers because they argue that (a) they found their own student lectures boring and (b) they believe that their pupils, in turn, will be similarly bored. The CSAE Project Director, accepting that this is the case, reasoned

from the outset that there was thus a need to clarify an alternative range of approaches. Nevertheless, in the testimonies of those pupils in whom a commitment to the visual arts was clearly discernible, time and again they indicate that it was in lessons of this type that their interests were first aroused. In some instances, the combination of slide material accompanied by the relevant information can add up to something very close to the gallery-based illuminating experience. One student in higher education even distinguishes the different level of her interest and motivation from that of her non-specialist peers as emanating from the fact that they had never had the opportunity to attend a really good lecture when they were at school. Whilst acknowledging as a fact that a majority of art teachers have rejected the art history lecture, it also has to be emphasised that there is something special about those teachers who are skilled in their use of slide material in a darkened room – whether or not we label their lessons as 'history', 'appreciation', or whatever. Their transmitted enthusiasm and the knowledge they impart make them worthy of study and wider emulation, even though the means they are adopting has come to be seen as the archetypal turn-off model.

4 Illuminating Experiences

Due account must be taken of these aversive reactions and how they can be aroused, sometimes from the best of teacher intentions, but they in no way diminish the benefits of properly implemented critical studies courses which inevitably lead to the art gallery itself – the 'natural arena' in which the illuminating experience most frequently takes place. Its aversive counterpart can often be linked to the extremes of art teaching: too much gallery lecturing of an inappropriate nature on the one hand, undirected pupils wandering aimlessly on the other; no classroom preparation at one extreme, too much talk overlaid with facts and dates at the other. Even though it is possible for any individual pupil to be unexpectedly subject to the illuminating experience, my researches have led me to art educators whose skills ensure that considerable numbers are consistently affected in this manner.

A central feature of the illuminating experience is that it involves the pupil in a face-to-face confrontation with the art object, and as such is to do with the inner essence that makes a work unique. The sensitive critical studies teacher acknowledges that this essence cannot be adequately summed up or described in words, but through the skilful application of language more pupils than would otherwise be the case can learn to 'read' works of art for themselves and in the gallery discover those inner essences for themselves in the process. It is one of the contentions of the CSAE Project that this frequently neglected aspect of art education should be one of its central concerns; art education should seek to engender in pupils a lifelong love of the visual arts as consumers without fear of this undermining the equally valid conviction that the art lesson is one of the few opportunities the school provides for pupils to learn through doing. In fact,

those true encounters with art objects which the pupils describe in such a moving manner also involve an active participation which fully engages both their feelings and their minds.

Many examples affecting pupils of school age have been recorded in these pages. They are important because they reveal that young children and adolescents have exactly the same potential and capacity to respond to gallery works as the mature adult. Their responses are at the heart of aesthetic learning and are in no way diluted initial forays which can only be properly substantiated in adulthood – even though life's experiences will inevitably enable them to penetrate further into the depths of truly great works. For this reason alone, the prevalent notion of a gallery having a general public which it hives off from its educational role can be self-defeating. The motivating nature of these heightened gallery responses cannot be over-estimated because, in contrast to so much of everyday learning, pupils begin to do things for their own sake: such as further background reading and gallery visits, the acquisition of their own collections of books and reproductions, the desire to see particular works and to find out about other artists, etc. In the process, they are continually expanding their overall knowledge in relation to their personal responses. This objective framework against which they gauge their subjective reactions has been termed artistic appraisals by the APU. Accepting the influence which examinations have over course content, it is argued here that one essential step which could help to modify the neglect of critical studies approaches to art education would be for the new common 16+ examinations to require all pupils to show some evidence of their awareness of the visual arts, additional to those relating simply to their own practice. A whole range of pupil responses which are currently under-valued and neglected in the classroom might then receive the attention which they warrant.

Similarly, additional time spent on introducing pupils to the visual arts is amply justified when it leads to pupils relating to art objects in the gallery in the manner defined. This enjoyment and insight into works in their own right is sufficient in itself and can benefit all pupils, irrespective of their practical levels of attainment. In addition, though, many practical benefits can emanate from gallery experiences which can give added meaning to the pupils' own work. Sense of revelation, an intrinsic feature of the illuminating experience, is to do with the recognition of qualities within the viewer as well as – or corresponding to – those perceived in the art object. A natural consequence, particularly when that viewer is also engaged in practical activity, is to give expression to related ideas made possible through the experience. Memory retention likewise contributes to heightened environmental awareness, a state in which one's view of the world is coloured by contact with the art object – hence Lara's Kings Road parallels to the George Grosz and pupils' descriptions of seeing familiar, even mundane, aspects of their everyday world through new eyes. A rewarding by-product of the gallery experience in itself, there are also obvious practical implications which are borne out in the work of many pupils so affected – though the sensitivity of the teacher is essential if the pupil is to benefit fully.

5 Home Art

Often, though, the pupil works out these parallels in private, as in the case of Lara. Most of the research areas of the CSAE Project were apparent from the outset – Home Art is the one clear exception. It was the repeated pupil references to Home Art related to gallery experiences, their analysis of their progress in this work rather than that done in 'official' lessons, their belief that it represented their 'natural' mode of expression and the importance which pupil after pupil attached to their work of this type which caused me to incorporate it into the main fabric of the Project. Home Art raises many important issues. Because inarticulateness is an aspect of the illuminating experience and talk about art responses is not sufficiently encouraged or valued in most classrooms, some pupils work out these related interests in private. Whereas Home Art tends to be content-based, many art lessons – particularly at certain stages – are based almost exclusively on formal concerns and technical means. It is significant that it was well into the second week of the Winner project before the ten-year-old pupils involved asked their first questions about the methods used – until then it was the artist's use of subject matter which had held the children. The pupil's story based on *Caroline's Cat* reflects a similar concern for content. Unfortunately it is while these interests are still so relevant, in the early years of secondary schooling, that they are most frequently ignored. The formally orientated colour, line, tone and texture lessons are invariably taught in isolation. Though these exercise-based courses often have a clear logic as set out in the scheme of work, the pupils' experiences are invariably of a fragmentary nature in practice. By comparison, a characteristic of Timothy's Home Art is his ability to gauge and monitor his own development over years, irrespective of changes of teacher or school. When Home and School Art values are reconciled, as in the sixth-form college example, the time voluntarily spent and the intense levels of concentration and activity can be extraordinary. Given the general emphasis which is placed on the value of personal expression in the art room, these Home Art implications are of great importance.

A pressing need of art education is for a natural continuity to be achieved in children's education within each school and in their moves from one school to another. Examples are rare but critical studies approaches could contribute significantly to their development. In their absence, a characteristic of the teaching examples set out in this book is that they are all of long-term projects or of continuous working methods, rather than being one-off lessons which happen to have worked well. As such, they all relate to the Home Art issues which have been raised. They feature pupils working coherently within broad enough time-spans to have opportunity to gauge their own development. Teaching resources are utilised in ways which enable pupils to know and enjoy visual arts objects in their own right and in relation to their own practical concerns. Empathy and understanding for these works are naturally developed in consequence, and the level and nature of classroom talk encourage pupils to see their own work in a broader context. The examples illustrate that, in addition to

the commonly encountered art teaching of an advisory and technical nature once work is underway, teachers can interact with pupils at the inception stages of a work. These approaches can combine to affect many pupils in such a manner that their thoughts and feelings about the visual arts cease to be restricted to set timetabled lessons and the classroom. They become an essential part of the pupils' lives, hence the additional voluntary commitment which is so apparent in many of the individual case studies described. The examples indicate the relevance of critical studies approaches for pupils of differing abilities and from varied backgrounds across the whole 7–18 age-range. One additional implication is that if these approaches were more widely practised across the age-ranges, they would also go a long way to broadening the range of options in the upper school by helping pupils to grasp something of the essential diversity of the visual arts.

The breadth of the CSAE Project has meant that many diverse strands have been developed, others merely touched upon, in this book. The case studies involving individual pupils and students are important because they reveal the learning potential and capabilities of young adolescents which are all too rarely recognised and catered for. A consideration of what is being consistently said could help teachers to implement critical studies strategies in a pertinent manner. It is therefore fitting to conclude on a similar individual note by citing one further case study example which draws many of these diverse strands together. It involves the balance between Home Art, school courses and examination requirements, is to do with multi-cultural needs and focuses on that intense identification with an artist which is common to all the other examples recorded.

Eram was born in Pakistan and has lived in this country from the age of three. Having dropped art at third-year option time, she took the subject up again 'to gain an extra qualification' at the 16+ stage, but also because she was interested in fashion as a hobby. In practice, this means that for a number of years Eram has designed and made her own clothes at home. The clothes she often wears in school, which she has made, are European in design, extremely smart and well made, and naturally enhancing to Eram. In addition, though, she also makes and wears her own Asian clothes and is the youngest practitioner in this field in the Asian community where she leads her private life. If her European clothes are enhancing, Eram looks stunning in her Asian dresses. The clothes she makes demand of her a wide variety of skills and her ideas crystallise in a quite unusual way: 'All these ideas come into my mind when I am in bed just before I go to sleep. Yesterday, for example, I had this idea which combines textile printing onto the material and then making it up into a skirt and blouse, and I am working on a design for that.'[2] Nevertheless, she could only achieve a Grade 3 in CSE Needlework and has subsequently failed O-level Needlework on three occasions (see facing p. 259).

Her school has recently benefited from Angela Cusani, a craftsperson-in-residence, practising there. Eram finds her work 'Fascinating – brilliant! I could never think of the ideas that she thinks up. The paper-making she

is doing at the moment to form a large-scale piece is just amazing with her skills and use of colours. I never realised that paper was made like that and I can make my own paper now.' But it is Angela's weaving skills which have benefited her the most. She knew nothing about weaving previously, but during the residency she has knitted and woven an extraordinary coloured dress. She feels that 'The woven dress is part of me.' She says that she lives two virtually separate lives: one related to school and her school friends, the other in her tight-knit Asian community. In making her woven dress, though, she feels that for the only time in her life to date, values from both cultures combined and inter-mingled, making the dress important to her in a special way. By responding to another artist and acquiring new skills in the process, Eram was able to make a deeply personal statement of her own which combined expression with knowing. In Part I, Section 2, the private but special insights of Lara were revealed; the equally hidden but extraordinary skills and interests of Eram contrast starkly with the mundane examination requirements of a curriculum area which relates closely to that of art and design.

Once the hidden 'home' interests of Eram had been successfully tapped in an educational context, she became conscious of values from two cultures coming together and inter-mingling. In the process there was certainly a similar interaction between her sensations and feelings – that 'world of private space and of the solitary subject' so valued by Witkin[3] – and the world which exists beyond the individual, brought into focus through her identification with another artist. In this reconciliation of two frequently unrelated and polarised aspects of art education, the pupil is simultaneously learning about aspects of the visual arts and about his or her specific skills and interests, and inner self. The pupil case studies demonstrate time and again how this combination can lead them beyond the normal constraints of timetabled lessons to voluntary practice and an unusual commitment to the visual arts, now clearly seen as central to their lives. Properly implemented and taught, therefore, a critical studies approach to art education is highly motivating to pupils and enriching to their lives, in marked contrast to so much of school learning. As such, it is an approach which is worthy of the attention of everyone involved in art and design education involving, as it does, a unique form of learning about the visual arts in all their breadth through experience.

Notes and References

PART I MOTIVATION AND AESTHETIC LEARNING

Section 1 Critical Studies and the Present Climate

1. Witkin, Robert W., *The Intelligence of Feeling*, Heinemann Ed. Books, 1974.
2. Hughes, Arthur, 'A Place for Art History in the Art and Design Curriculum?', *The Pull of the Future*, City of Birmingham Polytechnic, 1981.
3. *The Arts in Schools: Principles, Practice and Provision*, Calouste Gulbenkian Foundation, 1982.
4. Hughes, Arthur, op. cit. Note: Hughes supports his argument by using the words of Mel Marshak.
5. See Hargreaves, David, *The Challenge for the Comprehensive School*, Routledge and Kegan Paul, 1982.
6. Fry, Roger, *Vision and Design*, Pelican Books, 1937.
7. Witkin, Robert W., op. cit.
8. Perry, Leslie, 'The Educational Value of Creativity', *Crafts Conference for Teachers*, Crafts Council, 1982 Report.
9. *The Arts in Schools*, op. cit.
10. DES, *Art in Secondary Education, 11–16*, HMSO, 1983.
11. Smith, Brian, *Behind the Rainbow, Patrick Hughes: Prints: 1964–1983*, Paradox Publishing, 1983.

Section 2 Hidden Interests

12. The surname has been used when individuals have graduated and might officially be termed professional artists.
13. From a recorded interview between the author and pupil, 1983.
14. Taylor, Rod, *Broadening the Context*, CSAE Occasional Publication No. 1, Schools, Arts, Crafts Councils, 1982.
15. Witkin, Robert W., op. cit.
16. From a recorded interview between the author and the head of the art department at her school, 1983.

Section 3 Illuminating Experiences

17. DES, *Art in Schools*, Educational Survey 11, HMSO, 1971.
18. Taylor, Rod, 'Lydia's Embroidered Mills', *The Illuminating Experience*, CSAE, Occasional Publication No. 2, Schools, Arts, Crafts Councils, 1982.
19. Lewis, Brian N., 'The Museum as an Educational Facility', *Museums Journal*, Vol. 80, No. 3, December 1982.
20. Hargreaves, David, 'Education and the Art Curriculum – An Alternative View', *A.A.A. Conference Report*, 1981.
21. Hargreaves, David, 'The Teaching of Art and the Art of Teaching: Towards an Alternative View of Aesthetic Learning, *Curriculum Practice: Some Sociological Case Studies* (ed. Martyn Hammersley and Andy Hargreaves), Falmer Press, 1983.
22. Feldman, Edmund Burke, 'Varieties of Art Curriculum', *Journal of Art and Design Education*, Vol. 1, No. 1, National Society for Art Education, 1982.
23. Hargreaves, David, *The Teaching of Art*, op. cit.
24. Cardus, Neville, extract from *Manchester Guardian*, 4 May 1933 in *Guardian*, 30 April 1983.
25. Polan, Brenda, 'First Impressions' Series, *Guardian*, 15 June 1983.
26. Hargreaves, David, *The Teaching of Art*, op. cit.
27. Phillips, Melanie, 'First Impressions' Series, *Guardian*, 13 June 1983.
28. Hargreaves, David, *The Teaching of Art*, op. cit.
29. Phillips, Melanie, op. cit.
30. Hargreaves, David, *The Teaching of Art*, op. cit.
31. Harrison, M. and Waters, B., *Burne-Jones*, Barrie and Jenkins, 1973.
32. Hargreaves, David, *The Teaching of Art*, op. cit.
33. Levin, Bernard, *Enthusiasms*, Jonathan Cape, 1983.
34. Hargreaves, David, *The Teaching of Art*, op. cit.
35. Clark, Kenneth, *Looking at Pictures*, John Murray, 1960.
36. Bruner, Jerome, *In Search of Mind: Essays and Autobiography*, Harper and Row, 1983.
37. Clark, Kenneth, op. cit.

Section 4 Aversive Experiences

38. Witkin, Robert W., op. cit.
39. Witkin, Robert W., op. cit.
40. From *Art Collections Used by Children*, University of Birmingham/ATO-DES Course, undated.
41. From a recorded interview between the author and student, 1985.
42. From a recorded interview between the author and David Hargreaves and Bev Bytheway, 1982.
43. From a recorded interview between the author and David Hargreaves and the student, 1982.

PART II PUPILS AND STUDENTS TALKING

Section 1 Formative Gallery Experiences

1. Quotations in this sub-section are taken from a recorded interview between the author and Bev Bytheway and the pupil, 1982. (For an alternative account of this testimony see *The Illuminating Experience*, CSAE Occasional Publication No. 2, 1982.)
2. Hargreaves, David, *The Teaching of Art*, op. cit.
3. Written by Jane during Rochdale Art Gallery workshop, 19 April 1982.
4. Quotations in this sub-section are taken from a recorded interview between the author and pupil, 1982, and from a written piece of work produced for her art teacher.
5. Shaw, Sir Roy, 'Education and the Arts', *The Arts and Personal Growth* (ed. Malcolm Ross), Pergamon Press, 1979.
6. Brighton, Andrew, 'Ill-Education through Art', *Aspects*, No. 18, Spring Issue, 1982.

Section 2 Critical Studies Courses and the Original Work

7. Quotations in this sub-section are taken from a recorded interview between the author and the student, 1982.
8. Hargreaves, David, *The Teaching of Art*, op. cit.
9. Extract from the student's JMB A-level Personal Study, submitted in 1983.
10. Quotations in this sub-section are taken from a recorded interview between the author and the student, 1983.
11. Hargreaves, David, *The Teaching of Art*, op. cit.
12. Reid, Louis Arnaud, 'Assessment and Aesthestic Education', *The Aesthetic Imperative* (ed. Malcolm Ross), Pergamon Press, 1981.

Section 3 Three Male Responses

13. From a recorded interview between the author and the student, 1983.
14. From a recorded interview between the author and the student, 1982.
15. Extract from the student's notebook. Notes made in National Gallery, December, 1981.
16. Extract from the student's JMB A-level Personal Study, submitted in 1982.
17. From a recorded interview between the author and the student, 1982. (A fuller account of this case study can be found in *The Illuminating Experience*, CSAE Occasional Publication No. 2, 1982.)
18. Extract from the student's JMB A-level Personal Study, submitted in 1982.

PART III PRACTICAL STARTING POINTS AND DEVELOPMENTS

Section 1 Home Art

1. Silverman, Ron, *A Syllabus for Art Education*, California State University, Los Angeles, 1972.
2. See also *Six Children Draw* (ed. Sheila Paine), Academic Press, 1981, in

which the sequential drawings of six children are studied and the issues 'between school or tutored work and drawings done freely at home' are explored by different writers.

3. From a recorded interview between the author and the pupil, 1983.
4. Smith, Professor Ralph, 'The Function of Art in the Core Curriculum', *The Function and Assessment of Art in Education*, Association of Art Advisors, undated.
5. From a recorded interview between the author and the student, 1983.
6. *The Arts in School*, op. cit.
7. DES, *Art in Secondary Education, 11–16*, op. cit.
8. Silverman, Ron, op. cit.

Section 2 The Mature Artist and the Illuminating Experience
9. Clark, Kenneth, *The Romantic Rebellion*, Omega, 1973.
10. Riedl, Peter Anselm, *The Masters*, No. 28, *'Kandinsky'*, Purnell and Sons Ltd, 1966. (See also Rewald, John, *The History of Impressionism*, Secker and Warburg, 1980.)
11. Elgar, Frank, *Van Gogh*, Thames & Hudson, 1958.
12. *Chagall Catalogue*, Royal Academy of Arts, 1985.
13. Chagall, Marc, *My Life* (translated by D. Williams), Peter Owen, 1965.
14. From a recorded interview between the author and the Drumcroon Gallery Education Officer and Michael Rothenstein, 1983.
15. Lucie-Smith, Edward, *Brendan Neiland, Recent Paintings 1977-79 Catalogue*, Fischer Fine Art, 1979.
16. From a recorded interview between the author and the Drumcroon Gallery Education Officer and Brendan Neiland, 1983.
17. *The Arts in Schools*, op. cit.
18. Information imparted by Tadek Beutlich during a recorded interview with the author and the Drumcroon Gallery Education Officer, 1982.
19. Leach, Bernard, *Beyond East and West*, Faber, 1978.
20. Witkin, Robert W., op. cit.
21. Hargreaves, David, *The Teaching of Art*, op. cit.
22. Rose, Lauretta, What's Wrong with School Art?', *Education Bulletin*, 5, Arts Council of Great Britain, October 1981.
23. Witkin, Robert W., op. cit.
24. DES, *Art in Schools*, op. cit.
25. From a recorded interview between the author and the student, 1983.
26. Brighton, Andrew, 'Processed Art Education', *Arts Yorkshire*, March 1982. (Brighton quotes Hamilton as stating that, at Newcastle, 'the first aim of our course is a clearing of the slate. Removing preconceptions. People come to art school with ready-made ideas of what art is.')
27. Fuller, Peter, 'In Search of a Tradition', *New Society*, September 1983.

PART IV AGE, INTELLIGENCE AND BACKGROUND

Section 1 Critical Studies for All?
1. Hoggart, Richard, 'To the Shade of Lord Keynes . . .', *The Sunday Times*, 15 May 1983.
2. Braden, Su, *Artists and People*, Routledge and Kegan Paul, 1978.
3. Shaw, Sir Roy, op. cit.
4. Hargreaves, David, *The Teaching of Art*, op. cit.
5. Berger, John, *Ways of Seeing*, BBC, 1972.
6. Hargreaves, David, *The Teaching of Art*, op. cit.
7. Greer, Germaine, 'Star Girl', *The Sunday Times*, 3 April 1985.
8. Robinson, Ken, 'Arts in Schools' lecture, Wigan, Sept. 1984.
9. From *Culture for All*, Goethe-Institute, Council of Regional Art Associations, 1980.
10. Address by Sir Keith Joseph to Confederation of Art and Design Associations (CADA) at the Royal Society of Arts, 24 May 1984.
11. Quotations in this sub-section are taken from a recorded interview between the author and the teacher, 1983.
12. For a detailed account of 'B is for the Blue Lady' see *The Illuminating Experience*, CSAE Occasional Publication No 2, 1982.

Section 2 The Primary School Context
13. Witkin, Robert W., op. cit.
14. *Art 7–11*, Schools Council, 1978.
15. From a recorded interview between the author and a student, 1982.
16. *Art 7–11*, op. cit.
17. Clement, Bob, *Children's Use of Works of Art*, Devon Schools, 1981–4.
18. From a recorded conversation between the author and the pupils, 1983.
19. Extracts taken from pupils' writing executed in 1982.
20. Fry, Roger, op. cit.
21. Piece of writing produced by pupil in her school, 1982.
22. See *Using Pictures with Children*, A.A.A. (North Eastern Group), undated.
23. Quotations in this sub-section are taken from a recorded interview between the author and the teacher, 1984.
24. Benesch, Otto, *Munch*, Phaidon, 1960.
25. Piaget, Jean, *The Child's Conception of the World*, Paladin, 1973.

Section 3 Multi-Cultural Issues
26. Quotations in this sub-section are taken from a recorded interview between the author and the teacher, 1983.
27. From *Race in Britain*, Open University textbook (ed. Charles Husband), Hutchinson.
28. Best, David, 'Accountability: Objective Assessment in Arts Education', *The Function and Assessment of Art in Education*, A.A.A.
29. Prince, Eric, 'The Art and Drama Dharma', *2-D Drama and Dance*, Vol. 2, No. 1, Autumn 1982.

30. From a recorded interview between the author and the head teacher, 1984.
31. See *Changing Traditions*, an exhibition and conference catalogue published by the Changing Traditions Teachers' Group in association with Ethnographic Resources for Art Education, undated.
32. *Aims (Art & Design in a Multicultural Society)*, leaflet, Leicester Polytechnic, 1983.
33. Silverman, Ron, op. cit.
34. Quotations in this sub-section are taken from a recorded interview between the author and the deputy head teacher, 1984.
35. Silverman, Ron, op. cit.

PART V GOING OUTSIDE THE CLASSROOM

Section 1 Gallery and Workshop Practice
1. From a recorded interview between the author and the head of art department, 1985.
2. Berger, John, op. cit.
3. From a recorded interview between the author and a head of an art department, 1983.
4. Marcousé, Renée, *The Listening Eye*, HMSO, 1983.
5. Brighton, Andrew, 'Ill-Education through Art', op. cit.
6. Material used in this section is taken from a recorded interview between the author and the education staff of the gallery, 1982.
7. From a letter written by W. M. Terry, Curator, Northampton Museum to the Northamptonshire Advisory Teacher of Art, 1984.
8. Brighton, Andrew, 'Ill-Education through Art', op. cit.
9. For a detailed account of this and related workshops see *The Illuminating Experience*, CSAE Occasional Publication No. 2, 1982.
10. DES, *Art in Schools*, op. cit.
11. Ken Baynes speaking at a Royal College of Art seminar on Critical and Historical Studies in Art, 1982.

Section 2 Combined Gallery and School Approaches
12. Quotations in this section are taken from a recorded interview between the author and the head of art department, 1983.
13. Quotations in this section are taken from a recorded interview between the author and the Exhibitions Officer and her assistant, 1984.

Section 3 The Role of the Education Art Centre
14. Morgan, Jill, 'A New Way to Look at Art', *The Artful Reporter*, North West Arts, May 1982.
15. Lucie-Smith, Edward, 'Back in Touch with the Emotions', a review of the Sculpture Show, *The Sunday Times*, 21 August 1983.
16. From a recorded interview between the author and the Gallery Education Officer, 1983.
17. Transcribed from a video recording of Pierre Degen conducting the

workshop in the Drumcroon Centre, 1983.

18. From a recorded interview between the author and the class teacher, 1983.
19. From a recorded interview between the author and the Gallery Education Officer, 1983.
20. This, and subsequent examples, are taken from pupils' written work produced at school, 1983.
21. From a recorded interview between the author and the pupil, 1983.
22. Quotations in this sub-section are taken from written material on file at the Centre, 1982
23. Bevan, Oliver, *Report on 2nd 'Critical Studies in Art Education' Course*, 25 May 1982.

PART VI ORIGINAL WORKS IN THE CLASSROOM

Section 1 Original Works for All

1. Fairbairn, Andrew N., 'An Essential Ingredient', *Growing Up with Art*, catalogue of the Leicestershire Collection for Schools and Colleges, Arts Council of Great Britain, 1980.
2. Extracts from recorded interviews between the author and pupils and students, 1982–83.
3. Witkin, Robert W., op. cit.
4. DES, *Curriculum 11–16*, Working Papers by HM Inspectorate: a contribution to current debate, DES, 1977.
5. Quotations in this sub-section are taken from a recorded interview between the author and the art teacher, 1983.

Section 2 Unusual Classroom Initiatives

6. Taken from a recorded interview between the author and the teacher, who is now a college of higher education lecturer, 1984.
7. Taken from a recorded interview between the author and the present art teacher, 1984.
8. Quotations in this sub-section are taken from a recorded interview between the author and the head of the art department, 1984.

PART VII A QUESTION OF RESOURCES

Section 1 Art Department Resources

1. Berger, John, op. cit.
2. DES, *Art in Schools*, op. cit.
3. Penny, Nicholas, 'Seduced into Raphael's World', *The Sunday Times*, 6 April 1983.
4. DES, *Art in Schools*, op. cit.
5. Interview with the head of the art department, 1983.
6. DES, *Art in Secondary Education, 11–16*, op. cit.
7. From a recorded interview between the author and the art teacher, 1983.

8. Gough, Kevin, 'Art Put Us on the Map', *Leigh Journal*, 2 June 1983.
9. DES, *Art in Secondary Education, 11–16*, op. cit.

Section 2 A Sixth-Form College Approach
10. From a recorded interview between the author and David Hargreaves and the student (see also *The Illuminating Experience*, CSAE, Occasional Publication No. 2, 1982).
11. This and other material used in this section is taken from a recorded interview between the author and the acting head of the art department, 1984.
12. Extract from student's JMB A-level Personal Study, op. cit.
13. From a recorded interview between the author and David Hargreaves and the student (see also *The Illuminating Experience*, CSAE Occasional Publication No. 2, 1982).
14. From a recorded interview between the author and the student, 1983.
15. Bruner, Jerome, op. cit.
16. Hargreaves, David. *The Teaching of Art*, op. cit.

PART VIII ART AND THE SCHOOL COMMUNITY

Section 1 Beyond the Timetable
1. Rée, Harry, 'Education and the Arts: Are Schools the Enemy?' *The Aesthetic Imperative*, op. cit.
2. Rose, Lauretta, op. cit.
3. Rée, Harry, op. cit.
4. Hargreaves, David, *The Teaching of Art*, op. cit.
5. Fairbairn, Andrew N., op. cit.
6. 'Artists in Education' Supplement, *Artists Newsletter*, September 1983.
7. *5 Artists in Schools*, Calderdale Museums Service, 1982.
8. Hurst, Helen and Taylor, David (A-level students), 'Everyone can be an artist', *Schools North*, Northern Arts, Autumn 1983.
9. Information derived from a visit to the school by the author, 1983.

Section 2 A Kiln-Building Project
10. Quotations in this section are taken from a recorded interview between the author and the head of the art department, 1983.

Section 3 'Rigby Revisited'
11. Much of the information used in this section is taken from recorded conversations between the acting head of the art department and students and members of the art staff, 1984.
12. From a recorded interview between the author and the acting head of the art department, 1984.
13. Statements by the artists-in-residence used in this section are taken from a recorded interview between the author and the artists, 1983.

PART IX A WAY AHEAD

Section 1 Training
1. Sharp, Caroline, 'Uncritical, Unconfident, Uncommunicative', *Arts Express*, July 1984.
2. Smith, Fraser, 'Preparing for Examination in Art', *The Arts in Education*, Educational Analysis, Vol. 5, No. 2 (ed. Malcolm Ross), Falmer Press, 1983.
3. From a recorded interview between the author and the senior lecturer in art and design, 1984.
4. From *Museums and Art Galleries in the Teaching of Art and Design*, Course Handbook 1983–4, Brighton Museum, The Tate Gallery, Brighton Polytechnic, 1983.
5. From a recorded interview between the author and the tutor in charge of the PGCE (Art and Design) course, 1983.
6. From interview with Gallery Exhibitions Officer, op. cit.
7. Rée, Harry, op. cit.
8. *Using Pictures with Children*, op. cit.

Section 2 A Critical Language
9. Witkin, Robert W., op. cit.
10. *The Arts in Schools*, op. cit.
11. Smith, Fraser, op. cit.
12. Allison, Brian, *Art Education*, VCOAD (Voluntary Committee on Overseas Aid and Development), 1972.
13. Hargreaves, David, *The Teaching of Art*, op. cit.

Section 3 Examinations
14. Reid, Louis Arnaud, op. cit.
15. *Aesthetic Development-Discussion Document*, APU, 1983.
16. *Northern Examination Association Art and Design Syllabus* (Draft), 1985.
17. Since this section was written, the Northern Examining Association has added an additional assessment objective (1) which reads: 'Candidates will be expected to demonstrate the ability to make informed responses to contemporary and historical art and design through an awareness of artistic qualities, an analysis and evaluation of design, and the forming and expressing of judgements.'
18. Rose, Lauretta, op. cit.

CONCLUSION
1. Huby, Peter, 'To the Barricades . . .', *In Sight*, A Journal of Art Education, Issue No. 1, Autumn 1983.
2. From a recorded interview between the author and the student, 1985.
3. Witkin, Robert W., op. cit.

Appendix

Where to Go and See Fine and Decorative Arts and Crafts

Space does not permit the publication here of an exhaustive list of places to visit where good examples of historical and contemporary work can be seen. However, readers are referred to the following publications:

The Museums Year Book – published annually by the Museums Association, 34 Bloomsbury Way, London WC1A 2SF.

Museums and Galleries in Great Britain and Ireland – published annually by British Leisure Publications, Windsor Court, East Grinstead House, East Grinstead, West Sussex.
(These two publications provide complementary material: *Museums and Galleries* gives details of opening hours, collections and displays, while the *Year Book* gives names of staff and details of departments.)

The Directory of Exhibition Spaces – gives a complete list of exhibition spaces, with addresses and opening hours and names of staff. Edited by Neil Hanson and Susan Jones, published by Artic Producers Publishing Company, 1983.

Arts Centres in Great Britain – gives a complete list of arts centres with addresses and the names of their directors/managers. Available from Information and Research, Arts Council, 105 Piccadilly, London W1V OAU.

Historic Houses, Castles and Gardens of Great Britain and Ireland – gives opening hours and details of both privately owned and National Trust properties, many of which have excellent collections on display. Published annually by British Leisure Publications (see address above).

Major Public Collections of Contemporary Crafts in the UK – a handlist giving details of major post-1920 collections of British crafts, available free of charge from the Information Section of the Crafts Council (address below).

The Crafts Map – gives detailed information on shops and galleries that the Crafts Council recognises for the quality of work stocked, the standard of presentation and their knowledge of contemporary work. Published annually by the Crafts Council and available (free) from 12 Waterloo Place, London SW1 4AU or from selected shops and galleries. (As far as contemporary work in the crafts is concerned, some of the most interesting new work can be seen regularly

in changing commercial exhibitions. The owners of these galleries might be approached with a view to arranging visits by small groups of pupils.

Some galleries, museums and art centres offering educational facilities
Increasingly both publicly funded and privately owned institutions are concerned to support their permanent collections and temporary exhibitions by offering educational facilities. Again, space does not allow the publication of an exhaustive list; the basis of the list given below is an edited and updated version of *The Art Galleries Association's Art Gallery Education Survey* carried out in 1983 and published in a special edition of the Association's publication *The Bullet* in 1986. (Copies can be ordered through the Membership Secretary, c/o Yorkshire Arts Association, Glyde House, Glydegate, Bradford BD5 OBQ or the Editor, Winchester School of Art, Park Avenue, Winchester, Hampshire SO23 8DL.) For the present purpose, this survey has been extended as appropriate, using information supplied by the Crafts Council, to include institutions which have a particular concern for the educational support of the decorative arts and crafts.

Some galleries' programmes, staffing and facilities may well have changed since the following information was compiled. The range, scope and indeed quality of education facilities varies from institution to institution and those interested are advised to make direct contact and assess for themselves what can be offered before planning a programme of work. It is worth remembering that some of the most successful educational programmes have been carried out by galleries which have limited funds and few resources but benefit from the skills of committed and sensitive staff.

In order to try and represent galleries and museums from the length and breadth of the country there are included small institutions which have no regular education programme but which are, like large institutions, eligible for funding, on a matching basis, for educational work to support individual Arts Council touring exhibitions. The Crafts Council will also offer some support for educational activities to galleries who take their touring exhibitions. The letter **P** denotes that the institution houses a permanent collection of fine art; **p** denotes a permanent collection of historic or contemporary craft; **T** that it receives Arts Council touring exhibitions; **t** that it receives Crafts Council touring exhibitions. Telephone numbers show STD dialling code followed by the subscriber's number. If the exchange is a local one, the dialling code may be different and the telephone directory of the local code book should be consulted. In each case, indication of the officer to consult for educational advice is given.

In addition, the Visual Arts and Crafts officer of the appropriate Regional Arts Association will be able to provide information about the educational scope of the different institutions in their area.

Galleries, museums and art centres offering educational facilities

ABERDEEN	Pp Tt	Aberdeen Art Gallery and Museum, Aberdeenshire Keeper of Extension Services	0224 646333
ABERYSTWYTH	p Tt	Arts Centre, Dyfed Education Officer	0970 4277
AYR	P Tt	Maccalurin Art Gallery, Rozelle House, Ayrshire Museums and Gallery Organiser	0292 45447
BARNSLEY	P Tt	The Cooper Gallery, South Yorkshire Curator	0226 42905
BATH	p t	Crafts Study Centre, Avon Curator	0225 66669
	Pp T	Victoria Art Gallery, Avon Arts Officer	0225 61111
BATLEY	'T	Batley Art Gallery, West Yorkshire Senior Curator	0924 473141
BEDFORD	Pp	Cecil Higgins Art Gallery & Museum, Bedfordshire Curator	0234 211222
BELFAST	Pp T	Ulster Museum, Northern Ireland Education Officer	0232 668251/5
BILLINGHAM	T	Billingham Art Gallery, Cleveland Curator	0642 555443
BIRKENHEAD	P Tt	Williamson Art Gallery & Museum, Merseyside Senior Keeper	051 652 4177
BIRMINGHAM	Pp Tt	Barber Institute, West Midlands Assistant Director/Lecturer	021 472 0962
	P	City Museum & Art Gallery, West Midlands Schools Liaison Officer	021 235 2834

	T	Ikon Director	021 643 0708
BLACKBURN	P Tt	Blackburn Museum & Art Gallery, Lancashire Keeper of Art	0254 667130
BLACKPOOL	P Tt	Grundy Art Gallery, Lancashire Curator	0253 23977
BOLTON	Pp Tt	Bolton Museum & Art Gallery, Greater Manchester Senior Keeper, Educational Services	0204 22311 x 379
BOURNEMOUTH	Pp	Russell Cotes Art Gallery & Museum, Dorset Curator	0202 21009
BRACKNELL	t	South Hill Park Arts Centre, Berkshire Head of Visual Arts	0344 427272
BRADFORD	P T	National Museum of Photography, Film & Television, West Yorkshire Head of Education and Interpretation	0274 727488
	P Tt	Cartwright Hall, West Yorkshire Gallery Teacher/Assistant Keeper of Education	0274 493313
BRIGHTON	Pp Tt	Art Gallery & Museum, E. Sussex Education Services Officer	0273 603005
	Tt	Polytechnic Gallery, E. Sussex Exhibitions Officer	0273 604141 x 251
BRISTOL	T	Arnolfini Gallery, Avon Education/Liaison Officer	0272 299191
	Pp Tt	City Museum & Art Gallery, Avon	0272 299771
BURNLEY	P Tt	Towneley Hall Art Gallery & Museum, Lancashire Curator	0282 24213

BURY	**P Tt**	Bury Art Gallery & Museum, Greater Manchester Senior Curator	061 761 4021
BUXTON	**Pp**	Museum & Art Gallery, Derbyshire Education Officer	0298 4658
CAMBRIDGE	**P Tt**	Fitzwilliam Museum Assistant Keeper, Paintings, Prints and Drawings	0223 69501
	P Tt	Kettle's Yard Assistant Curator Education	0223 352124
	T	Darkroom Education Officer	0223 350725
CANTERBURY	**P Tt**	Canterbury City Museums, Kent Curator	0227 452747
CARDIFF	**P t**	National Museum of Wales, South Glamorgan Museum Schools Service Officer	0222 397951
	t	Chapter Arts Centre, South Glamorgan Visual Arts Programmer	0222 396061
CARMARTHEN	**P Tt**	Carmarthen Museum, Dyfed Museum Curator	0267 231691
CHELTENHAM	**Pp** **Tt**	Cheltenham Art Gallery & Museum, Gloucestershire Education Officers	0242 43399
CHESTER	**Pp** **Tt**	Grosvenor Museum, Cheshire Education Officer	0244 21616
CHICHESTER	**P Tt**	Pallant House Gallery, West Sussex Assistant Curator	0243 774557
CIRENCESTER	**t**	Cirencester Workshops, Gloucestershire Education & Exhibition Officer	0285 61566

CLEVELAND	p t	Cleveland Crafts Centre, Middlesbrough Crafts Officer	0642 226351
	Tt	Cleveland Gallery, Middlesbrough Museum Officer	0642 248155 x 3375
COLCHESTER	P Tt	The Minories, Essex Director	0206 577067
COOKHAM	P	Stanley Spencer Gallery, Berkshire Honorary Secretary	06285 24580
COVENTRY	P Tt	Herbert Art Gallery & Museum, West Midlands Education Officer	0203 25555
DARLINGTON	Tt	Darlington Arts Centre, Durham Education Officer	0325 483271
DERBY	P Tt	Derby Museums & Art Gallery, Derbyshire Museums Education Officer	0332 31111 x 405
DEWSBURY	T	Dewsbury Exhibition Gallery, West Yorkshire Curator	0924 465 151
DUDLEY	P Tt	Dudley Art Gallery, West Midlands Senior Museums Keeper	0384 55433 x 5530
DUNDEE	P Tt	Dundee Museums & Art Gallery, Tayside Schools Liaison Officer	0382 23141
DURHAM	Tt	DLI Museum & Arts Centre, Durham Keeper in Charge	0385 42214
EASTBOURNE	P Tt	Towner Art Gallery, East Sussex Curator	0323 21635/25112
EDINBURGH	P	Scottish National Gallery of Modern Art Education Officer	031 556 8921 x 219
	P	Scottish National Portrait Gallery Education Officer	031 556 8921 x 219

P	National Gallery of Scotland Education Officer	031 556 8921 x 219
Pp	Royal Museum of Scotland Education & Public Relations Officer	031 225 7534
p	Scottish Development Agency Crafts Manager	031 337 9595
T	Fruitmarket Gallery Education Officer	031 225 2383
P Tt	City Art Centre Assistant Keeper (temporary exhibitions)	031 225 2424 x 6650

EXETER **P Tt** Royal Albert Memorial
Museum, Devon
Education Officers — 0392 56724

FALMOUTH **P T** Falmouth Art Gallery,
Cornwall
Curator — 0326 313863

GATESHEAD **Pp Tt** Shipley Art Gallery, Tyne &
Wear
Group Education Officer — 0632 327734

GLASGOW **Pp Tt** Art Gallery & Museum,
Kelvingrove
Museum Education Officer — 041 334 1131

P t Hunterian Art Gallery,
Glasgow University
Curator — 041 339 8855 x 7431

Tt Third Eye Gallery
Director — 041 332 1132

GUERNSEY **P T** Guernsey Museum & Art
Gallery, Channel Islands
Education Officer — 0481 26518

GUILDFORD **P Tt** Guildford House Gallery,
Surrey
Exhibitions Officer — 0483 503406

HALIFAX **P T** Piece Hall Pre-Industrial
Museum & Art Gallery,
West Yorkshire
Art Education Officer — 0422 59031

HARTLEPOOL	**P T**	Gray Art Gallery & Museum, Cleveland Keeper of Art	0429 66522 x 259
HASTINGS	**P Tt**	Hastings Museum & Art Gallery, East Sussex Curator	0424 435952
HUDDERSFIELD	**P Tt**	Huddersfield Art Gallery, West Yorkshire Senior Curator	0484 513808
IPSWICH	**Pp** **Tt**	Museum & Art Gallery, Suffolk Education Liaison Officer	0473 213761
JARROW	**T**	Bede Gallery, Tyne & Wear Director	091 489 1807
JERSEY	**T**	The Jersey Museum, Channel Islands Director	0534 75940
KENDAL	**Pp** **Tt**	Abbot Hall Art Gallery, Cumbria Education Officer	0539 22464
KING'S LYNN	**Tt**	Fermoy Art Gallery, Norfolk Exhibition Organiser	0553 774725
KINGSTON UPON HULL	**P Tt**	Ferens & Posterngate Art Galleries, North Humberside Senior Keeper	0482 222750
LEEDS	**P Tt**	Leeds City Art Gallery, West Yorkshire Senior Assistant Keeper of Education	0532 462495
	p t	Lotherton Hall, West Yorkshire Keeper	0532 813259
LEICESTER	**Pp** **Tt**	Leicestershire Museum & Art Gallery, Leicestershire Keeper of Education	0533 554100
LINCOLN	**P Tt**	Usher Gallery, Lincolnshire Assistant Keeper of Art	0522 27980

LIVERPOOL	t	Bluecoat Gallery, Merseyside Director	051 709 5689
	P t	Walker Art Gallery Education Officer	051 227 5234 x 2064
	P t	Lady Lever Art Gallery Education Officer	051 227 5234 x 2064
	P	Sudley Art Gallery Education Officer	051 227 5234 x 2064
	Pp Tt	Merseyside County Museums, Lancashire Keeper of Education Services	051 207 0001
LLANDUDNO	T	Mostyn Art Gallery Director	0492 79201
LONDON	Tt	Art Gallery, Camden Education Officer	01 278 7751
	P T	Barbican Art Gallery Assistant Keeper	01 638 4141 x 306/346
	Pp	British Museum, Great Russell Street Head of Education	01 636 1555/8
	T	Camden Arts Centre The Administrator	01 435 2643
	Pp Tt	Commonwealth Institute, Kensington Education Centre	01 603 4535
	p T	Courtauld Institute Galleries, Bloomsbury Curator	01 580 1015
	p t	Crafts Council, Piccadilly Circus Education Officer	01 930 4811
	P	Dulwich Picture Gallery Keeper	01 693 5254
	T	Hayward Gallery, South Bank Gallery Superintendent	01 928 3144
	Tt	ICA (Institute of Contemporary Arts) Director of Exhibitions	01 930 0493

P	The Iveagh Bequest, Kenwood Assistant Curator	01 348 1286
P	Marble Hill House, Twickenham Assistant Curator	01 348 1286
Pp	Ranger's House, Blackheath Assistant Curator	01 348 1286
Pp	Museum of London, Barbican Education Officer	01 600 3699
p t	Museum of Mankind, Piccadilly Education Officer	01 437 2224/8
P	National Gallery, Trafalgar Square Schools Officer	01 839 3321
P	National Portrait Gallery, St Martin's Lane Education Officer	01 930 1552
P T	Orleans House Gallery, Twickenham Assistant Curator	01 892 0221
	Photographers Gallery, Covent Garden Administrative Director	01 240 5511/2
P	The Queen's Gallery, Buckingham Palace Education Officer	01 930 4832
T	Riverside Studios, Hammersmith Education Officer	01 741 2251
T	Royal Academy of Arts, Piccadilly Education Officer	01 734 9052
T	Serpentine Gallery, Kensington Park Gallery Organiser	01 402 6075

P	South London Art Gallery, Camberwell Keeper	01 703 6120	
P	Tate Gallery, Millbank Curator (Education)	01 821 1313	
Pp t	Victoria & Albert Museum, S. Kensington Education Department	01 589 6371	
P	The Wallace Collection, W1 Assistant to the Director	01 935 0687	
	Whitechapel Art Gallery, Whitechapel Community Education Officer	01 377 0107	
t	William Morris Gallery, Walthamstow Assistant Keeper	01 527 5544 x 4390	
	Woodlands Art Gallery, Blackheath Art Gallery Assistant	01 858 4631	

MAIDSTONE	P Tt	Maidstone Museum & Art Gallery, Kent Keeper of Fine Arts	0622 54497
MANCHESTER	P Tt	City Art Gallery Education Department	061 236 9422
	Tt	Cornerhouse Education Officer	061 228 7621
	P Tt	Whitworth Art Gallery Gallery Services Officer	061 273 4865
MILTON KEYNES	Tt	Milton Keynes Exhibition Gallery, Buckinghamshire Education Assistant	0908 605538
MOLD	T	Theatre Clwyd, Clwyd, Arts and Exhibitions Officer	0352 56331
NEWCASTLE UPON TYNE	T	The Hatton Gallery Exhibitions Director	0632 28511 x 2047
	p Tt	Laing Art Gallery Art Education Officer	0632 327734/326989

NEWPORT, GWENT	**Pp** **Tt**	Newport Museum & Art Gallery, Gwent Schools Service Officer	0633 840064
NEWPORT, IOW	**t**	The Quay Arts Centre, Isle of Wight Director	0983 528825
NORTHAMPTON	**Pp**	Northampton Museums & Art Gallery, Northamptonshire Keeper of Education and Extension Services	0604 34881 x 395
NORWICH	**P Tt**	Castle Museum, Norfolk Museums Education Officer	0603 611277 x 279
	Tt	School of Art Gallery, Norfolk Gallery Curator	0603 610561
	P Tt	Sainsbury Centre for the Visual Arts, Norfolk Assistant Keeper	0603 56161 x 2465/68
NOTTINGHAM	**P Tt**	Castle Museum Education Officer	0602 411881
	Tt	Midland Group Exhibitions Organiser	0602 582636
OLDHAM	**P Tt**	Oldham Art Gallery, Greater Manchester Curator (Art Gallery)	061 624 0505
OXFORD	**P Tt**	Ashmolean Education Officer (voluntary)	0865 512651
	Tt	Museum of Modern Art Education Officer	0865 722733
	P	Christ Church Picture Gallery Assistant Curator	0865 242102
PAISLEY	**p t**	Museum & Art Gallery, Scotland Education Officer	041 889 3151
PENZANCE	**P Tt**	Newlyn Orion Galleries Ltd, Cornwall Director	0736 3715

PERTH	Pp Tt	Museum & Art Gallery, Scotland Education Officer	0738 32488
PETERBOROUGH	P Tt	City Museums & Art Gallery, Cambridgeshire Assistant Curator (Exhibitions and Fine Art)	0733 43329
	t	Lady Lodge Arts Centre, Cambridgeshire Exhibitions Organiser	0733 237073
PLYMOUTH	Pp Tt	City Museum & Art Gallery, Devon Keeper of Art	0752 668000 x 4378
	Pp Tt	Arts Centre, Devon Official Art Co-ordinator	0752 660060
PORTSMOUTH	Pp t	Portsmouth City Museum & Art Gallery, Hampshire Education Services Officer	0705 827261
PRESTON	P Tt	Harris Museum & Art Gallery, Lancashire Education Officer	0772 58248
READING	P	Reading Museum & Art Gallery, Berkshire School Liaison Officer	0734 55911 x 2242
ROCHDALE	P Tt	Art Gallery, Greater Manchester Assistant Art and Exhibition Officer	0706 47474 x 764
ROTHERHAM	T	Art Gallery, South Yorkshire Keeper, Fine and Applied Art	0709 2121
ST IVES	P	Barbara Hepworth Museum, Cornwall Curator	0736 796226
	P	Penwith Gallery, Cornwall Curator	0736 795579
SALFORD	P T	Salford Museum & Art Gallery, Greater Manchester Assistant Keeper of Art	061 736 2649

SCARBOROUGH	**P**	Crescent Art Gallery, North Yorkshire Curator of Art	0723 374753
SHEFFIELD	**p Tt**	Graves Art Gallery, South Yorkshire Education Officer	0742 734781
	P Tt	Mappin Gallery, South Yorkshire Education Officer (based at Graves Art Gallery)	0742 26281
SOUTHAMPTON	**Pp** **Tt**	Art Gallery, Hampshire Art Education Officer	0703 832769
	Tt	John Hansard Gallery, Hampshire Art Education Officer	0703 559122 x 2158
SOUTHPORT	**P Tt**	Atkinson Art Gallery, Merseyside Keeper of Fine Art	0704 33133 x 129
STALYBRIDGE	**P T**	Astley Cheetham Art Gallery, Greater Manchester Museums Officer	061 338 2708
STOCKPORT	**P Tt**	Stockport War Memorial and Art Gallery, Greater Manchester Education Office	061 480 9433
STOKE ON TRENT	**Pp** **Tt**	City Museum & Art Gallery, Staffordshire Keeper of Art	0782 273173
STROMNESS	**P**	Pier Arts Centre, Orkney Curator	0856 850209
STYAL	**p t**	Quarry Bank Mill, Cheshire Museum Education Officer	0625 527468
SUDBURY, DERBYSHIRE	**Pp**	Museum of Childhood, Sudbury Hall, Derbyshire Assistant Curator (Education)	028 378 305
SUDBURY, SUFFOLK	**P Tt**	Gainsborough's House, Suffolk Curator	0787 72958

SUNDERLAND	**P T**	Sunderland Museum & Art Gallery, Tyne & Wear Group Education Officer	0783 41235
SWANSEA	**Pp** **Tt**	Glynn Vivian Art Gallery & Museum, West Glamorgan Education Officer	0792 55006/51738
SWINDON	**P Tt**	Swindon Museum & Art Gallery, Wiltshire Assistant Curator	0793 26161 x 3129
WAKEFIELD	**P**	Wakefield Art Gallery, West Yorkshire Keeper of Art	0924 370211 x 8031
	Tt	Elizabethan Exhibition Gallery, West Yorkshire Keeper of Art	0924 370211 x 8031
WALSALL	**P Tt**	Walsall Museum & Art Gallery, West Midlands Keeper of Fine Arts	0922 21244 x 3124
WIGAN	**t**	Drumcroon Education Art Centre Education Officer	0942 321840/33303
	Tt	Turnpike Gallery, Leigh Gallery Officer	0942 679407
WOLVERHAMPTON	**P Tt**	Wolverhampton Art Gallery, West Midlands Assistant Keeper, Fine Art	0902 24549
WOODSTOCK	**p t**	Oxfordshire County Museum, Oxfordshire Education Officer (Art & Craft)	0993 811456
WORCESTER	**P Tt**	City Museum & Art Gallery, Hereford & Worcestershire Education Officer	0905 25371
WORTHING	**P Tt**	Worthing Museum & Art Gallery, West Sussex Curator	0903 39999 x 121
WREXHAM	**Tt**	Wrexham Arts Centre, Clwyd, Wales Visual Education Advisory Teacher	0978 261932

YORK **Pp T** York City Art Gallery 0904 23839
 Art Assistant

 T Impressions Gallery of 0904 54724
 Photography and Events
 Co-ordinator

Index